Coral Gardens

Also by Leni Riefenstahl

THE PEOPLE OF KAU
THE LAST OF THE NUBA

Coral Gardens

PHOTOGRAPHS, TEXT
AND LAYOUT BY

Leni Riefenstahl

Translated from the German
by Elizabeth Walter

Harper & Row, Publishers
New York, Hagerstown, San Francisco, London

This book is dedicated to

DOUGLAS FAULKNER

underwater photographer
of genius

Contents

HOW I BECAME A DIVER

In October 1972 chance made me acquainted with the secret world beneath the sea.

On the last day of my holiday in Malindi on the shores of the Indian Ocean I saw the word 'goggling' scrawled in chalk on a blackboard. I learned that 'goggling' meant snorkeling. Although as a child I had been constantly in and out of the water, I had since had little opportunity for swimming as I had spent all my free time in the mountains. Climbing and ski-ing were my main hobbies.

In the Hotel Eden Roc I joined a group of snorkelers, and we took a boat out with the ebbing tide. After about half an hour I saw peaks of coral projecting above the water. Several boats from other hotels were already anchored at this spot. We joined them, and masks, snorkels and fins were given out.

When I first viewed the underwater world through a mask I was enchanted by the multicoloured fish which swam unperturbedly around us. I could not see enough. I was dazzled by the abundance of different fish, their incredible colours, the infinite variety of their shapes, and the fantastic patterns and ornaments which adorned them. Slowly I began following certain fish, but they soon vanished under the coral. Then a group of three large ruby-red

fish sailed past me and I was able to follow them for some time. But they too disappeared into a little grotto. I tried to dive deeper, but I always surfaced again. As I was very anxious to see the red fish once more, I tried to cling to the coral after I had dived. The fish regarded me curiously under the water. Unfortunately I could only remain submerged very briefly because I could not hold my breath long enough. When I sought to cling on again after repeated dives, I had a nasty shock. I had laid hold of something slippery which moved and clung to my hand. Before I realized what was happening, I found myself in a darkened world. The 'coral' was a huge inkfish, which was probably every bit as frightened as I was! My reflex movement caused me to scrape my knees and elbows on the sharp coral, and to swallow a good deal of water.

I now swam very cautiously over the coral, without getting too close. I was watching a big green fish nibbling at the coral when I was aroused by shouts and whistles. All the others were in the boat and only I was still in the water. I could not believe that an hour had gone by already. I had lost all sense of time. What I had seen was so fascinating that I felt I was very unlucky to have discovered it only on the last day of my holiday. I remembered how excited I had been by the films of Hans Habe and Cousteau, but to have experienced something of them for myself was even more exciting. I had only one thought: to go diving again.

A year later I was able to fulfil my wish. This time I flew back to Kenya equipped with my own snorkel, mask and fins. On the first day after my arrival I went snorkeling off the hotel beach. I was just as thrilled as I had been a year earlier. For fourteen days I spent several hours a day in the water, and each time I discovered something new and interesting. I grew accustomed to diving, and realized joyfully that day by day I was finding it easier to dive deeper and remain under water for longer. But it was not enough. I wanted to stay even longer under water, and that would only be possible with a compressed air cylinder. But how to get hold of such a cylinder? A week of my holiday had already gone when I learned that there was a diving school in one of the nearby hotels. I made enquiries there about obtaining a compressed air cylinder, but it was not as simple as that. It was

impossible to obtain one without a diver's certificate, and to hold such a certificate it is necessary to take a diving course lasting several days and pass all the prescribed tests. How could a woman who was past her 71st year take part in such a course? What diving instructor would accept such a risk and enrol so 'young' a pupil? But I was so keen to dive with a compressed air cylinder and be able to remain under water a long time that I racked my brains to find a way of joining the course. So I hit on a little trick. I enrolled in my passport name of Helene Jacob and cheated over my date of birth. Instead of 1902 I put 1922 on the enrolment form. Despite taking twenty years off my age, I was easily the oldest participant. They accepted me on the course with a shrug of the shoulders, and probably thought: she'll never make it.

DIVING TESTS

The diving course began in the large swimming pool of the Turtle Bay Hotel. It was made easier for me by the fact that the instruction was given in German, since it was a diving school belonging to the Poseidon-Nimrod Club of Hamburg. There were about ten of us. My colleague Horst also enrolled. Most of the participants were very young. When I heard how some of these young people complained about the exercises, I had grave doubts whether I should be able to manage them. Indeed, the very first exercise caused me problems. It consisted of clearing the mask under water. The procedure was as follows: dive, remove mask, replace it, clear the water that had accumulated, and resurface. However simple it sounds, it is extremely difficult for a beginner, but it is a very important and indeed indispensable exercise for divers. Then we practised diving and clearing our ears, and taking off and putting on diving equipment in 4 metres of water. The pleasantest and easiest exercise was swimming under water with the compressed air cylinders, during which we practised adjusting our buoyancy and sharing a lung.

In addition to these exercises, the theoretical instruction was very important. This included acquaintance with a diver's metabolism, underwater sign language, first aid for divers, and especially the protection of

[10]

divers against danger. The most common dangers are: currents, 'raptures of the deep', air embolism, bends, and above all panic, which has caused the death of even experienced divers.

Of the tests, I found the 300-metre swim with full diving equipment the most difficult. That nearly finished me. I also had difficulty with the test which had to be carried out on the sea bed at a depth of 10 metres. Unfortunately, on the day of my test the sky was grey and the sea dark and choppy, in contrast to the calm, crystal-clear water of the swimming pool. My heart thudded as I sat on the edge of the boat and gazed at the dark, unfriendly depths into which I had to dive. My diving instructor said to me: 'You'll find me down there by the anchor.' Then he plunged in. Suppressing my fear, I followed him. When I first opened my eyes under water it was dark. I could not see the instructor, but I saw the anchor cable and dived down beside it. I encountered a strong current, and was relieved when I could make out the outline of the instructor awaiting me on the sea bed. Visibility was two metres at most. The instructor took my hand and we swam over the sea bed to a coral reef, where the current was less fierce and we could cling to the coral. Here I had to go through all the exercises learnt in the swimming pool: removing weight belt, compressed air cylinder and mask, replacing them, clearing the mask. Then followed sharing a lung with the instructor, and finally the emergency ascent. I was glad when I clambered into the boat again—I had done it. During the little celebration that evening when the longed-for certificates were presented, I made myself known. When my true age emerged, there was a great shout and it was lavishly toasted.

From now on I was able to take part in diving expeditions to the outer reefs in deep water. What an experience that was. What a contrast to the day of my test. The sea was calm, especially on morning expeditions, and the visibility excellent.

The most delightful thing about diving is floating under water. I think this otherwise unknown sensation of weightlessness which a diver has is one of the main reasons why almost all those who have once experienced it become diving enthusiasts. I too became more and more enchanted with each successive day. At the end of an expedition I was always 'high' and

[11]

waited impatiently for the next. In addition to the pleasurable sensation of floating, I was daily garnering new experience of the underwater world. I did not know which impressed me more: the beautiful undersea flora, or the dwellers in the deep. To me it was a fairytale world. I shall never forget the experience of switching on a diver's headlamp for the first time at a depth of 35 metres and letting the light play on the coral walls which gleamed with breathtaking colour. For those unfamiliar with the underwater world, I should explain that colours disappear at a depth of 10 metres. The deeper you go, the more the underwater landscape appears blue-green. But even this blue-green twilit landscape is fascinating; it grows on you imperceptibly. The profound silence which reigns in the deep heightens still further the experience of diving.

DIVING IN THE RED SEA

Ayear later I had the opportunity to go diving in the Mecca of all divers, the highly esteemed Red Sea. Port Sudan was only two hours' flying time from Khartoum, where I was staying after an expedition to the Sudan. I joined a diving group from Munich, who were making daily expeditions from Port Sudan to the outer reefs. The group consisted mainly of men, with one or two women. When I noticed that the men talked of nothing but sharks, I was extremely frightened. The captain was instructed to seek out those reefs where there was the greatest likelihood of finding sharks. I had never yet encountered a shark in the Indian Ocean. I had seen huge morays, barracudas, and other large fish, but they were not dangerous. I must admit that I was very scared of encountering a shark. Fortunately the divers were disappointed: there was a marked absence of sharks. Throughout the two weeks we spent diving on the wonderful coral reefs, we only occasionally saw a few sharks going past at a safe distance. As I kept as close as possible to the coral reefs, I soon lost my fear.

The one dangerous situation in which I found myself was due to my own inexperience, not to sharks. In the Indian Ocean the water is warm enough to permit diving in a bikini; in the Red Sea, by contrast, the water is cold enough to make a wet suit essential. On my first dive in one of these

neoprene suits, I made a serious error and weighted myself too heavily. Another woman diver had been wearing the same lead weights, but I did not then know that this lady had been wearing an adjustable buoyancy life jacket which enabled her to adjust her buoyancy at any depths. I did not have such a jacket.

At all events, I shall never forget that dive. When I was about 25 metres under, I noticed that I was being drawn down steadily deeper. It took all my strength to stop myself sinking further. Luckily I found myself near a vertical wall of coral, and I could pull myself up by that, thus avoiding the jettisoning of my weight belt.

A few hours later I dived again. This time I carried less than half the previous weight, and all was well. We dived on the wreck of the *Umbria* which Cousteau and Hans Habe have made famous. Despite poor visibility, it was possible to observe between the ship's coral-encrusted ribs many beautiful fish which have made this long-sunken wreck their home.

From now on I grew more and more confident with every dive. Each day was devoted to a different reef, and each day afforded fresh impressions and experiences. The variety of the corals in the Red Sea is exceptional. I had acquired a little Konica camera, with which I took my first underwater photographs. The results were no more than a few pleasant souvenir pictures. I was still far too occupied with diving to be able to concentrate on photography, and I suspected it was going to be very difficult to capture on film what I had seen with my own eyes.

IN THE CARIBBEAN

Six months later I had the chance to get to know yet another diving centre. This was the island of Roatan in the Caribbean, which belongs to Spanish Honduras. There are some outstandingly beautiful and still relatively undisturbed diving grounds there. The journey was long and rather difficult, but when we arrived in the Land-Rover which took us from the small landing-strip to the other side of the hilly island, we were impressed by the natural tropical vegetation. The underwater world was equally beautiful, though different again from that of the Indian Ocean or the Red Sea. The water was very calm and clear. The many large sea-fans which swayed to and fro in the slight current were particularly striking. The underwater flora here seemed to be even more luxuriant and varied.

On my very first dive I was able to observe a splendid large sand shark. He lay motionless on the floor of a deep canyon. We approached him cautiously. Just as we could almost touch him, he suddenly roused himself and swam off.

One particular grotto provided me with yet another memorable experience. It was reached by way of a long dark tunnel. When the grotto was entered from this pitch darkness, the effect was overwhelming. It was like being in a cathedral. Through the openings in the high roof of the grotto

streamed the noonday sun. Its beams pierced the deep blue water in which shoals of tiny fish were moving; they glittered silver when the sunbeams caught them.

The underwater world here was like a unique film set. I was looking forward to trying out my new Nikonos II camera soon, but it was not to be. The strongest hurricane for a hundred years laid waste the island and, as we learned later, large areas of the mainland also. The hours we spent on the island during this crazy storm were terrifying. When the storm had passed and we ventured out of the main building, we saw a devastated landscape. Huge old trees had been uprooted, or their mighty trunks snapped in two. The hurricane had destroyed the whole of the roof and the first floor of the building in which we had sat it out. The rest of the building had also been badly damaged by the hours of tropical downpour. On the mainland the death toll of Hurricane 'Fifi' reached over 10,000.

Naturally, there was no more thought of diving now. We were thankful to have survived this dreadful natural disaster without damage.

After a further year's interval, in the summer of 1975, I was again able to find time to go diving. This time I chose Spanish Bay Reef, a diving resort on the island of Grand Cayman in the Caribbean. Here only divers congregated. Among them were some good underwater photographers and also a marine biologist, so there were some very interesting discussions on diving and related subjects. For me, the time I spent at Spanish Bay Reef was the equivalent of another course. I found the marine biologist's illustrated talks particularly instructive. Whereas I had so far concentrated on large fish and corals during my dives, I now began to take an interest in the many tiny forms of plant and animal life which I had never previously noticed. When I went diving now, I saw my surroundings with new eyes. Every dive was a thrilling experience. For the first time too I was able to go night diving. It is quite a sensation to plunge into the dark water at night and see in the beam of an underwater torch sleeping fish almost within touching distance. I also discovered fish and plants which I had never seen by day.

I took photographs on every dive. But I noticed that with one lens— I had only a 35 mm.—it was quite impossible to photograph everything.

[16]

In particular I lacked a wide-angle lens and a macro lens. I also confirmed my suspicion that underwater photography is infinitely more difficult than surface photography. Water is a very different medium from air, where there are no problems in obtaining definition and the correct lighting. I endeavoured to extend my knowledge of underwater photography by reading specialist works. I kept an album of my photographs in order to learn from my mistakes. When I saw my films developed after my return, I was so disappointed that I was tempted to give up altogether. But I could not leave it alone. I was already hooked. I acquired additional underwater photographic equipment and was able to achieve better results on subsequent diving expeditions.

Among new diving centres, the Virgin Islands impressed me particularly, especially when I dived on the famous wreck of the *Rhône*. Later, the underwater photography for the Hollywood film *The Deep* was done here. The diving grounds off the Turks and Caicos Islands in the Caribbean also linger in my memory, where, in autumn 1977, I took my last underwater pictures for the present volume.

RUINED REEFS

Other diving grounds were by contrast very disappointing. I dived on famous reefs which divers had guaranteed swarming with fish, but all I found were a few small fish who were so frightened that they took refuge in their coral caves as soon as they caught sight of a diver. The reefs appeared to be extinct. What had happened? In the few years between my visit and that of my delighted informants, the fish on the reef had been shot. I made the same painful discovery when, after a three-year interval, I revisited the reefs I had known in the Red Sea. I did not recognize the underwater life on these reefs. The many large fish which I had previously seen there had vanished. In four weeks I did not see a single large specimen. The fish had not been exterminated by native fishermen, nor by divers who occasionally caught a fish to enliven their diet. They had been exterminated simply and solely by 'specialist' diving groups, which in so short a time had tragically decimated the reef's fish population. They brought with them bundles of the most up-to-date harpoons and simply shot everything in the water that moved. Many of them took part in competitions, in which the number of fish shot was taken into account, as well as their size and weight. The champion was the one with the most fish; it did not matter whether these were tiny butterflyfish or angelfish. I encountered these

[18]

'supermen' everywhere—in the Virgin Islands, the Grenadines, and in Tanzania's Mafia Island in the Indian Ocean. In the evenings on the beach they proudly displayed their booty. It consisted for the most part of tiny coral fish, hopelessly mutilated by harpoons. As a rule they were thrown straight back into the water.

Unfortunately governments often do not learn until much too late of the great damage inflicted by these diving groups and their harpoons. After the reefs are fished out, not only do the 'specialist' groups stay away, but also all the other serious divers, who come merely to observe, to photograph or to film. For who wants to dive on an already denuded reef?

Only very rigorous action can save the diver's paradise at this late date. There must be a worldwide ban on harpooning, regardless of any outcry by harpoon manufacturers and the clubs which persist in regarding underwater harpooning as a form of 'sport'. So I should like to take this opportunity of begging all those concerned about the preservation of the underwater world to leave their harpoons at home. The pollution of the sea is getting steadily worse, thanks to refuse and oil from tankers. We divers must see to it that at least the marvels of the coral world are not completely destroyed. Anyone who has once experienced this magical world will understand my plea.

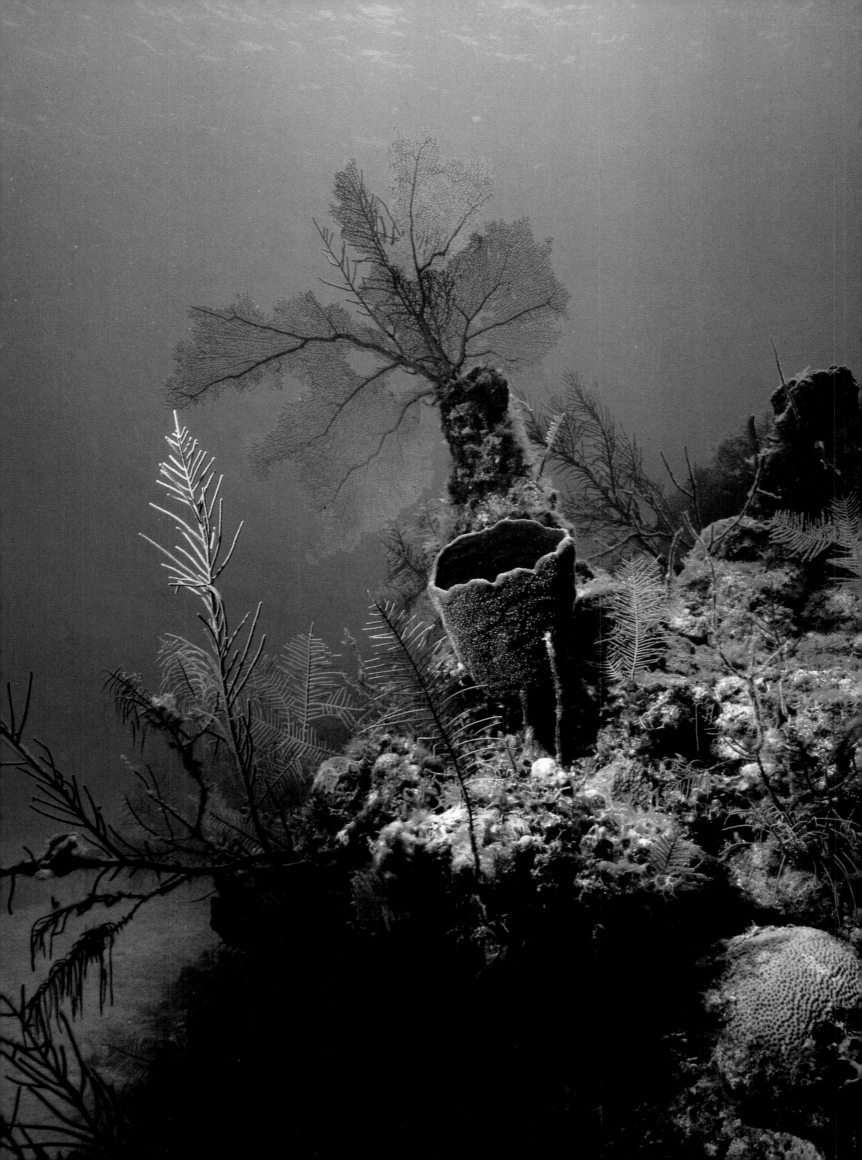

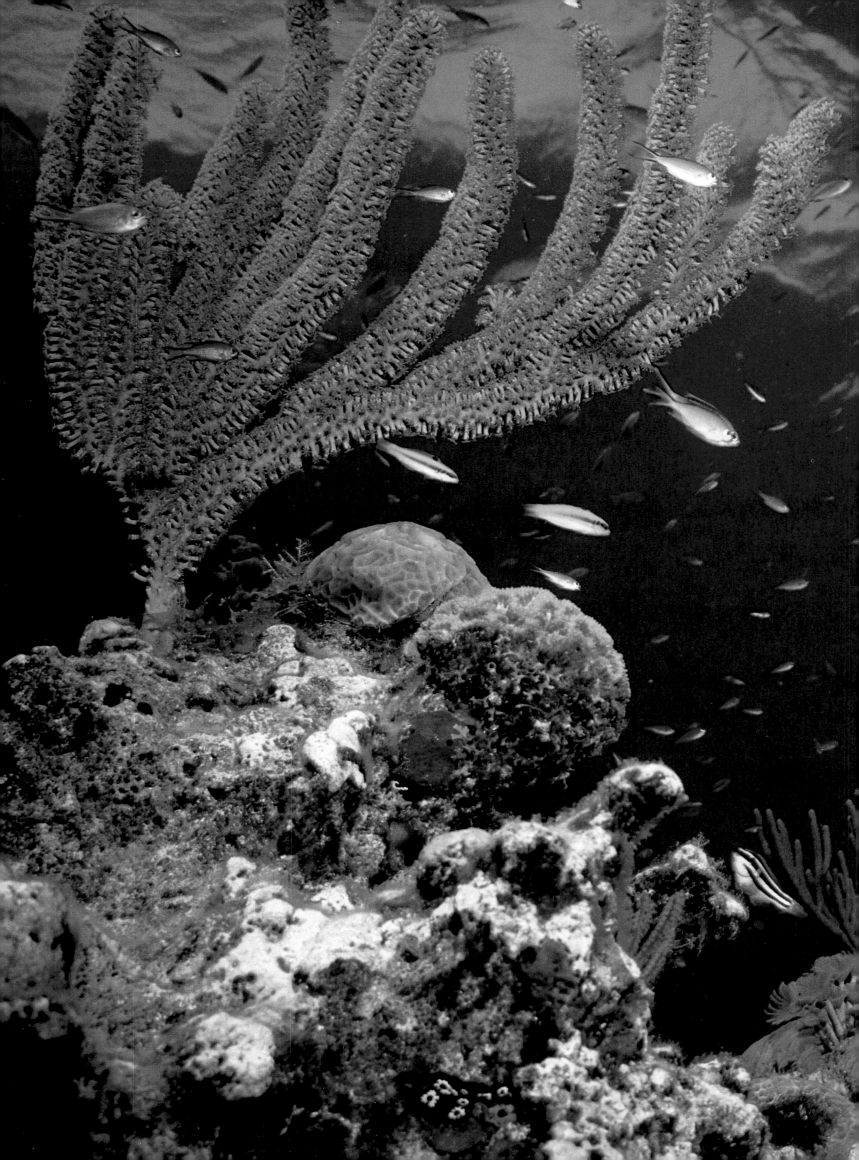

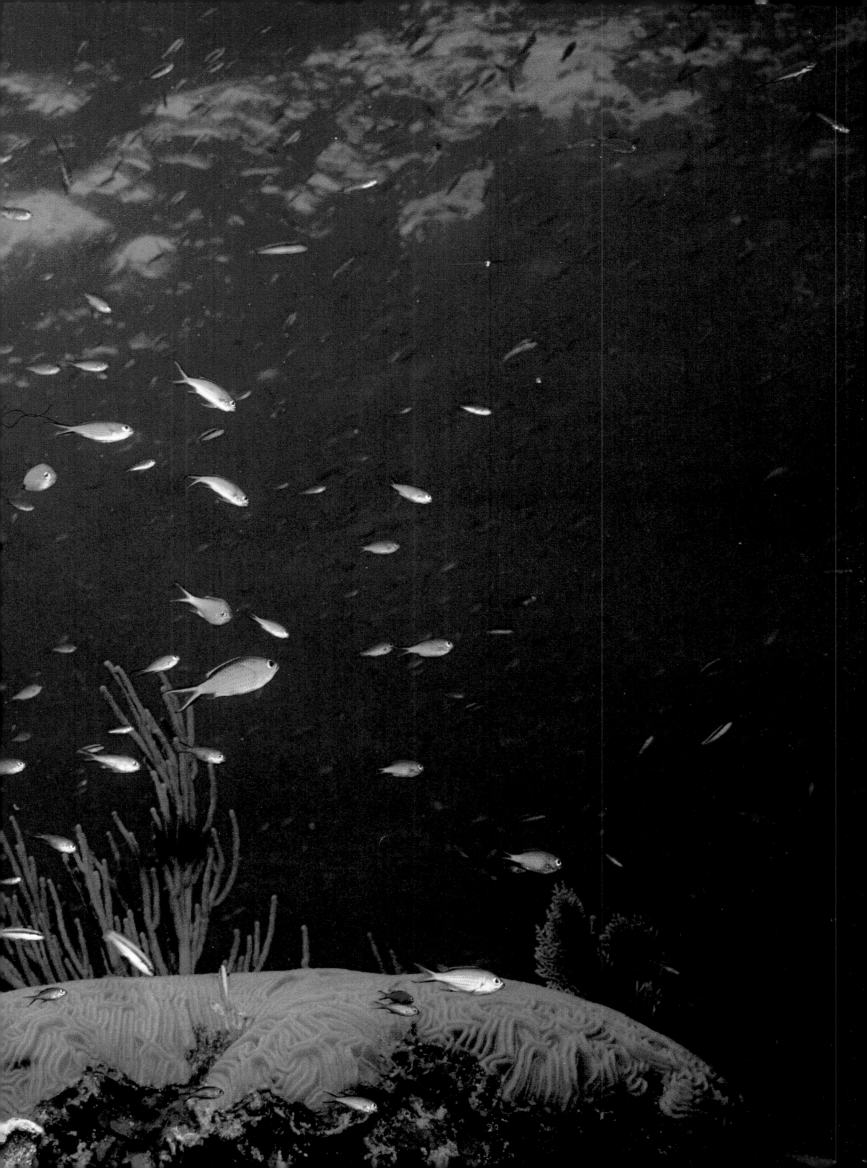

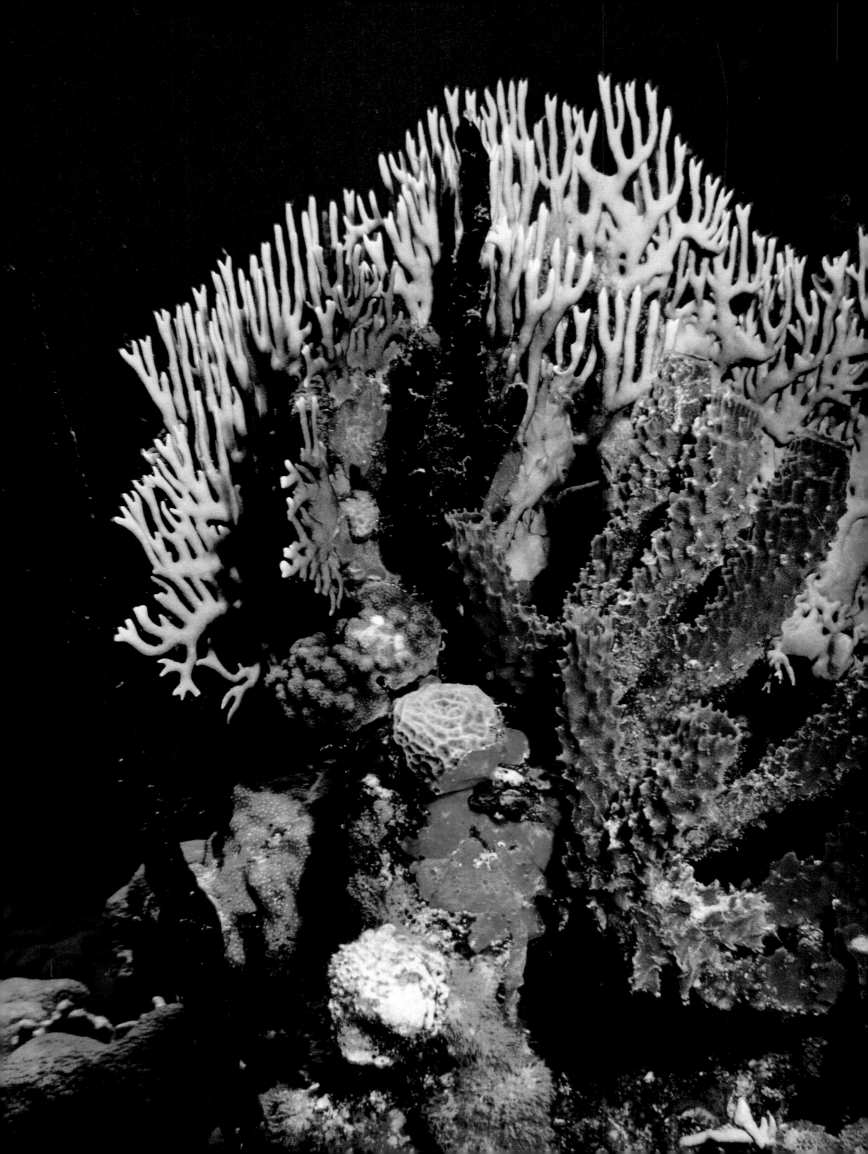

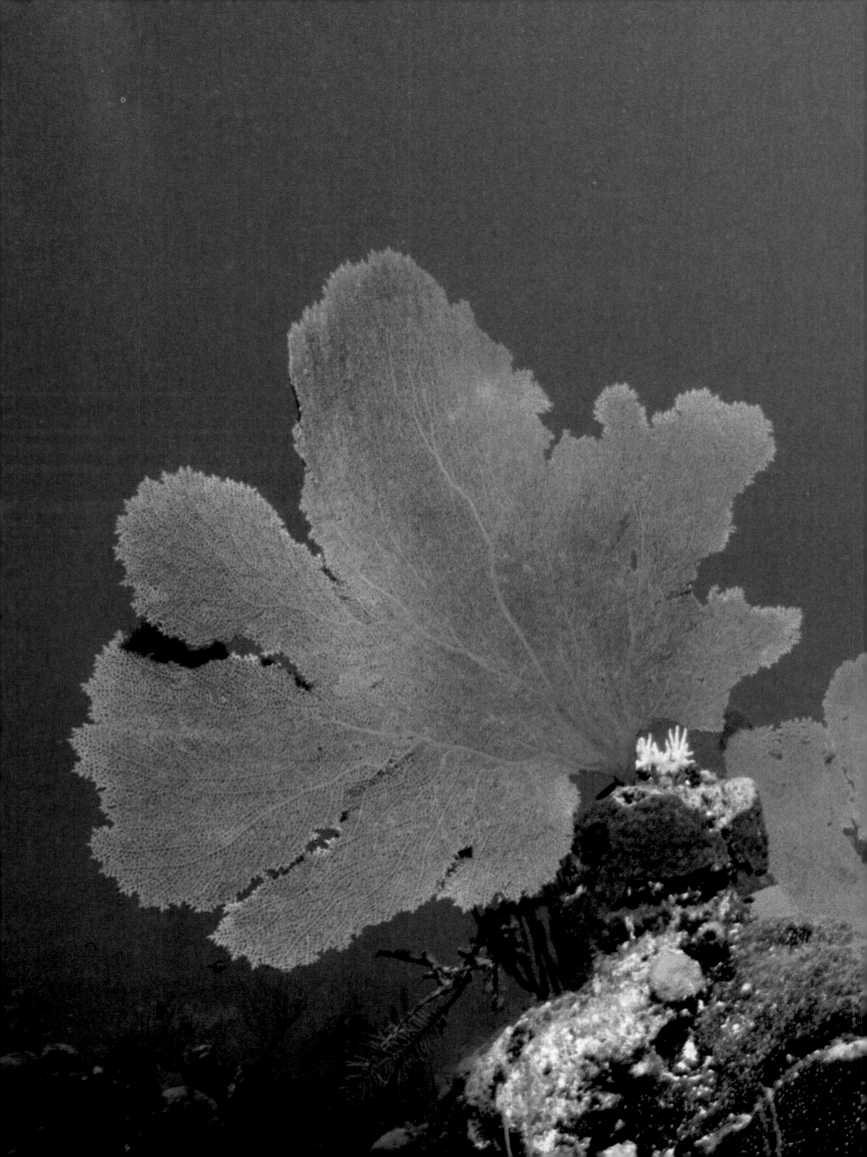

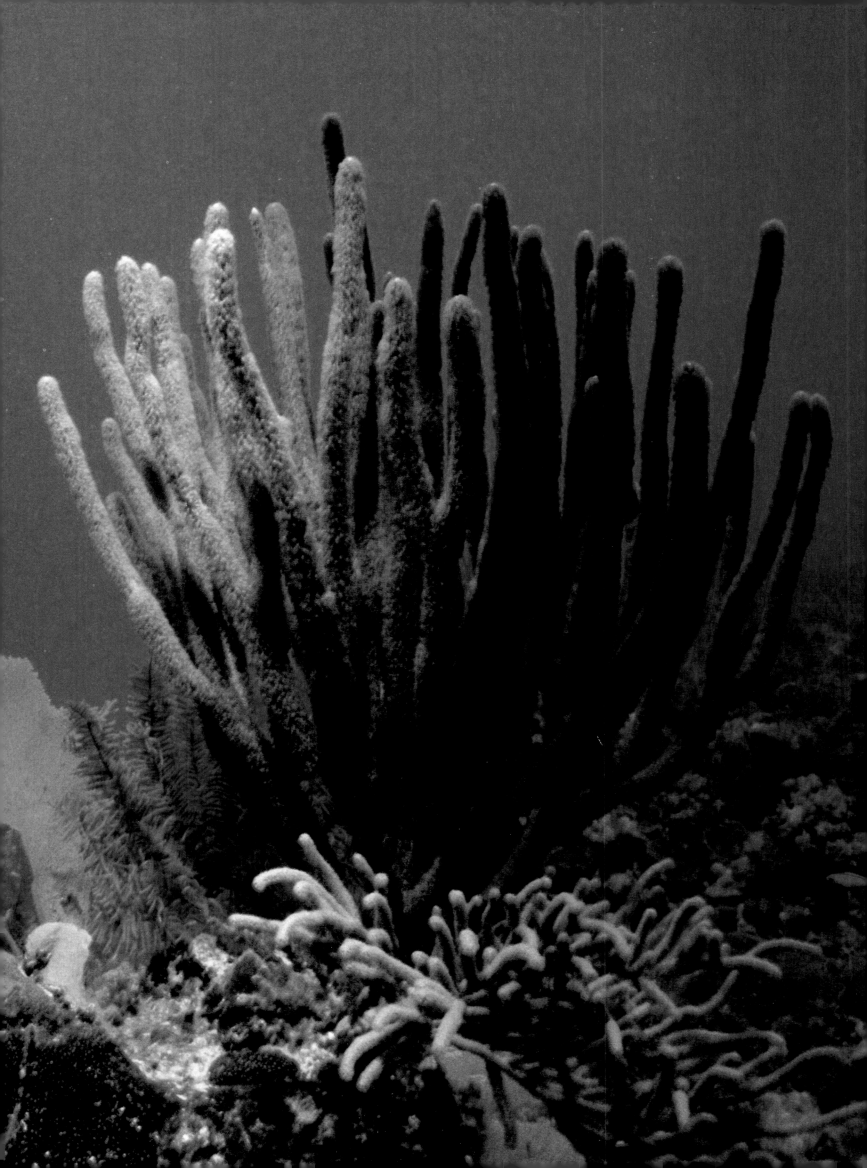

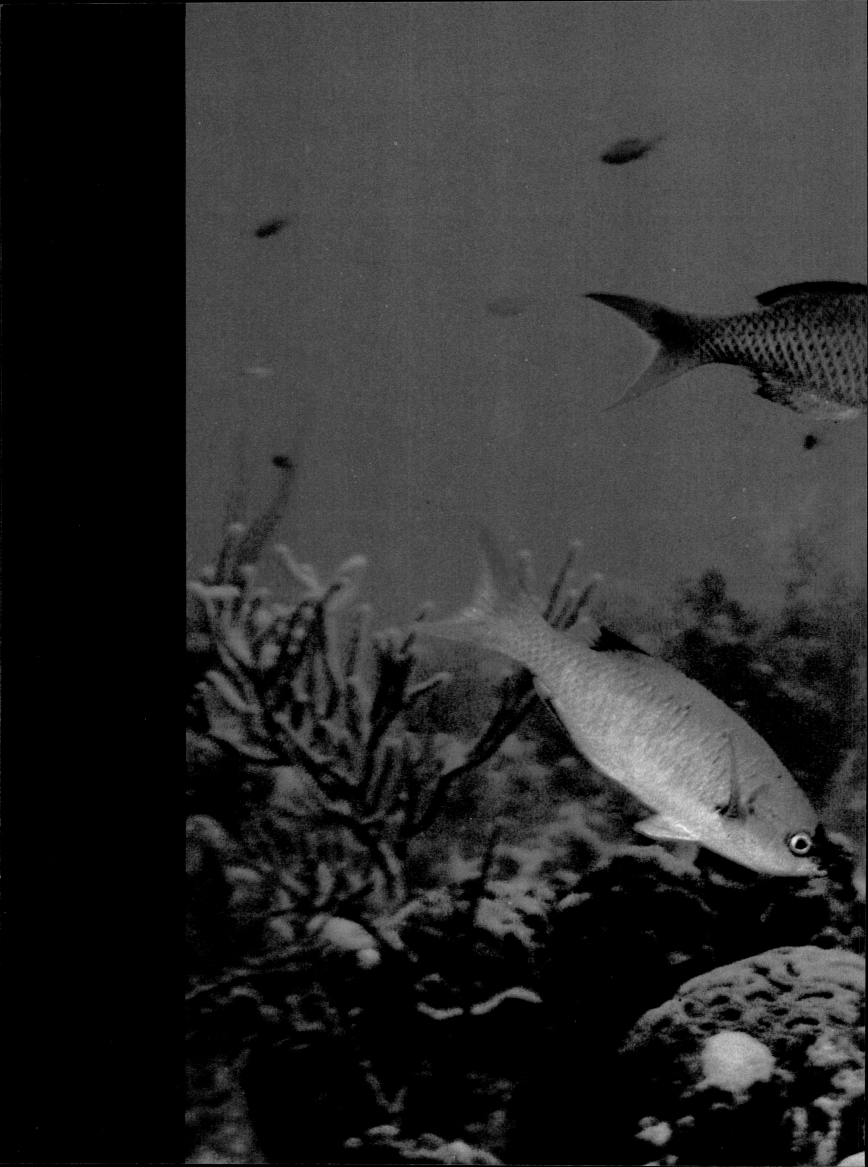

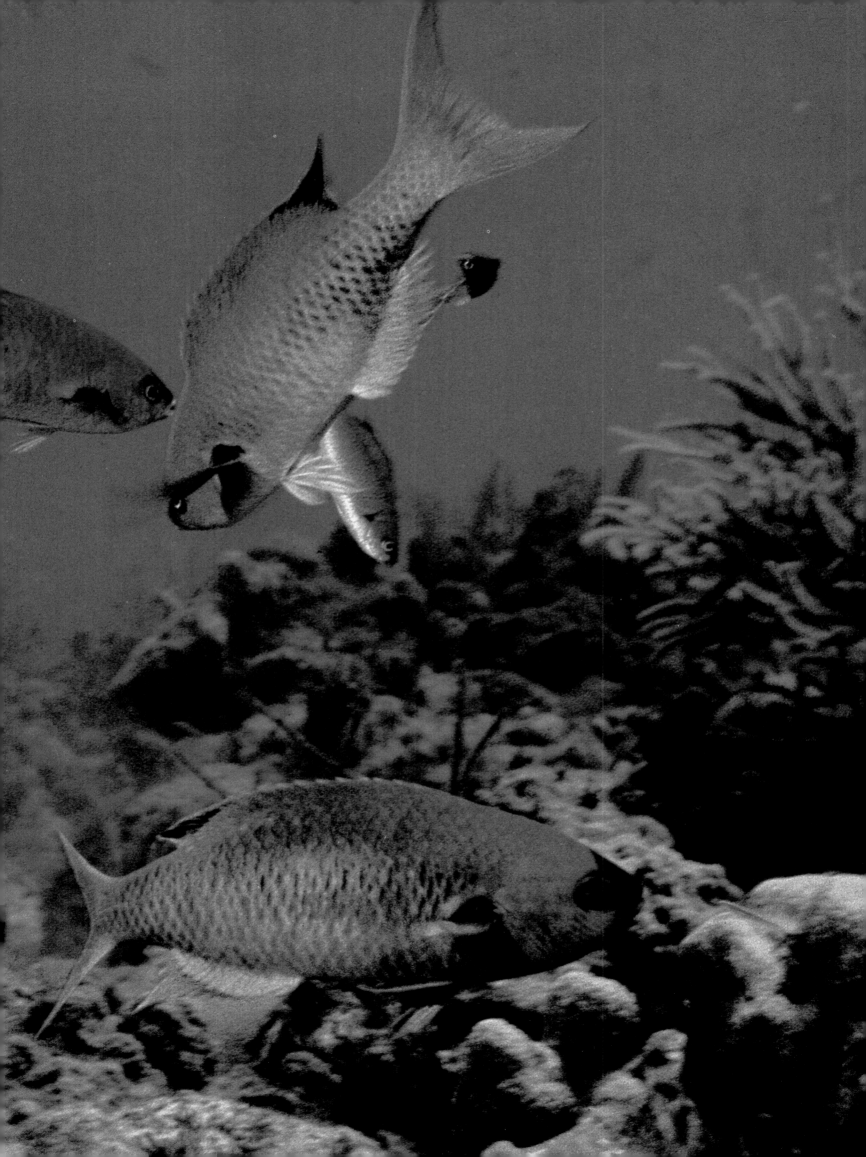

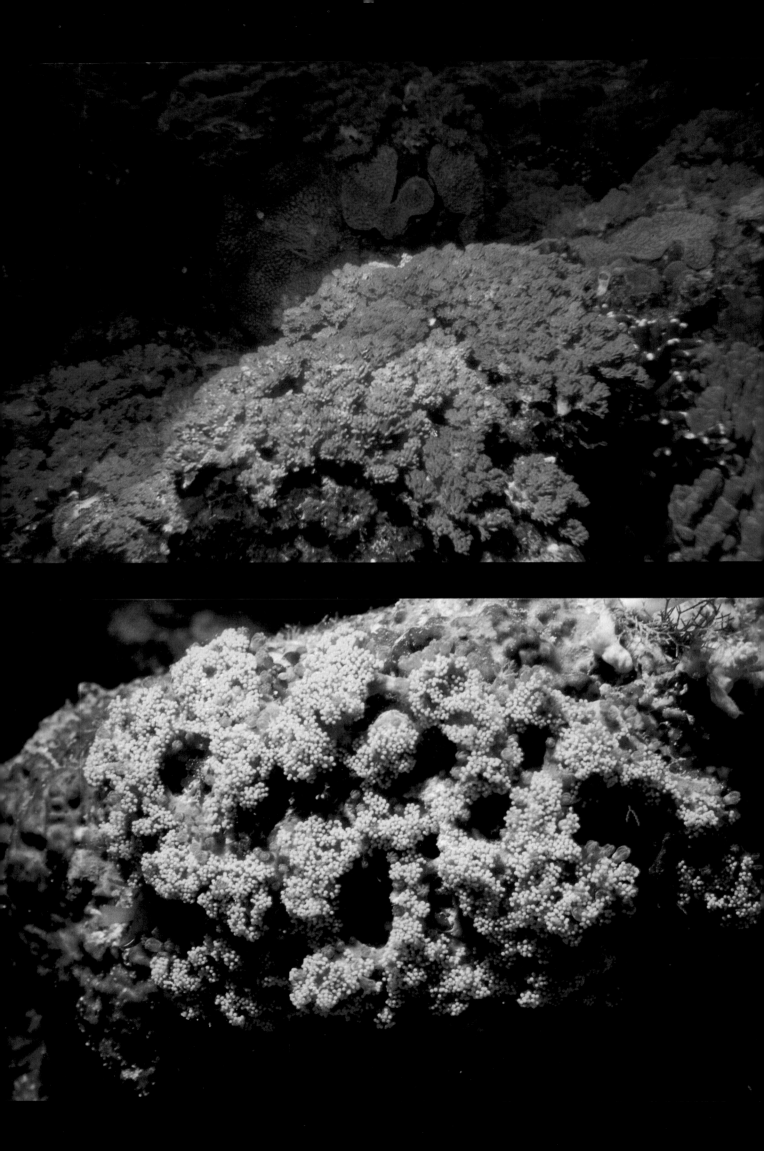

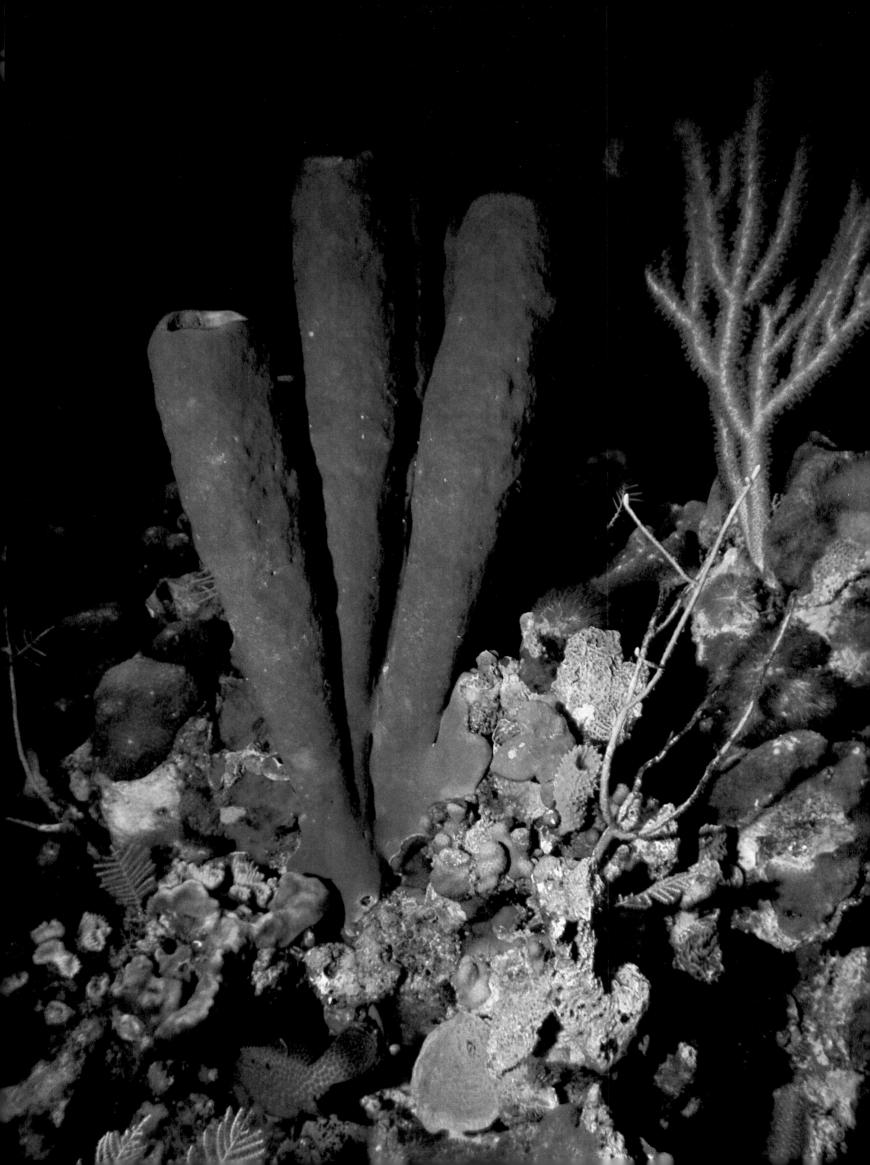

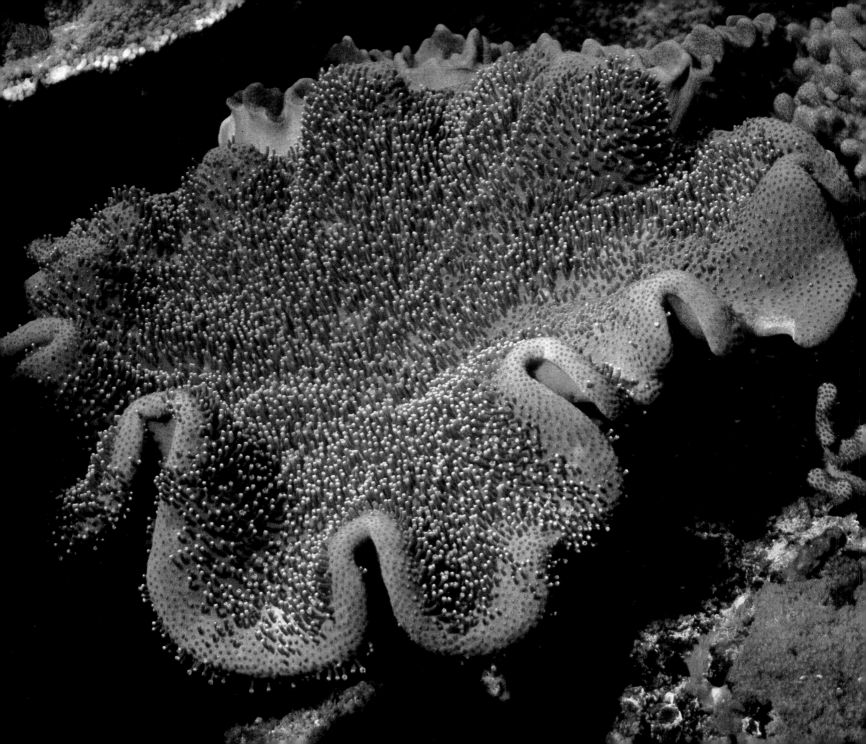

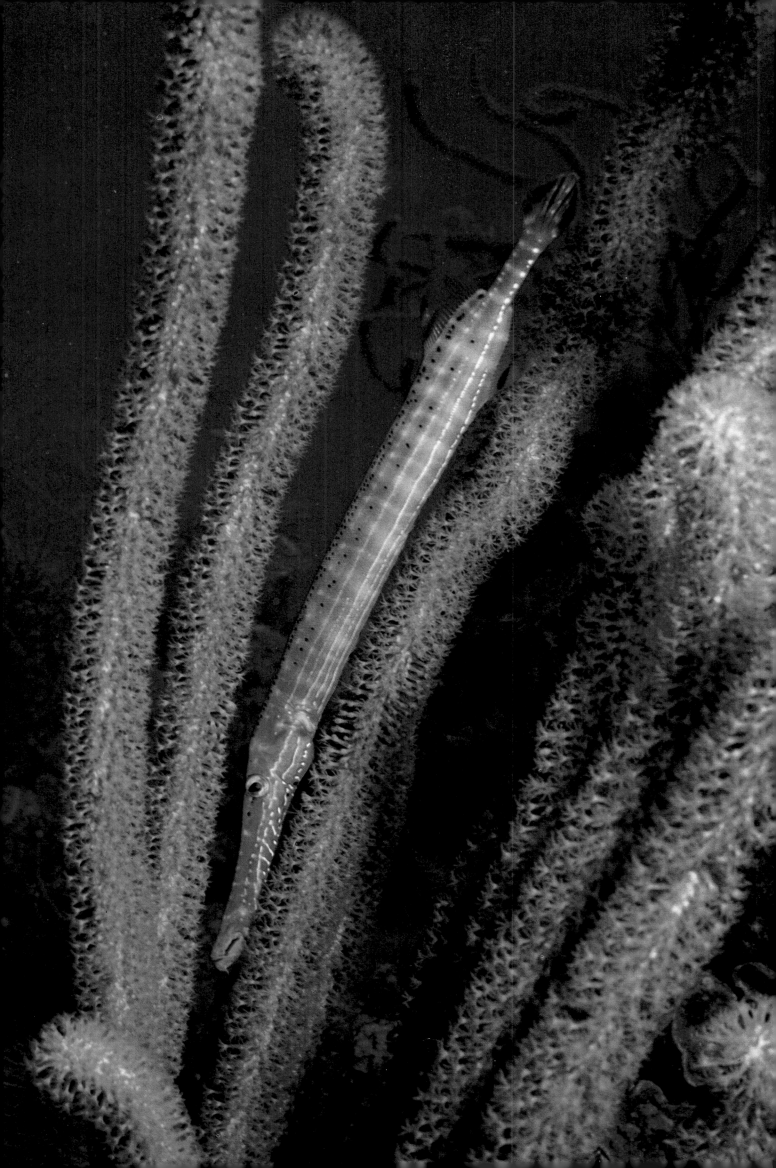

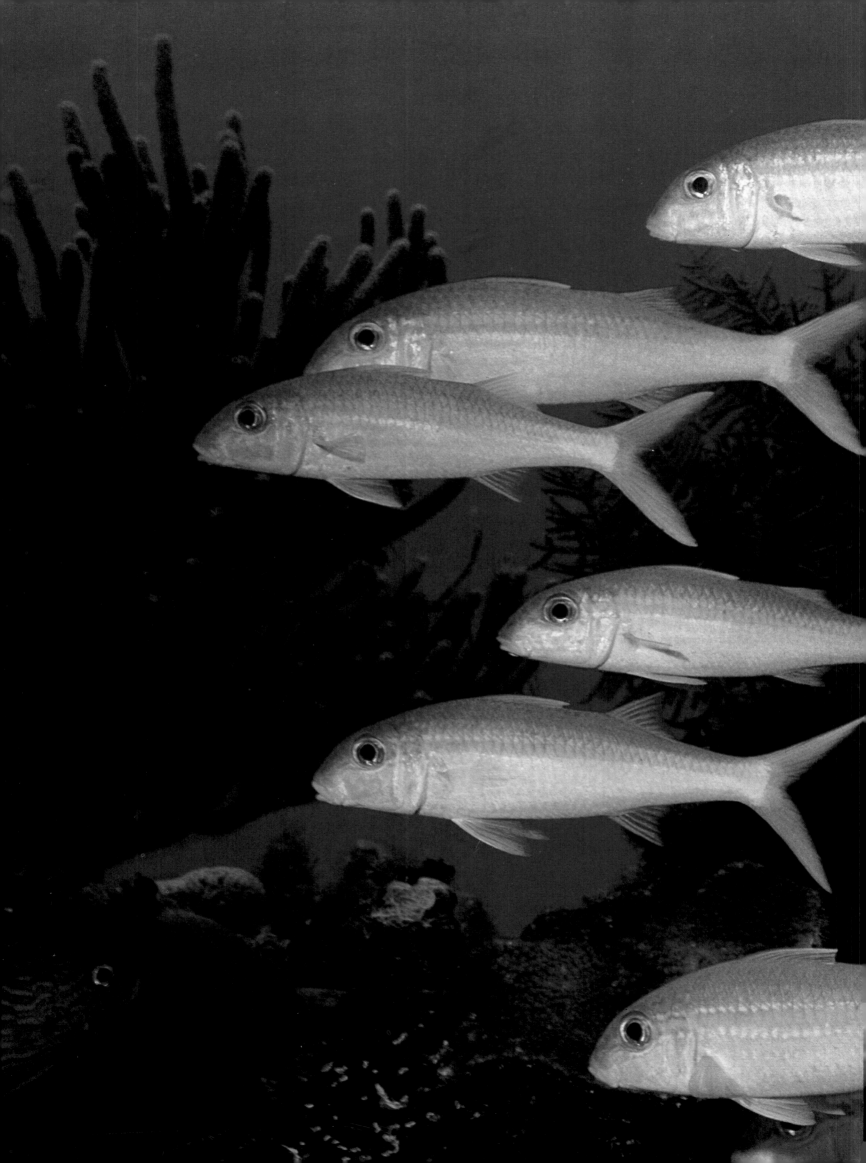

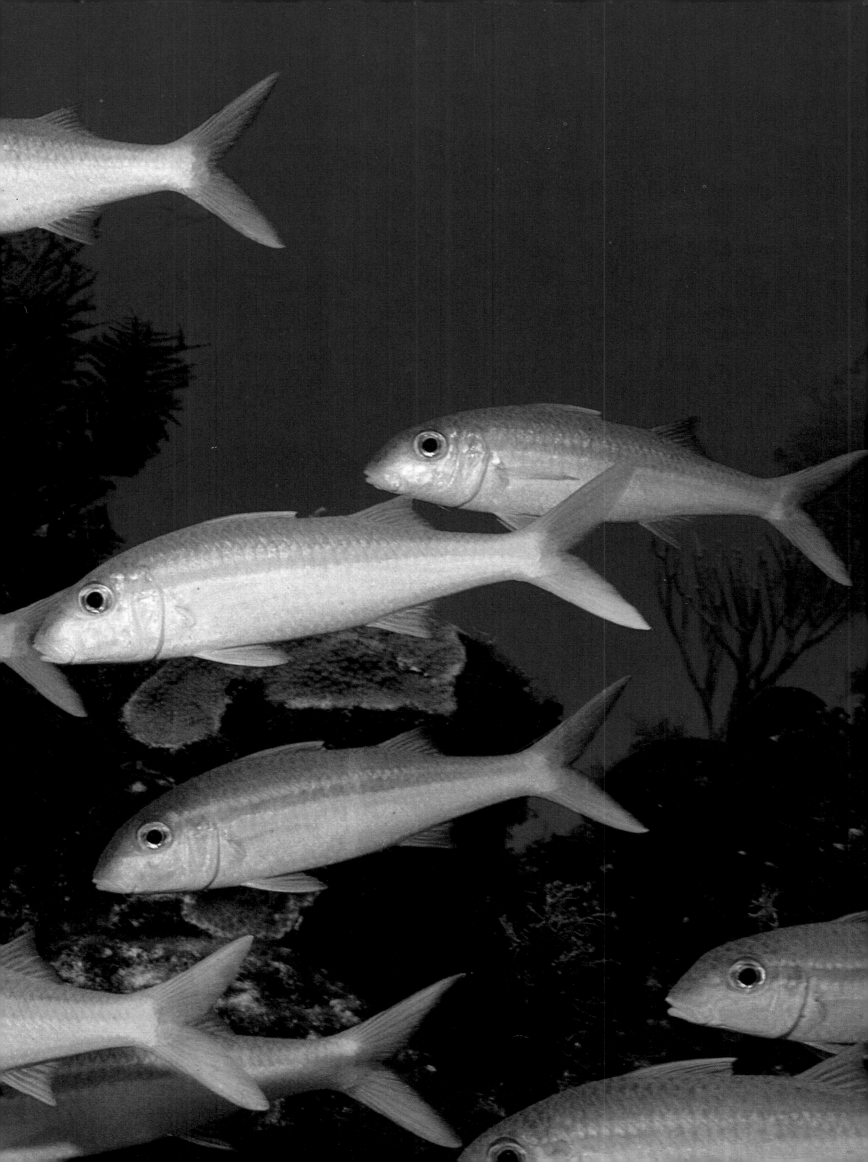

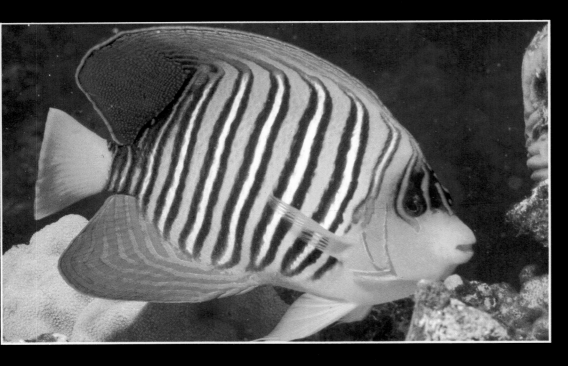

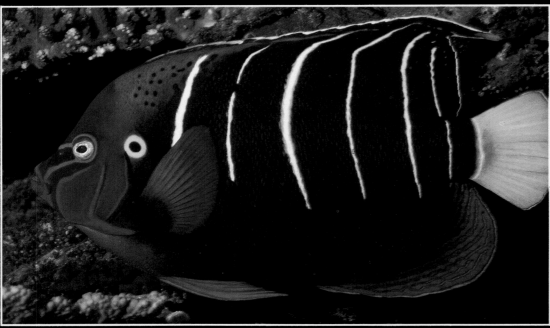

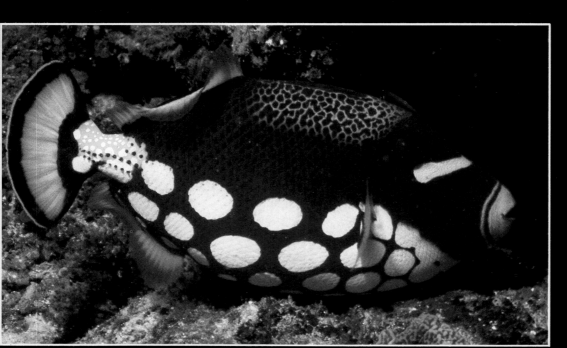

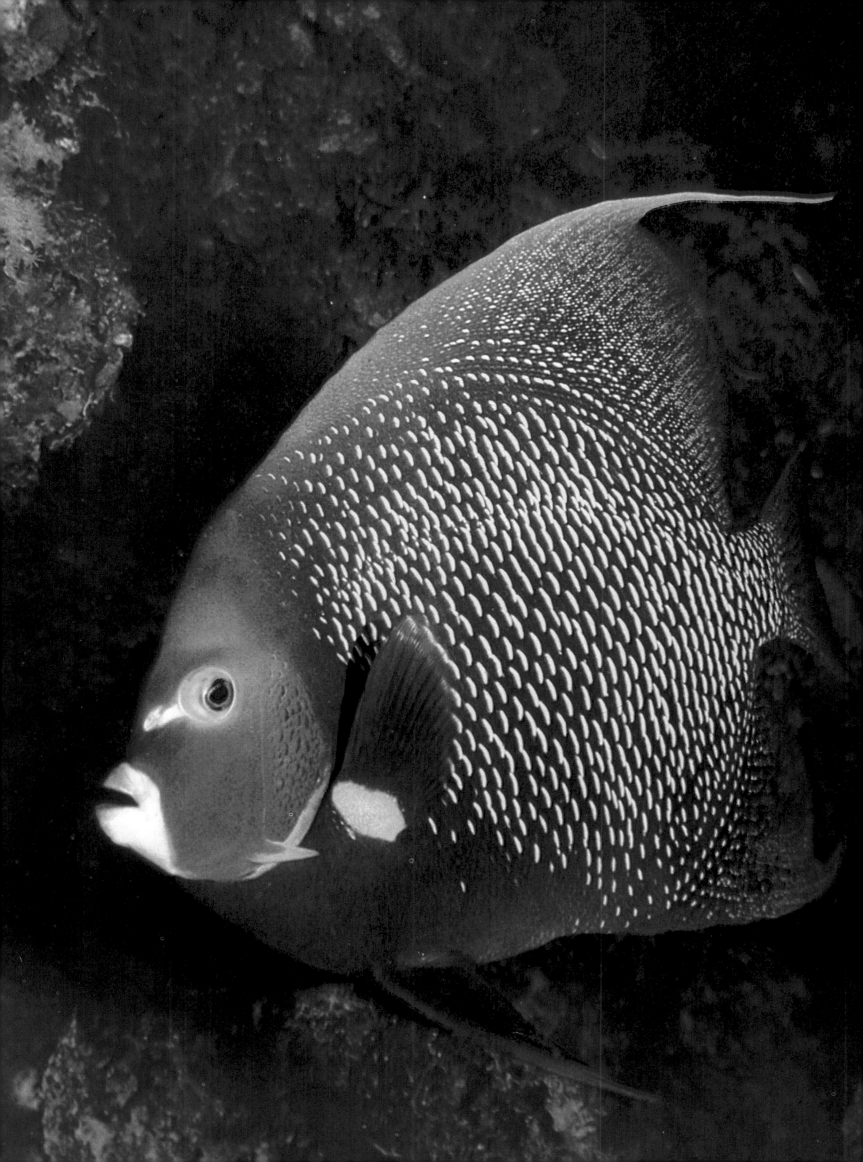

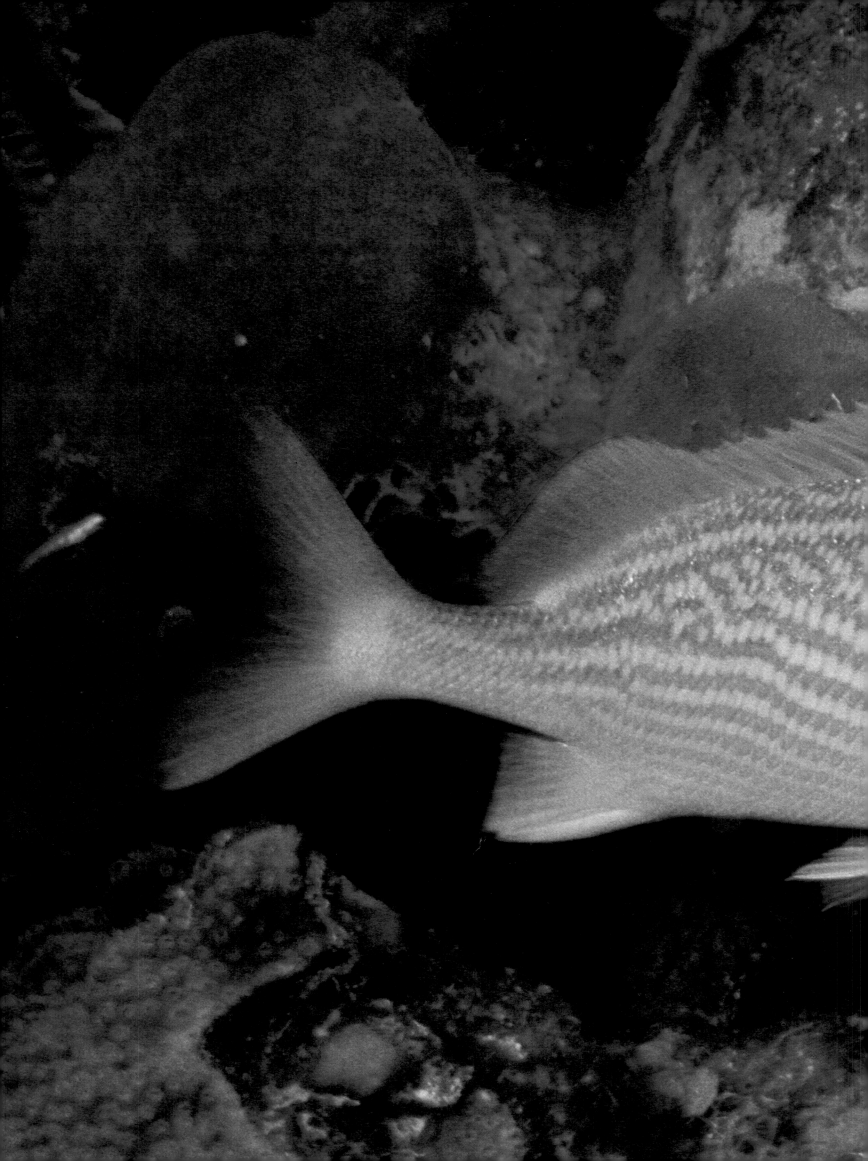

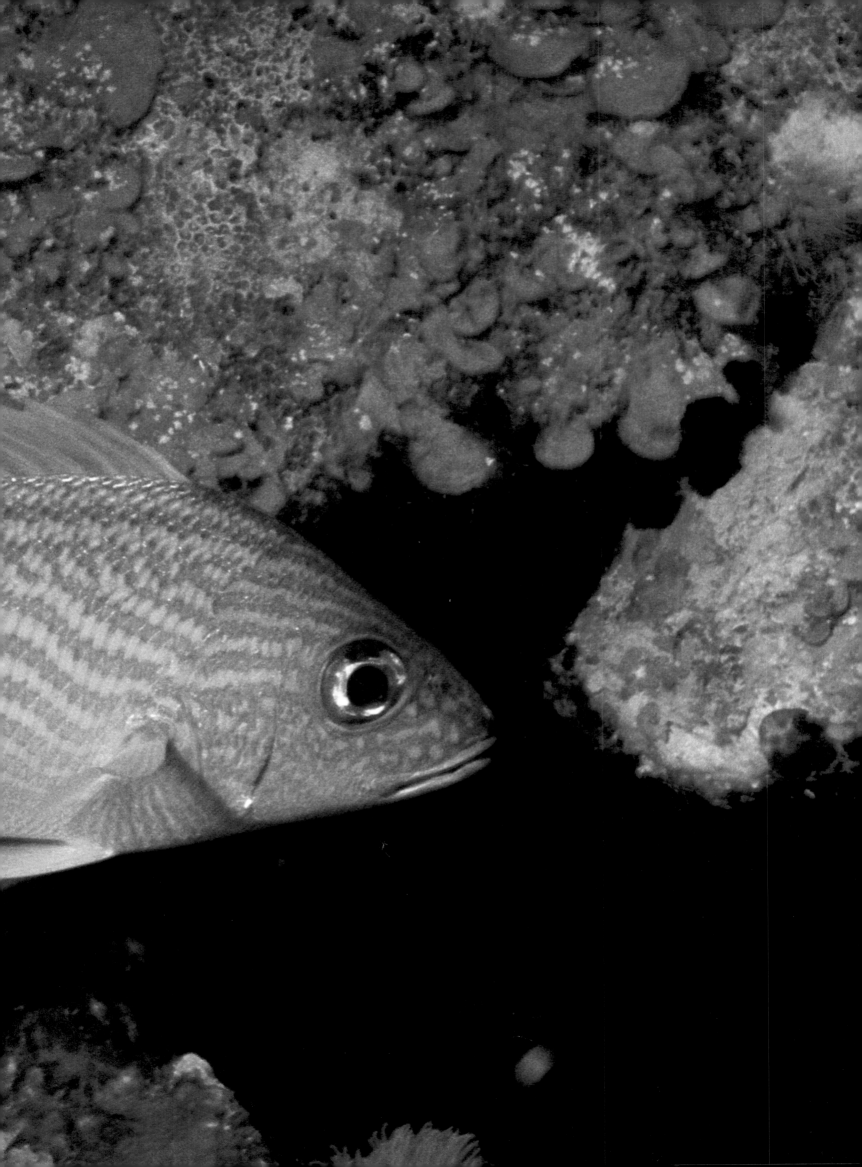

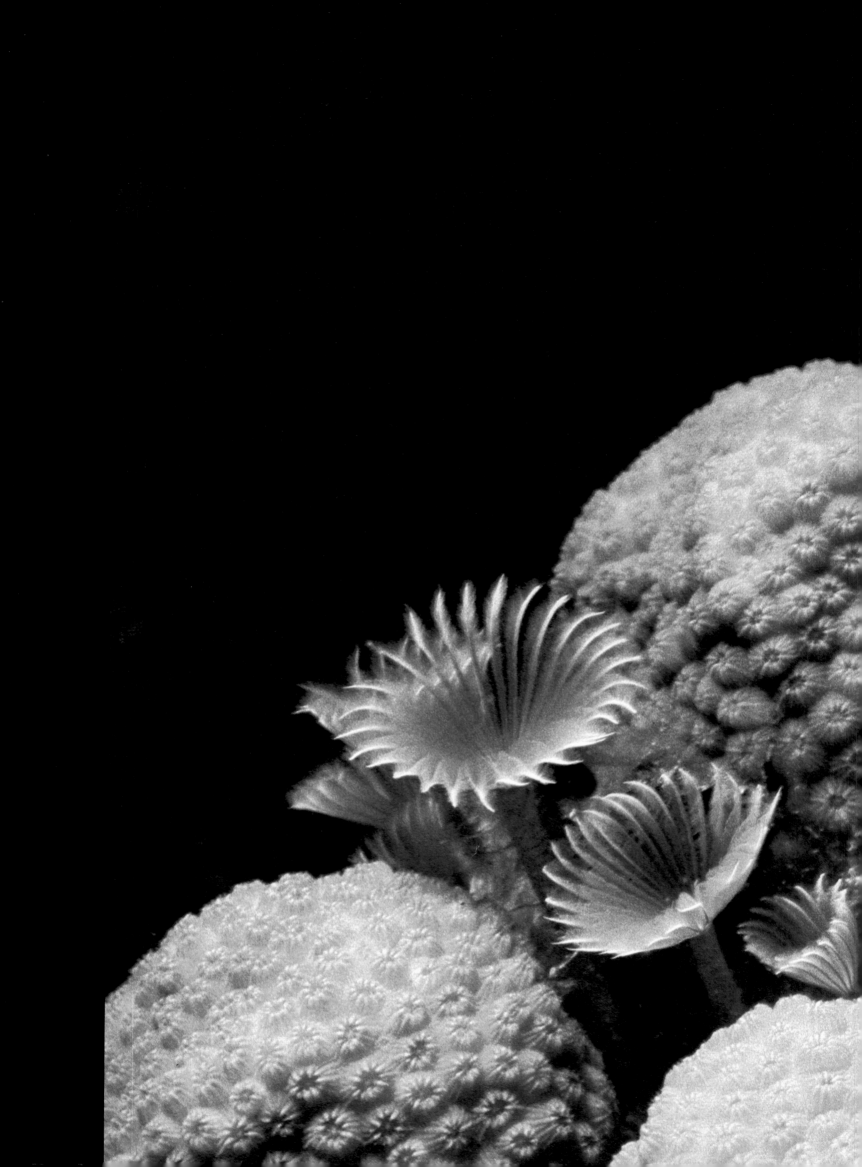

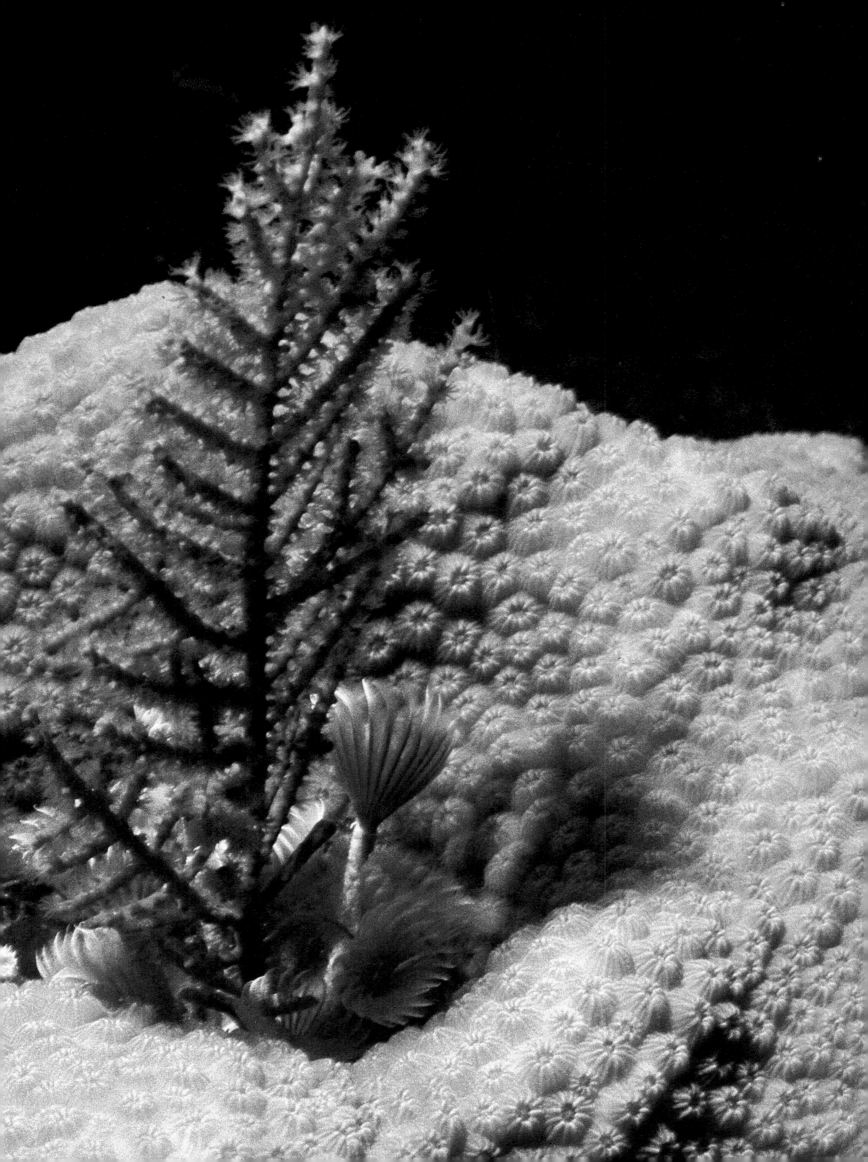

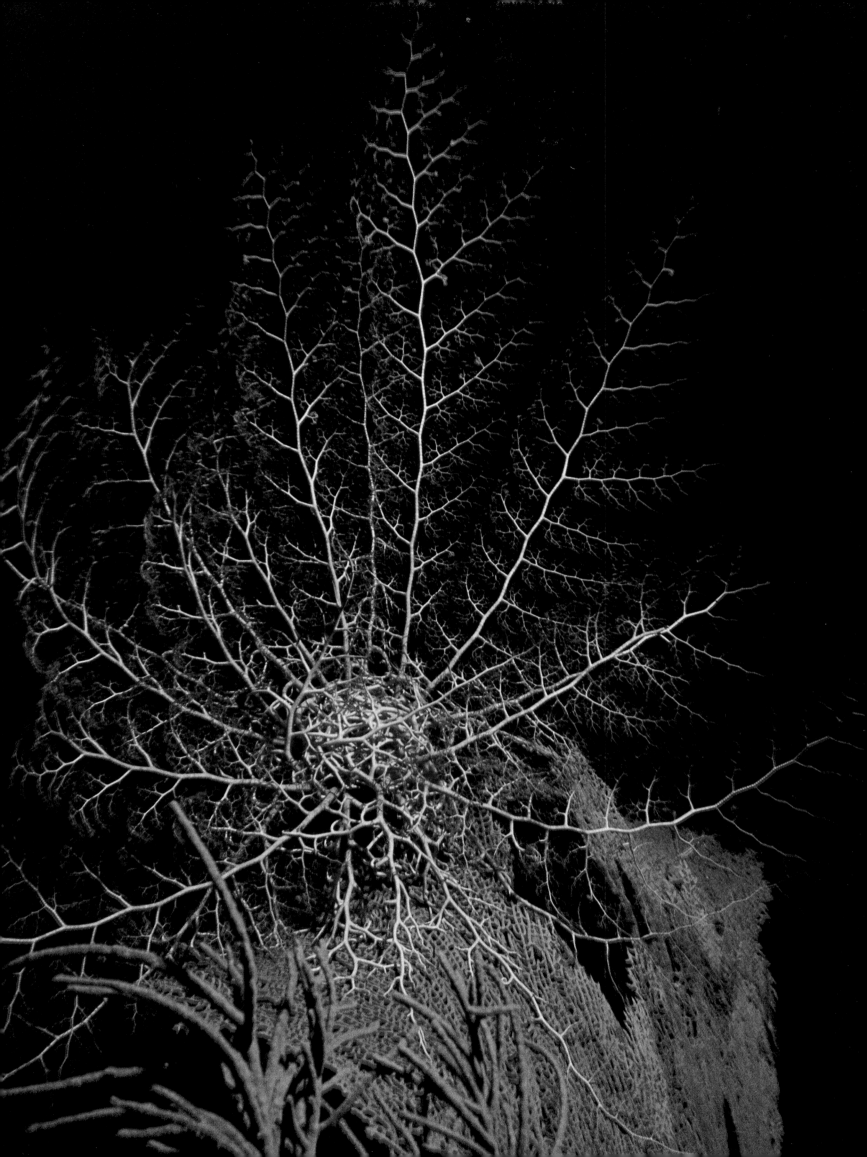

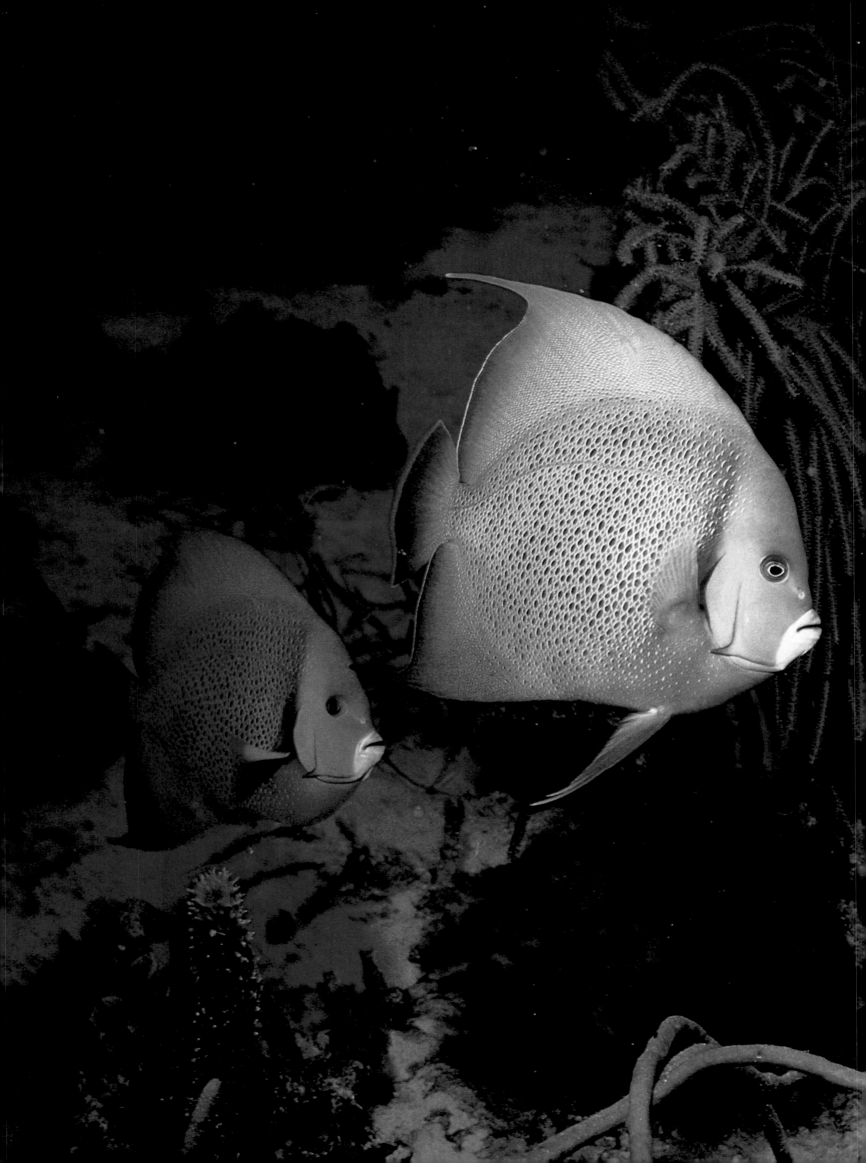

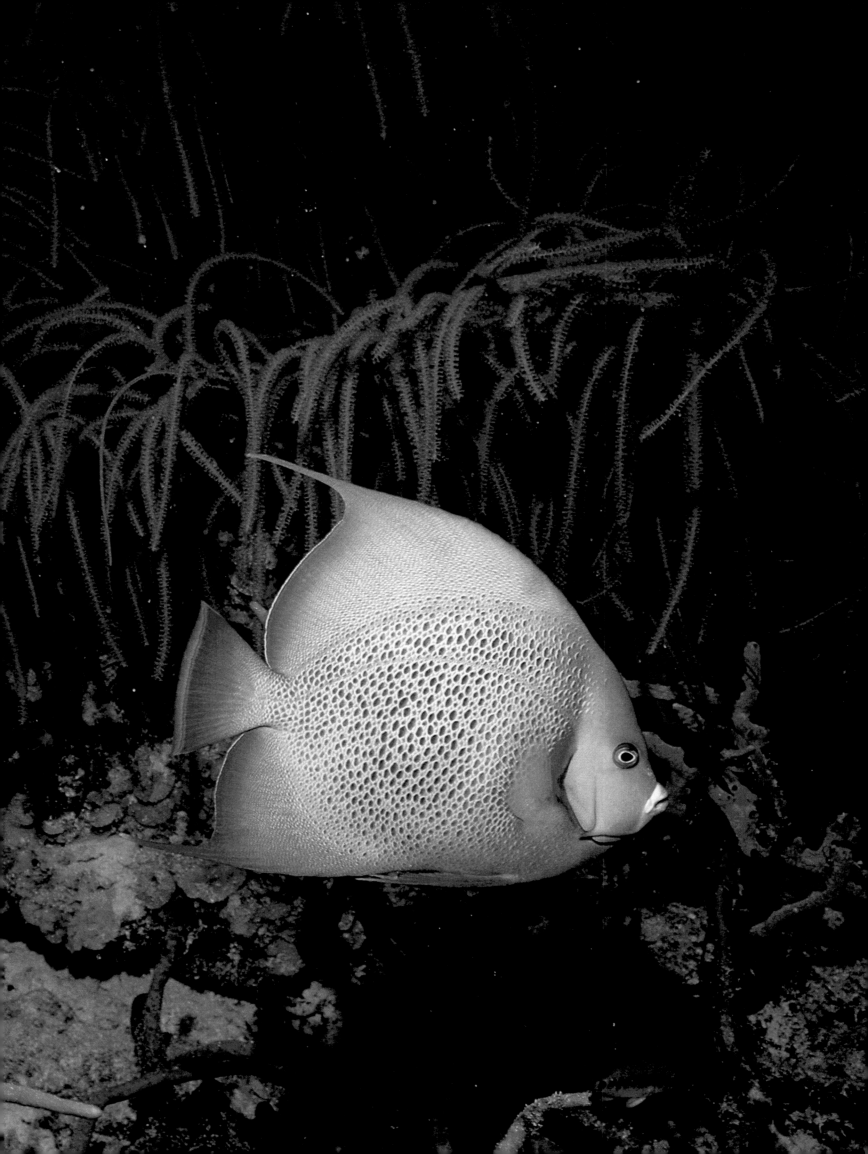

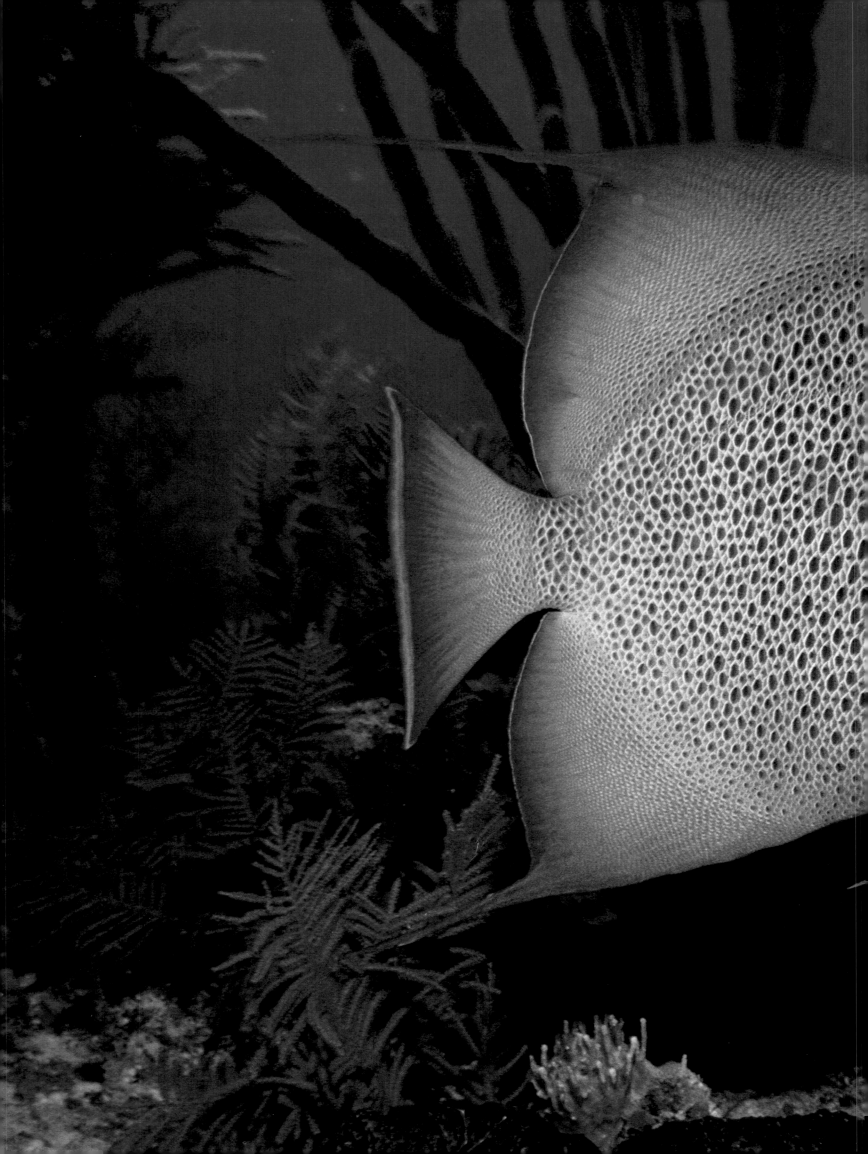

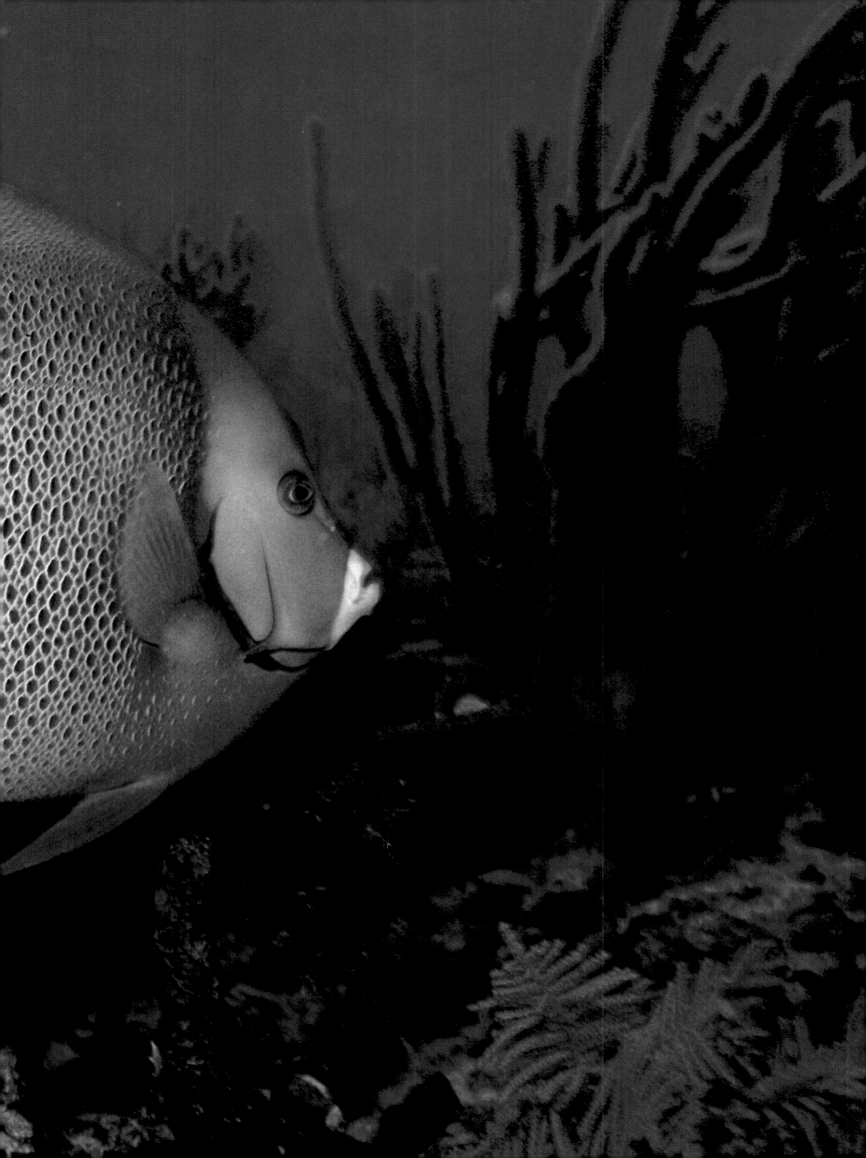

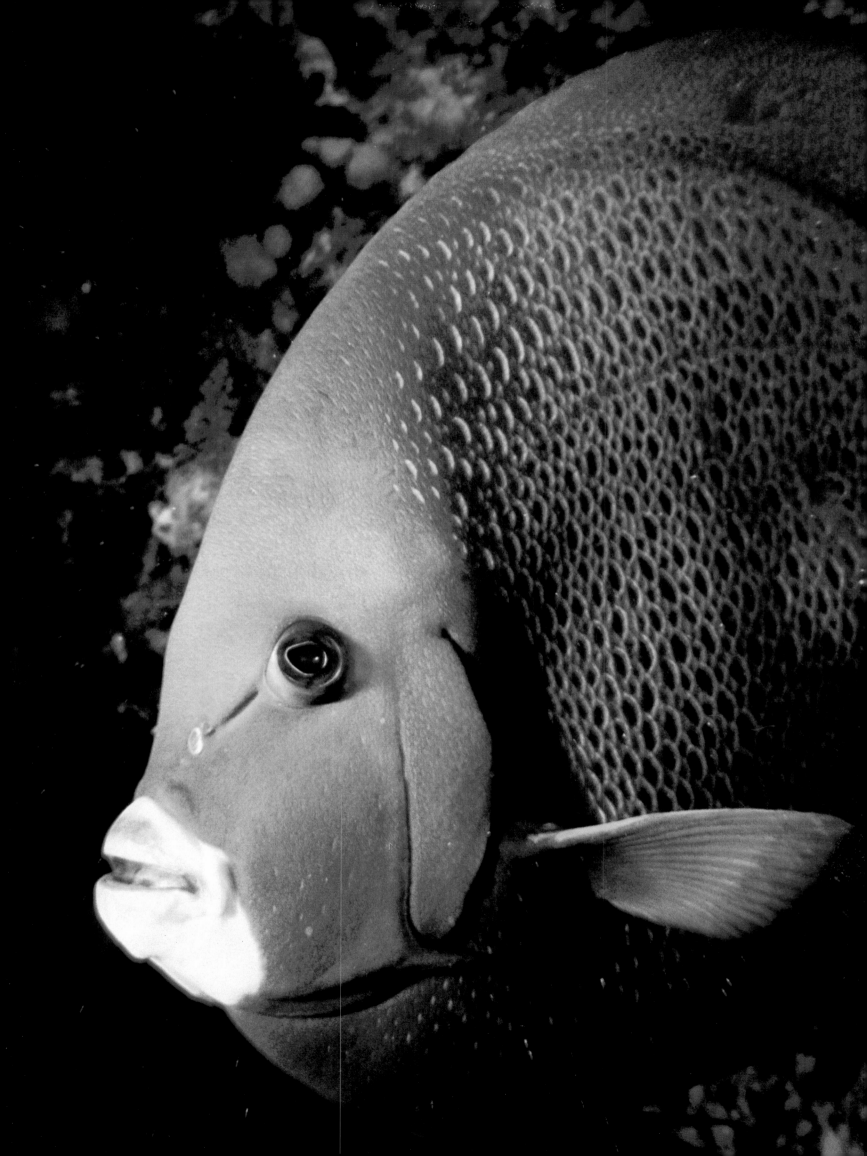

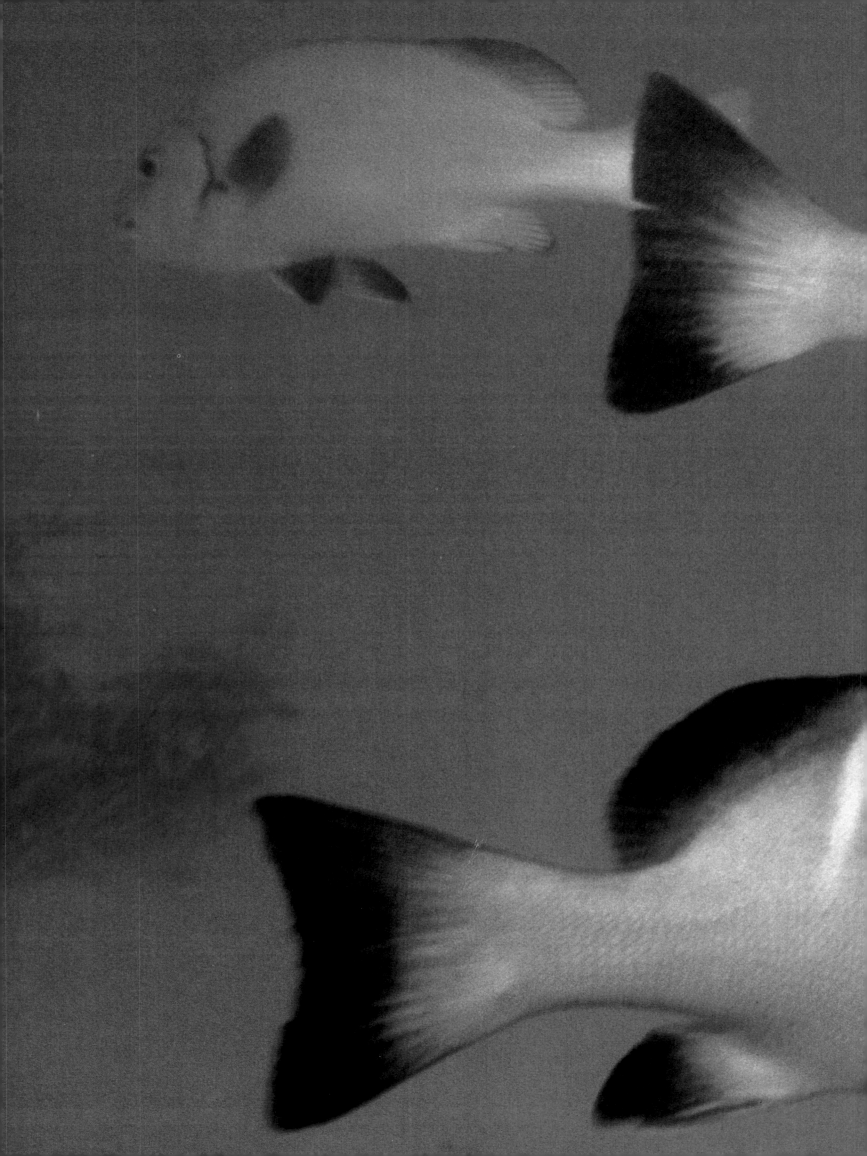

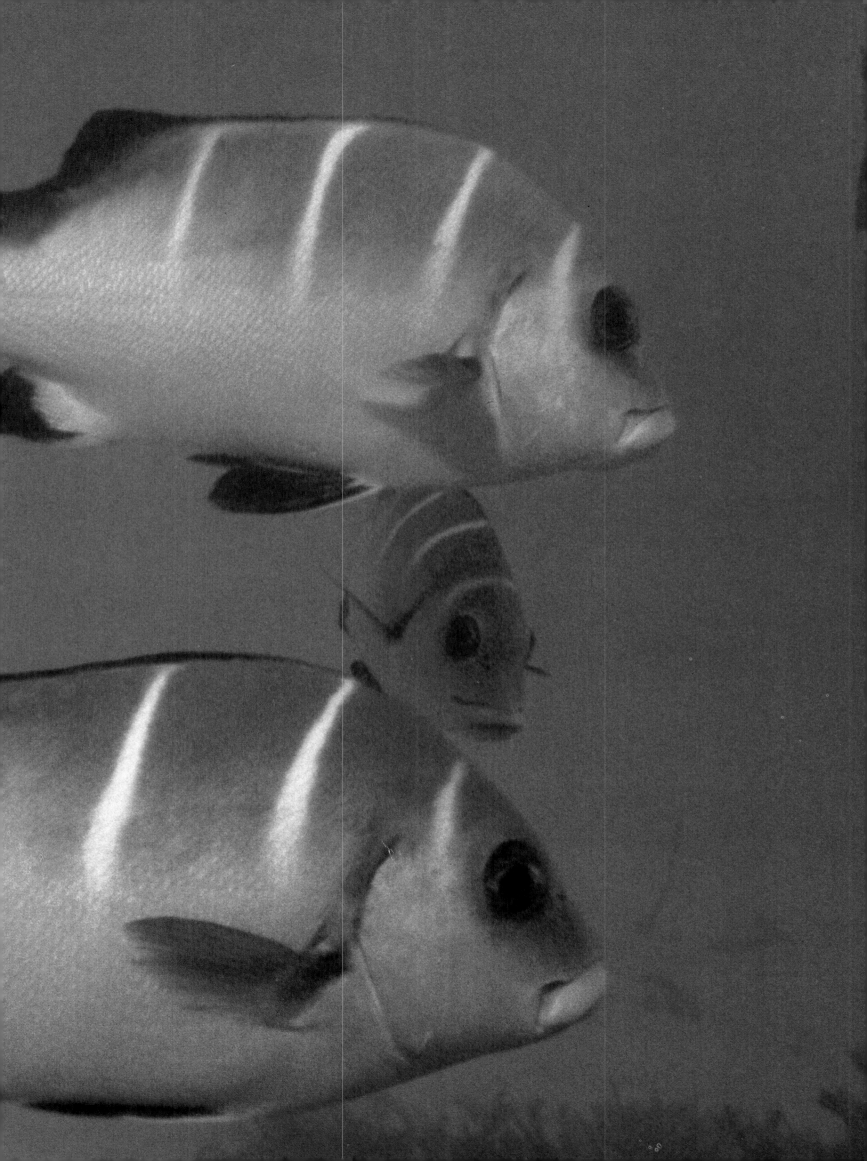

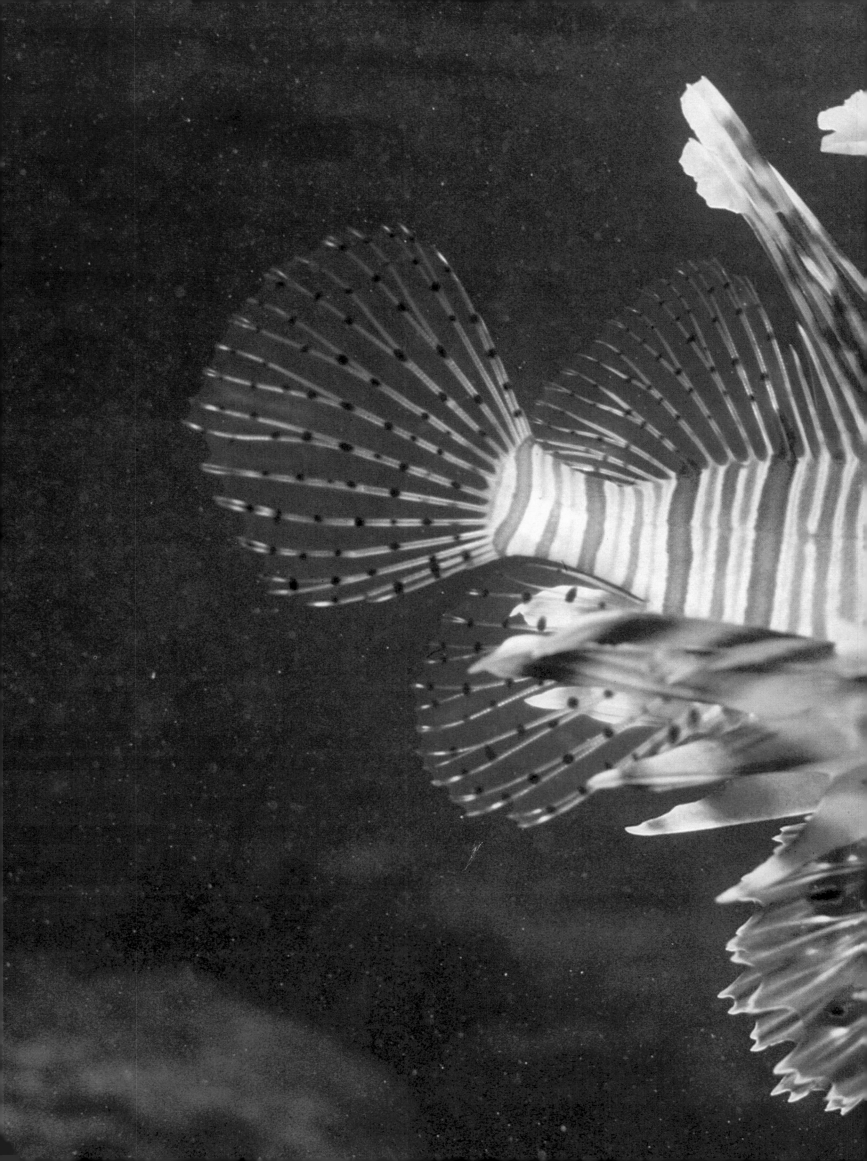

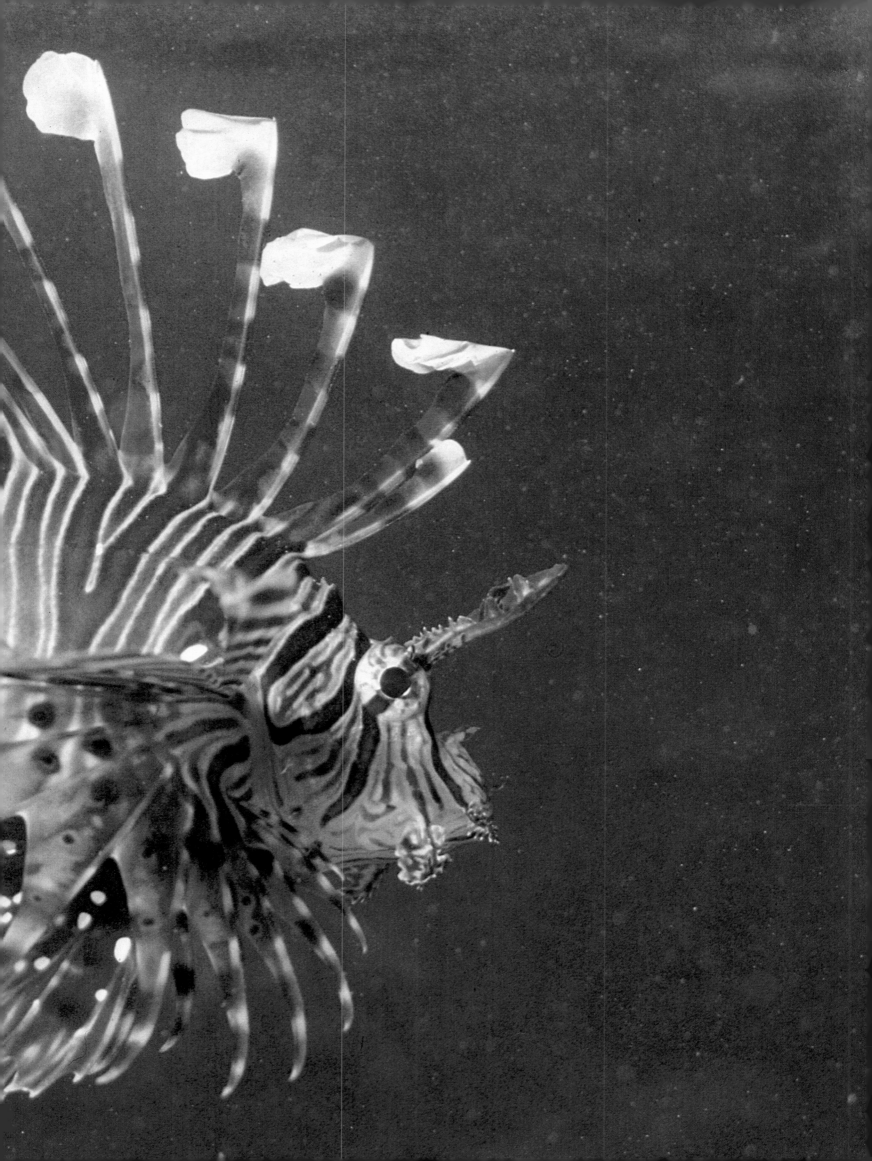

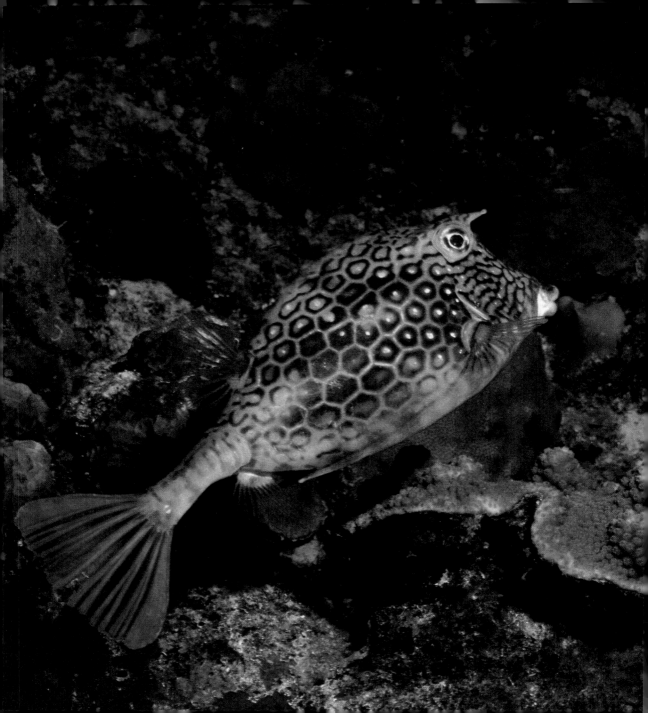

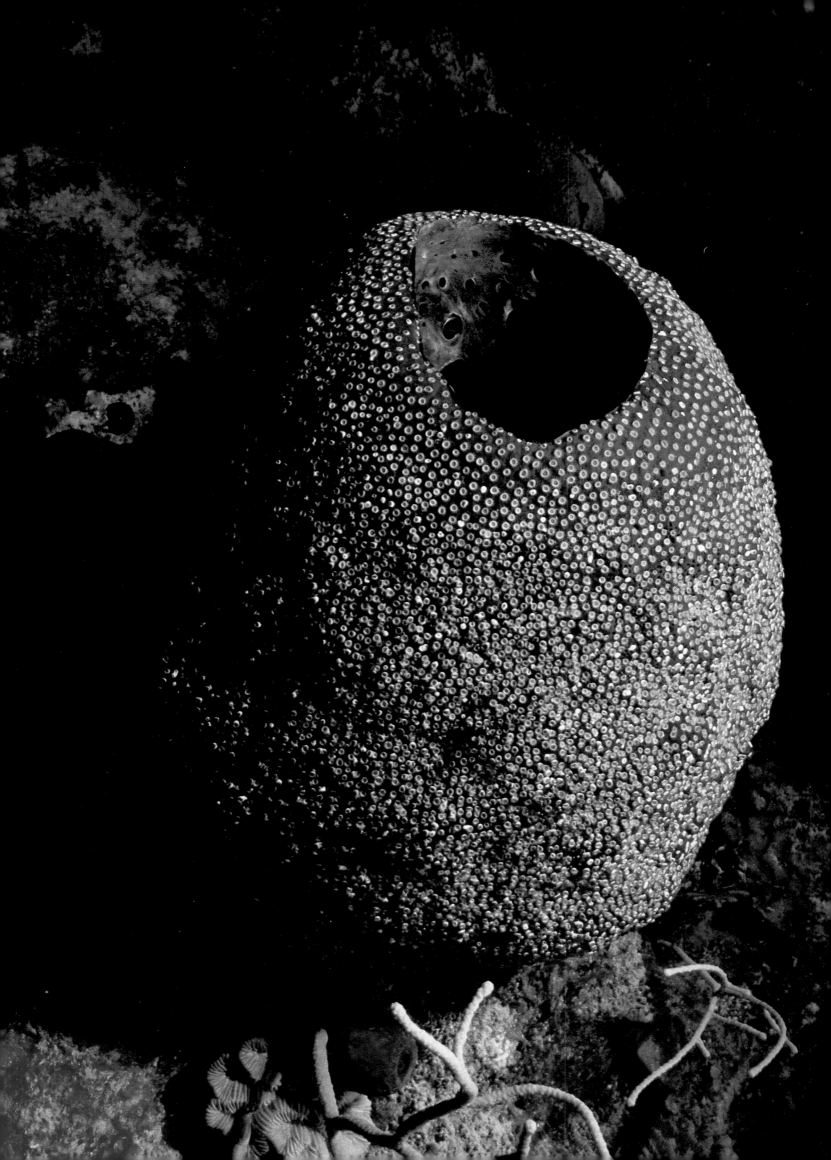

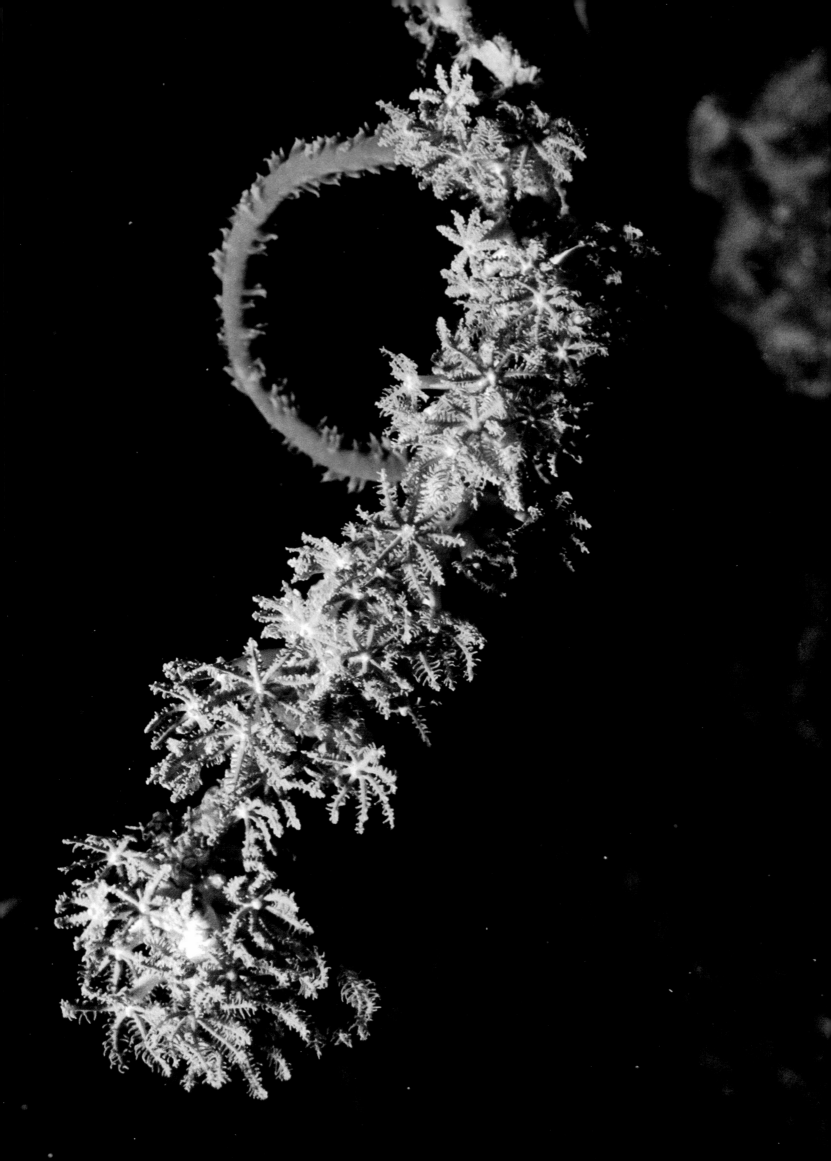

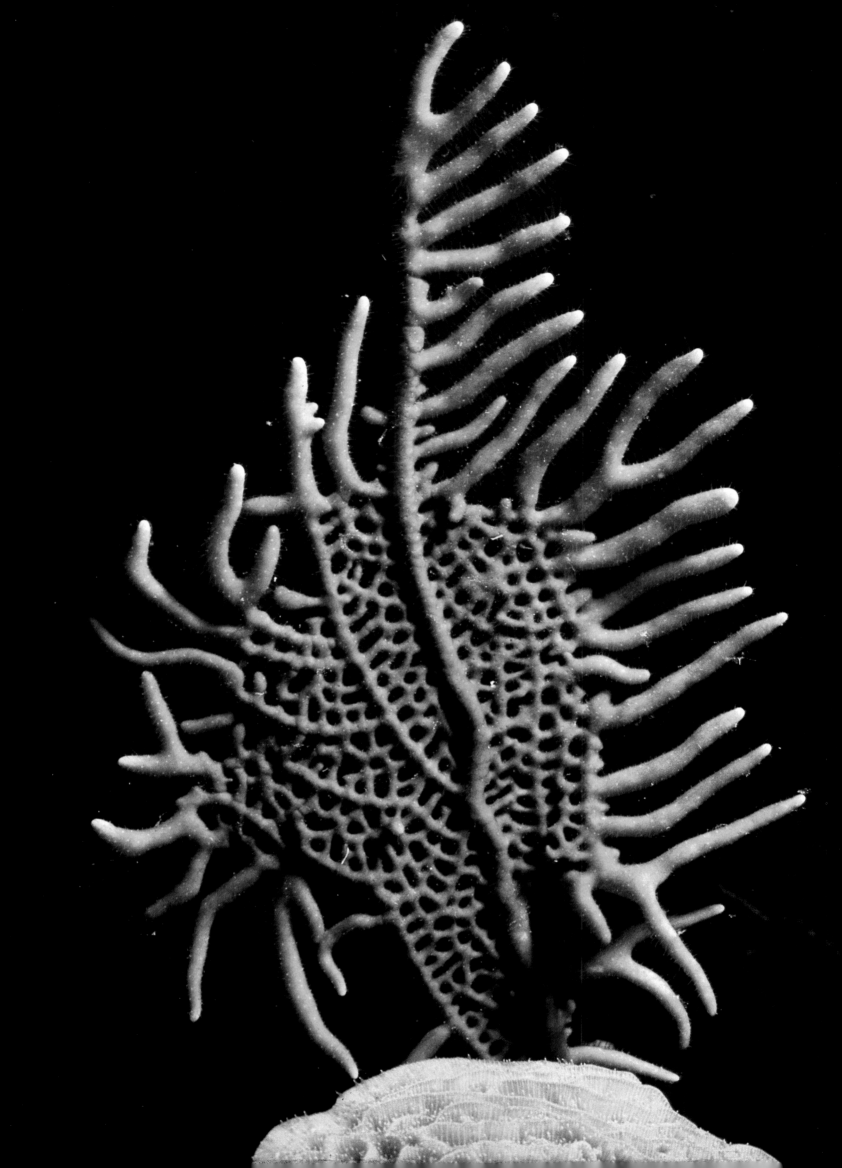

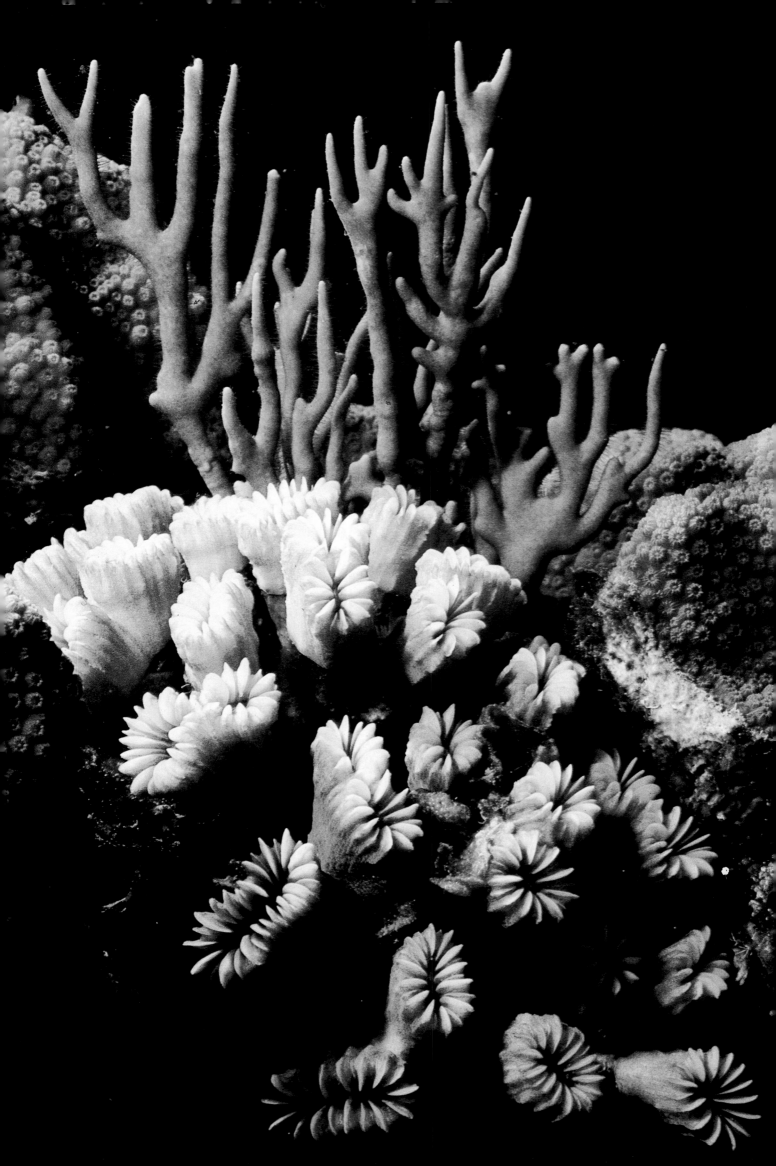

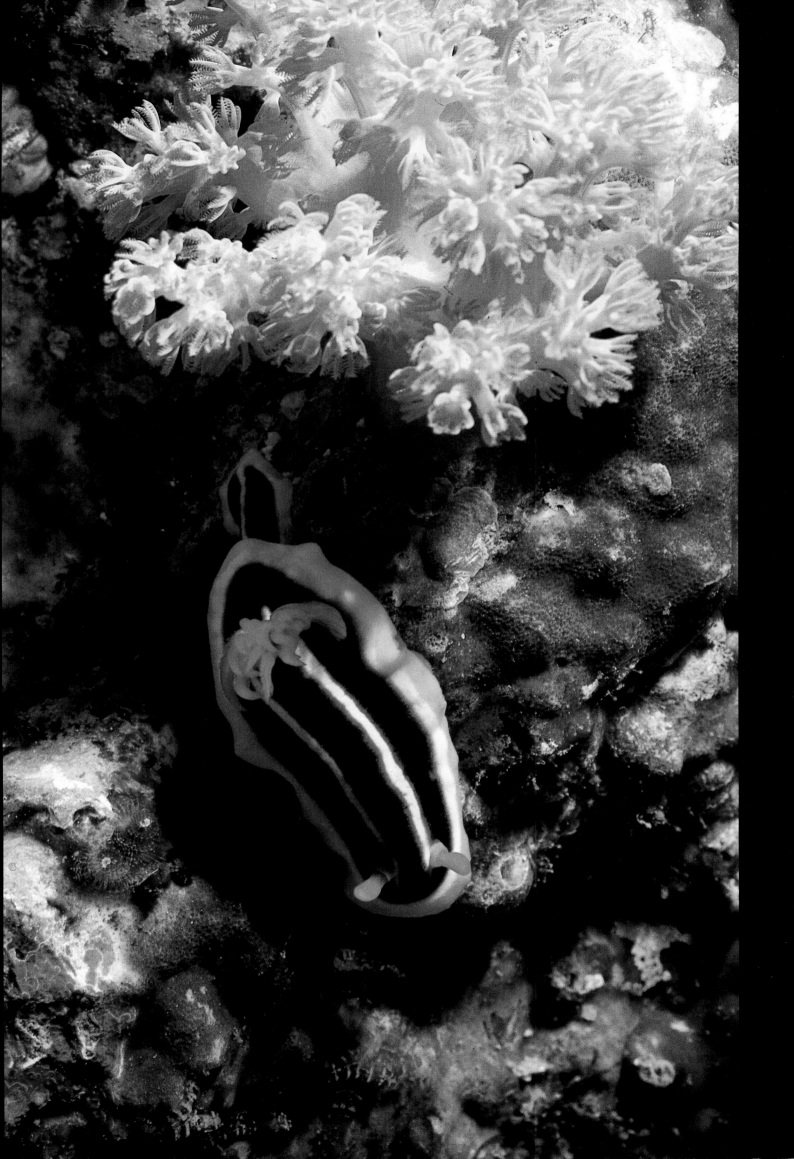

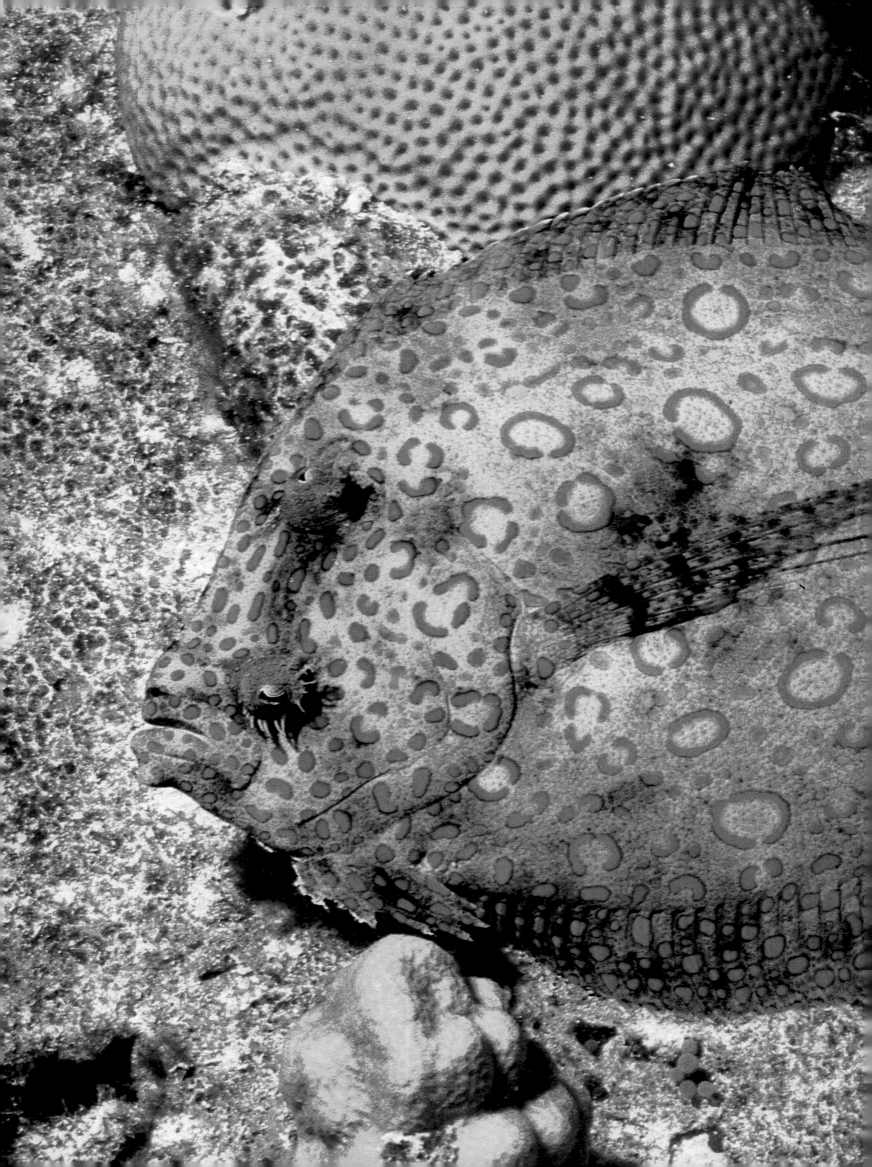

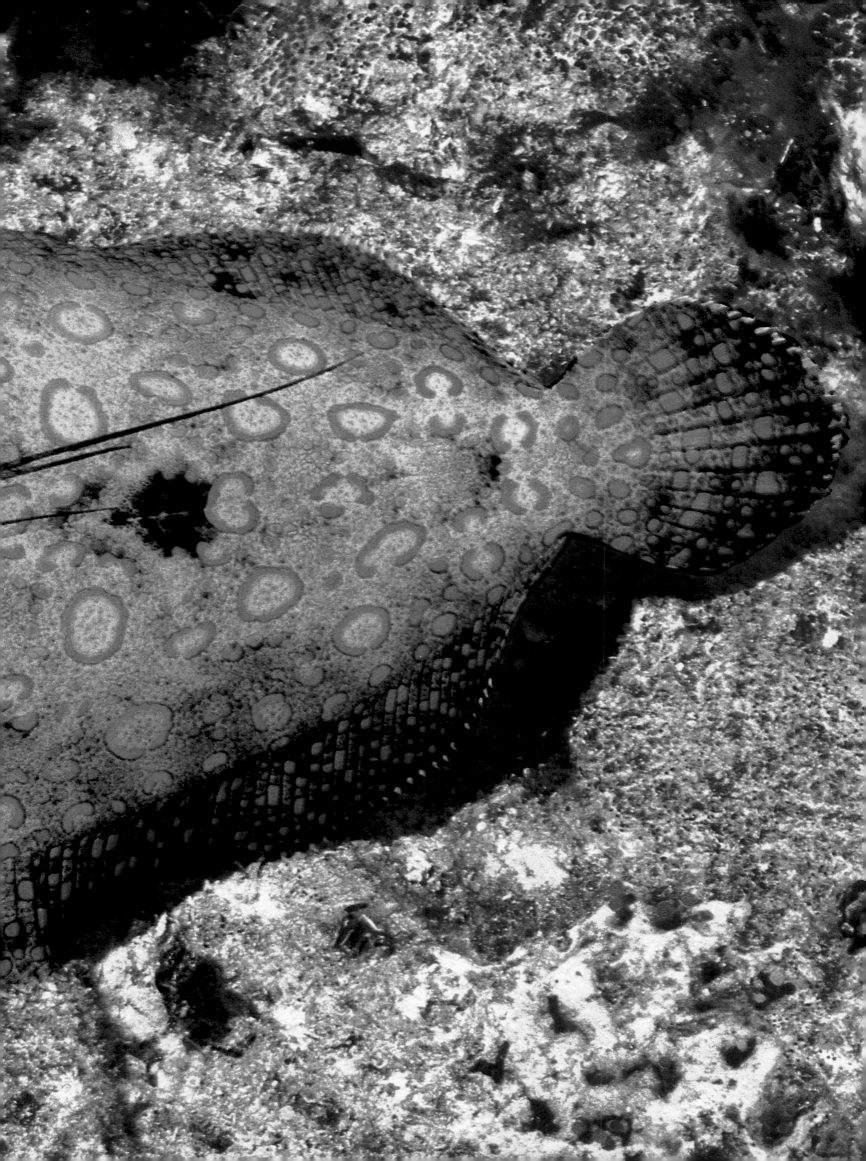

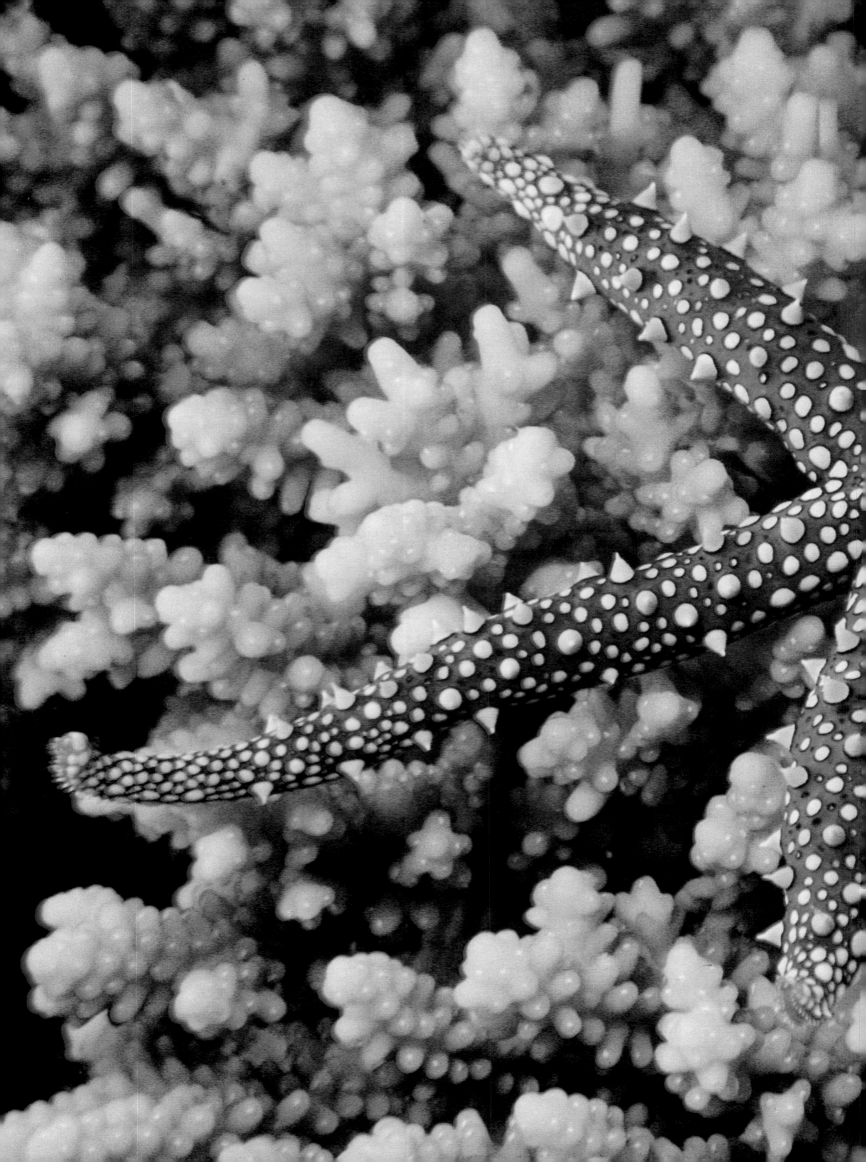

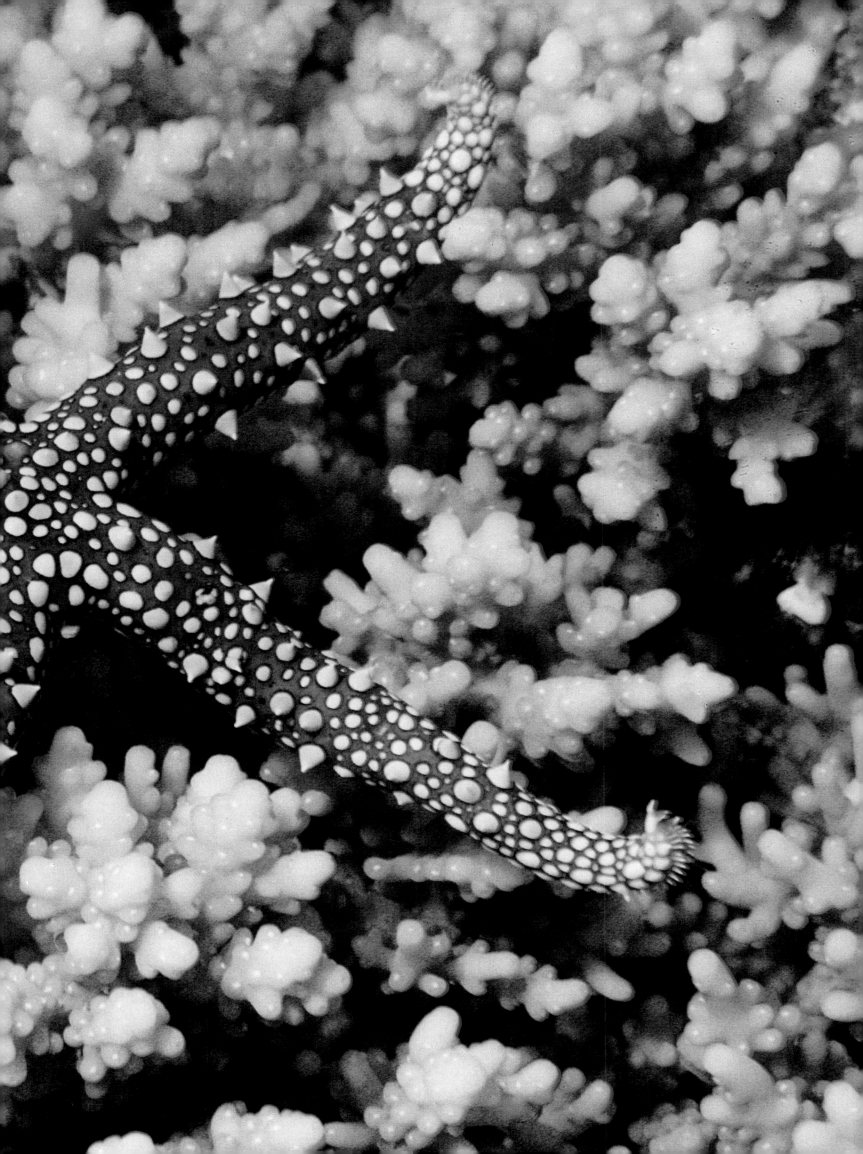

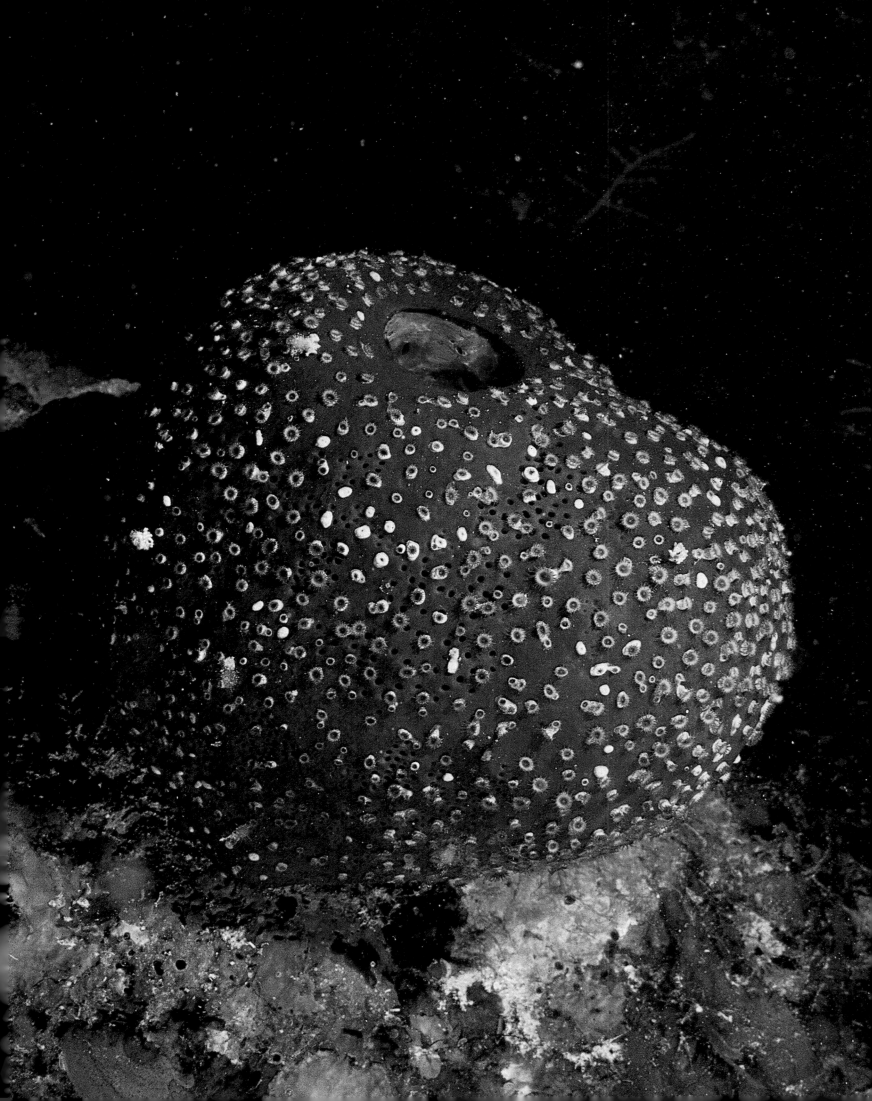

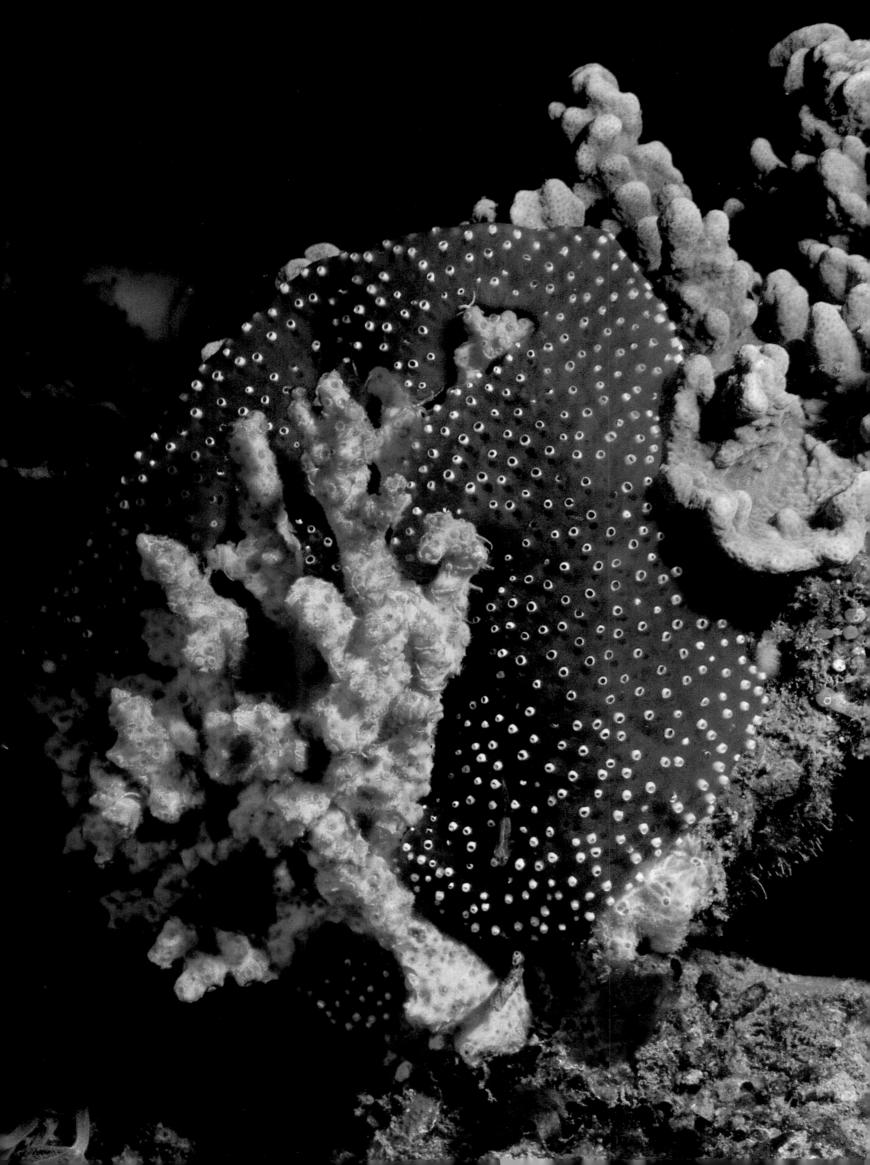

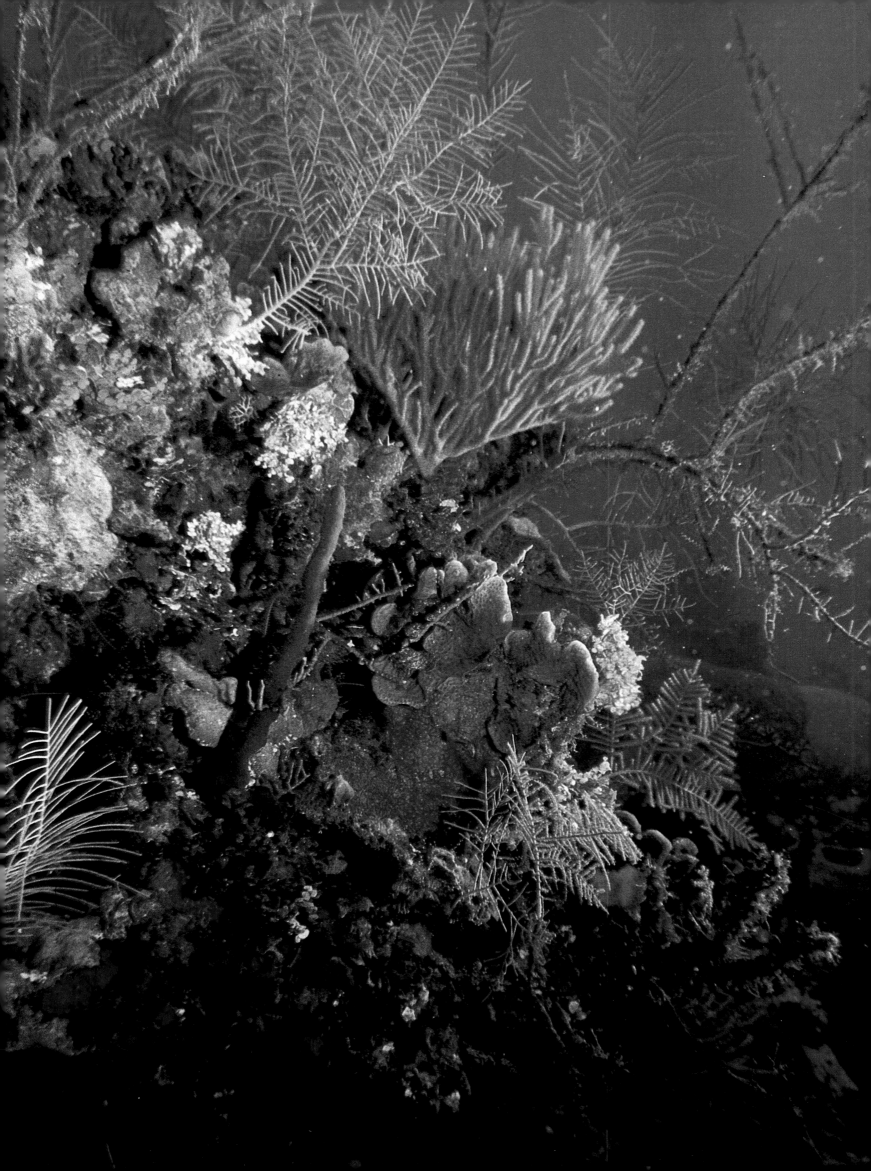

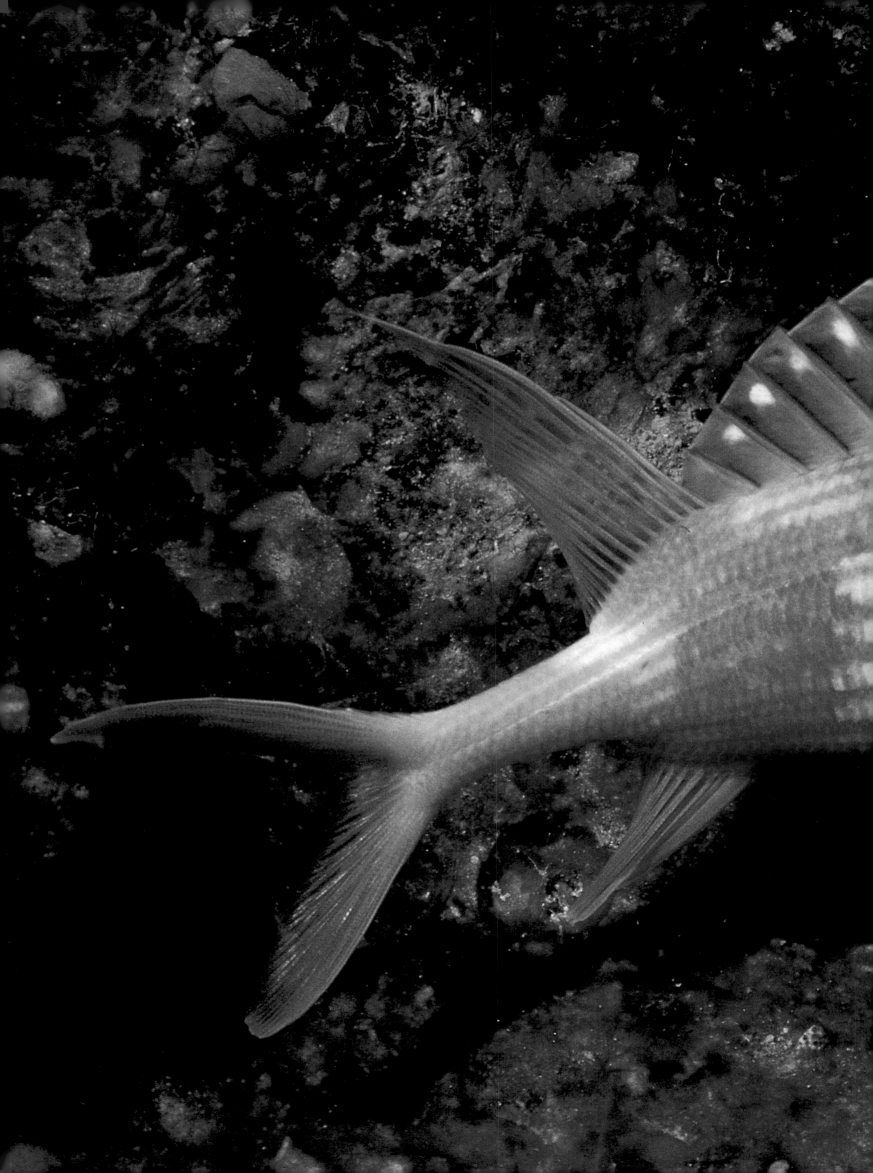

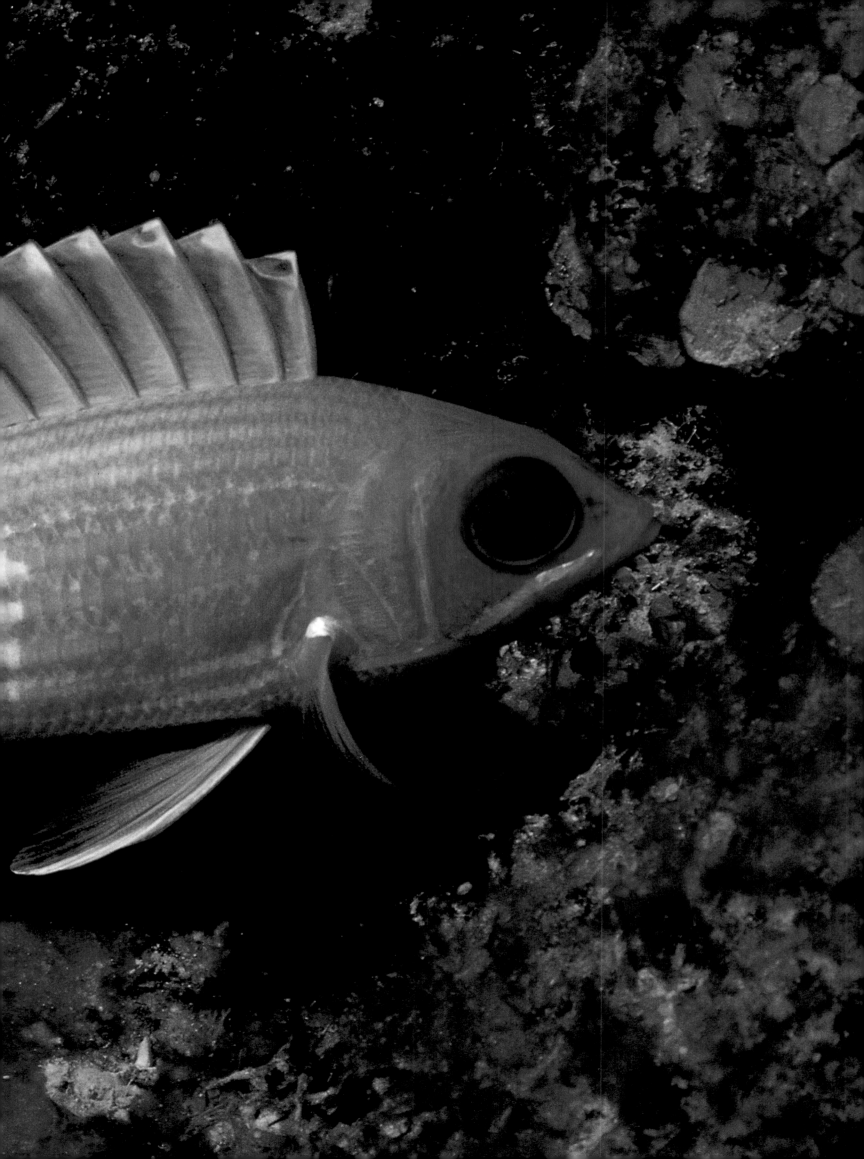

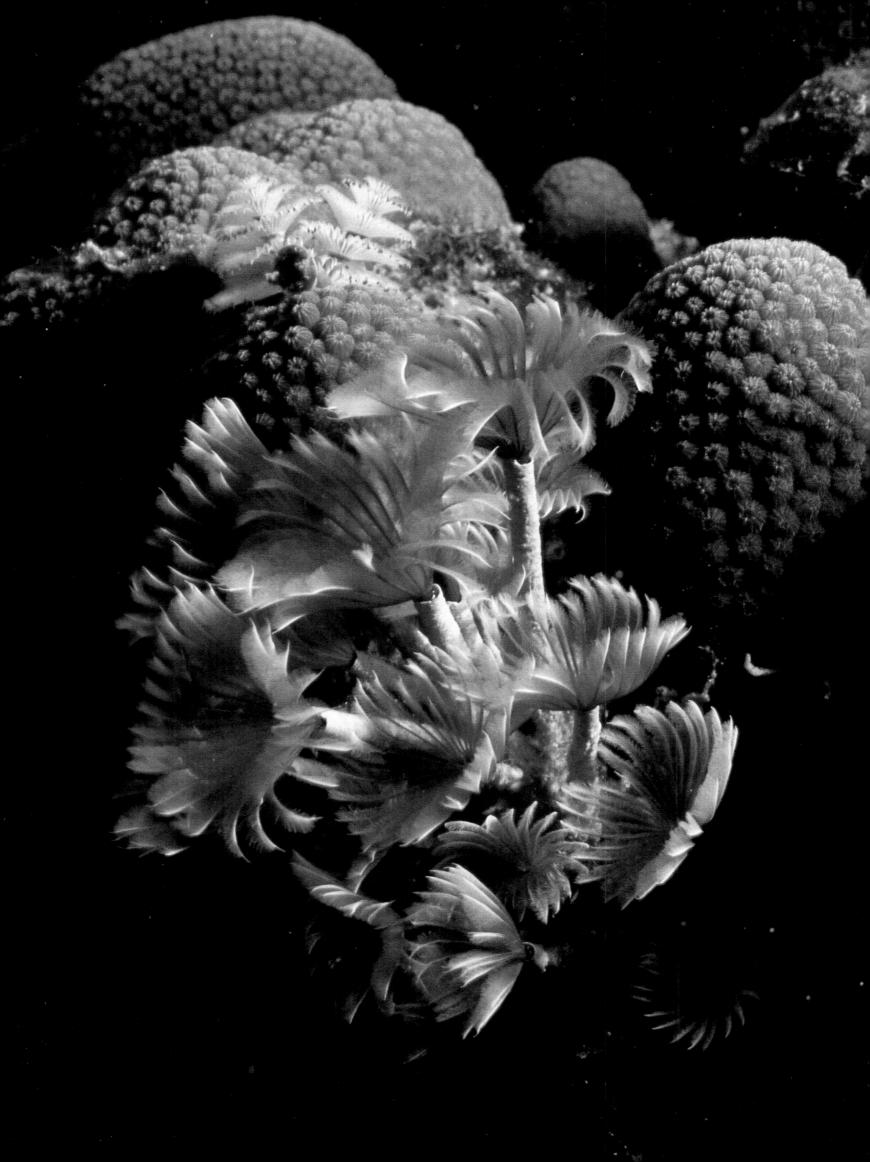

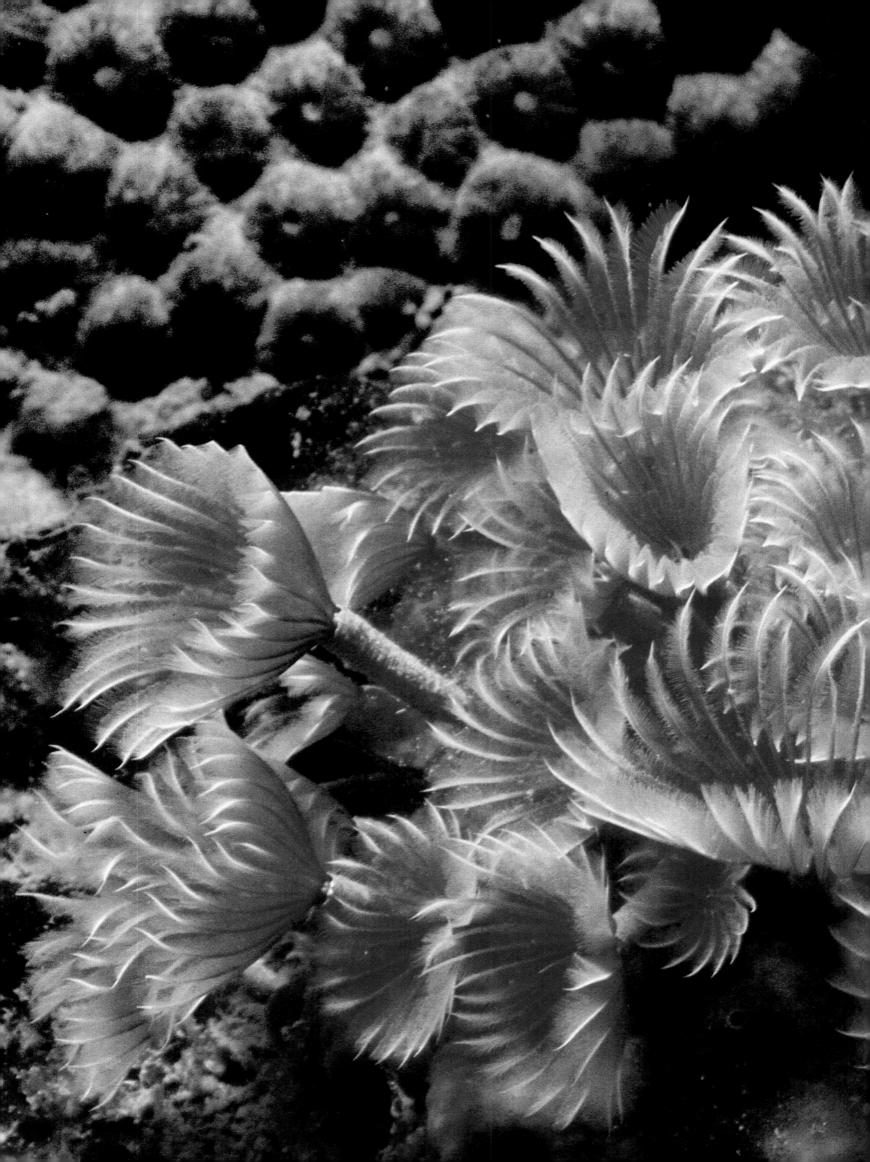

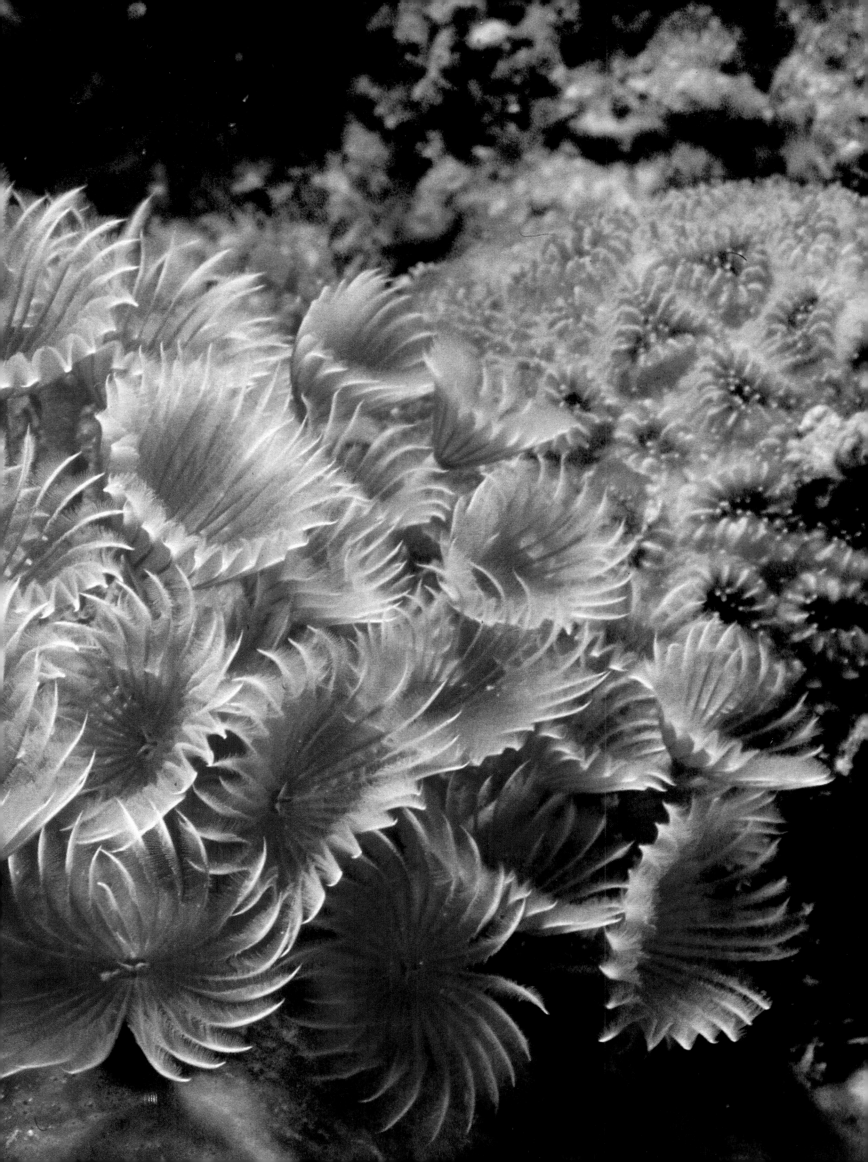

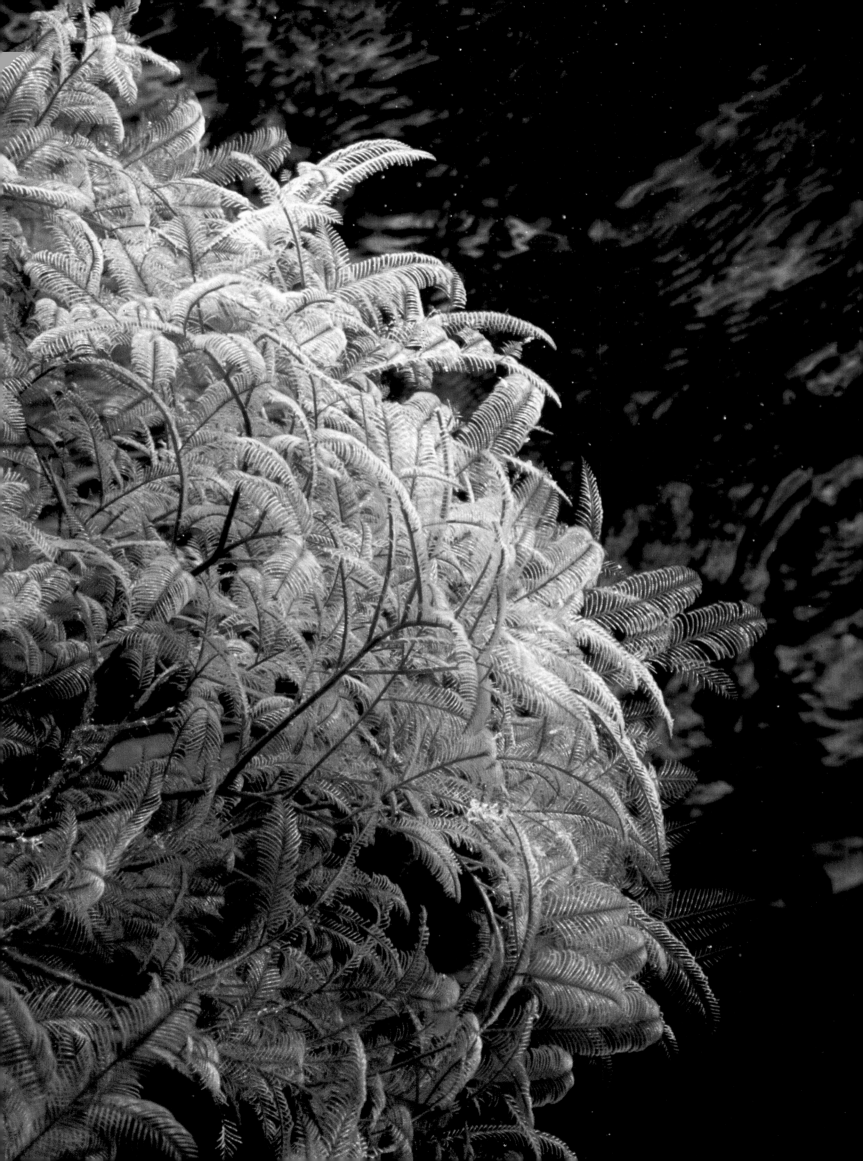

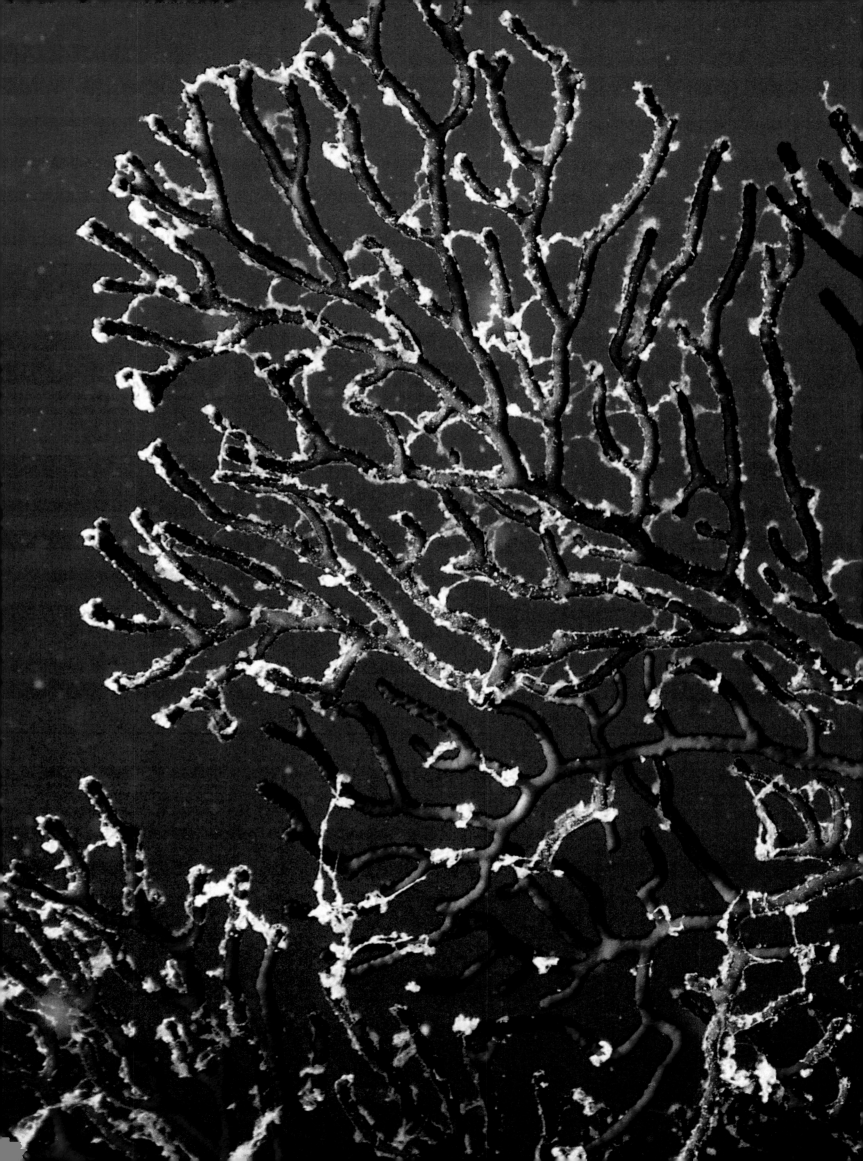

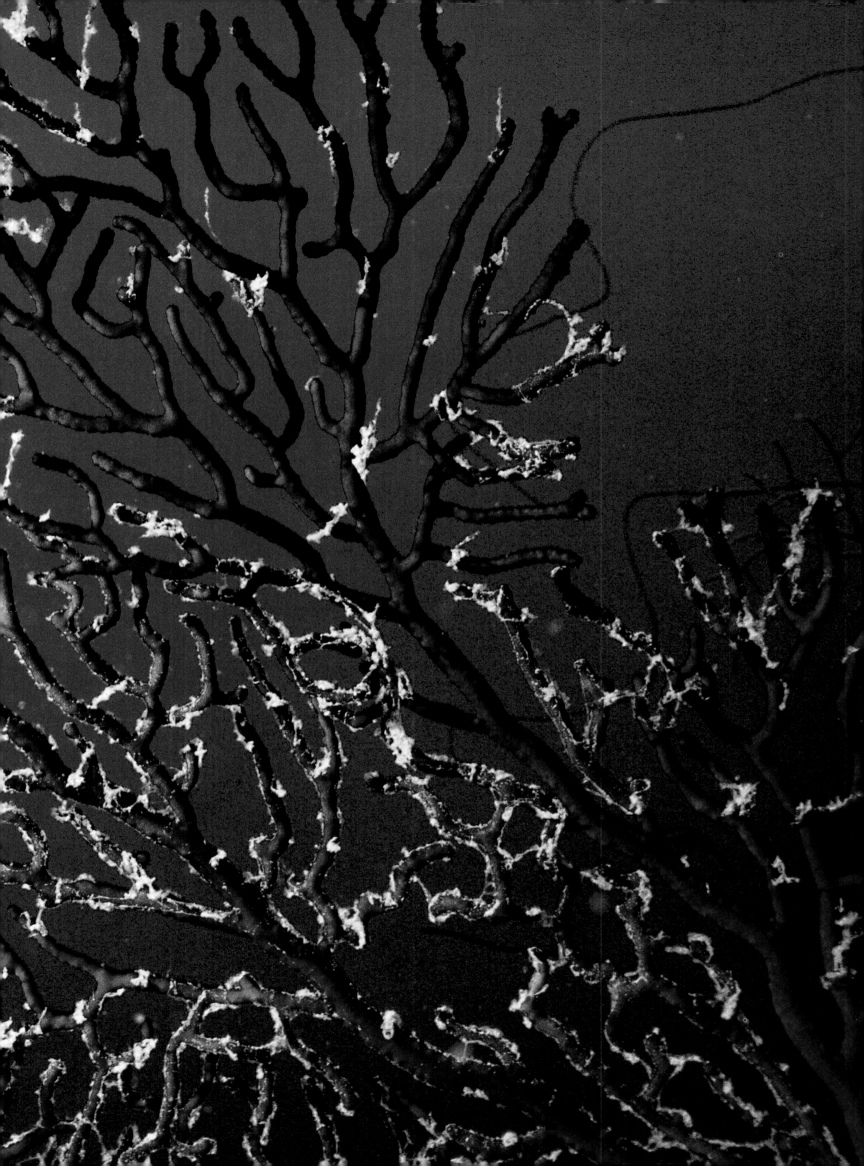

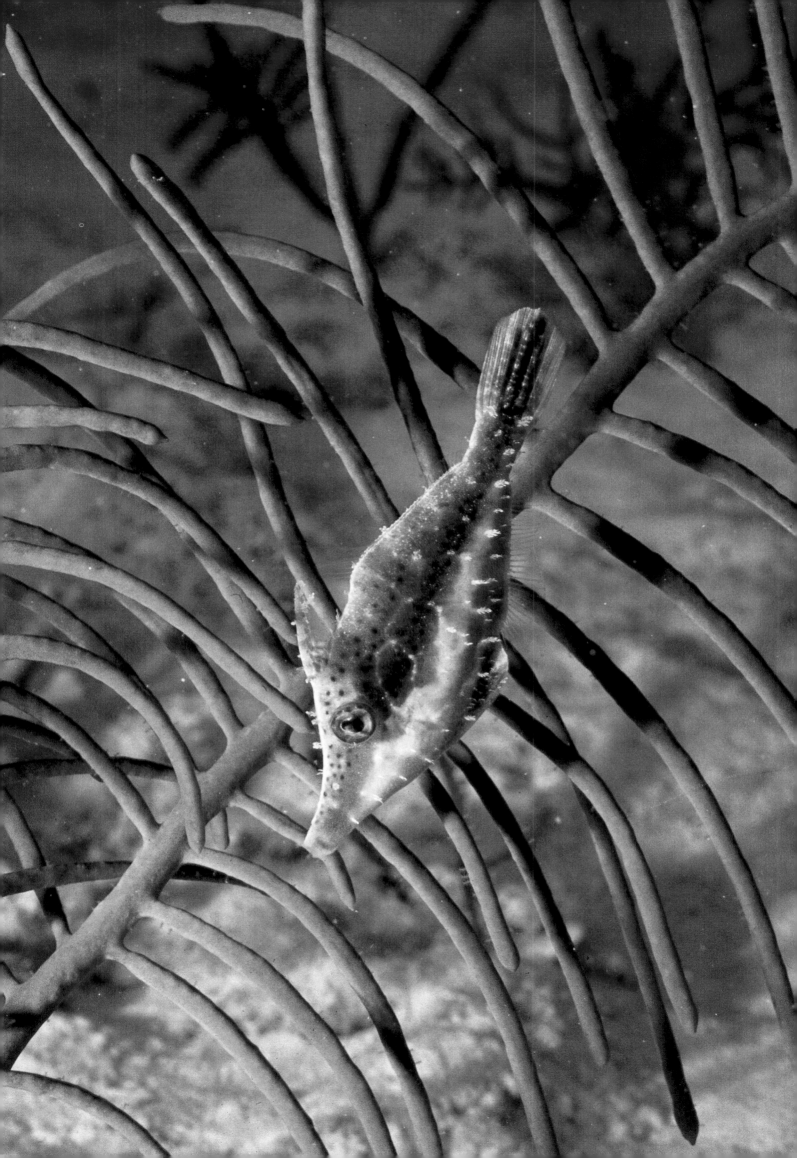

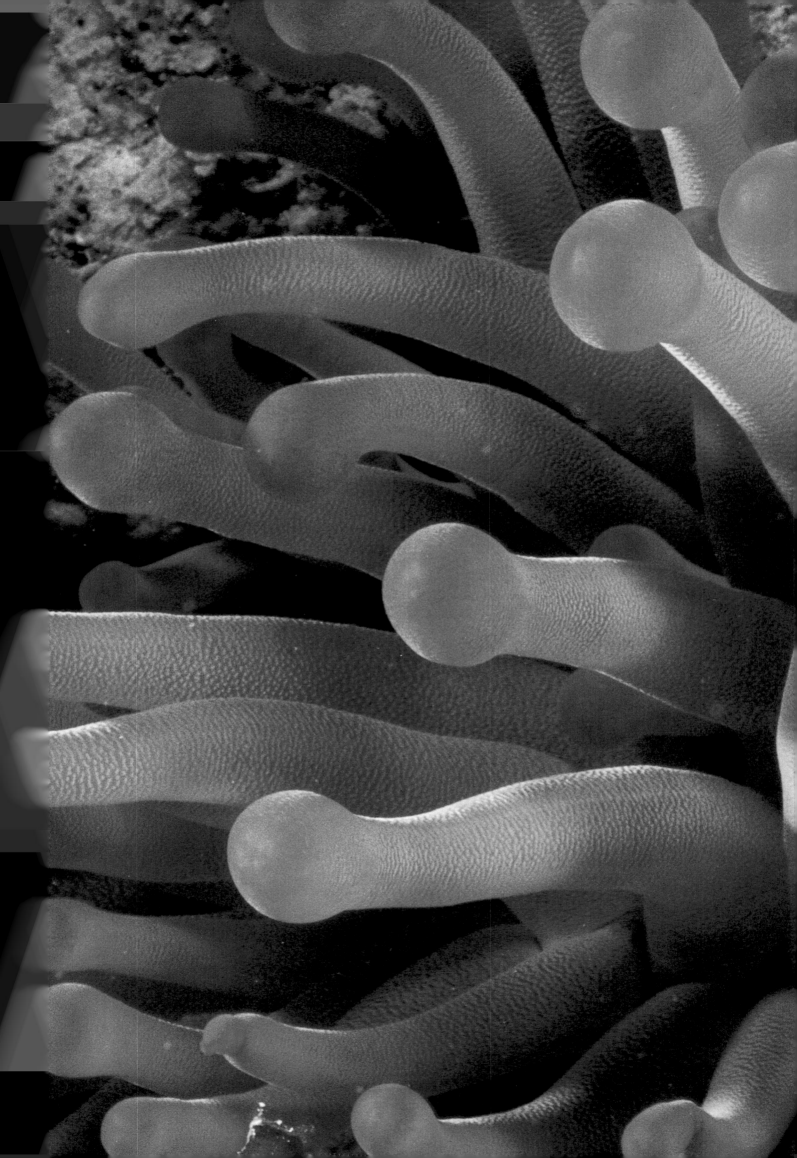

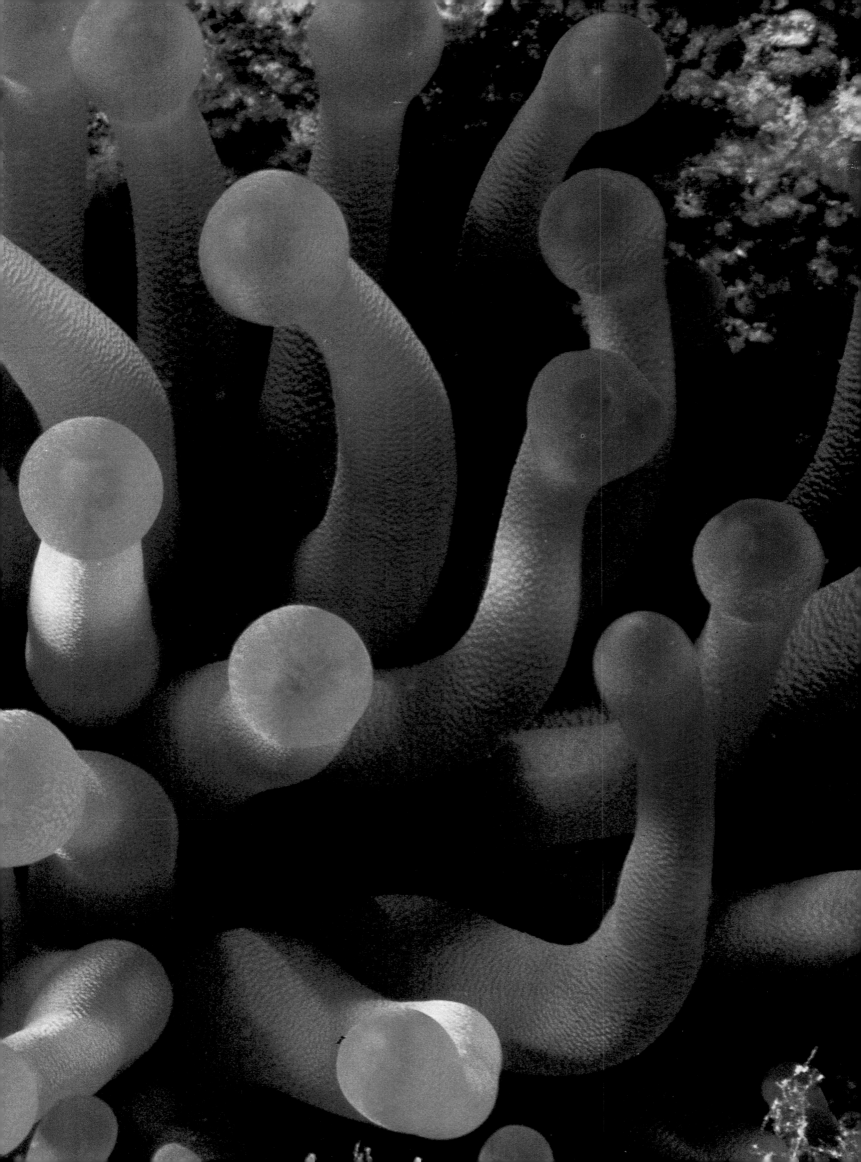

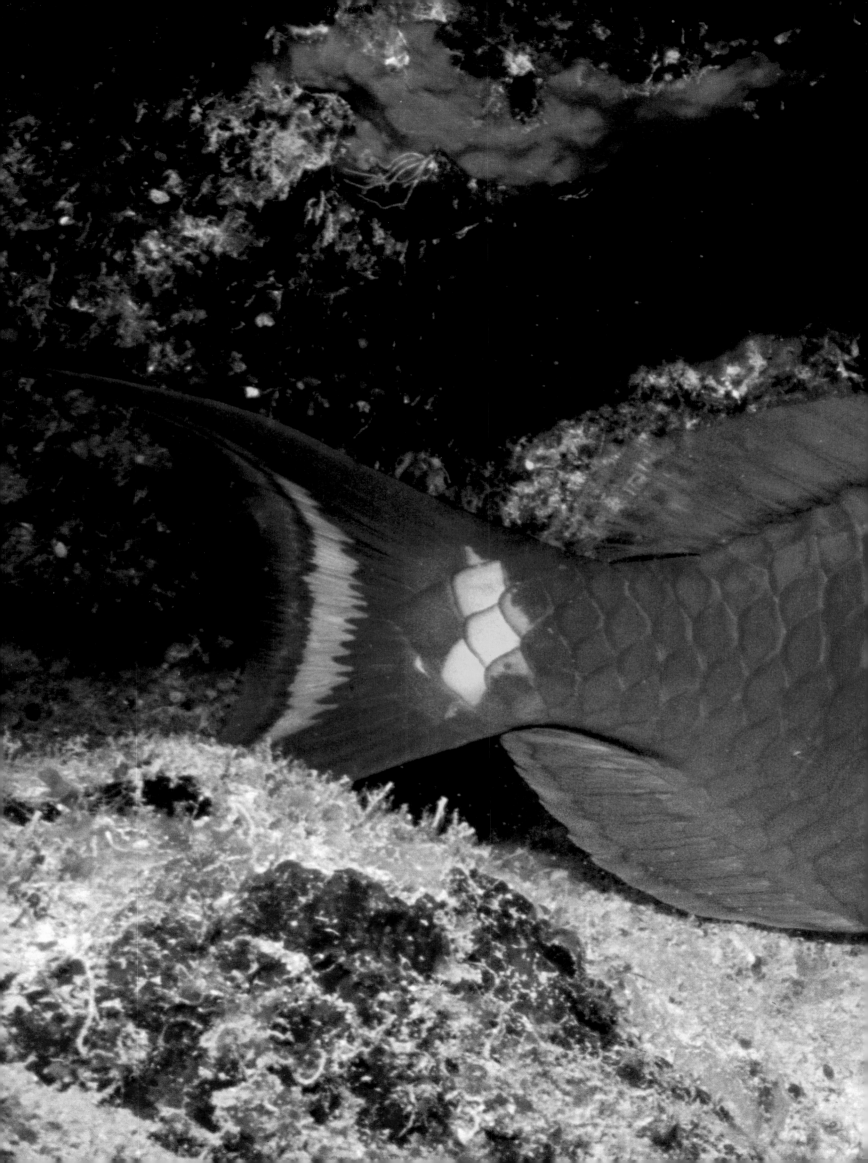

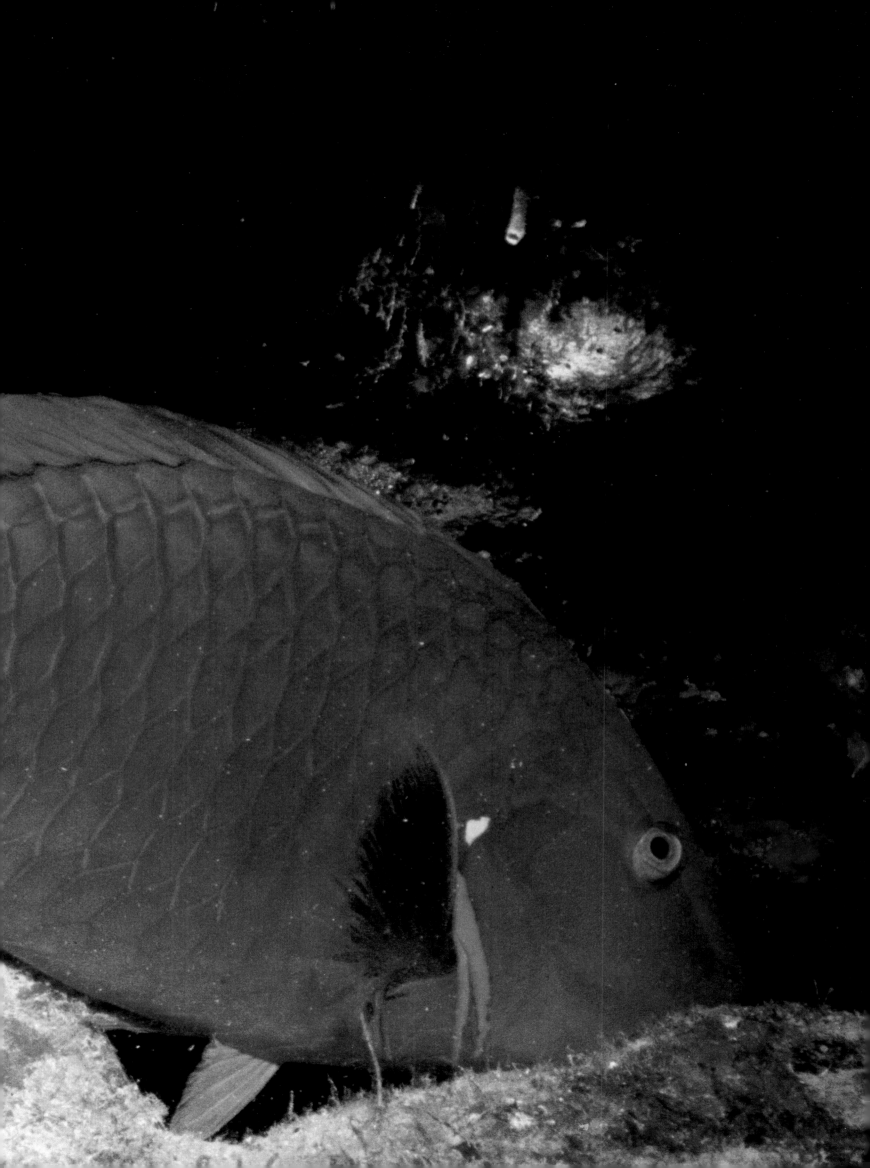

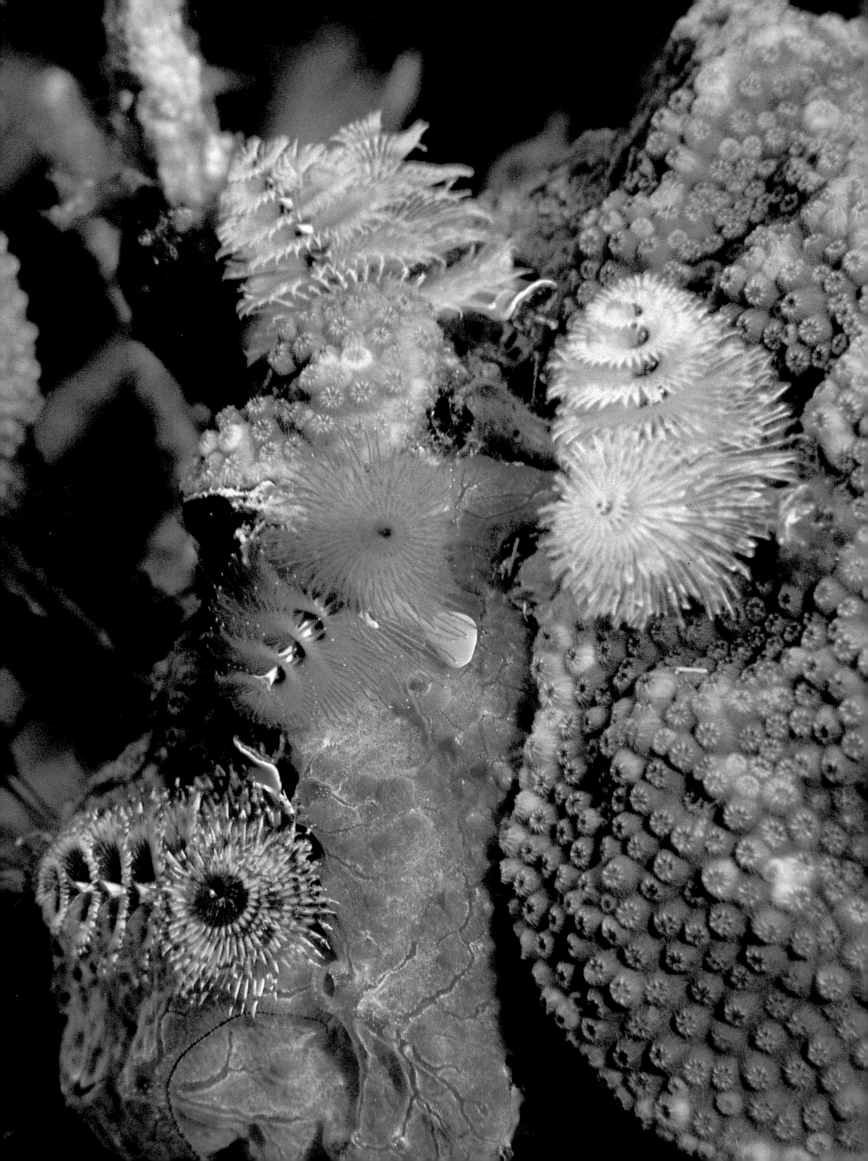

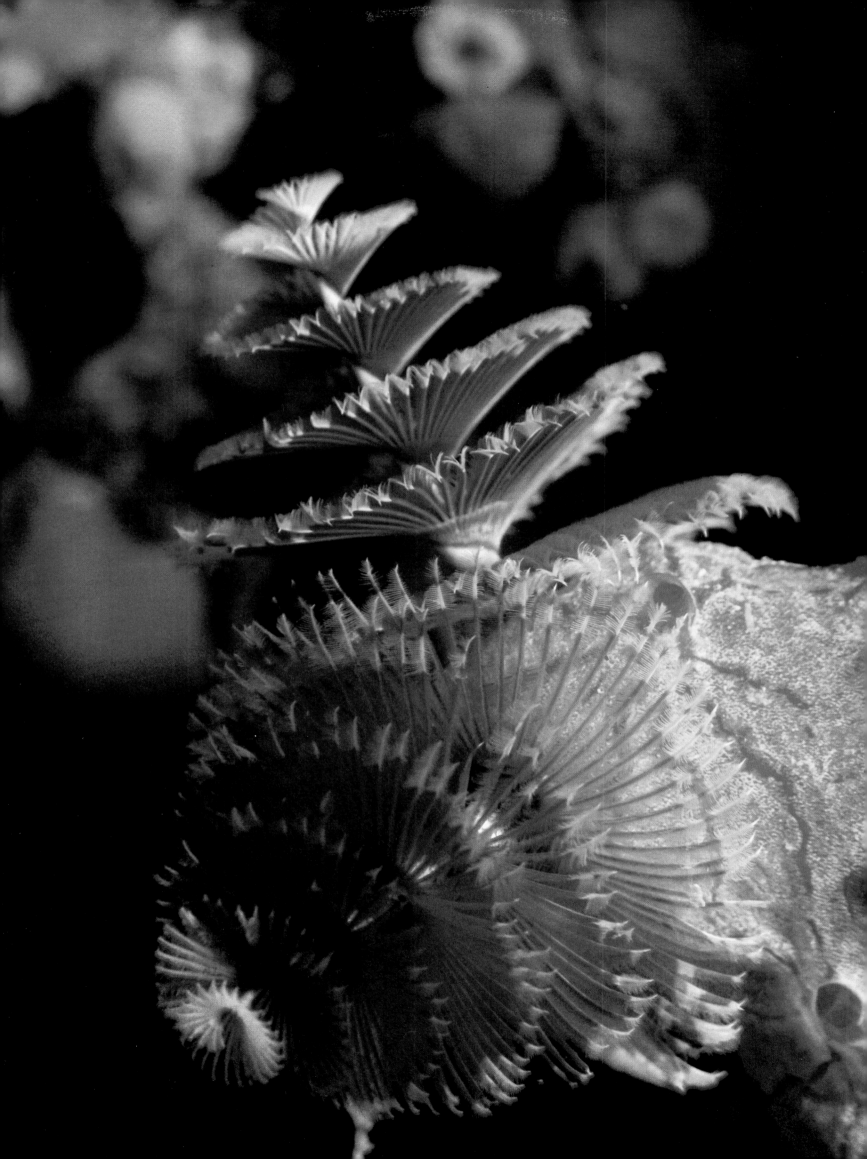

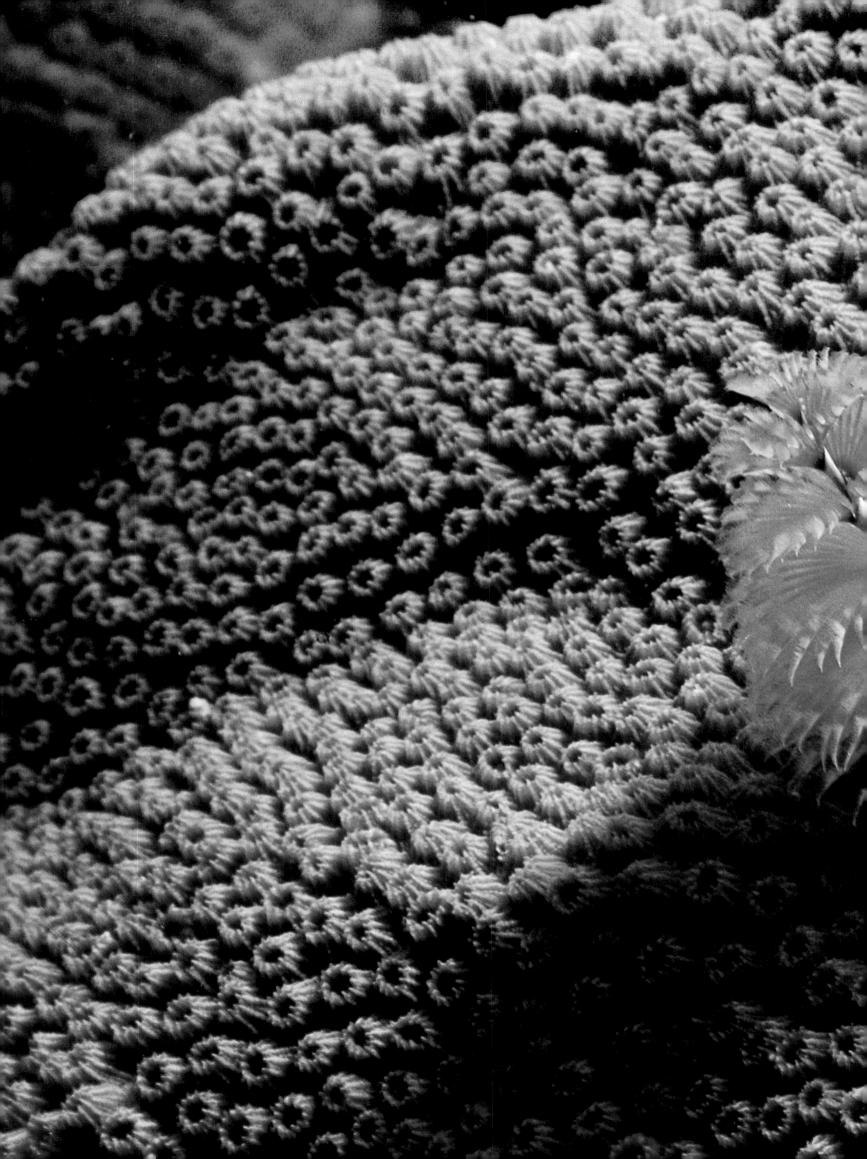

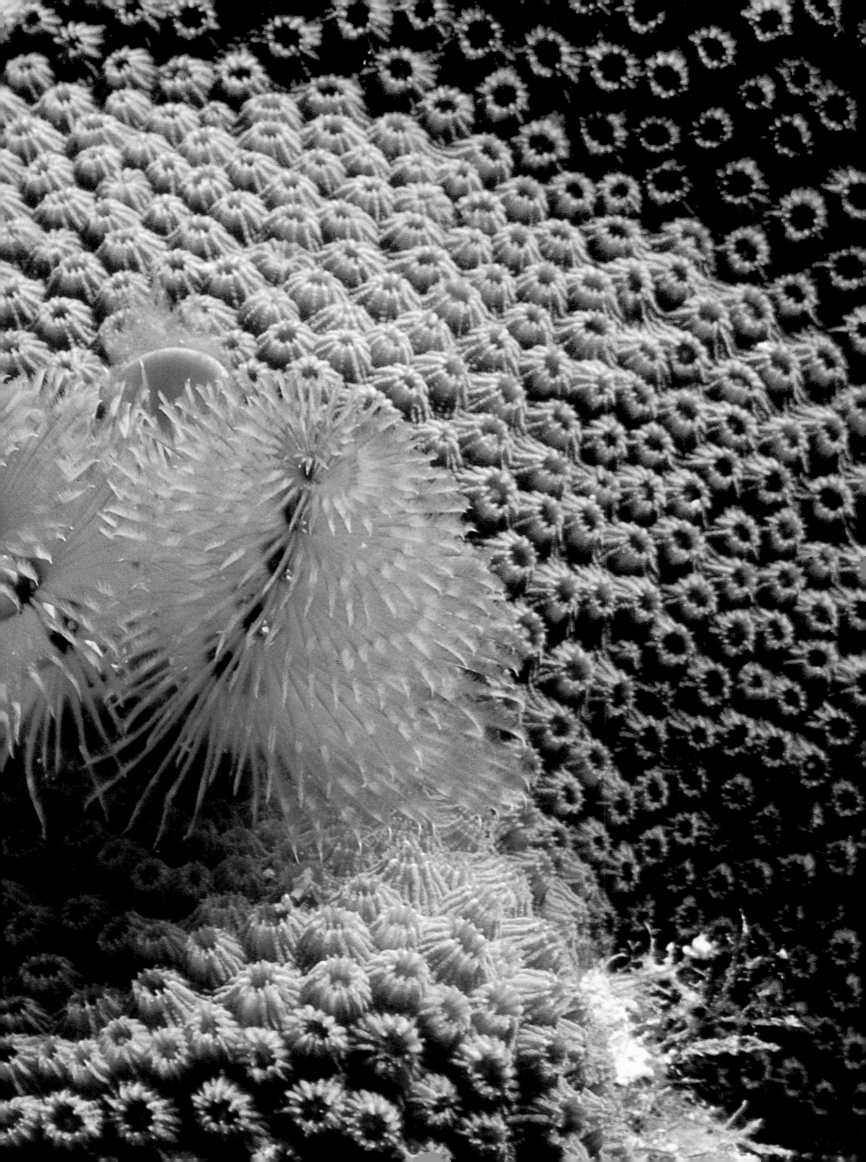

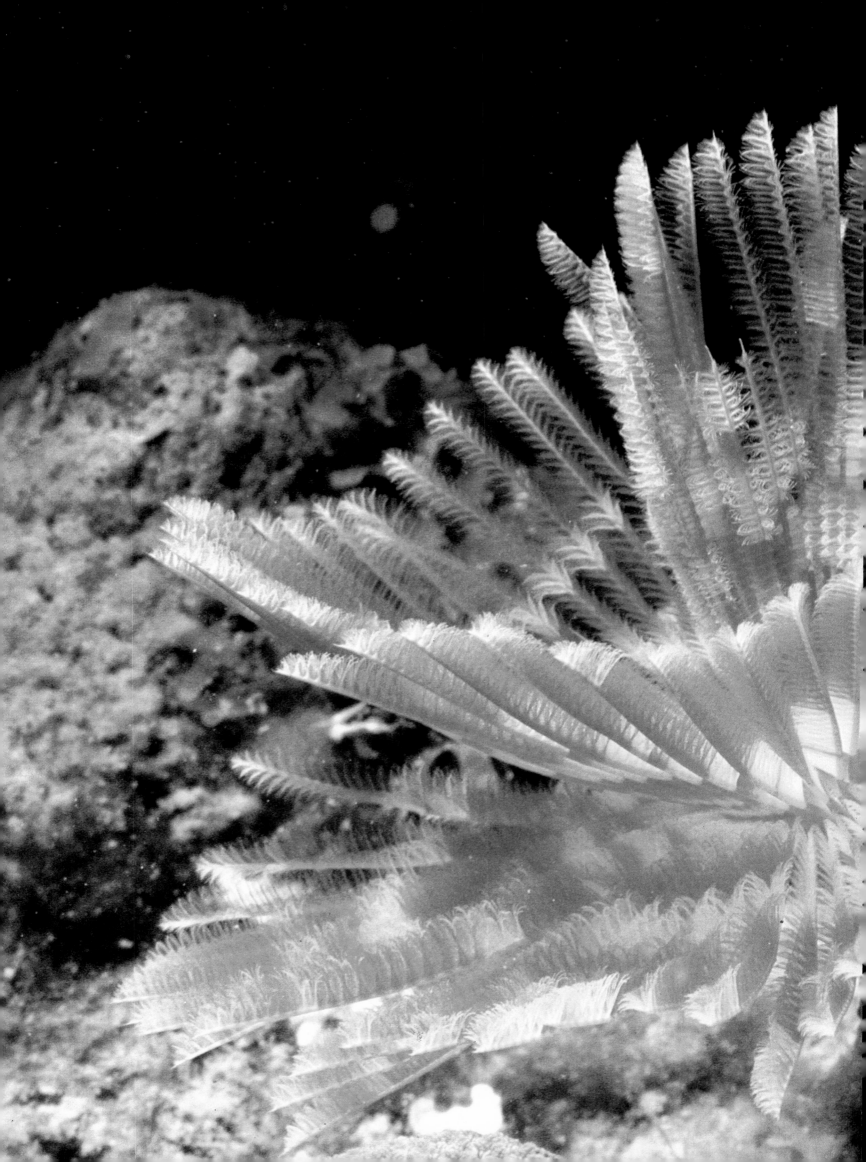

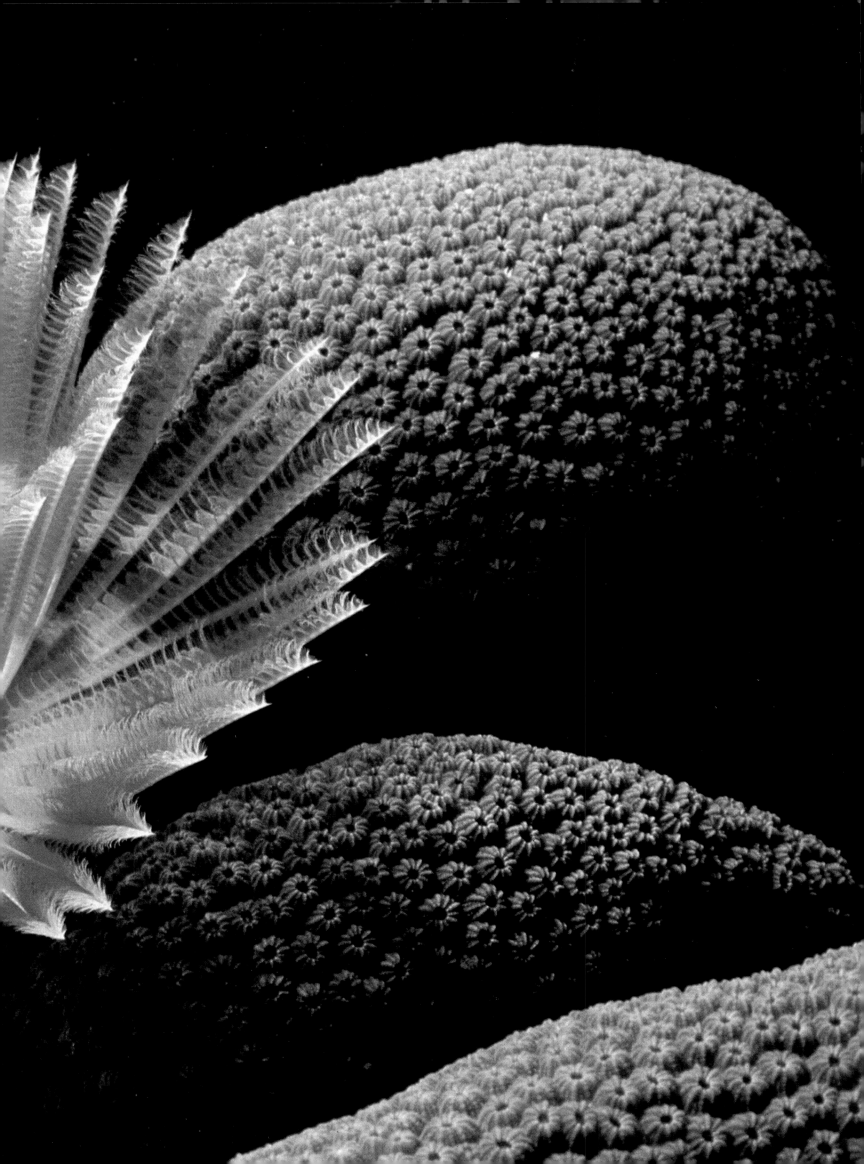

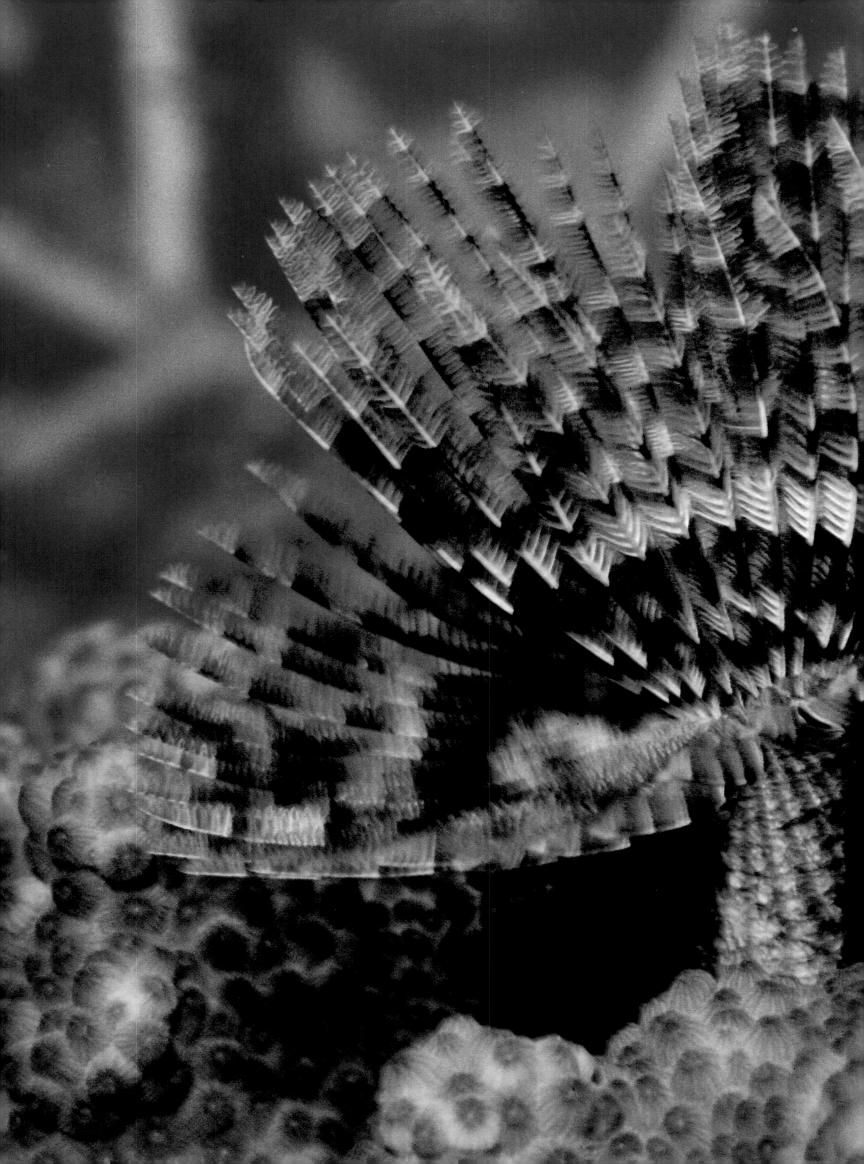

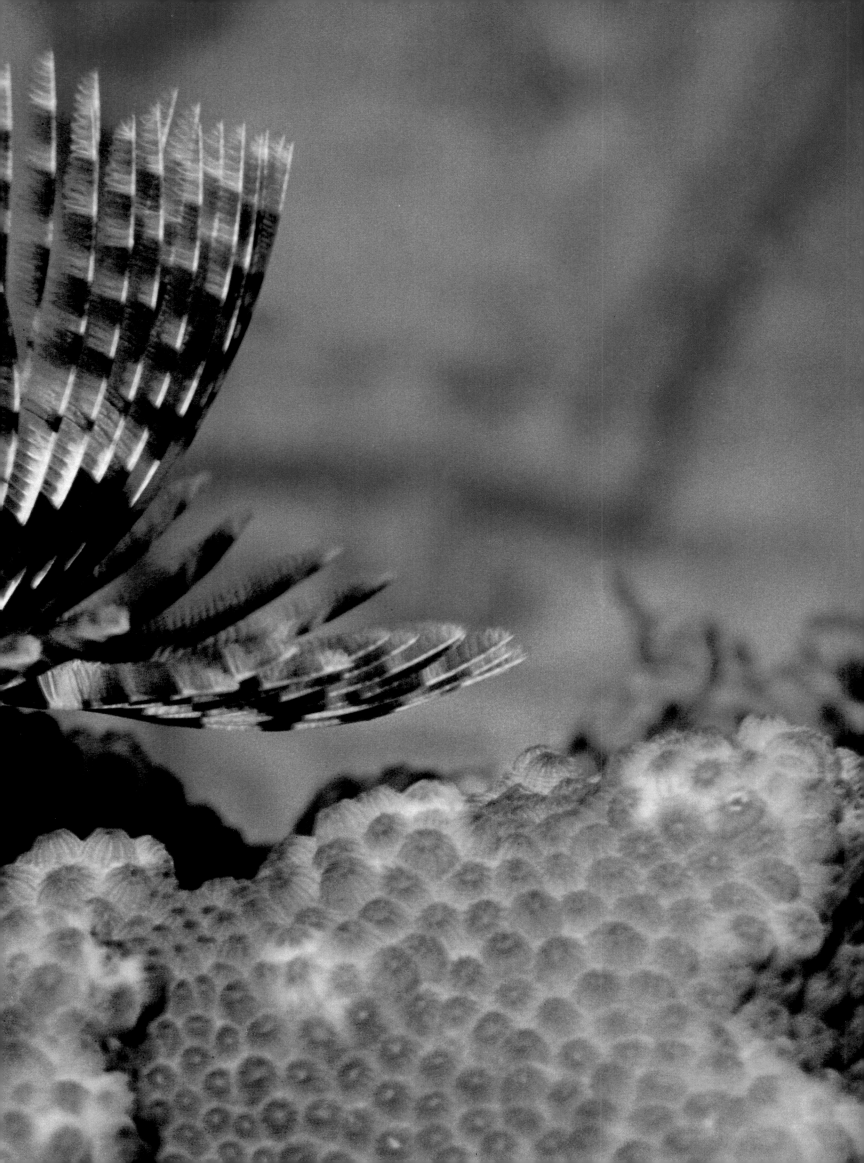

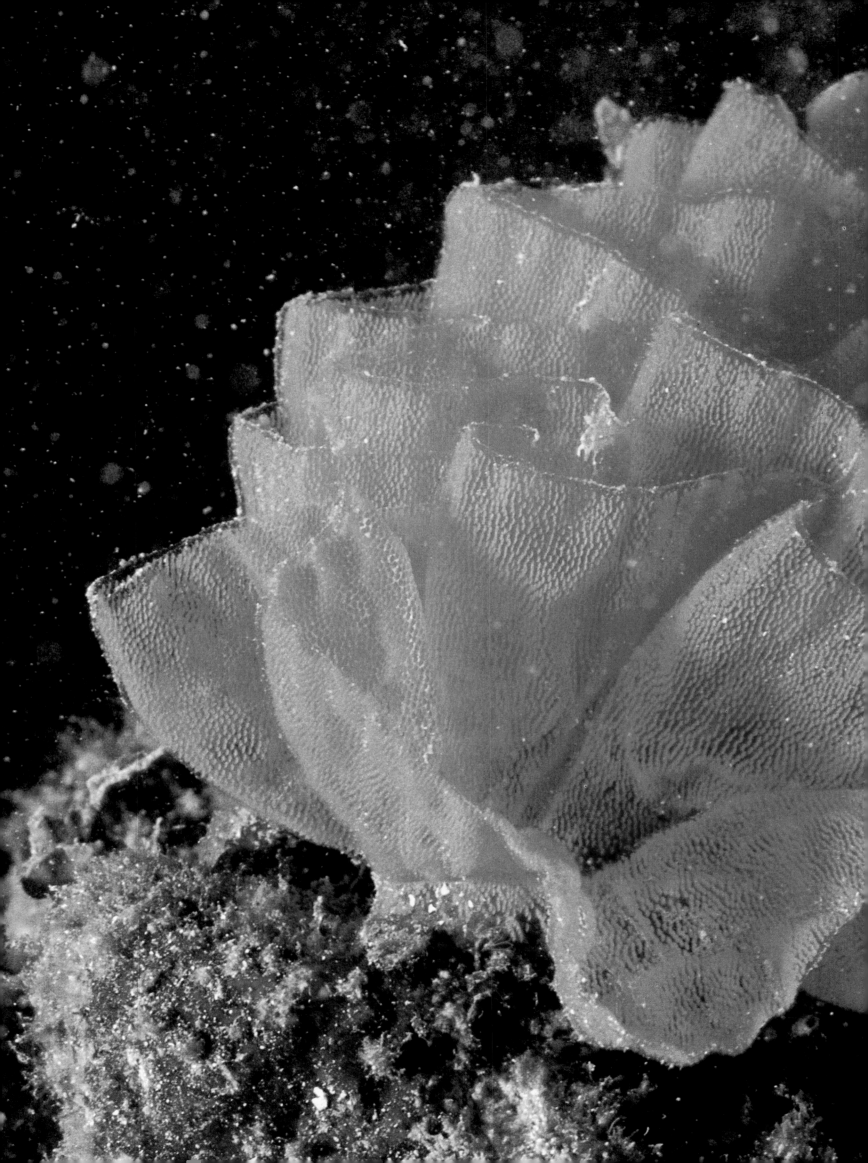

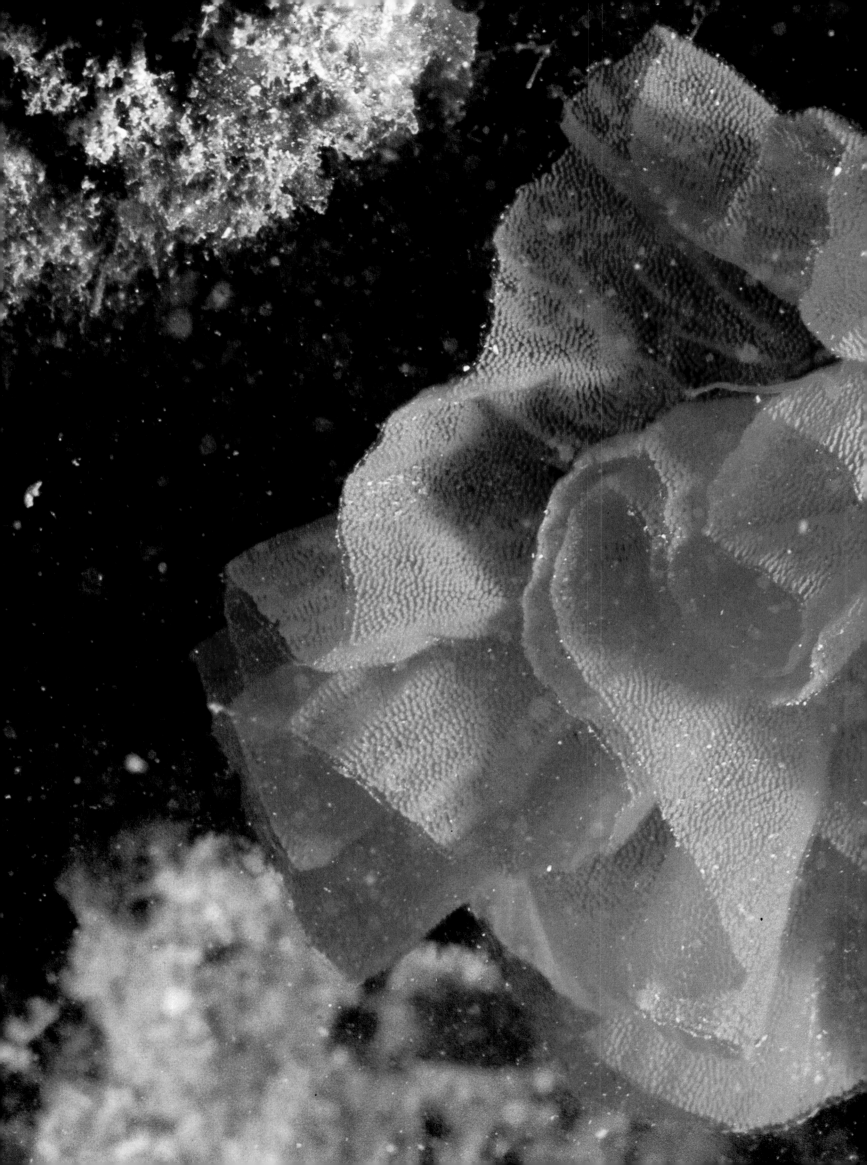

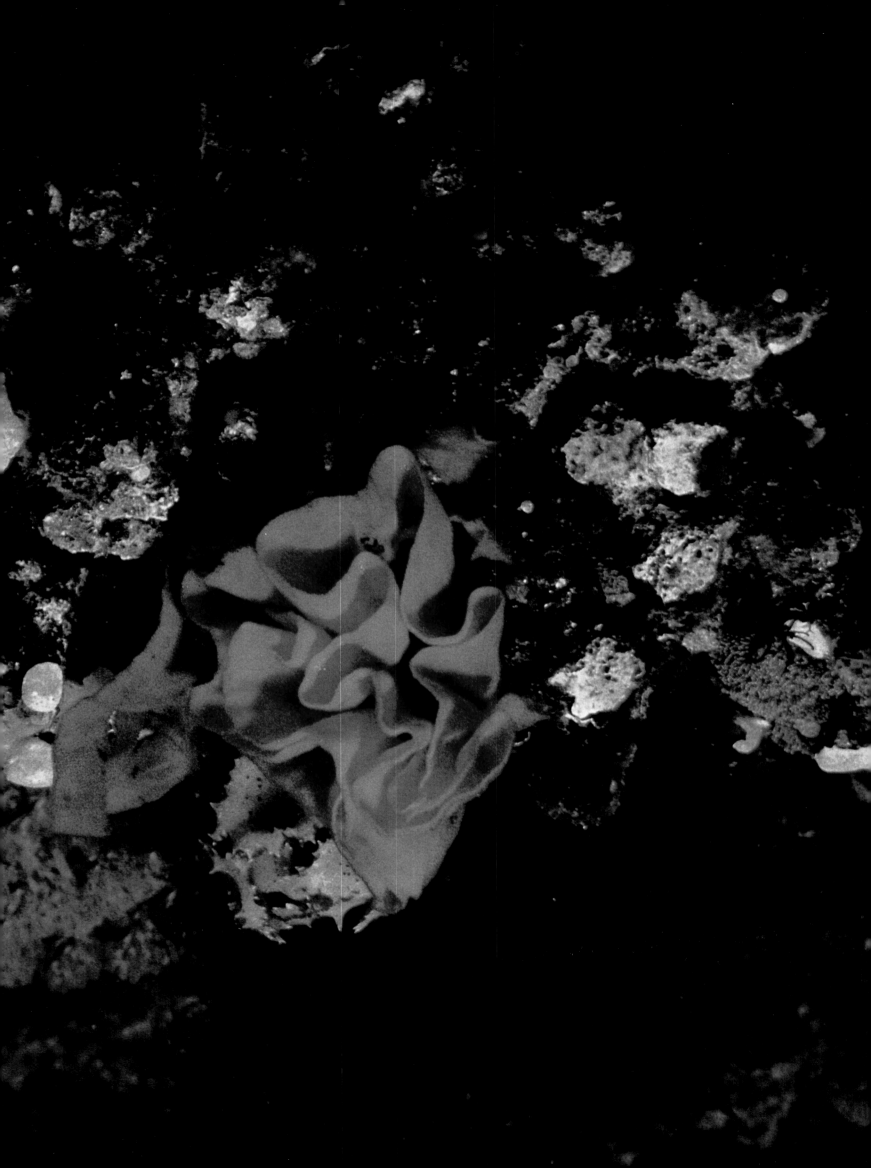

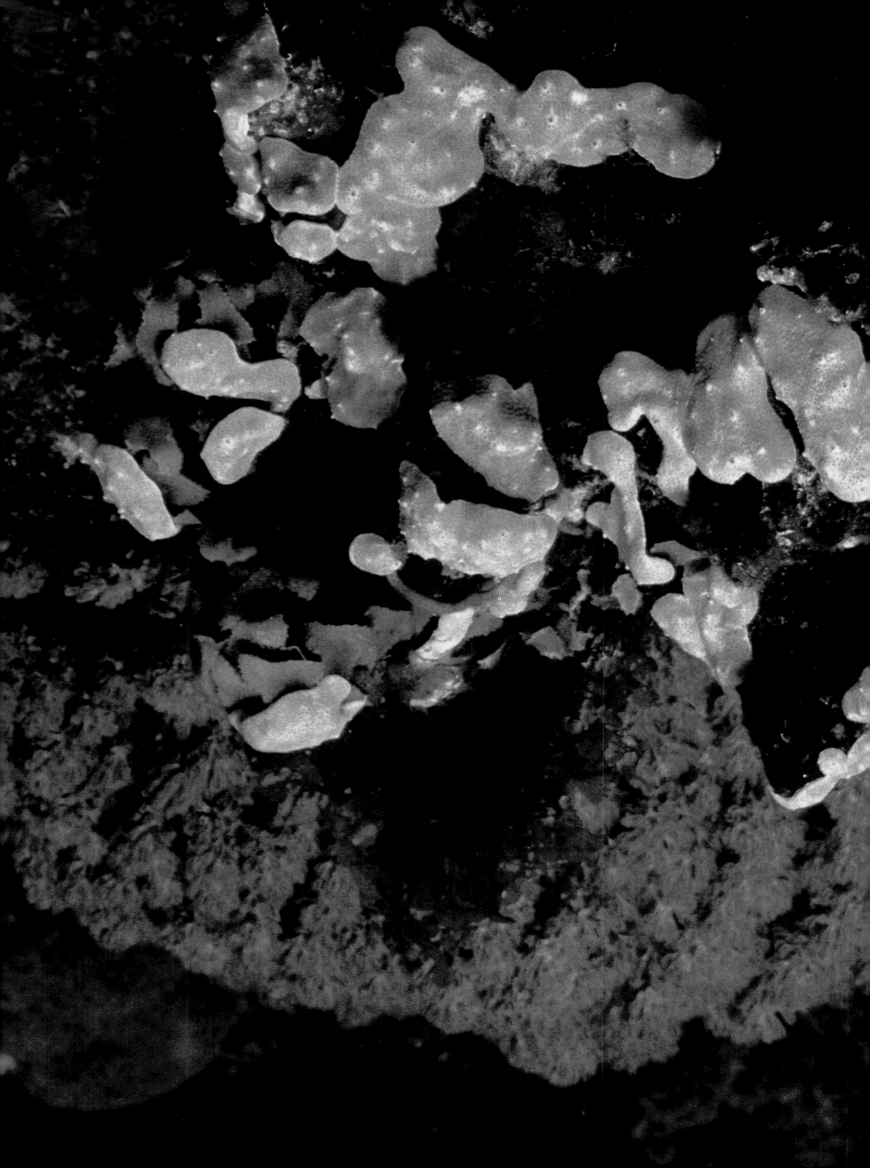

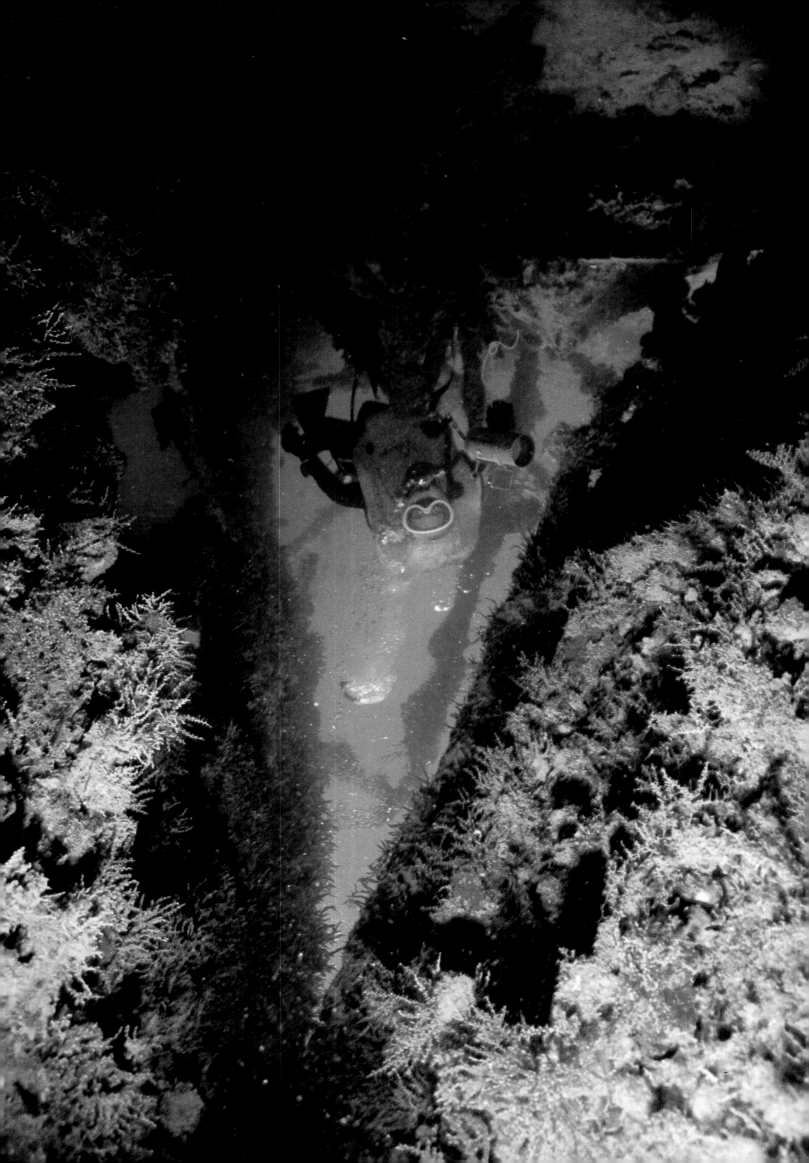

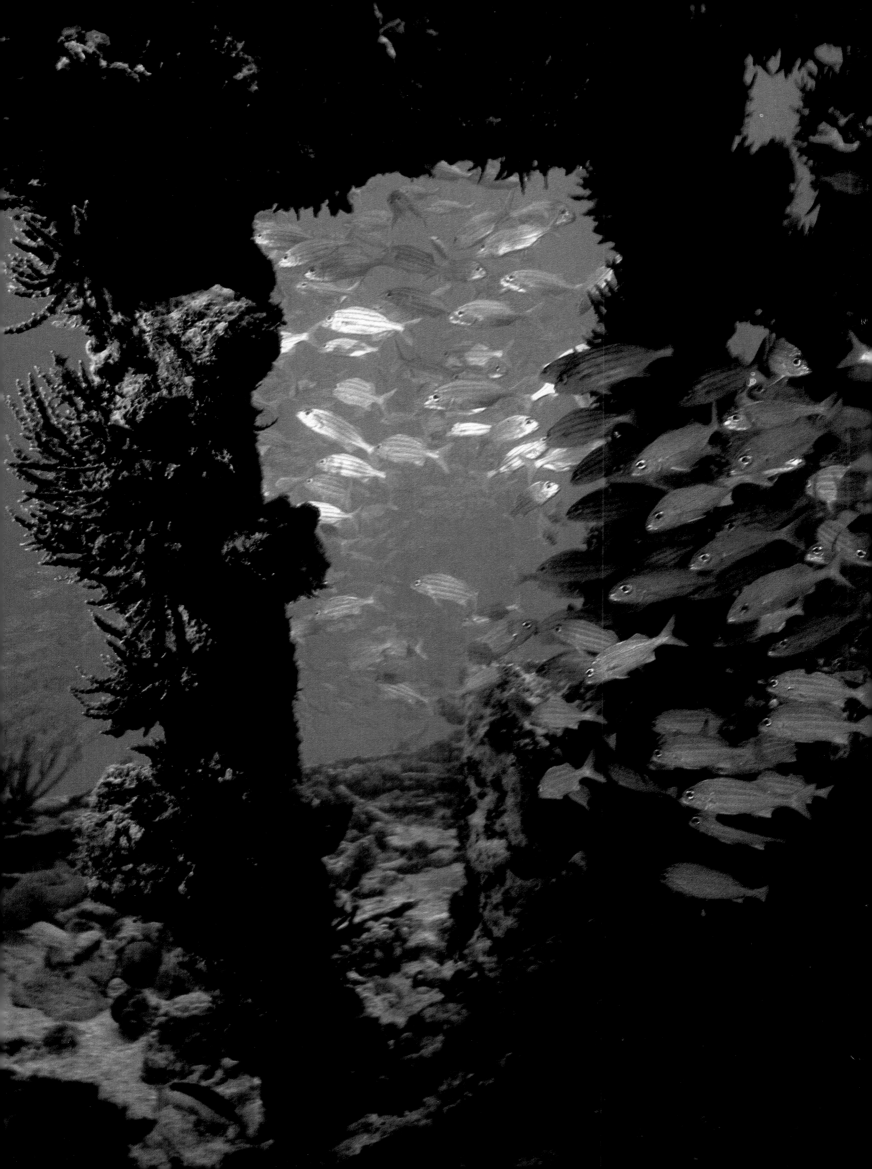

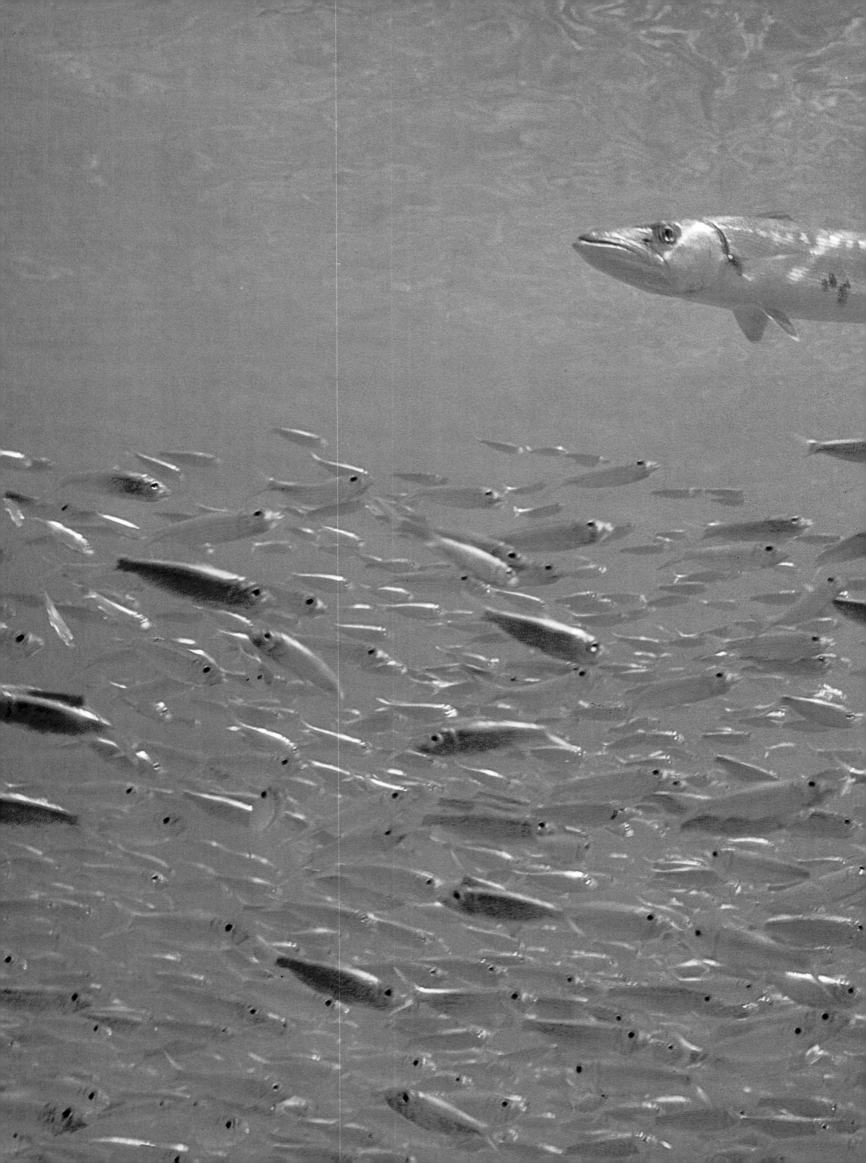

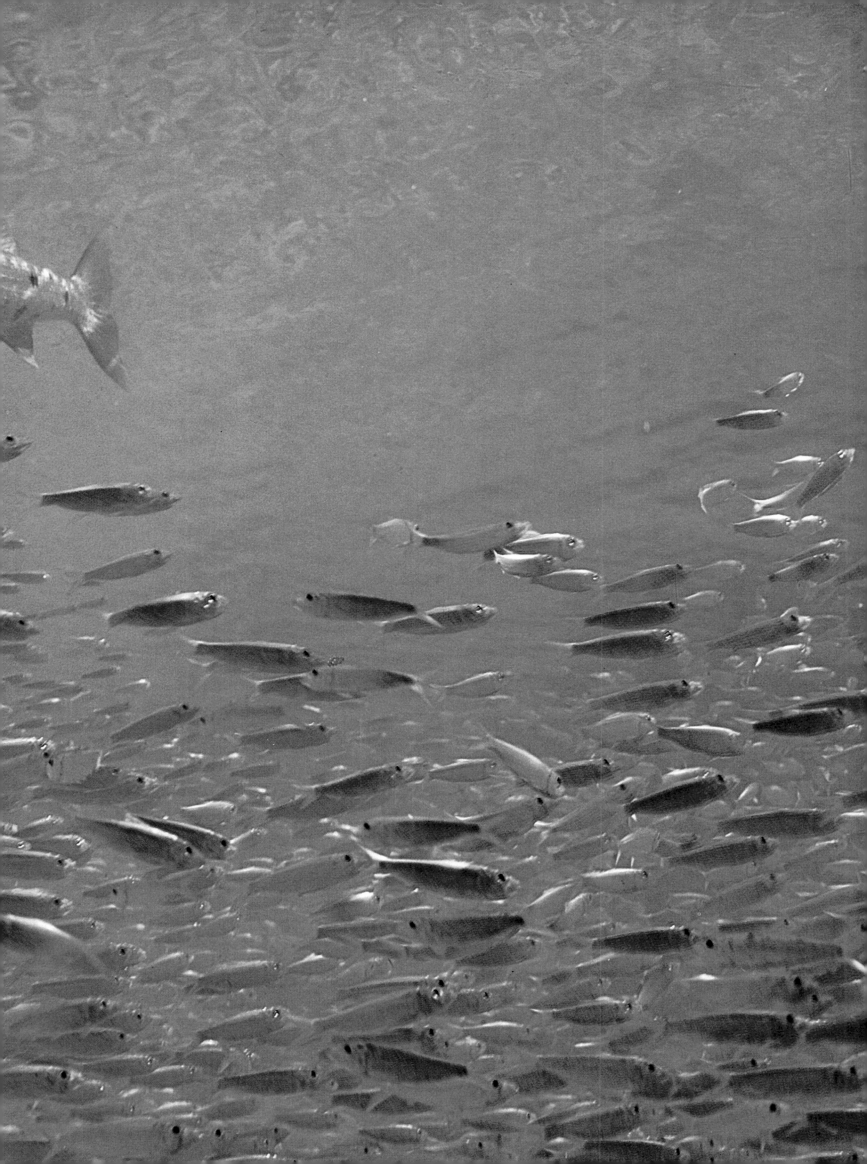

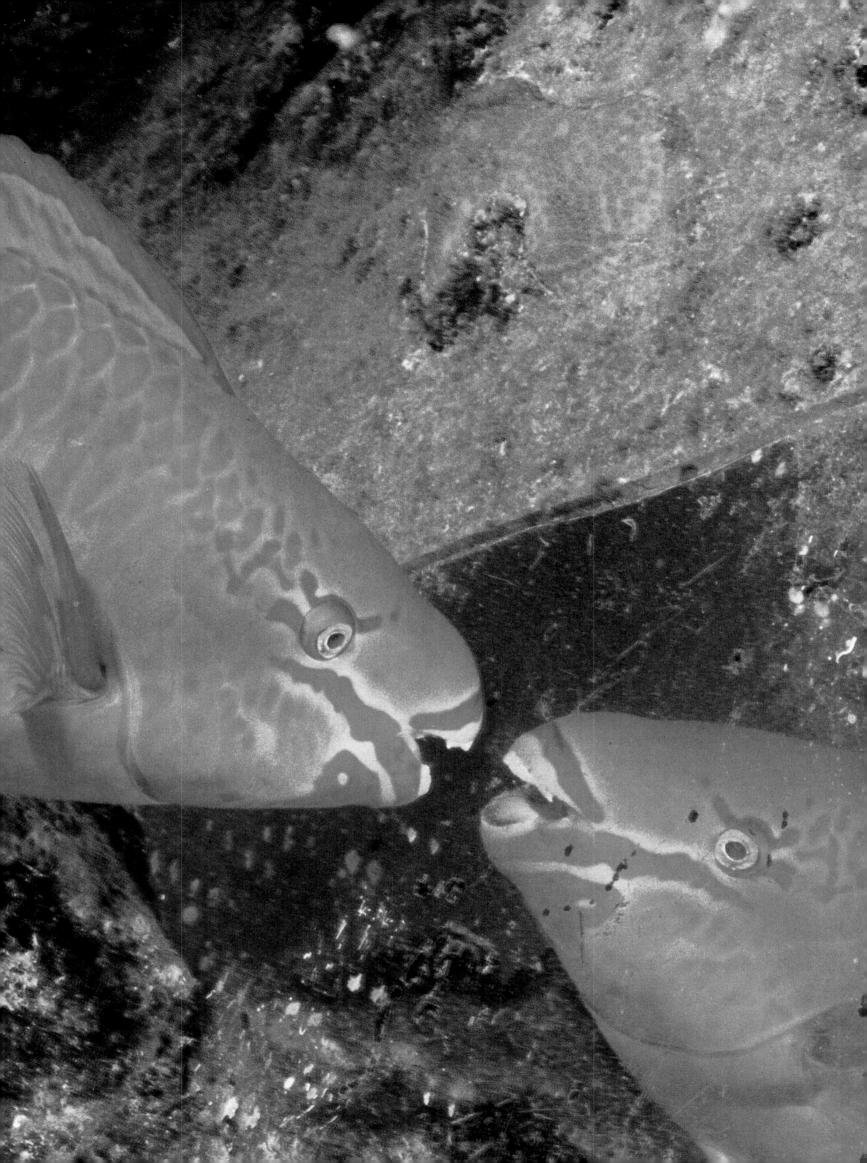

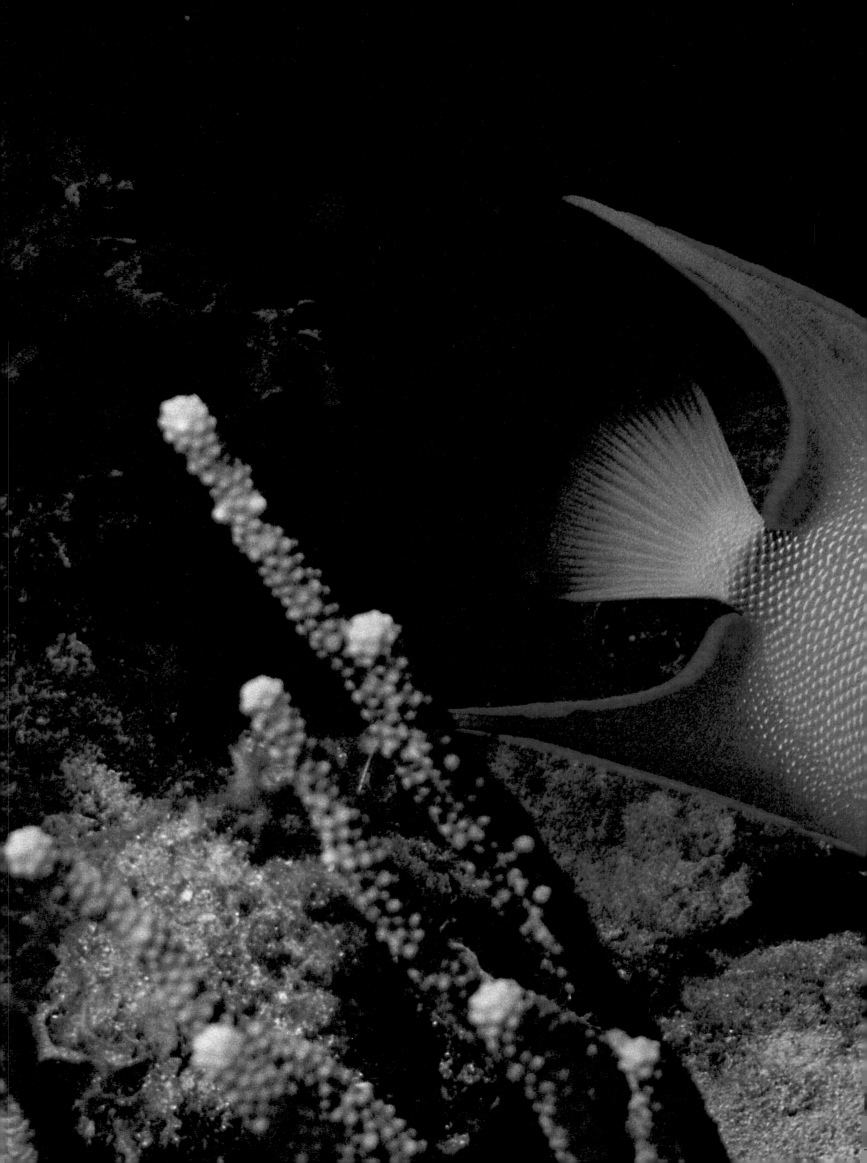

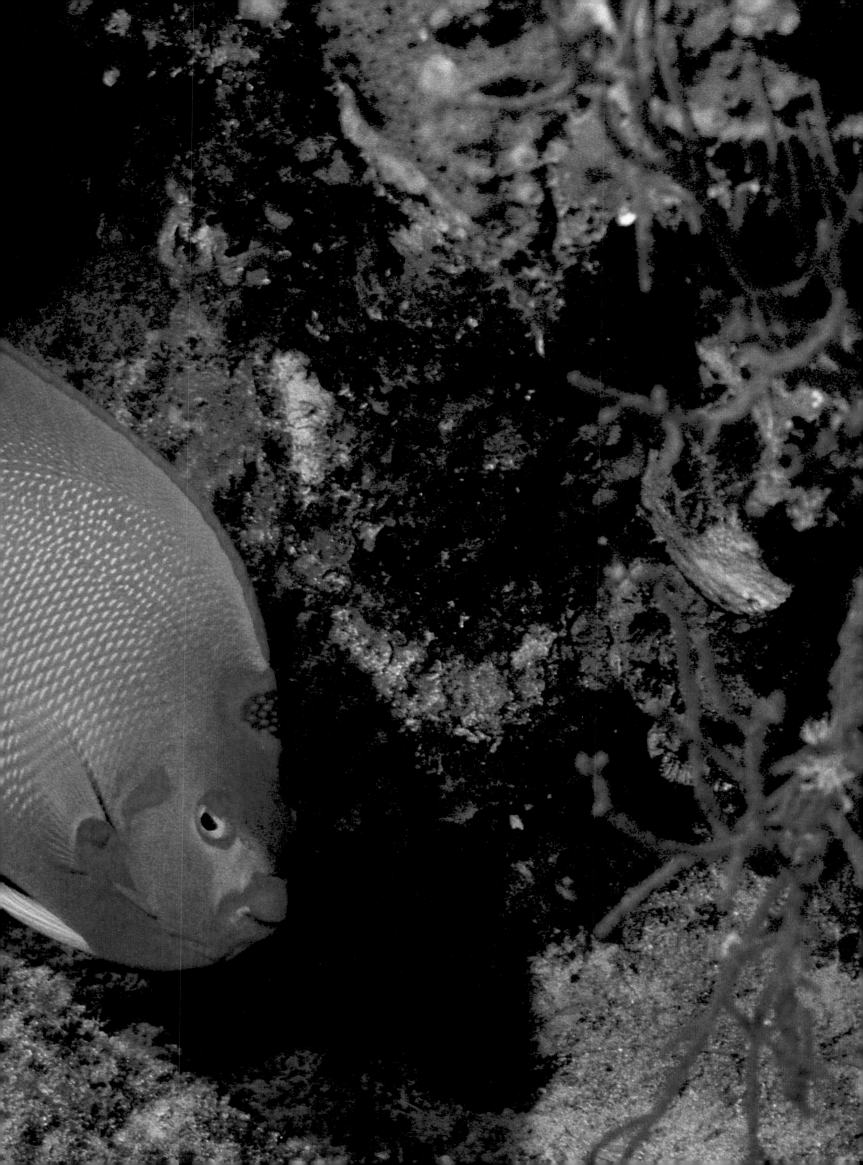

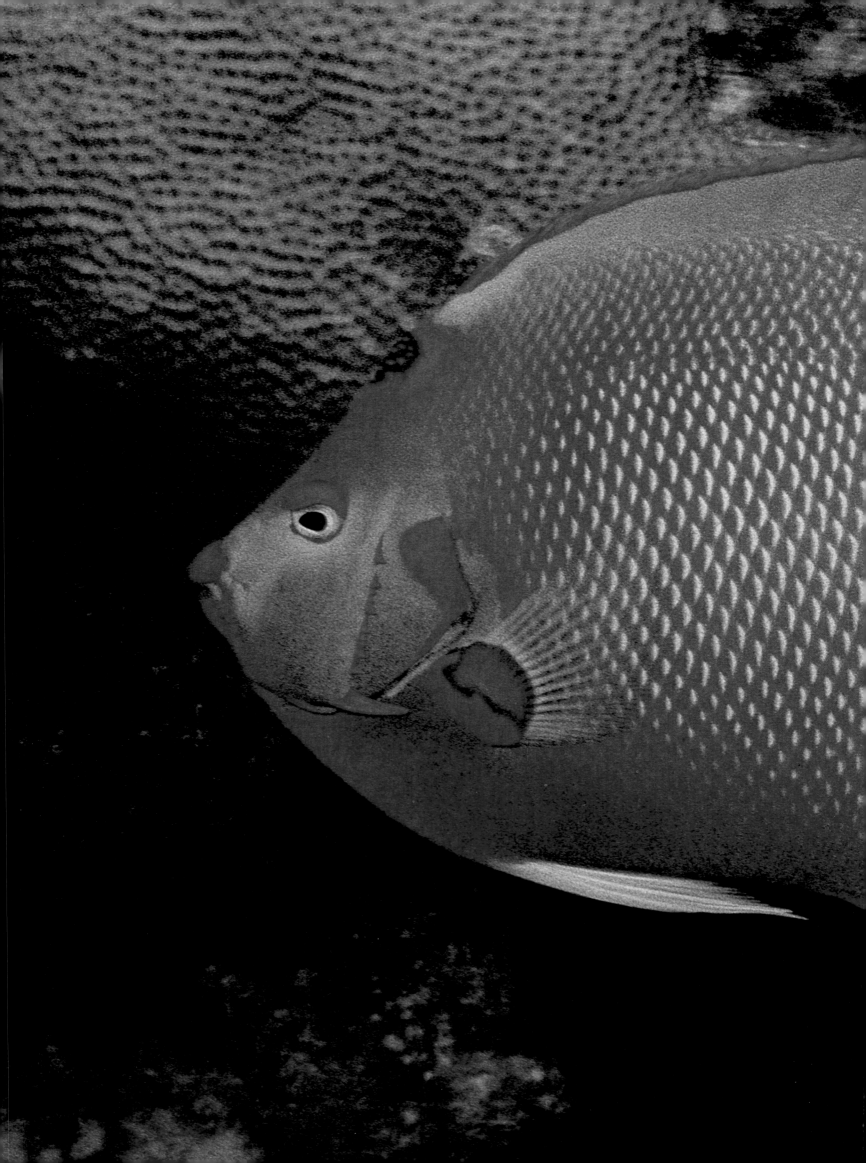

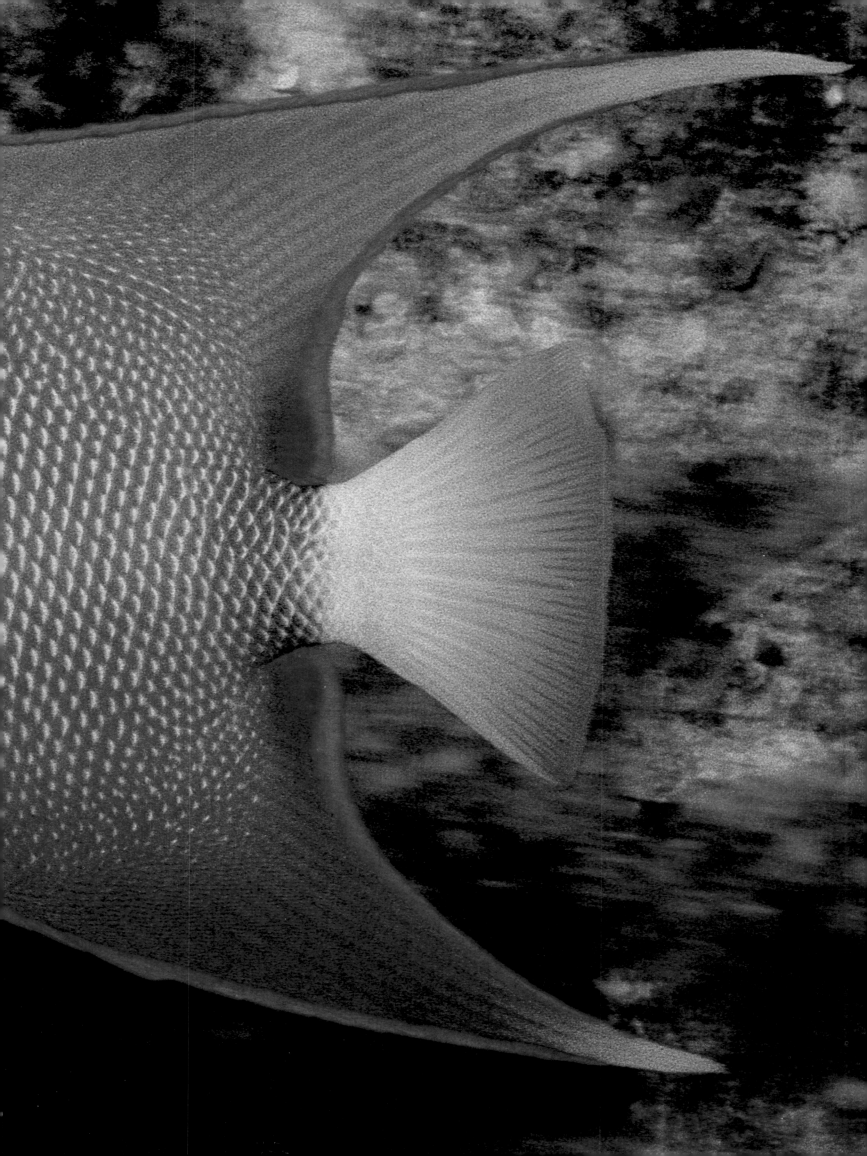

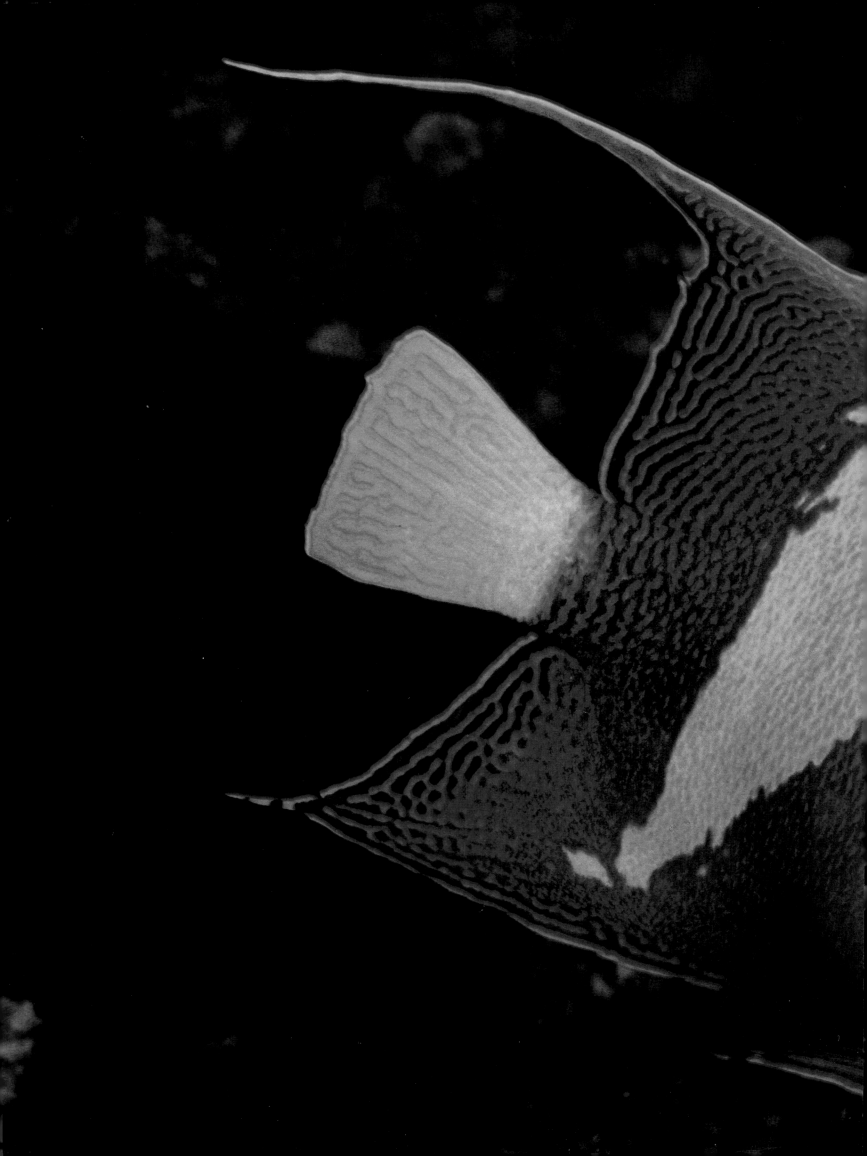

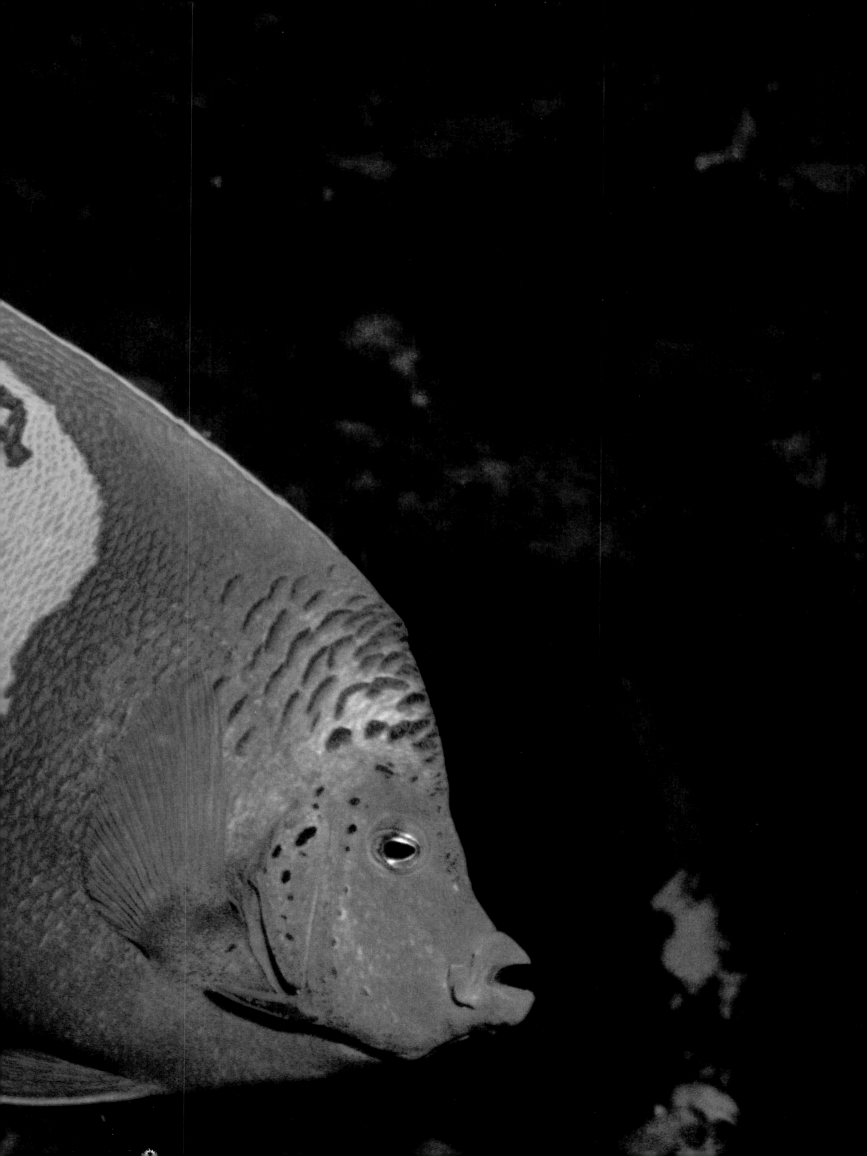

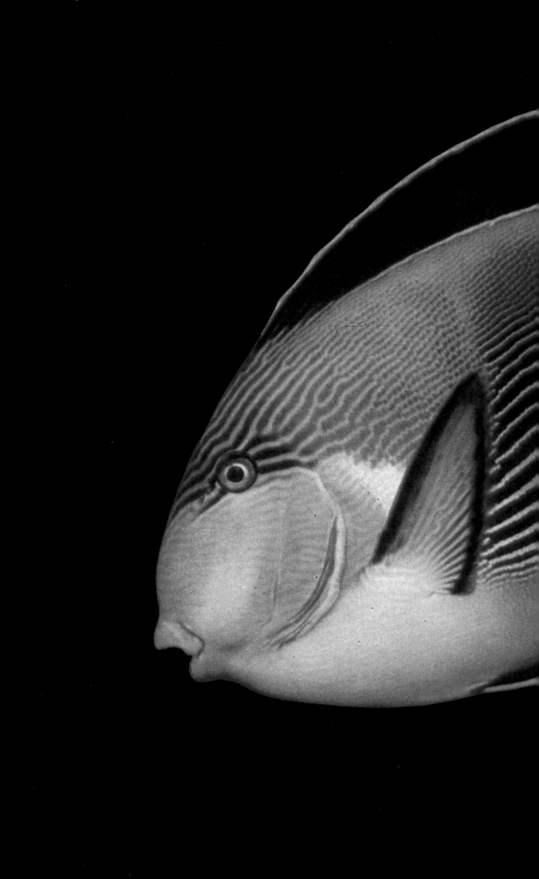

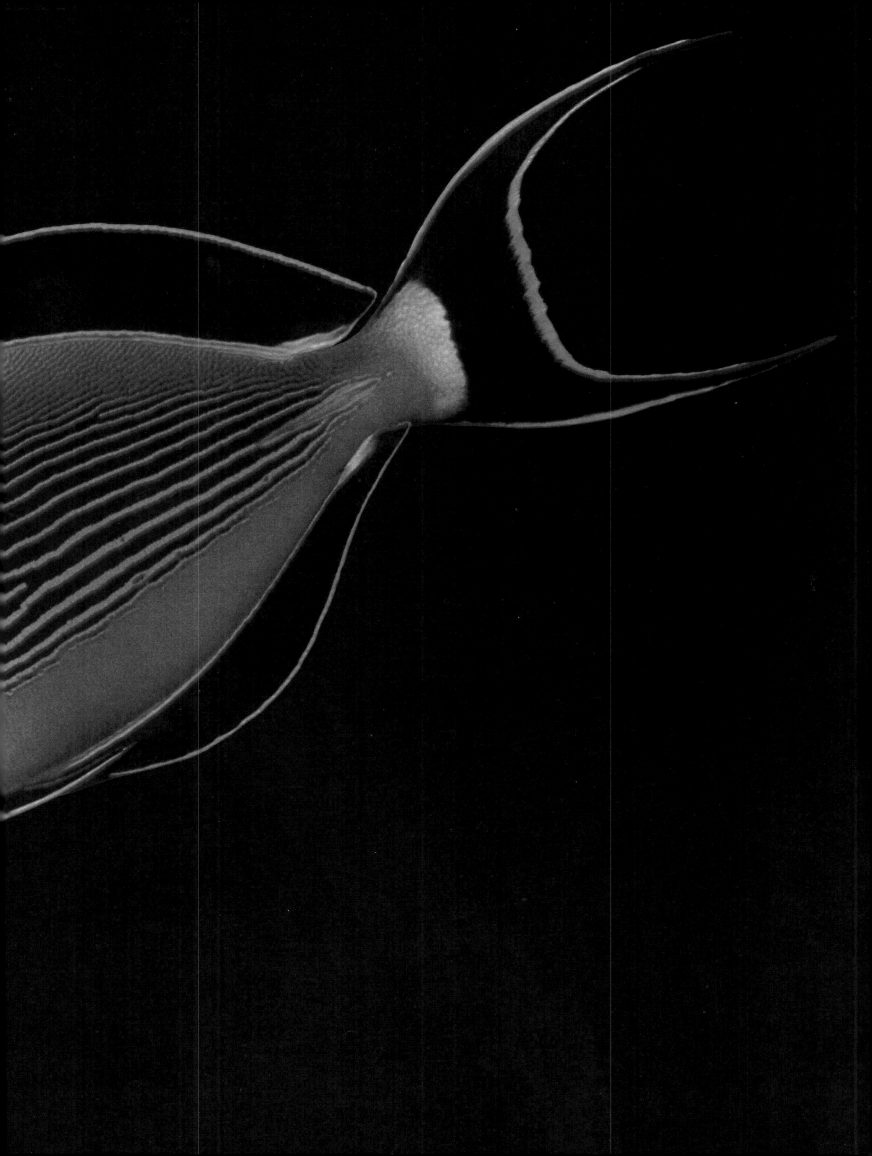

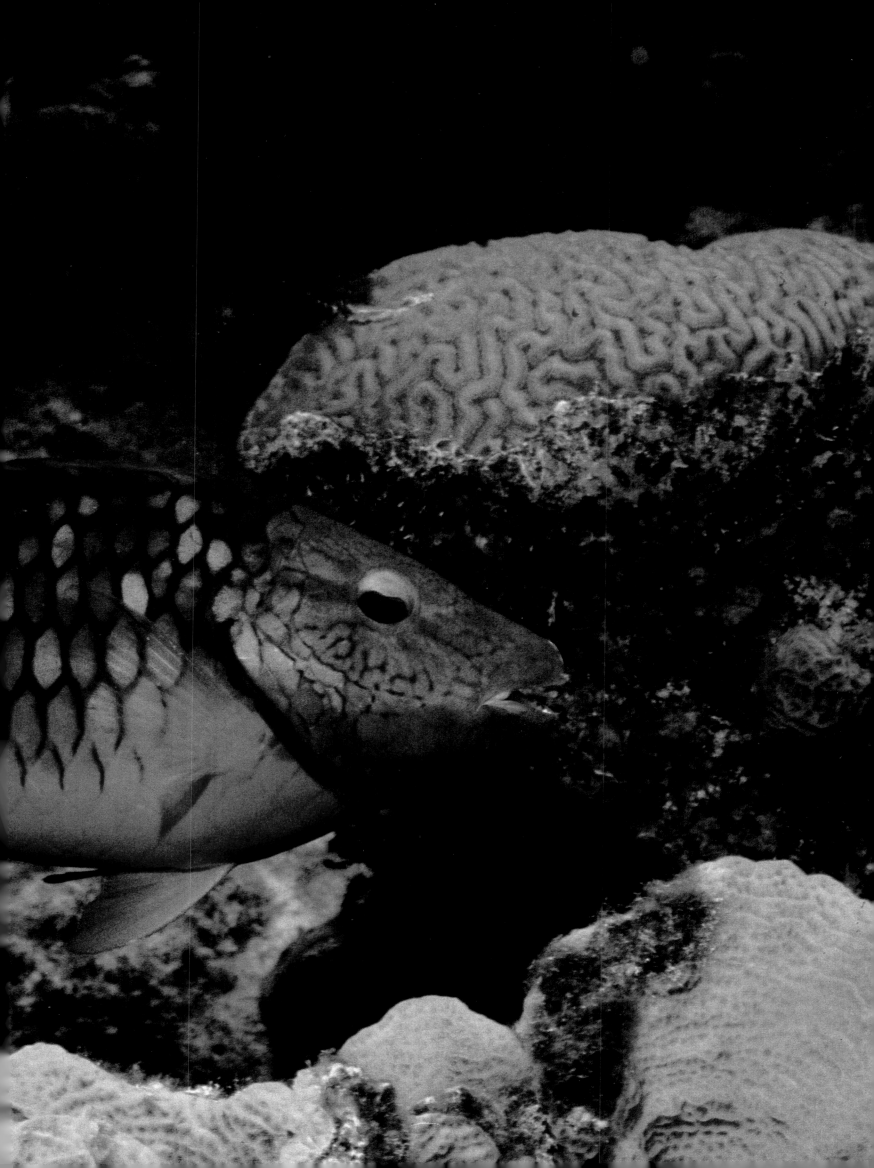

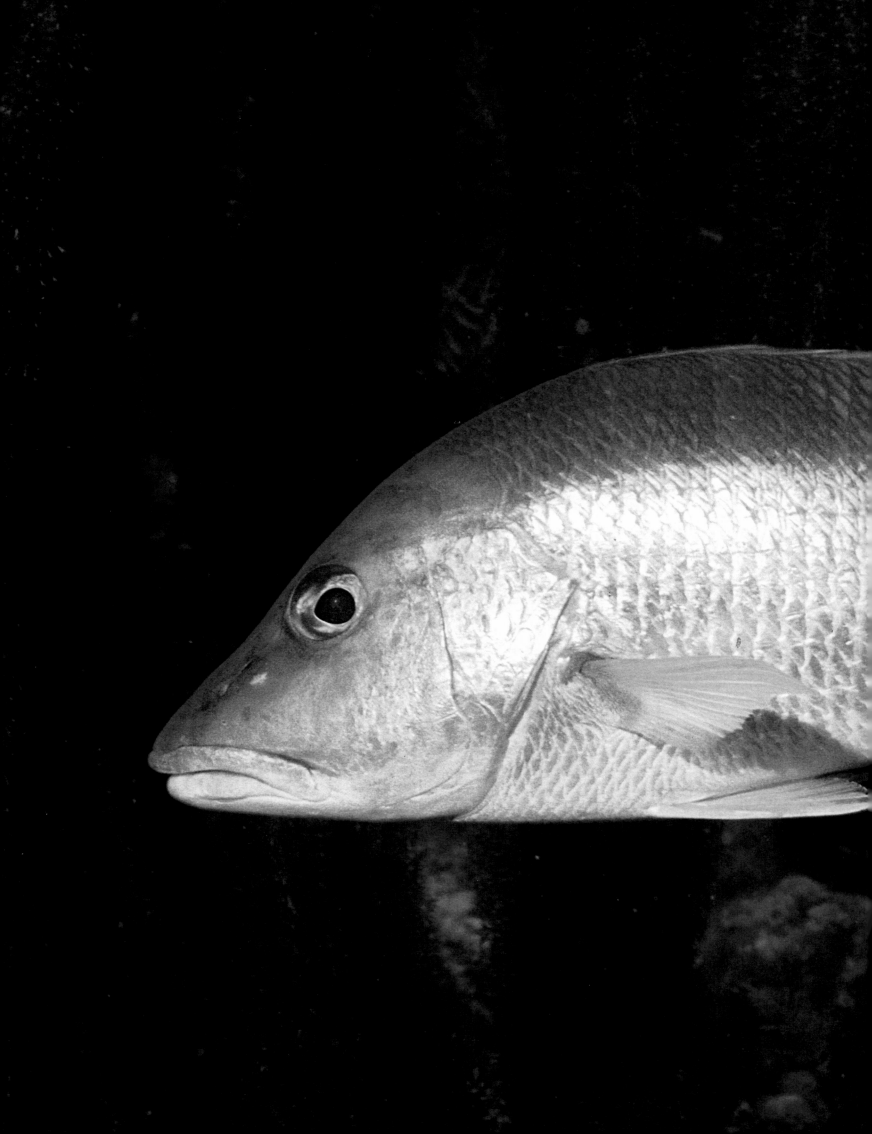

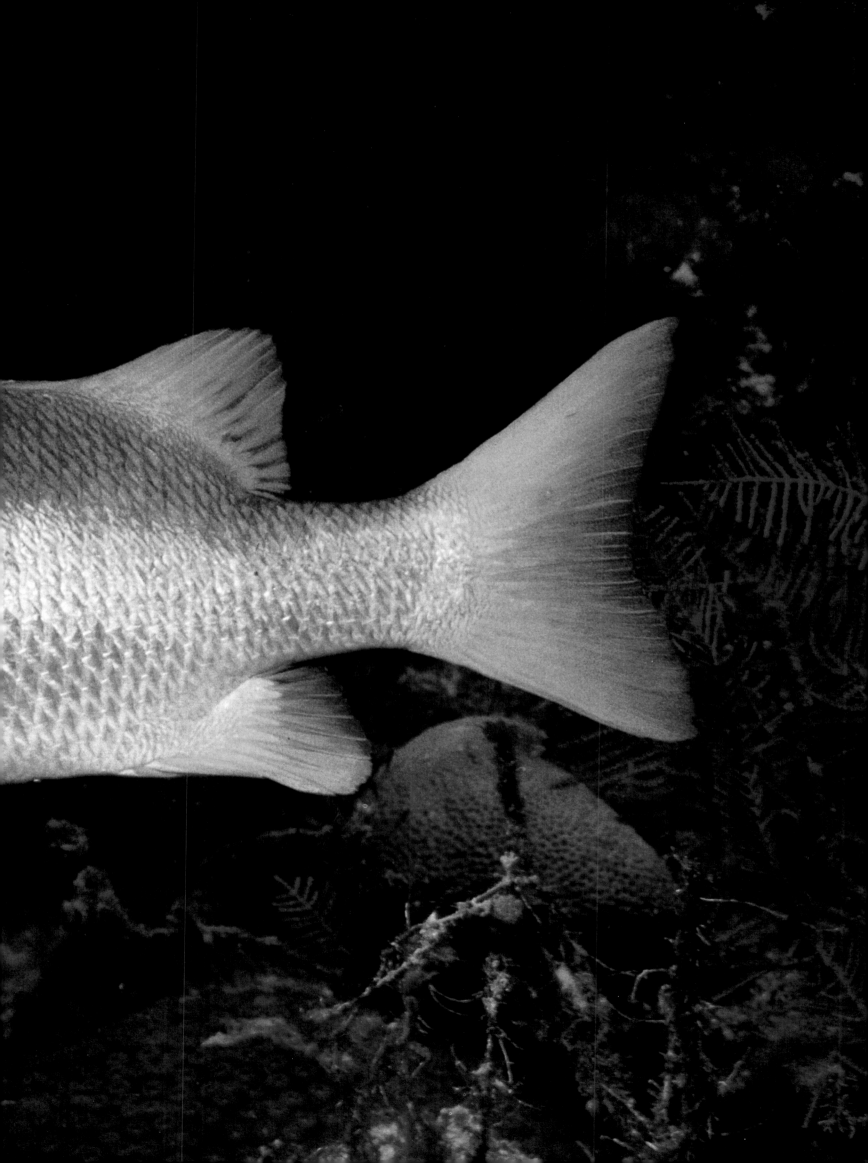

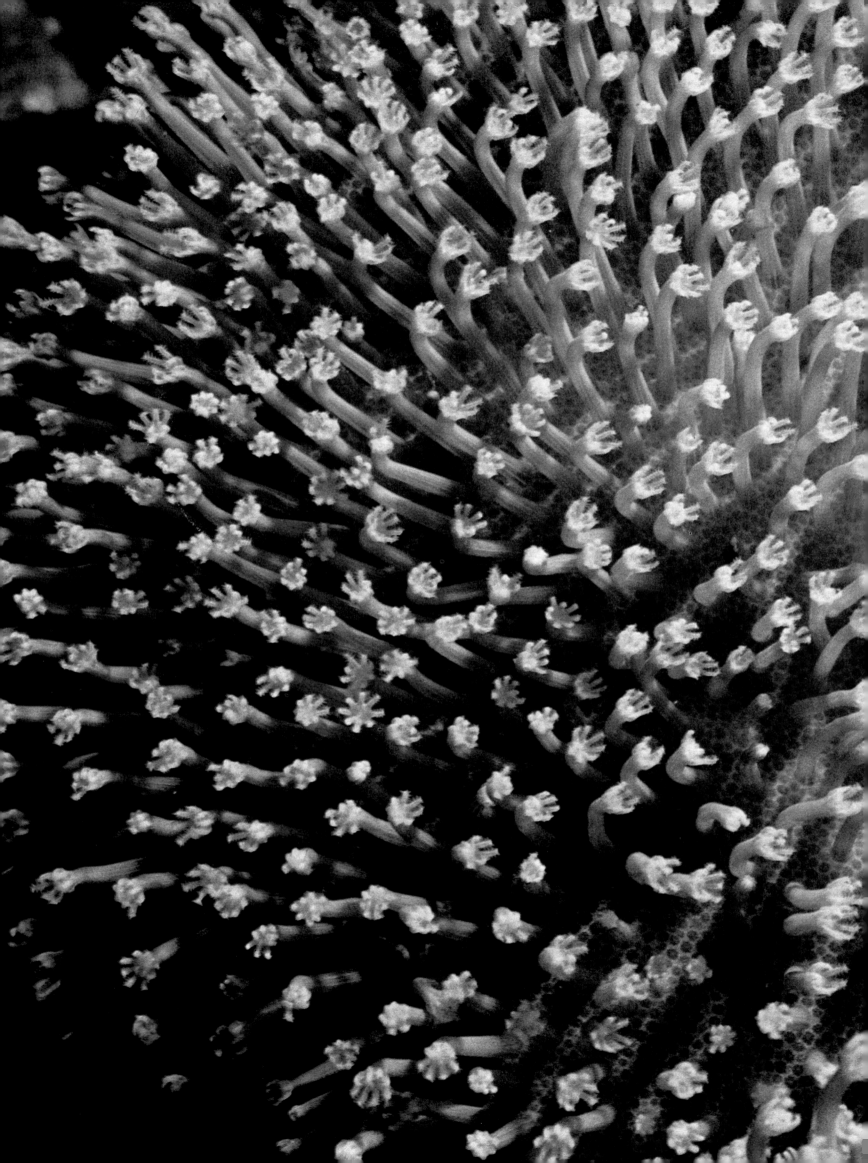

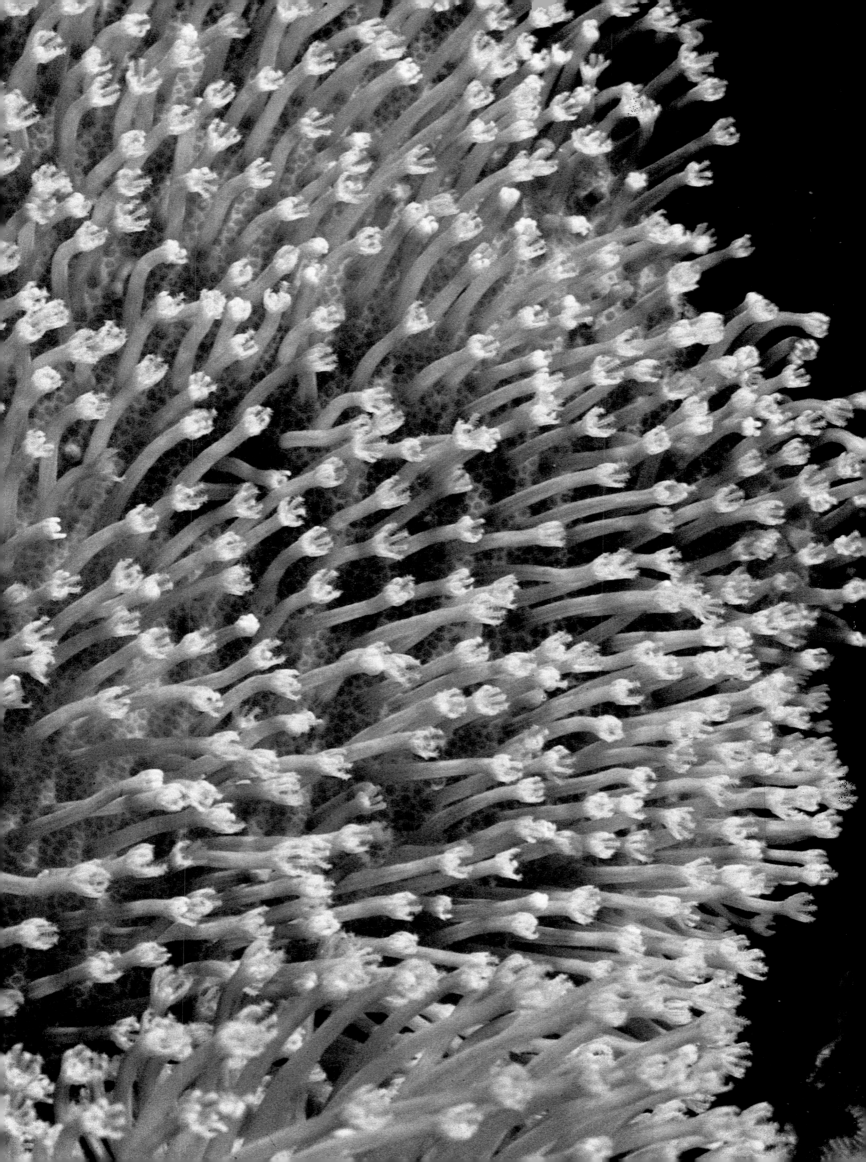

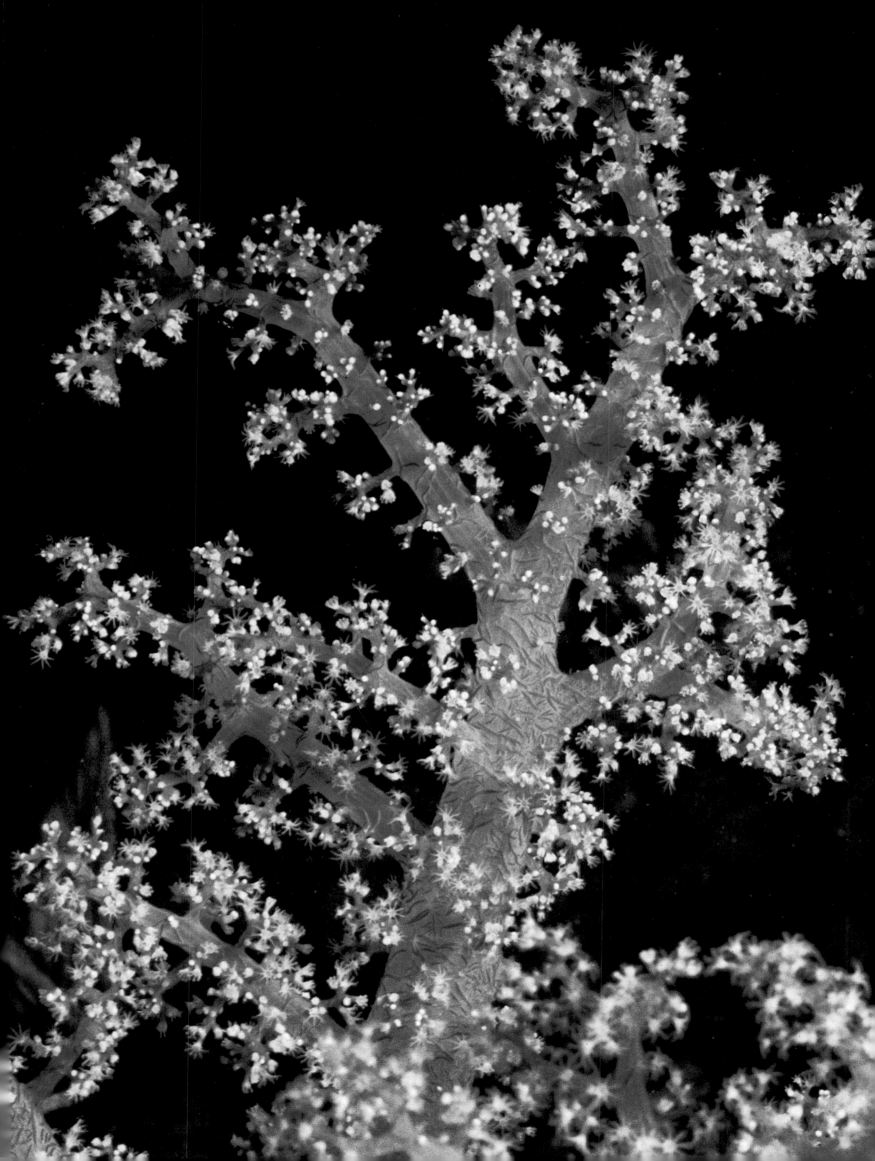

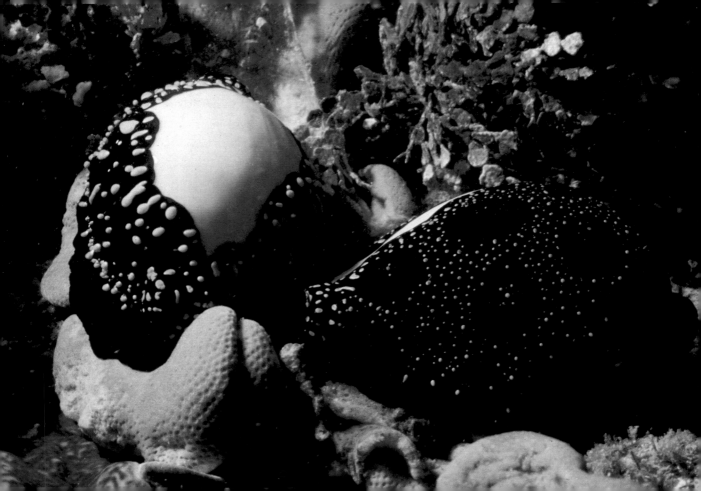

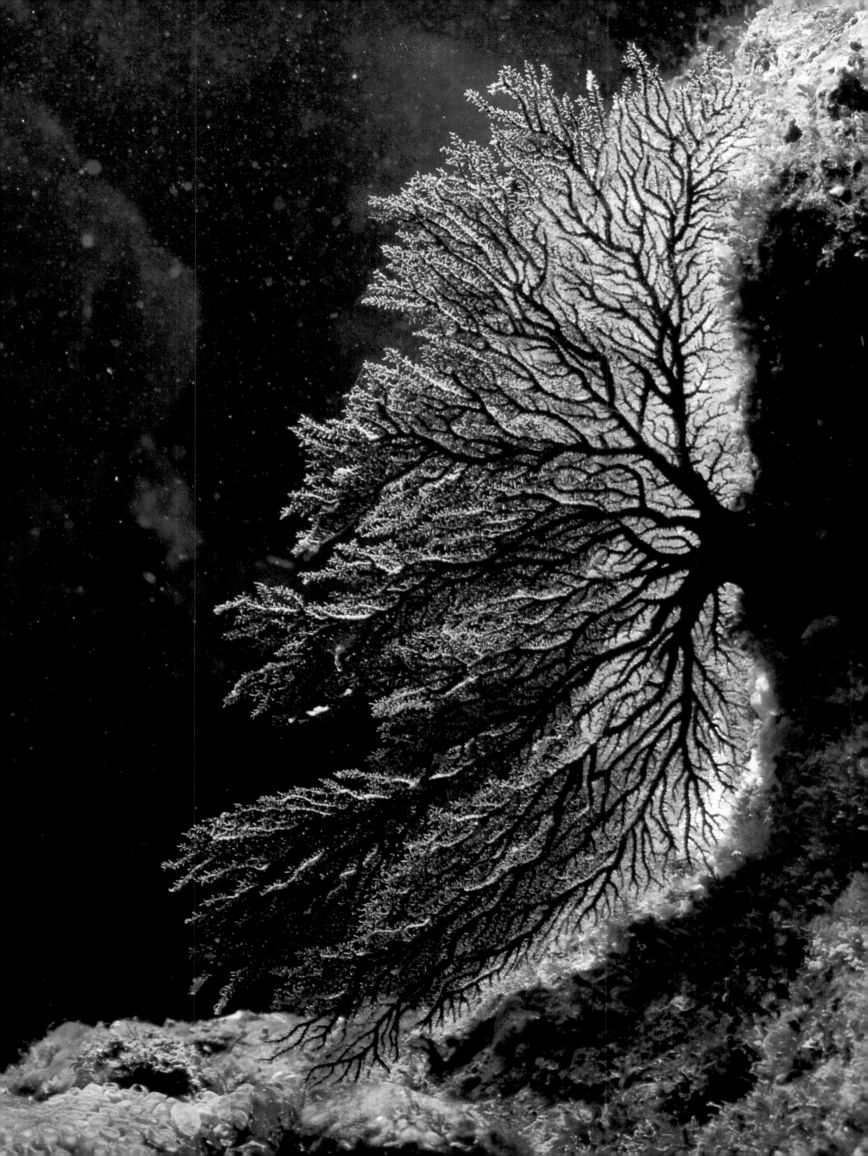

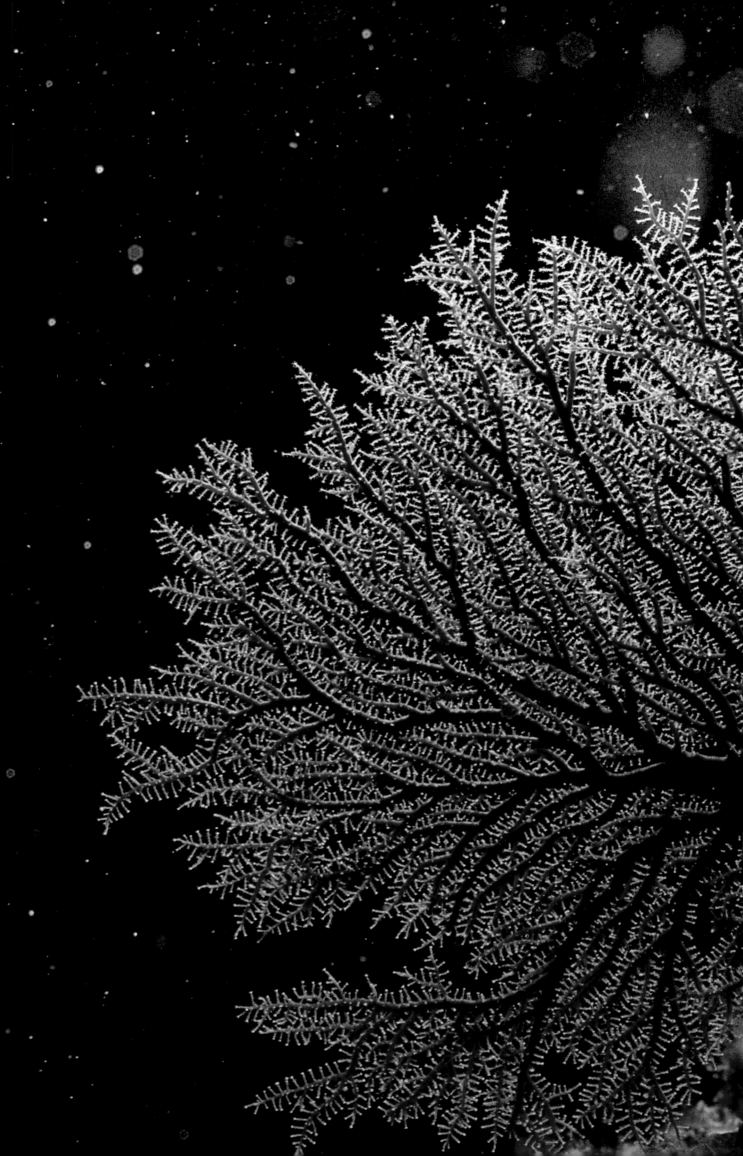

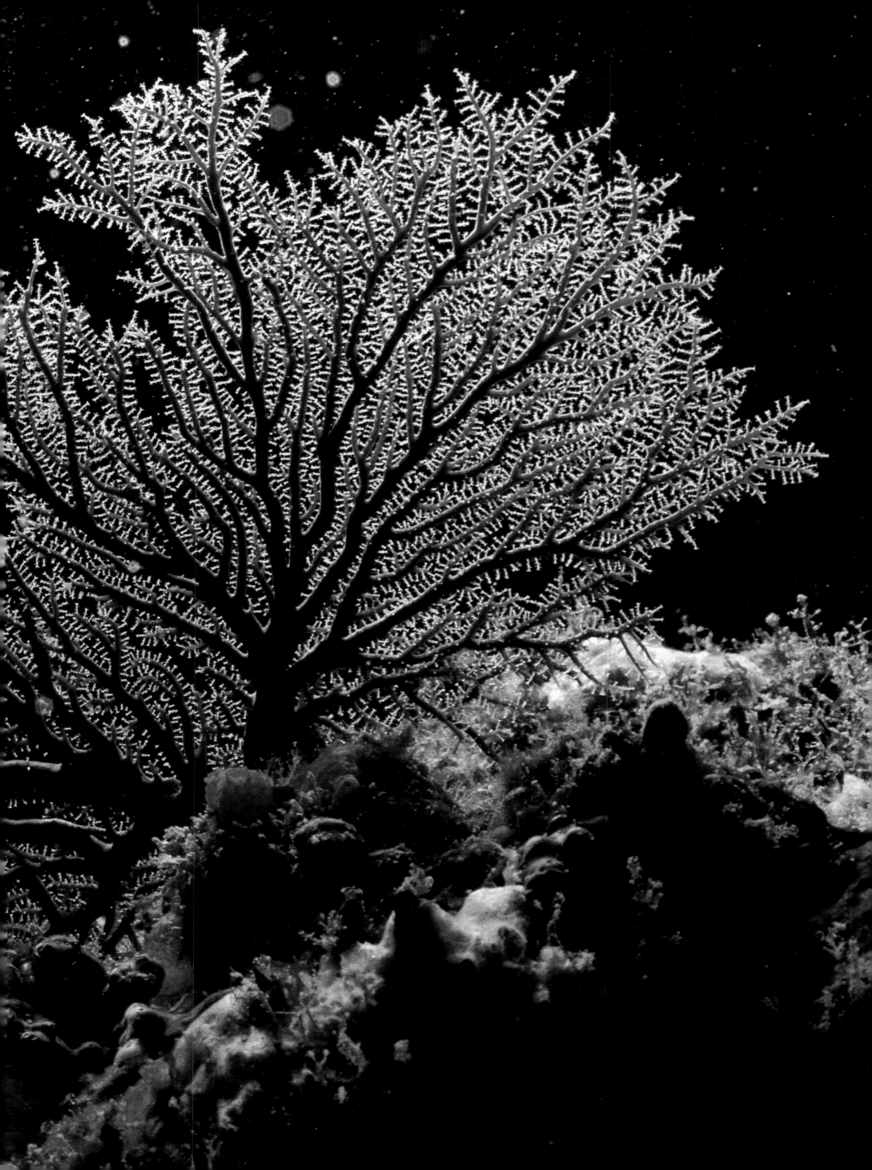

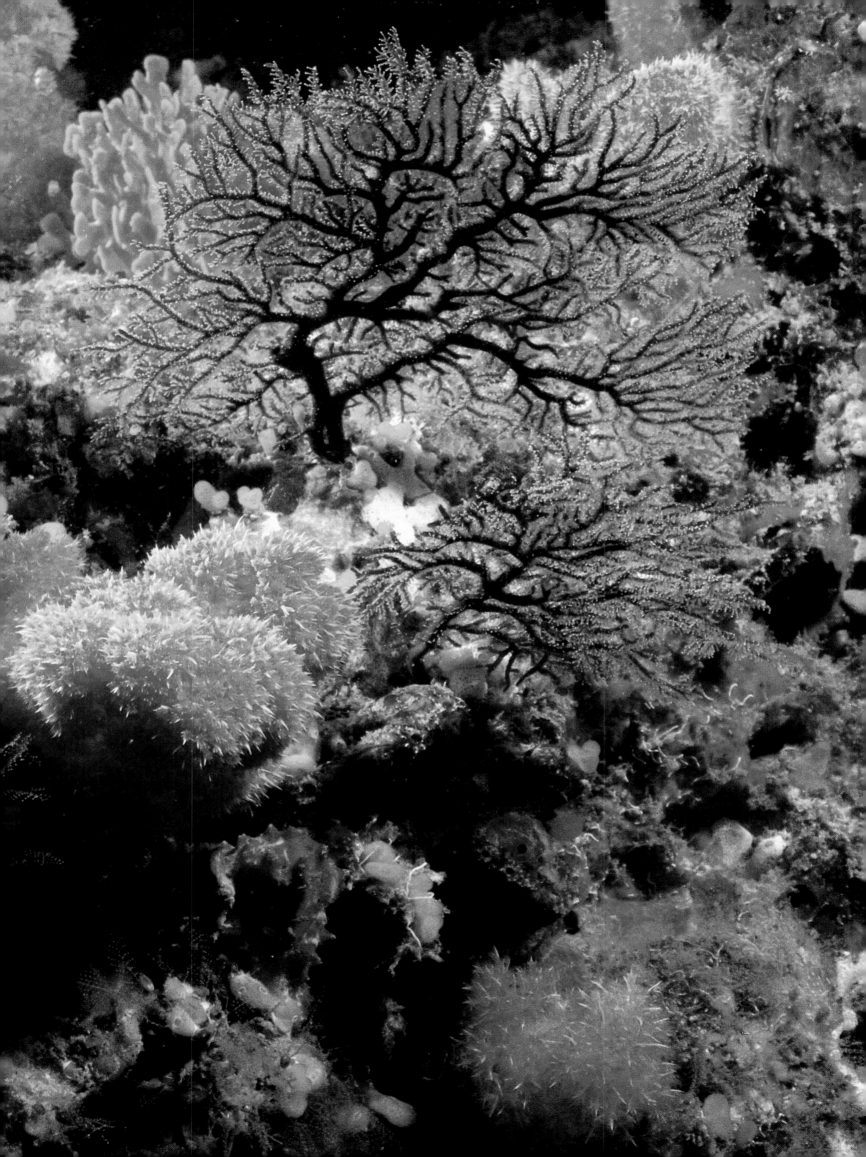

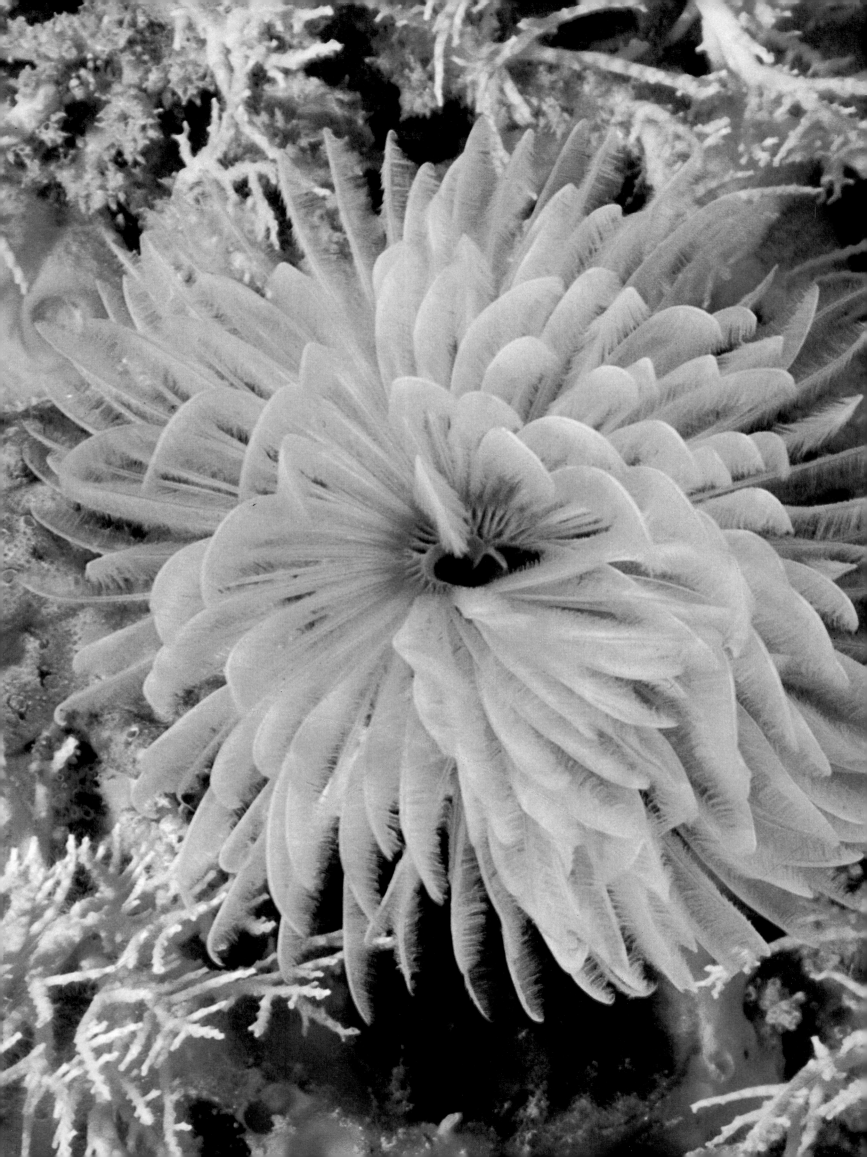

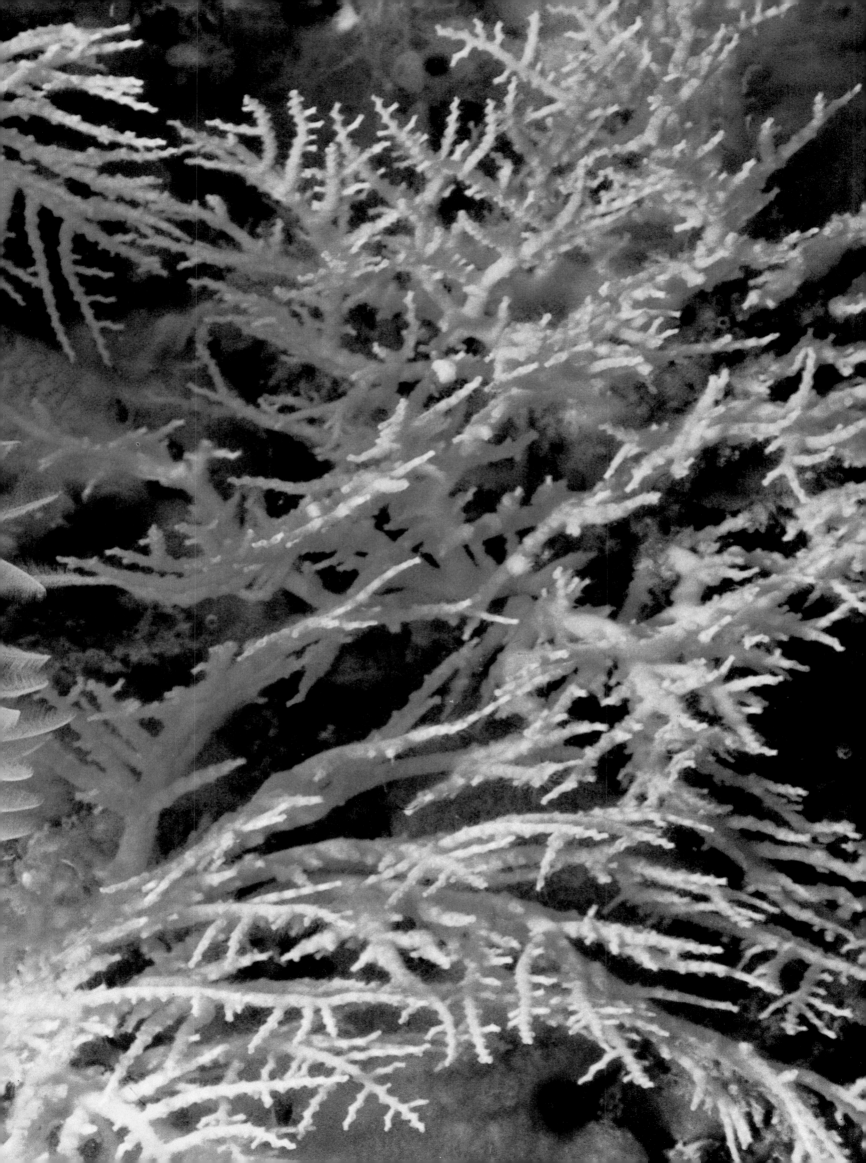

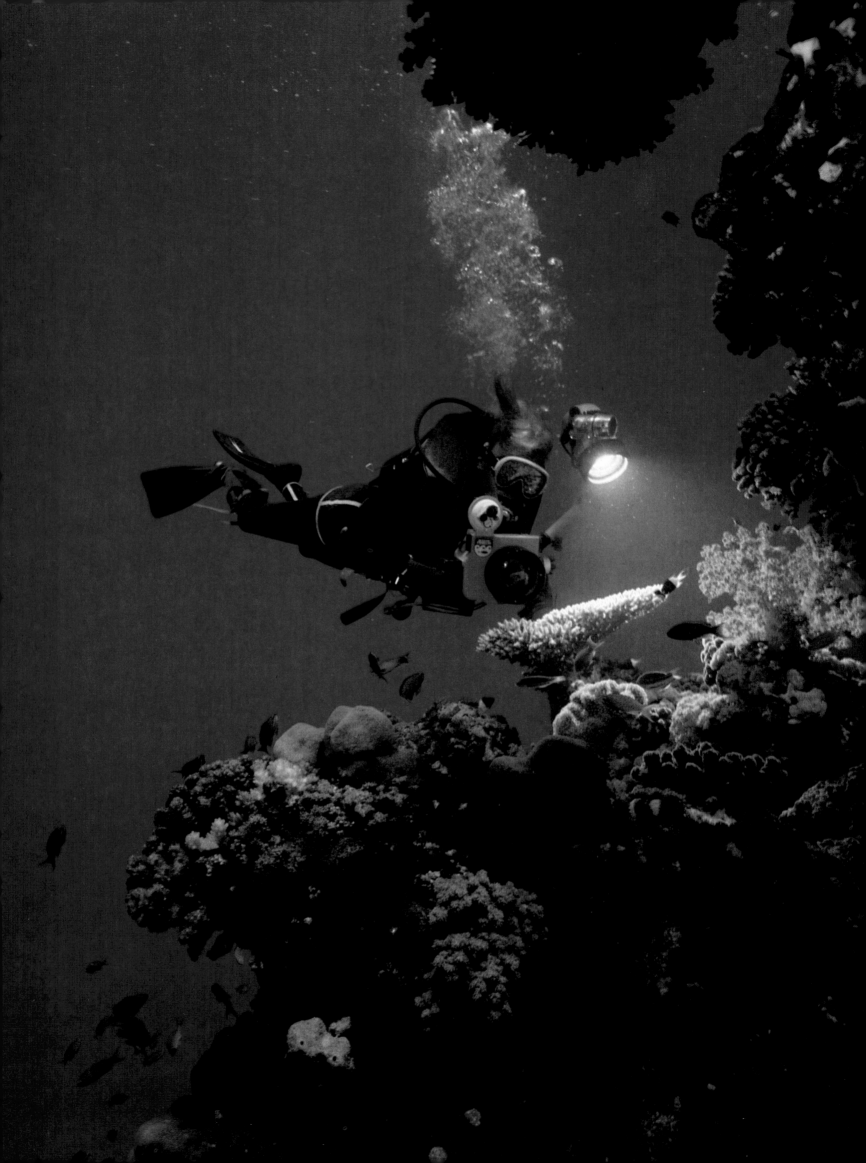

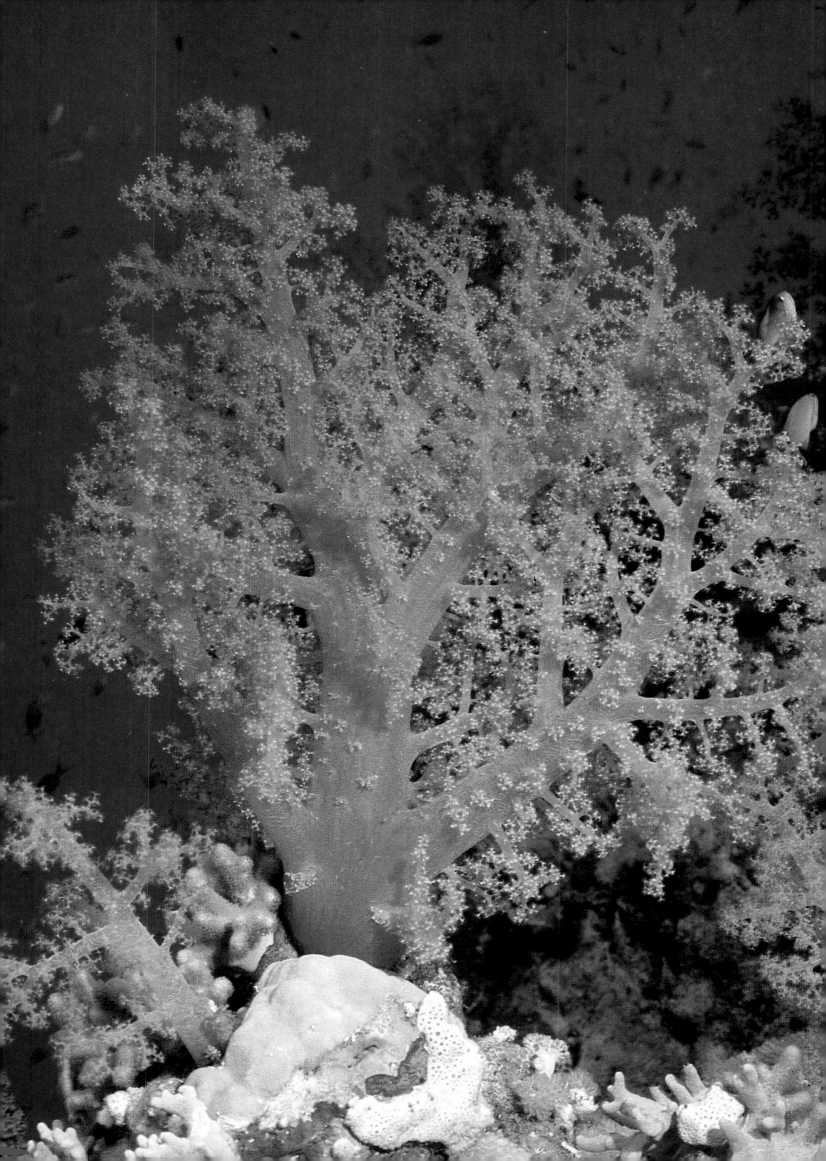

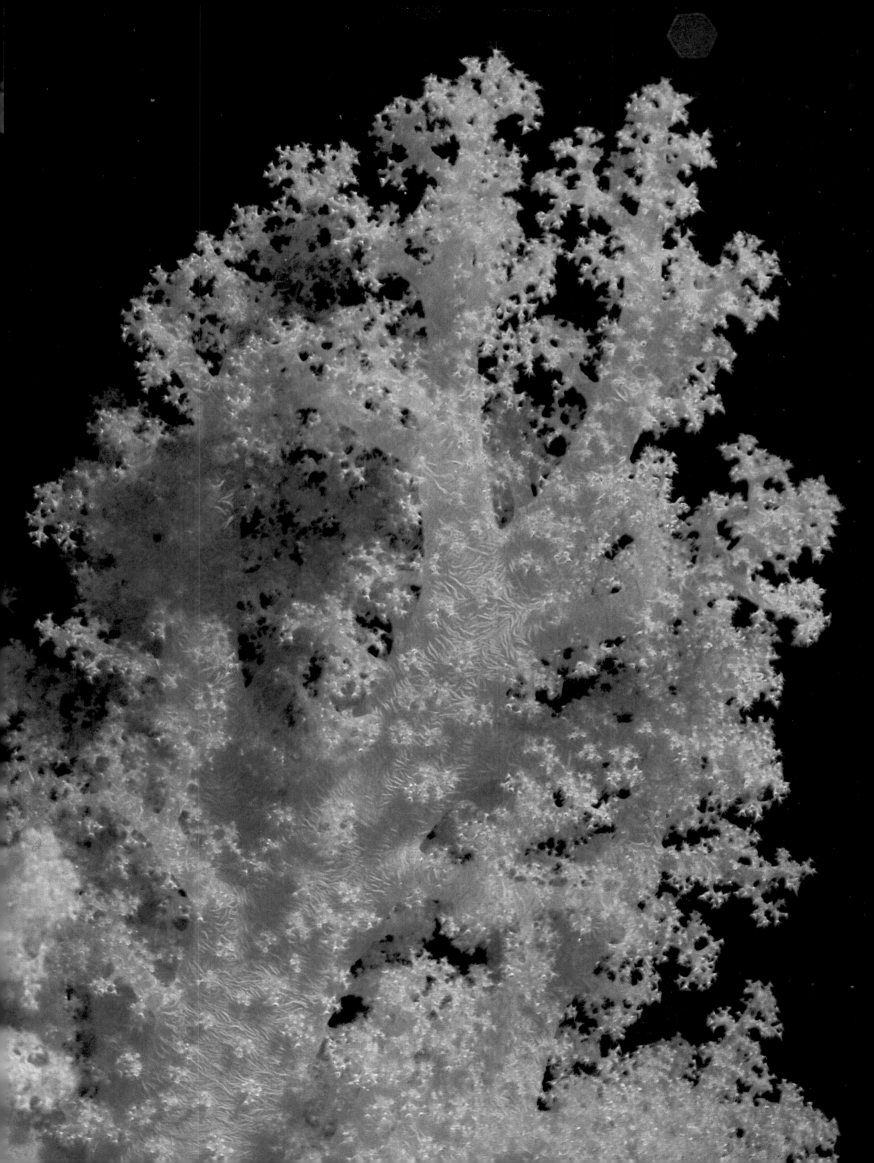

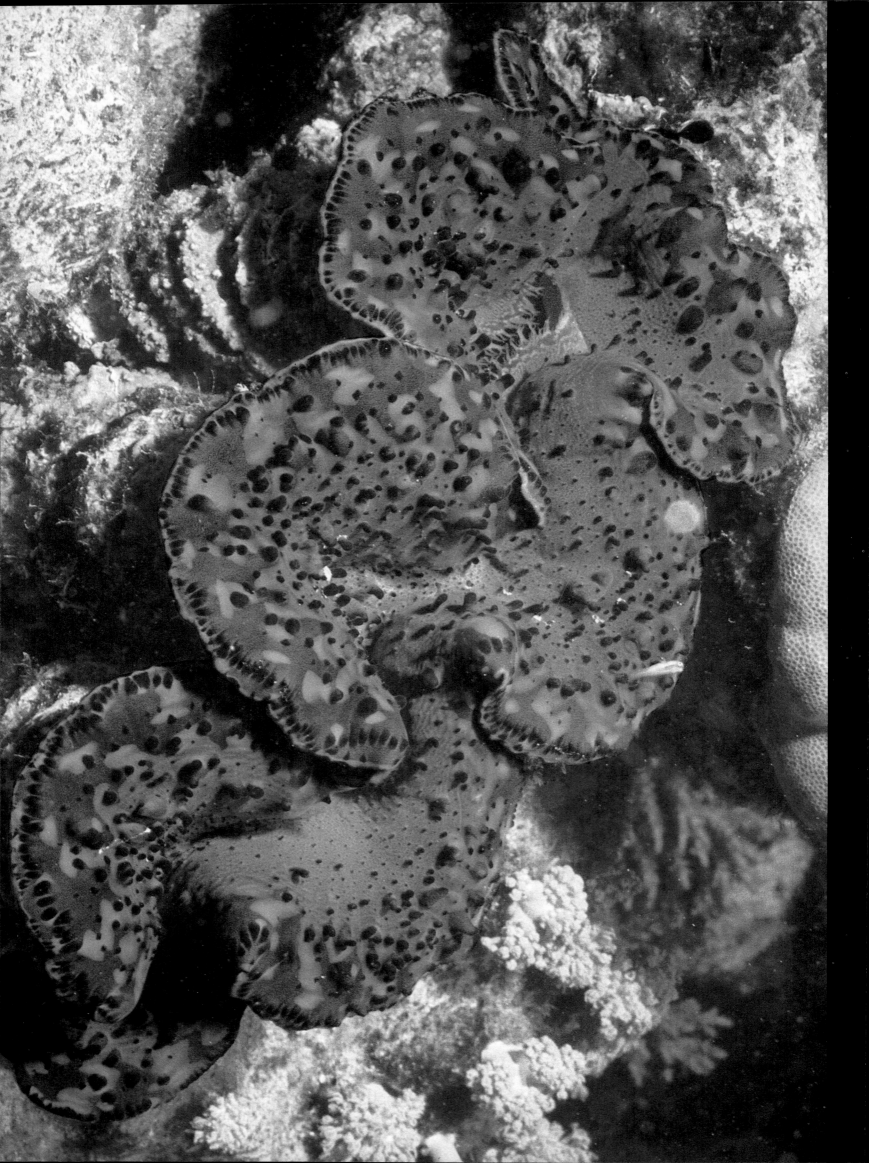

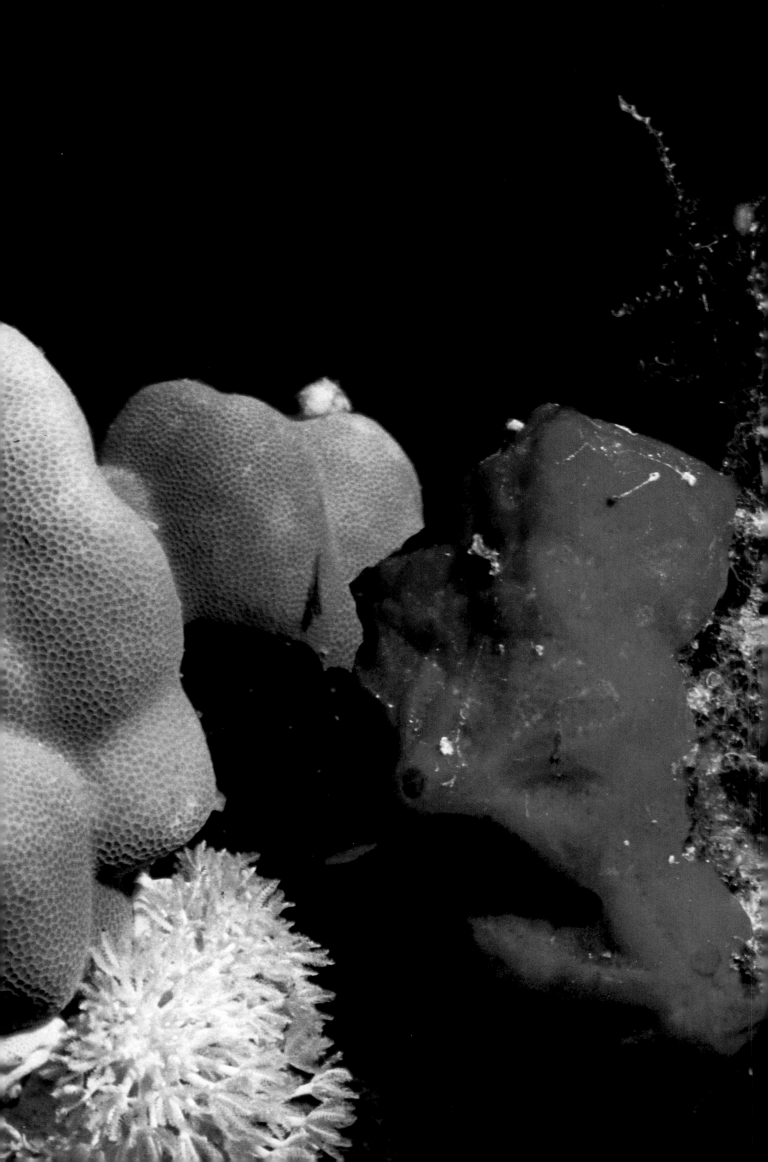

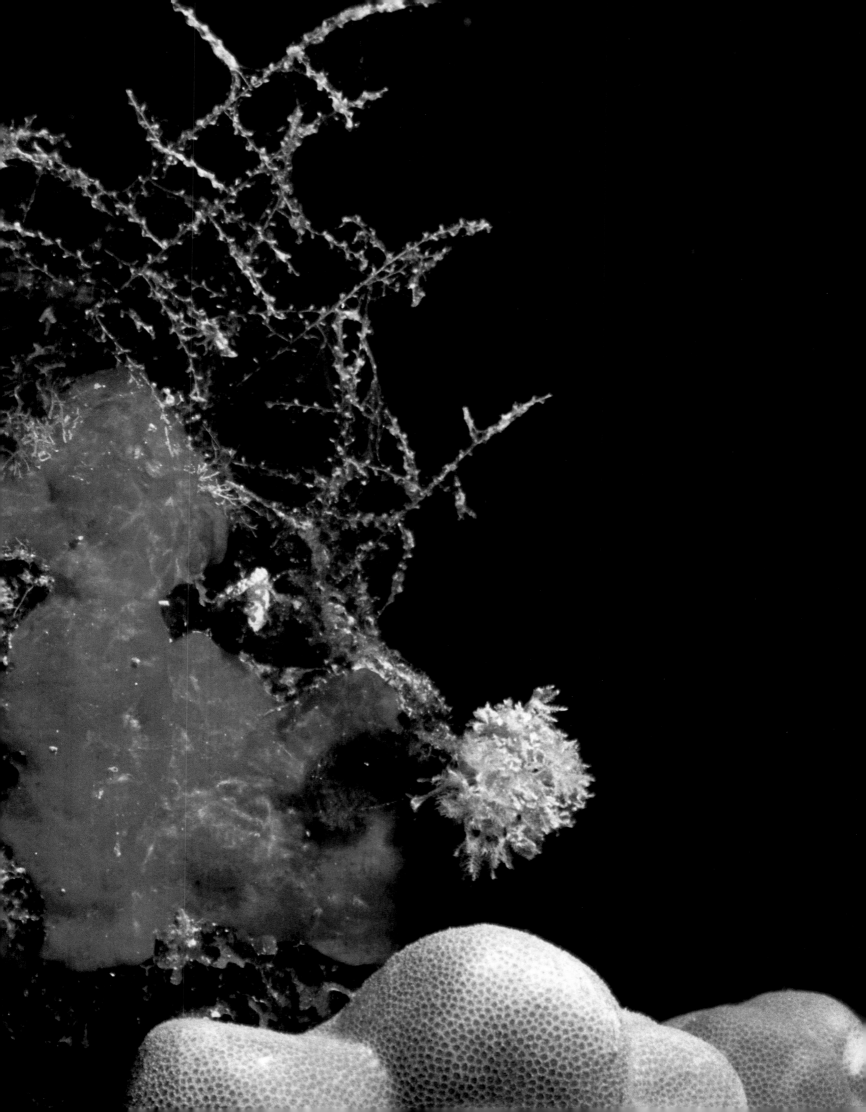

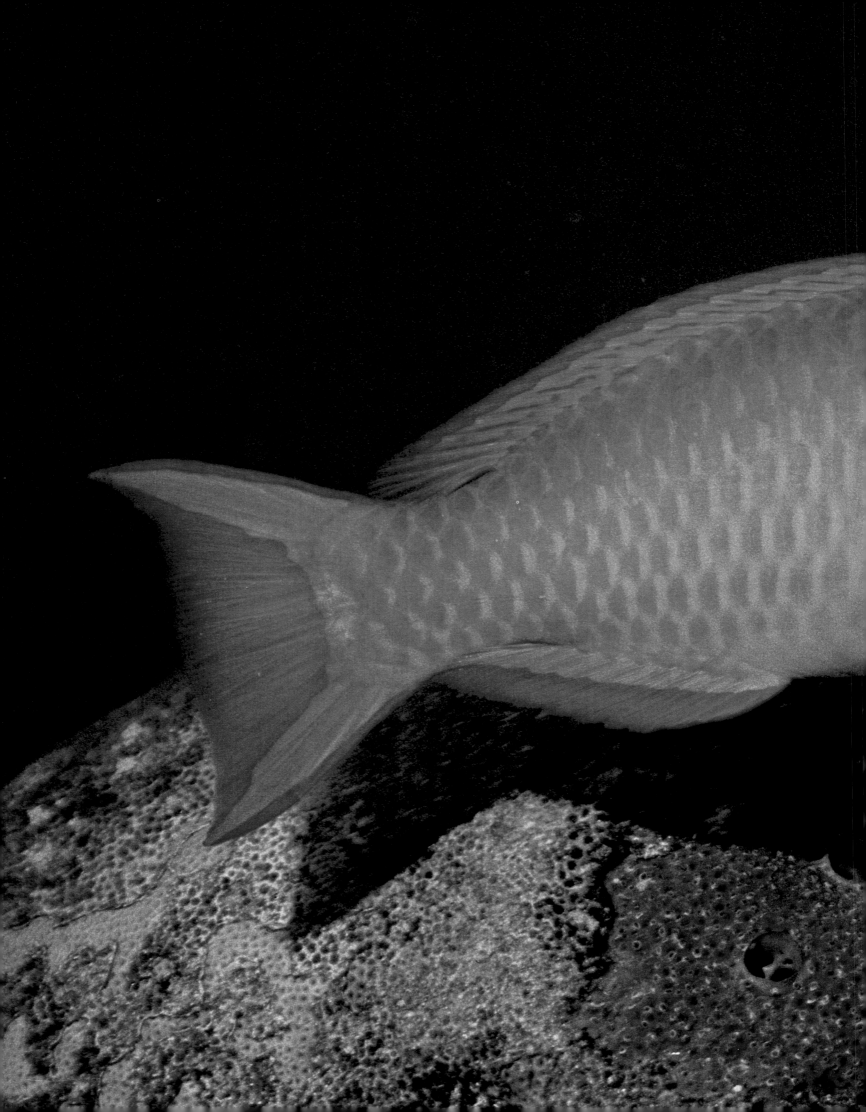

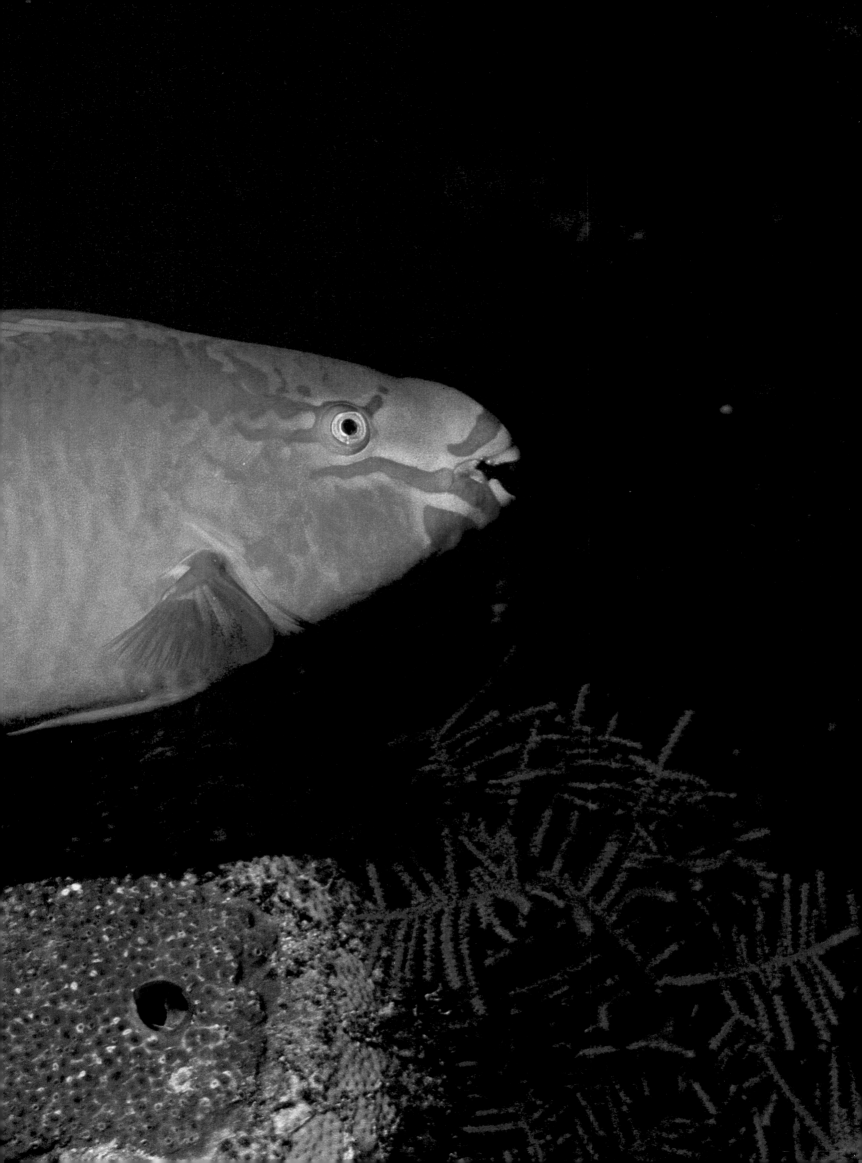

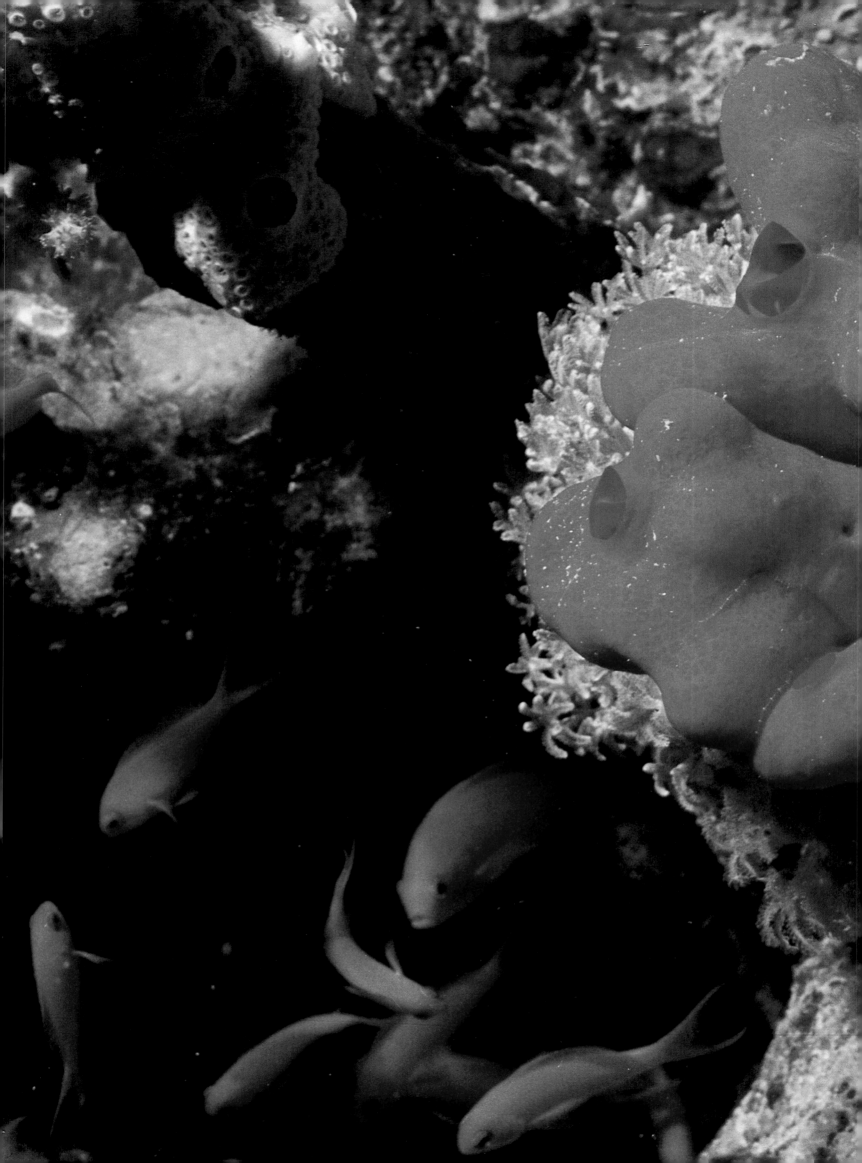

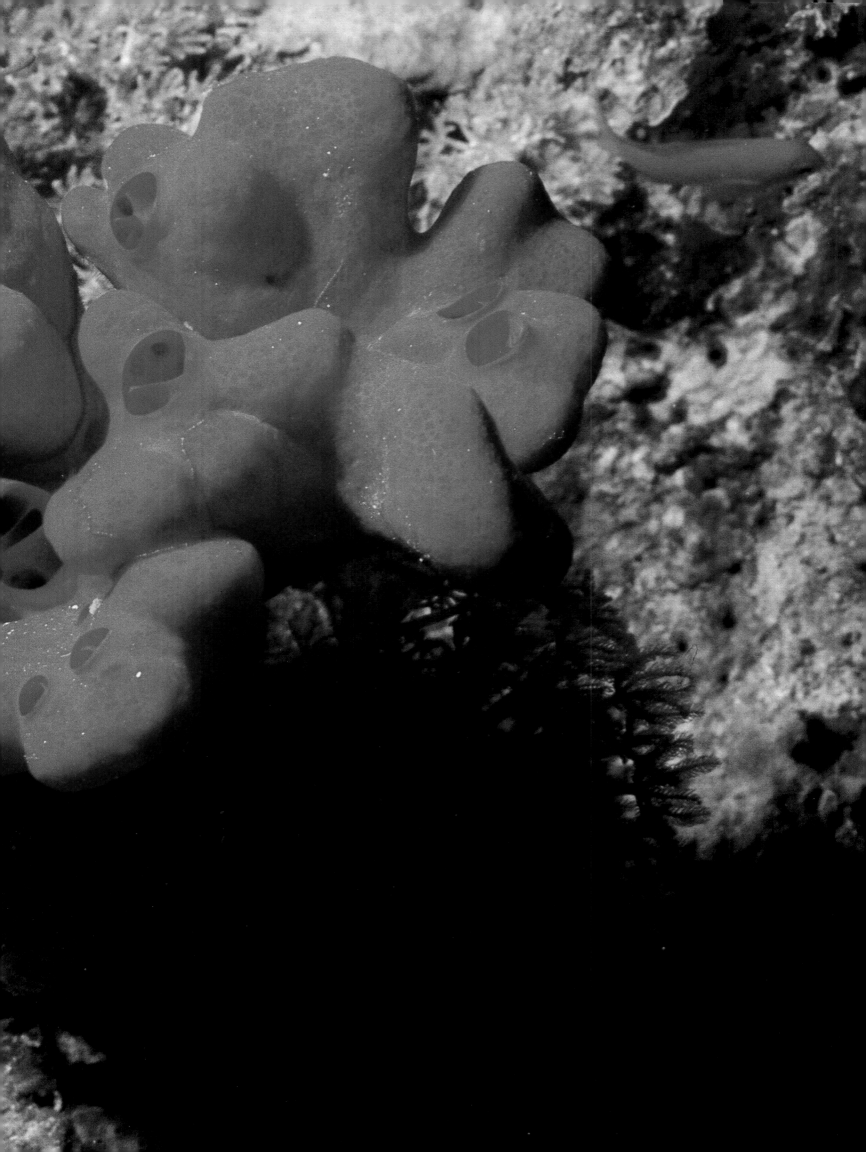

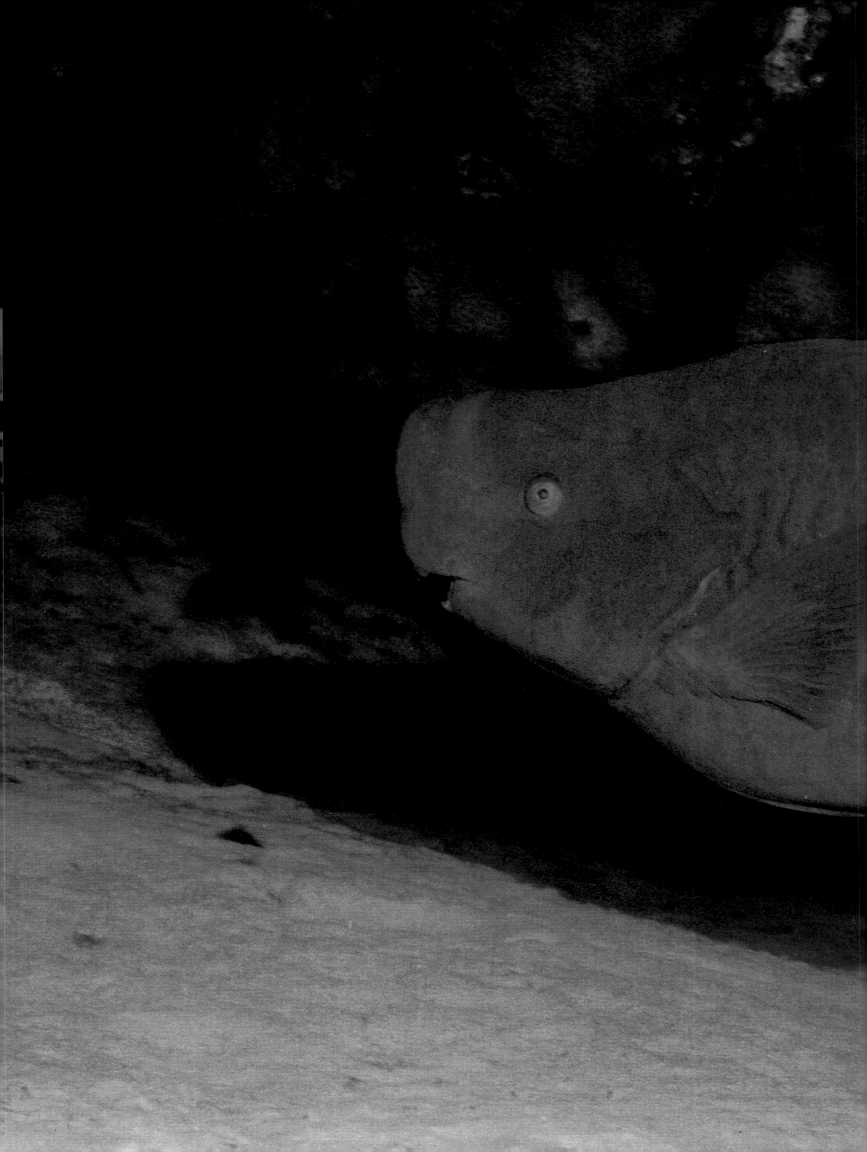

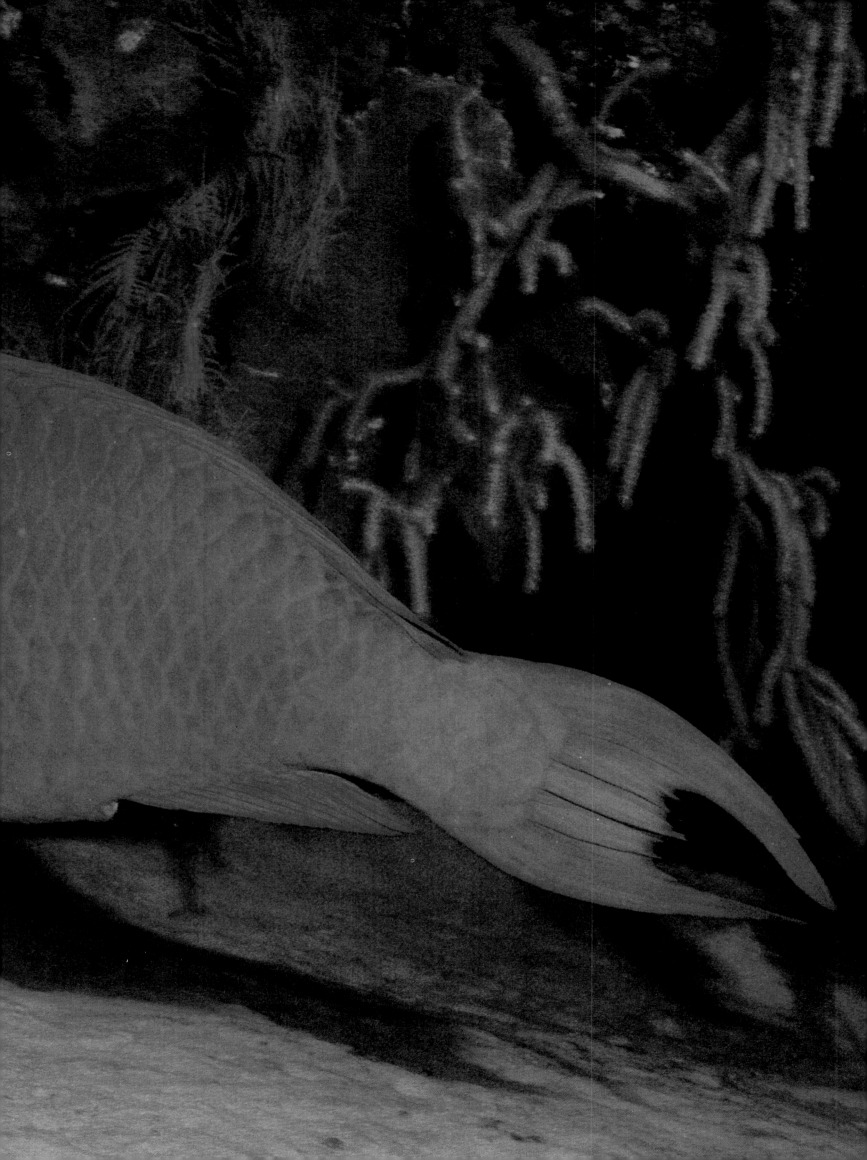

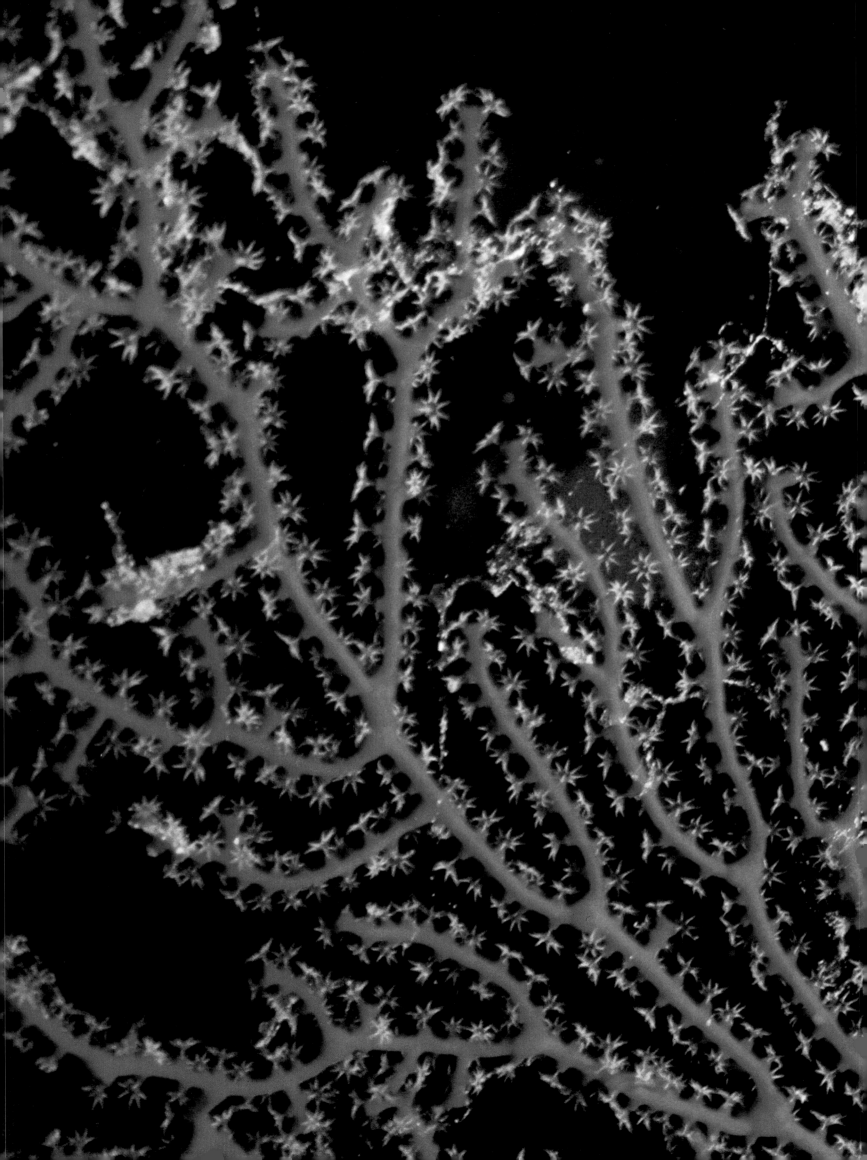

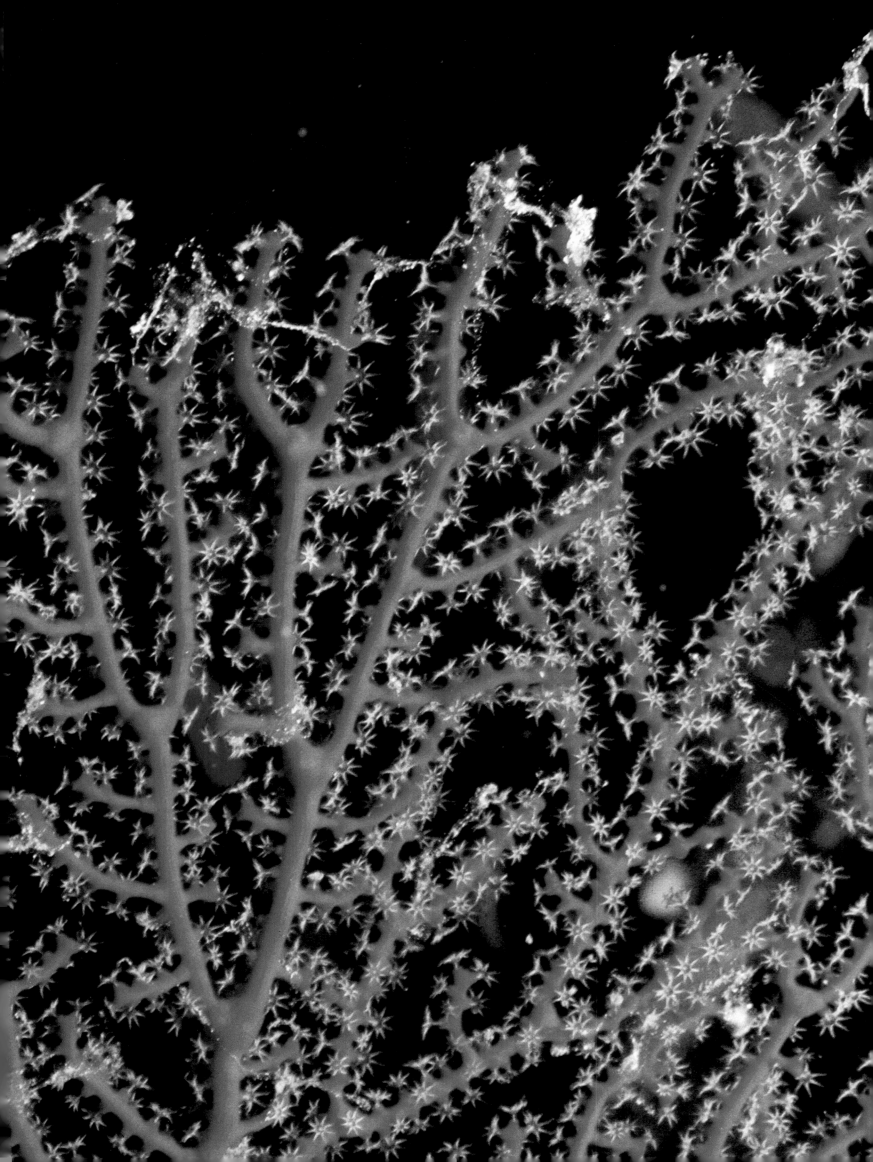

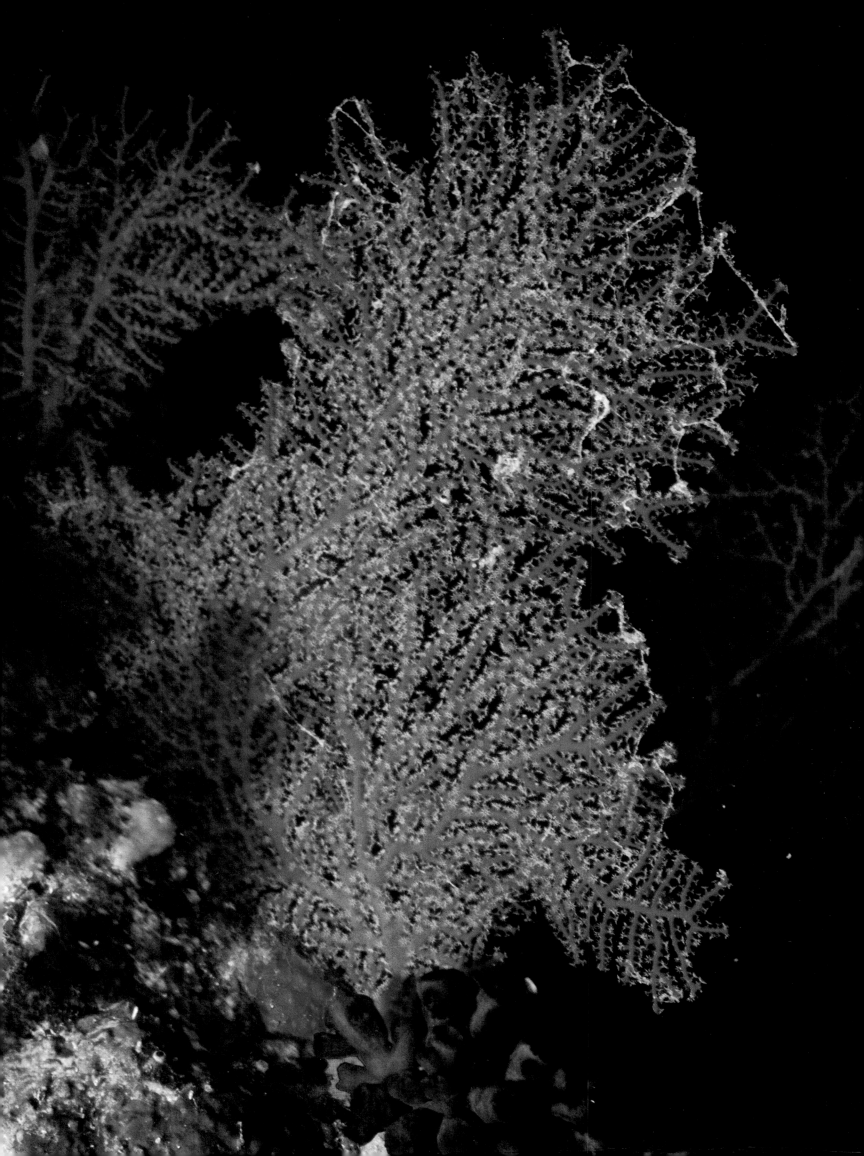

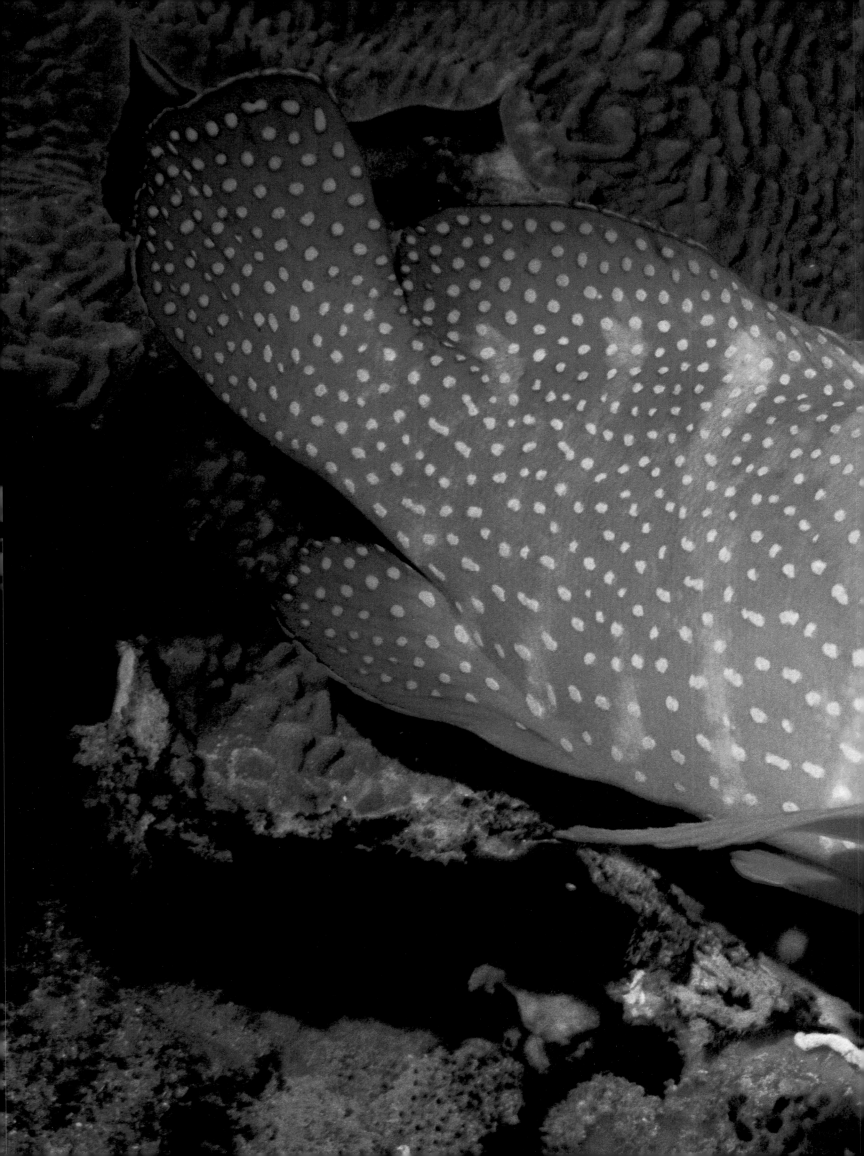

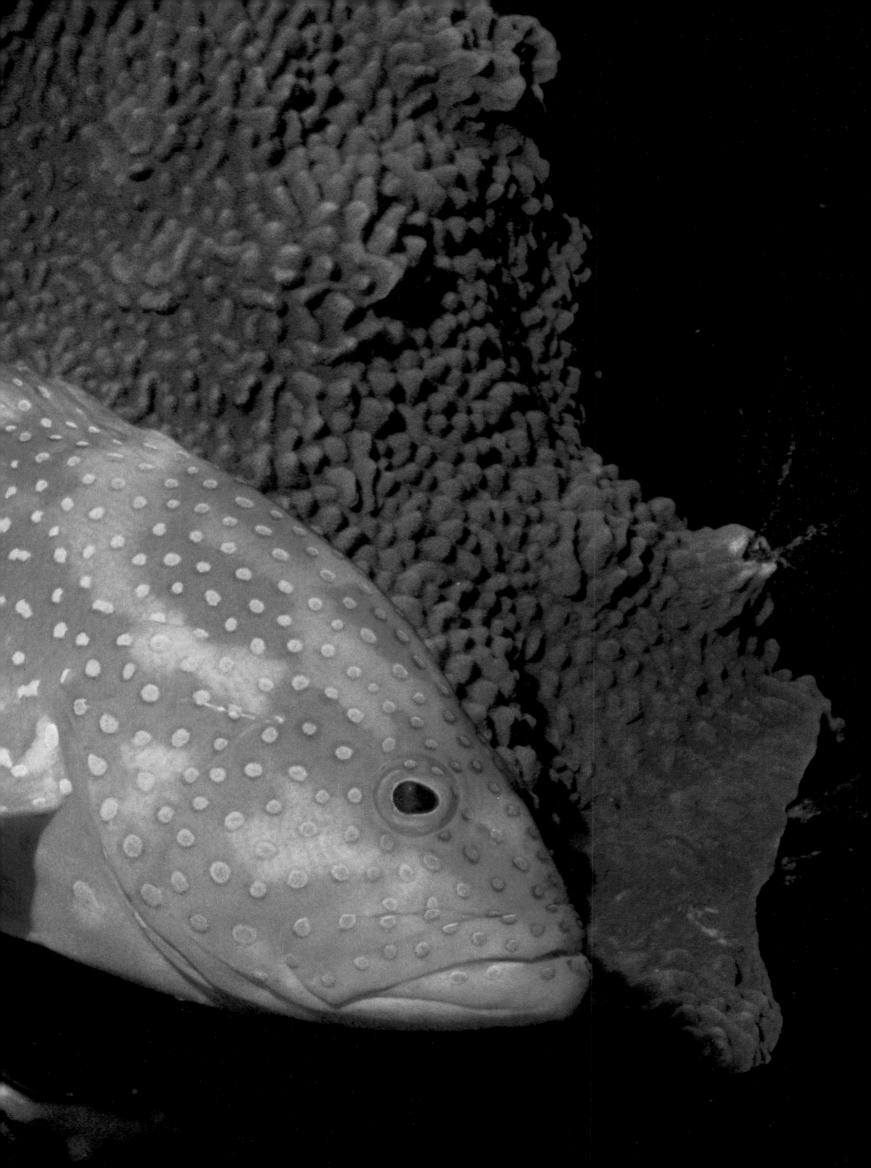

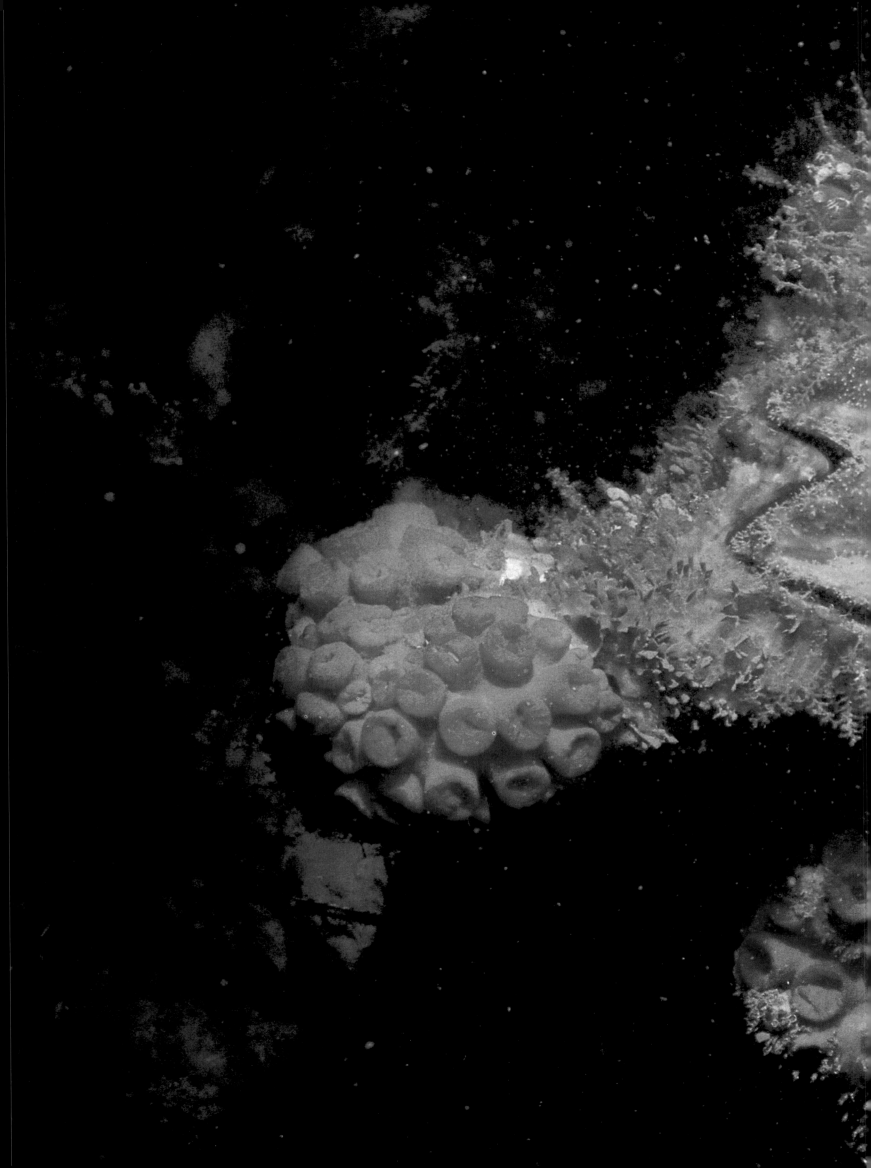

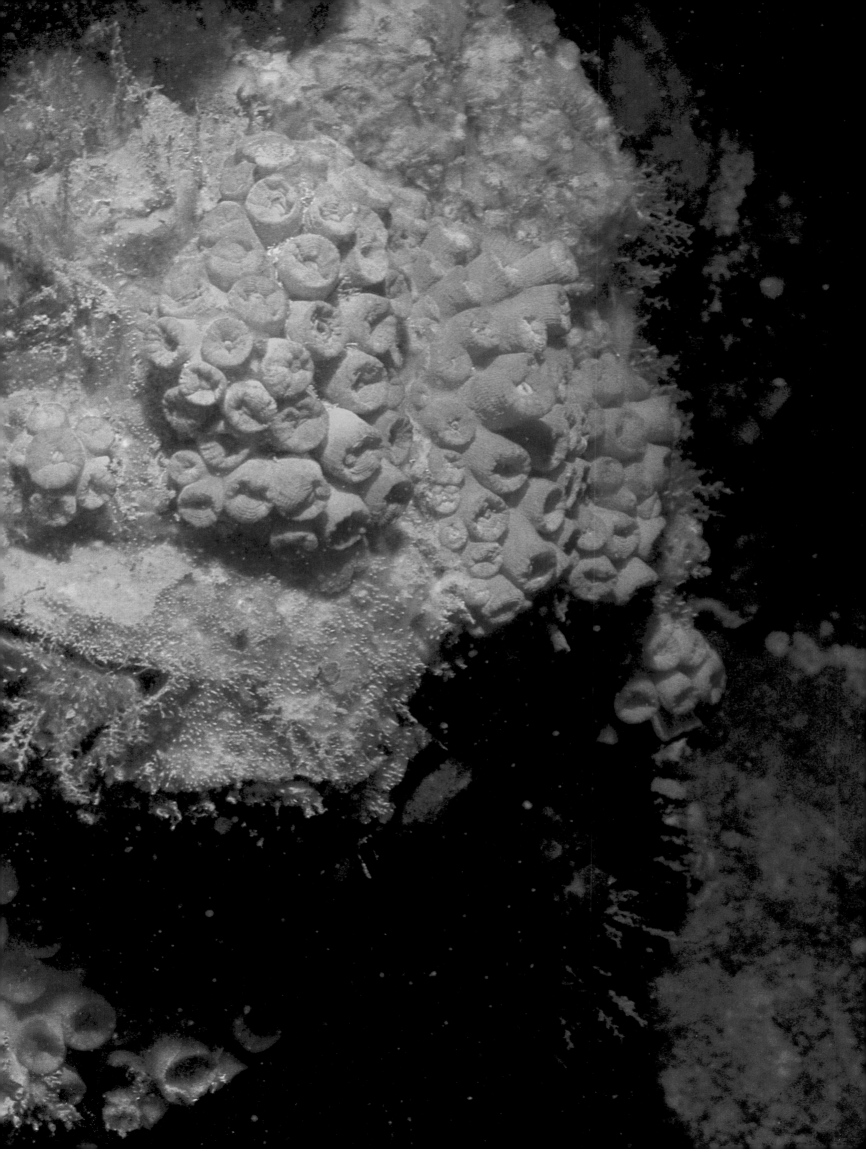

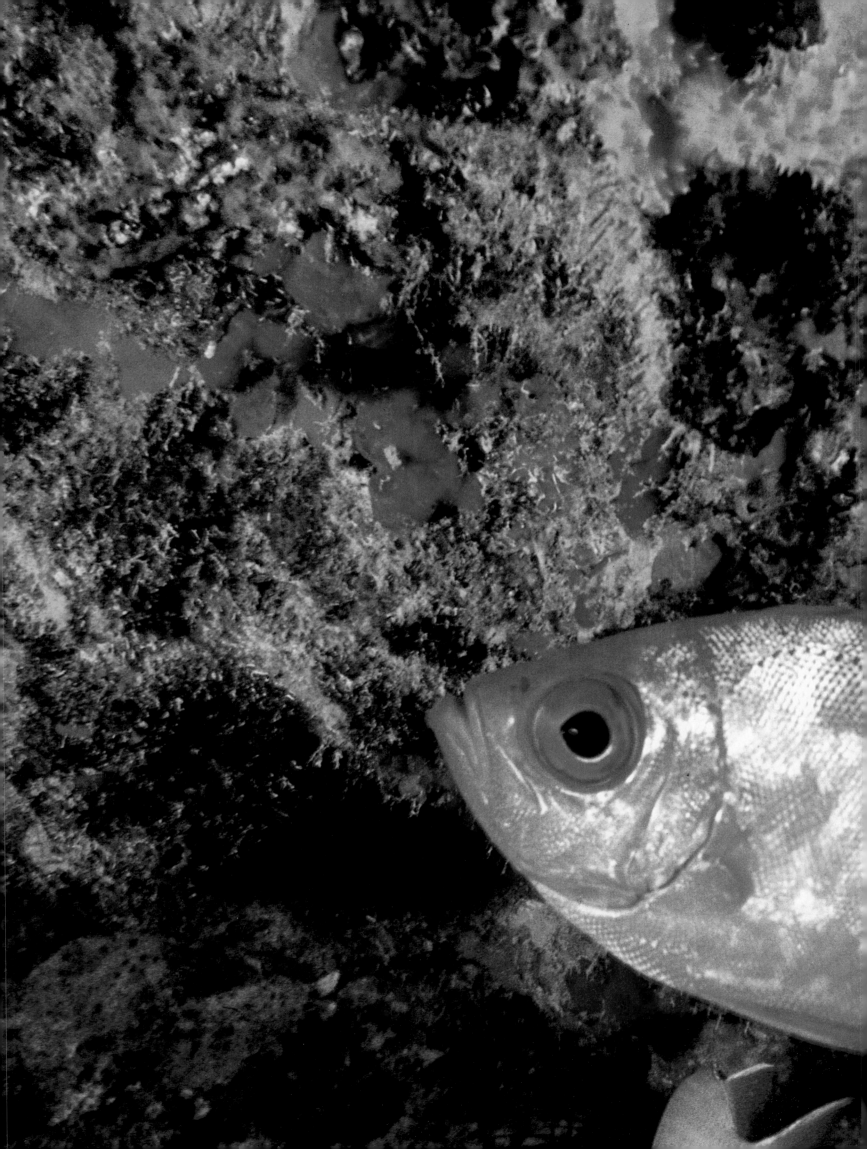

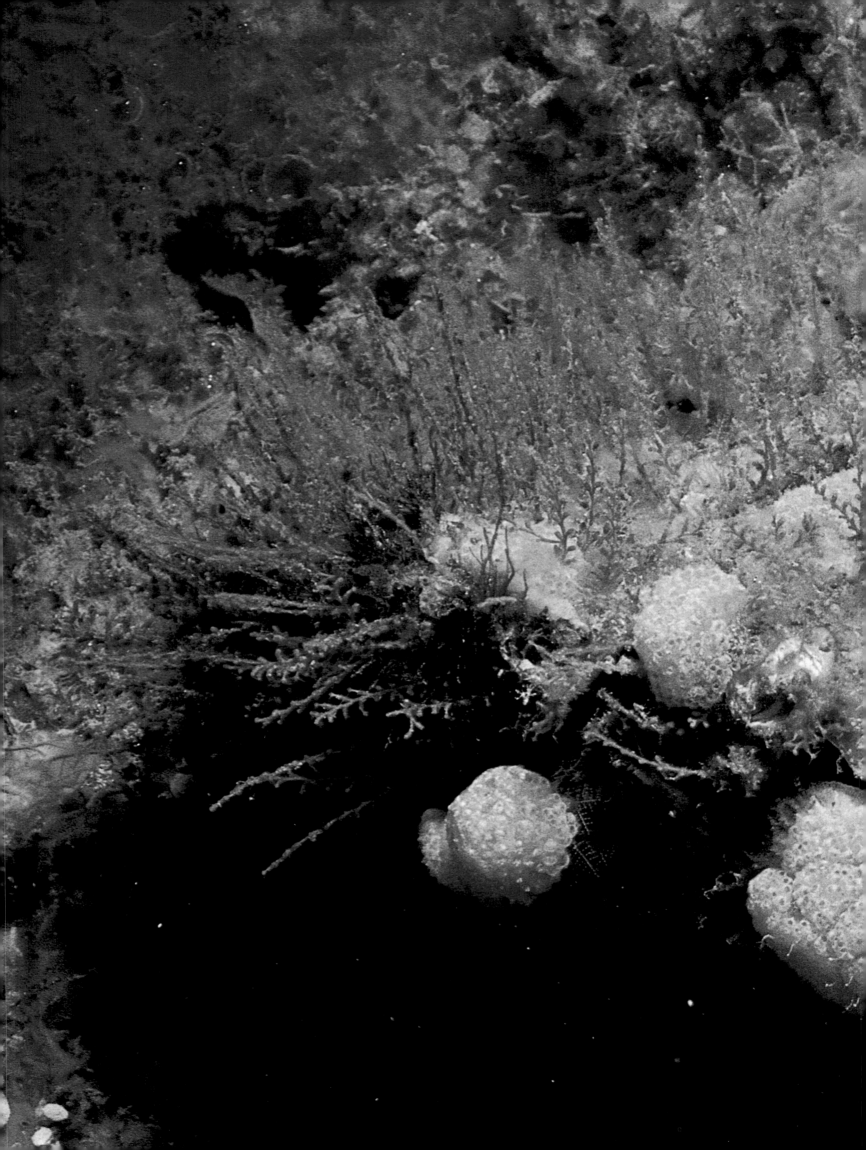

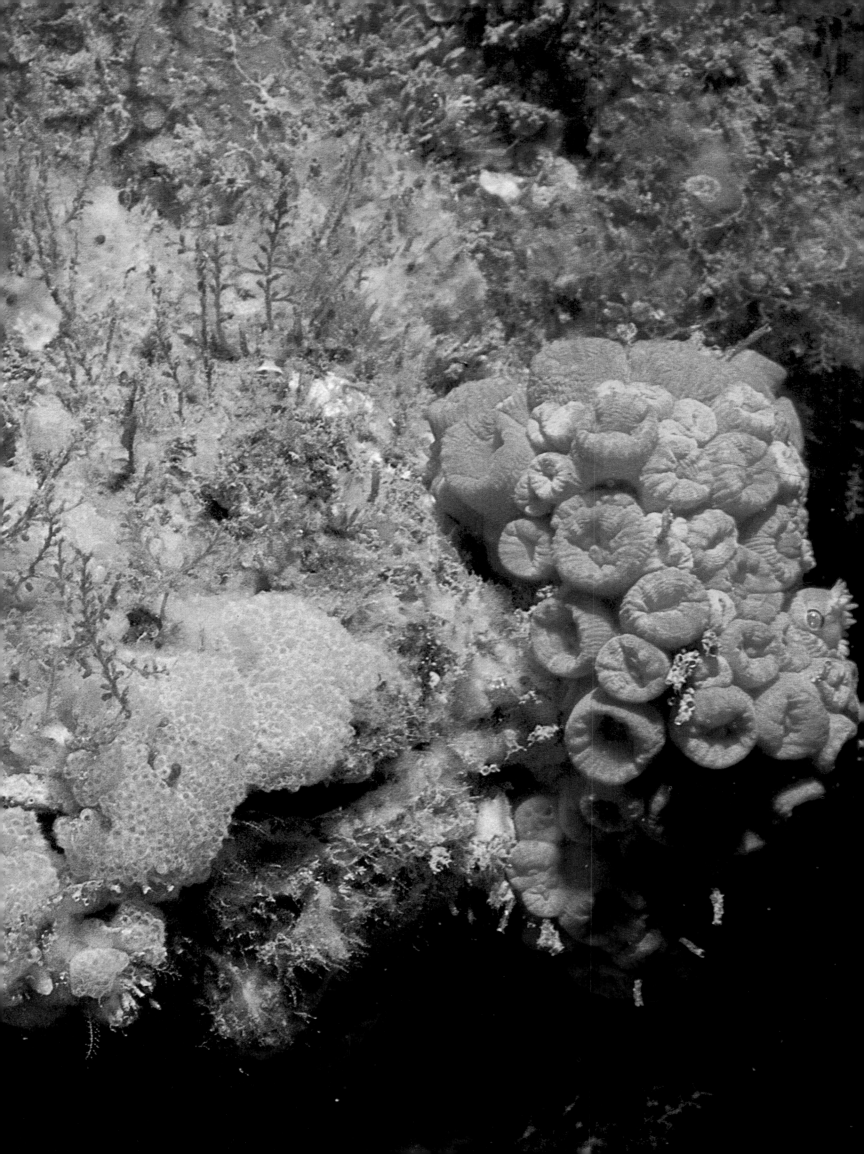

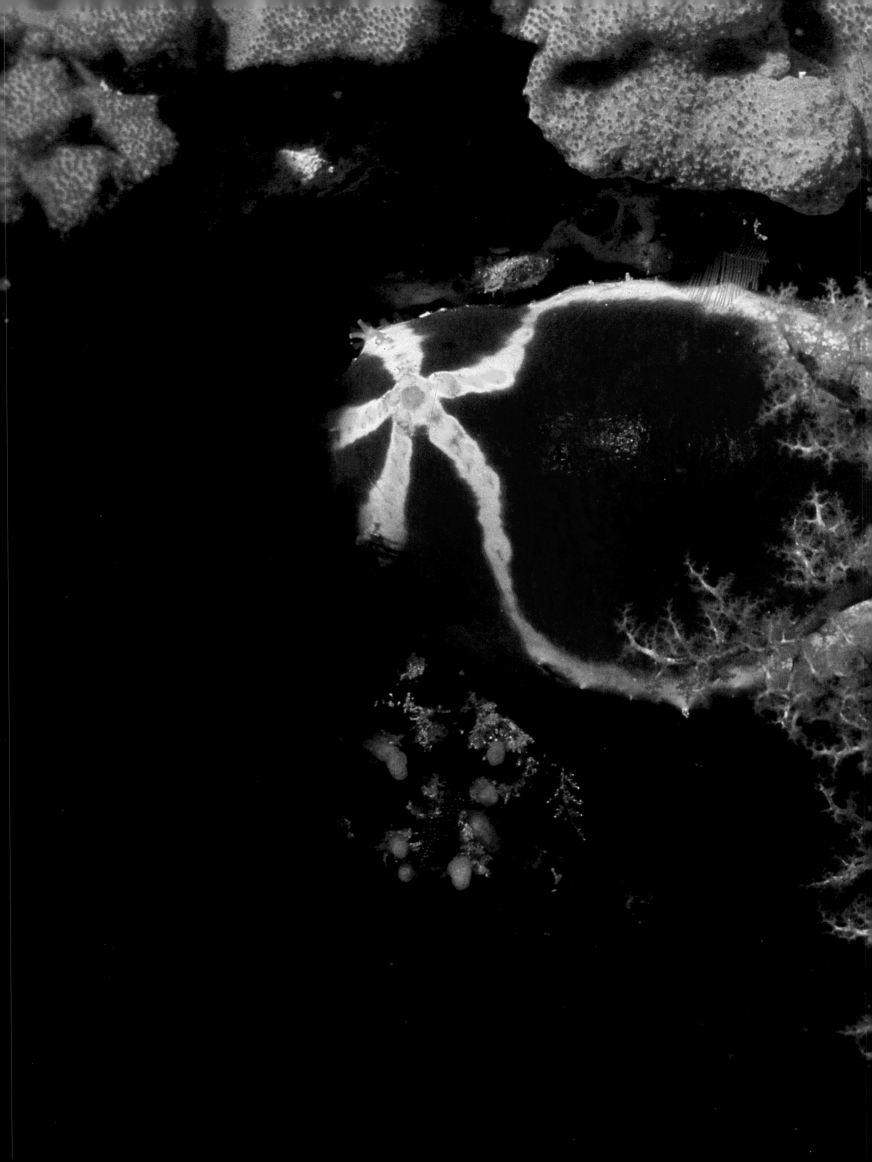

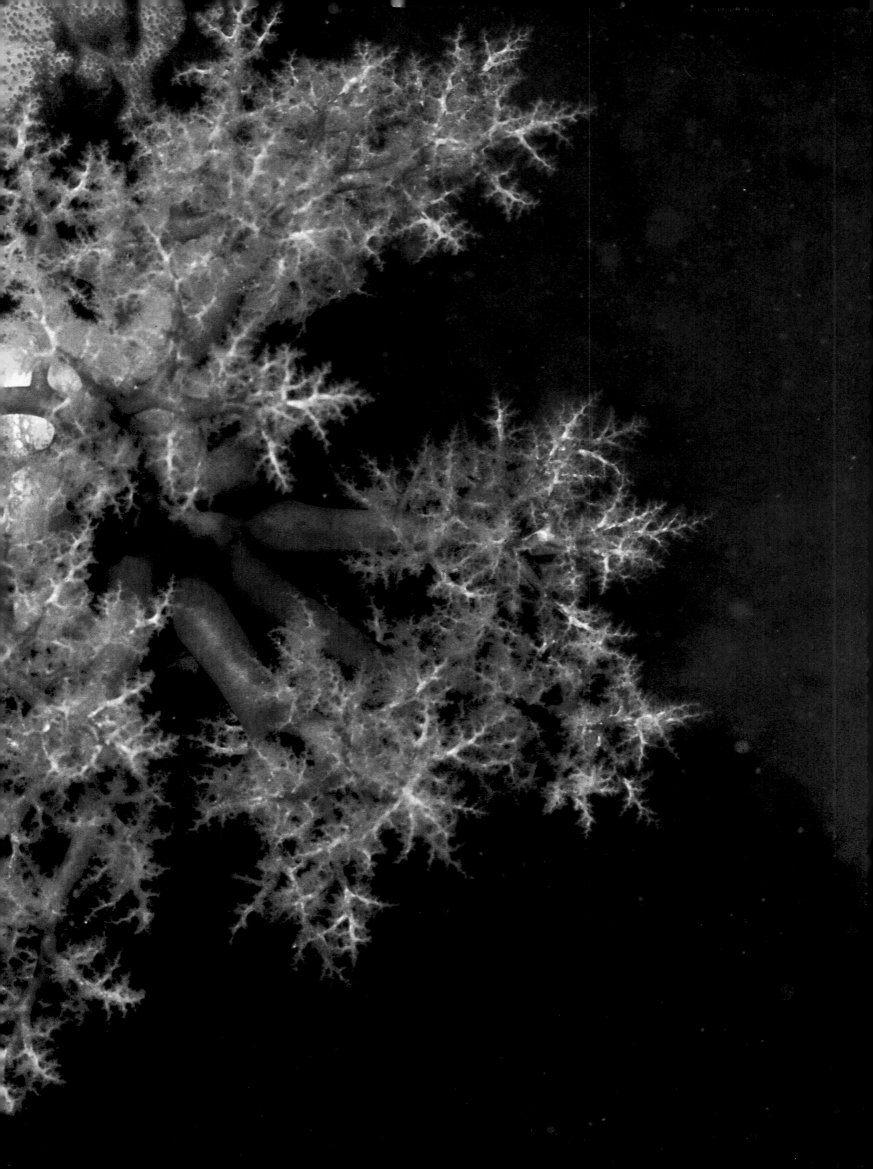

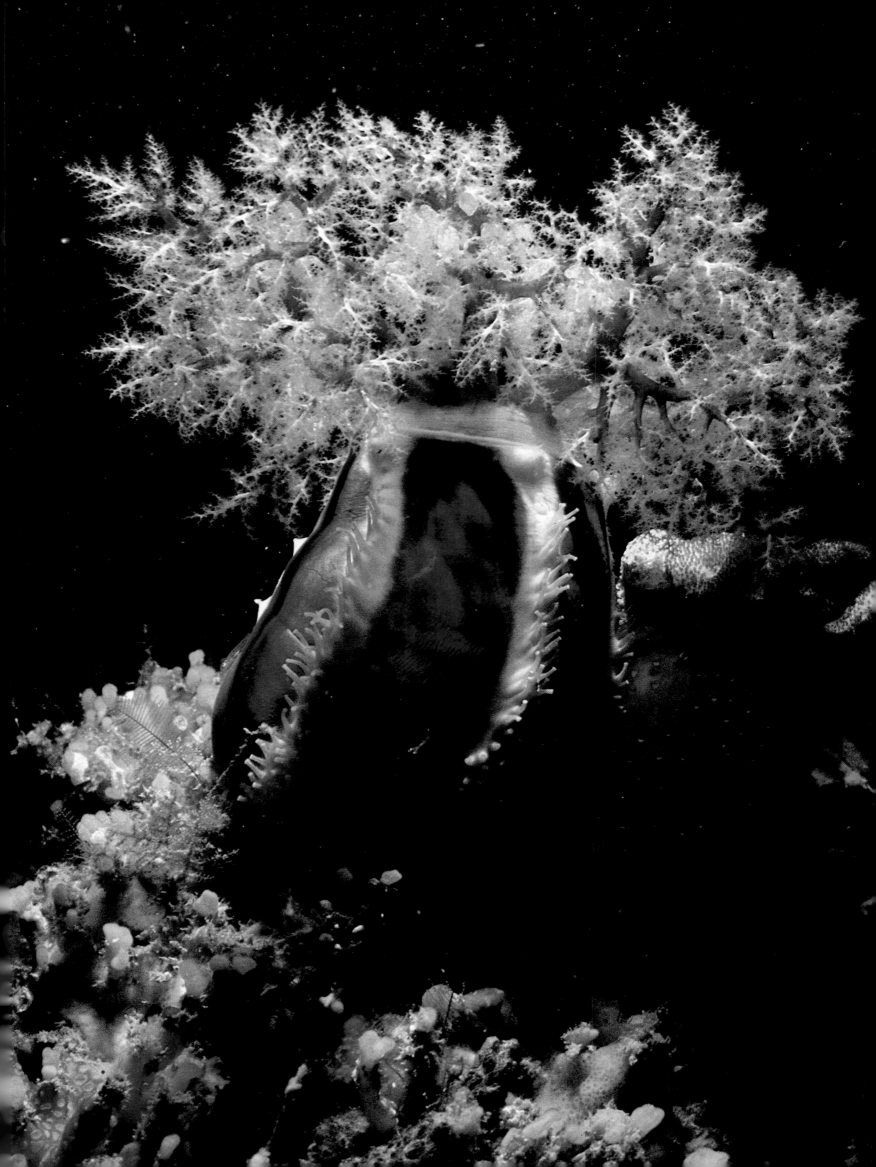

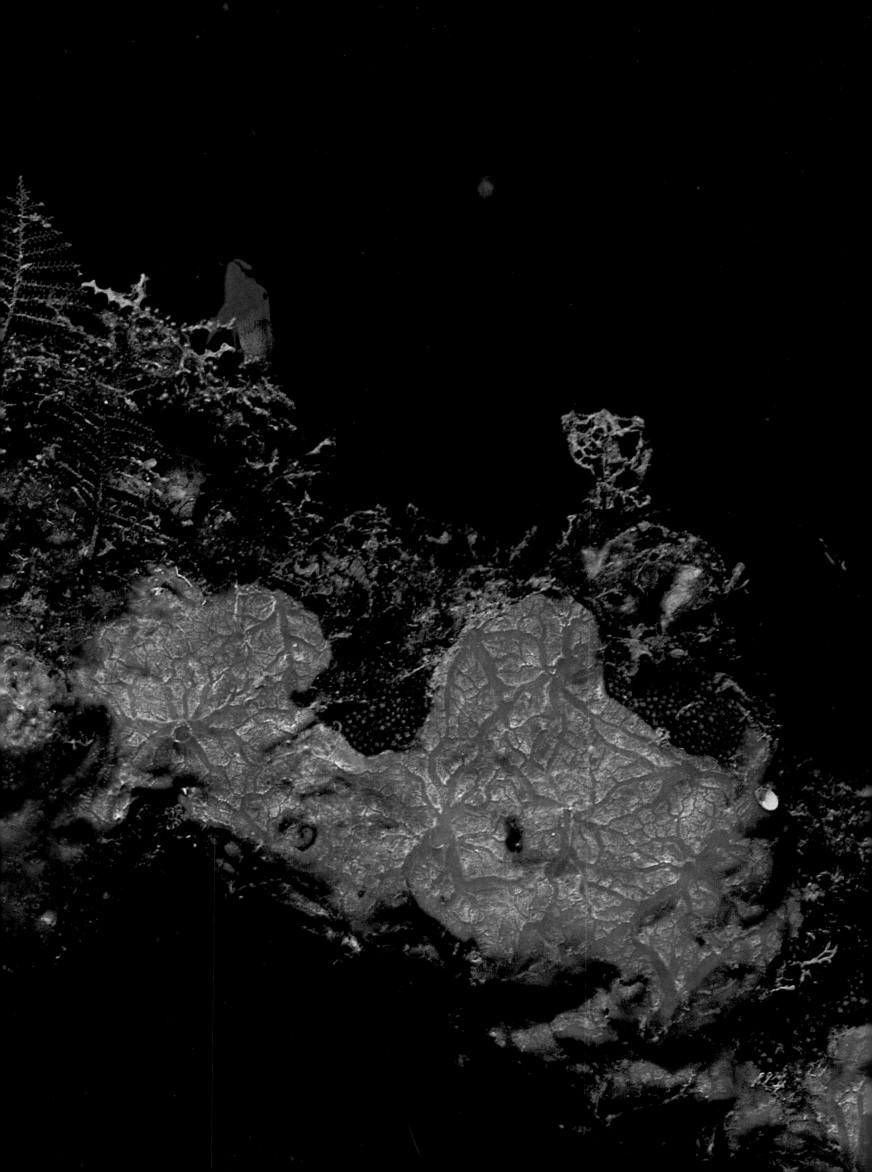

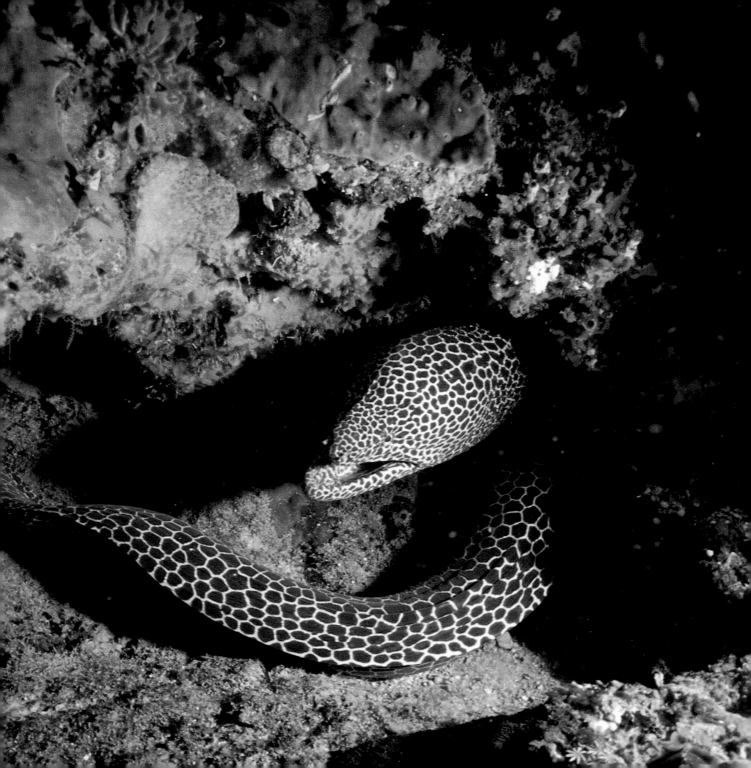

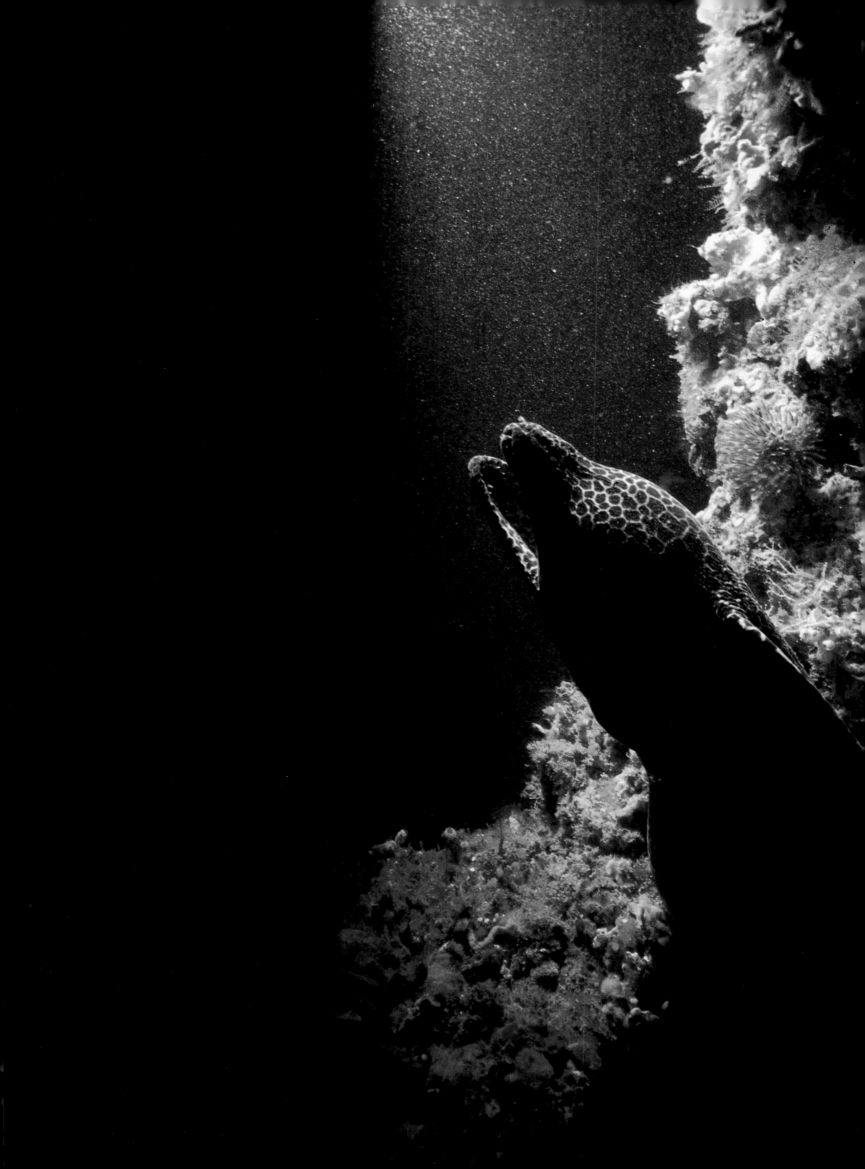

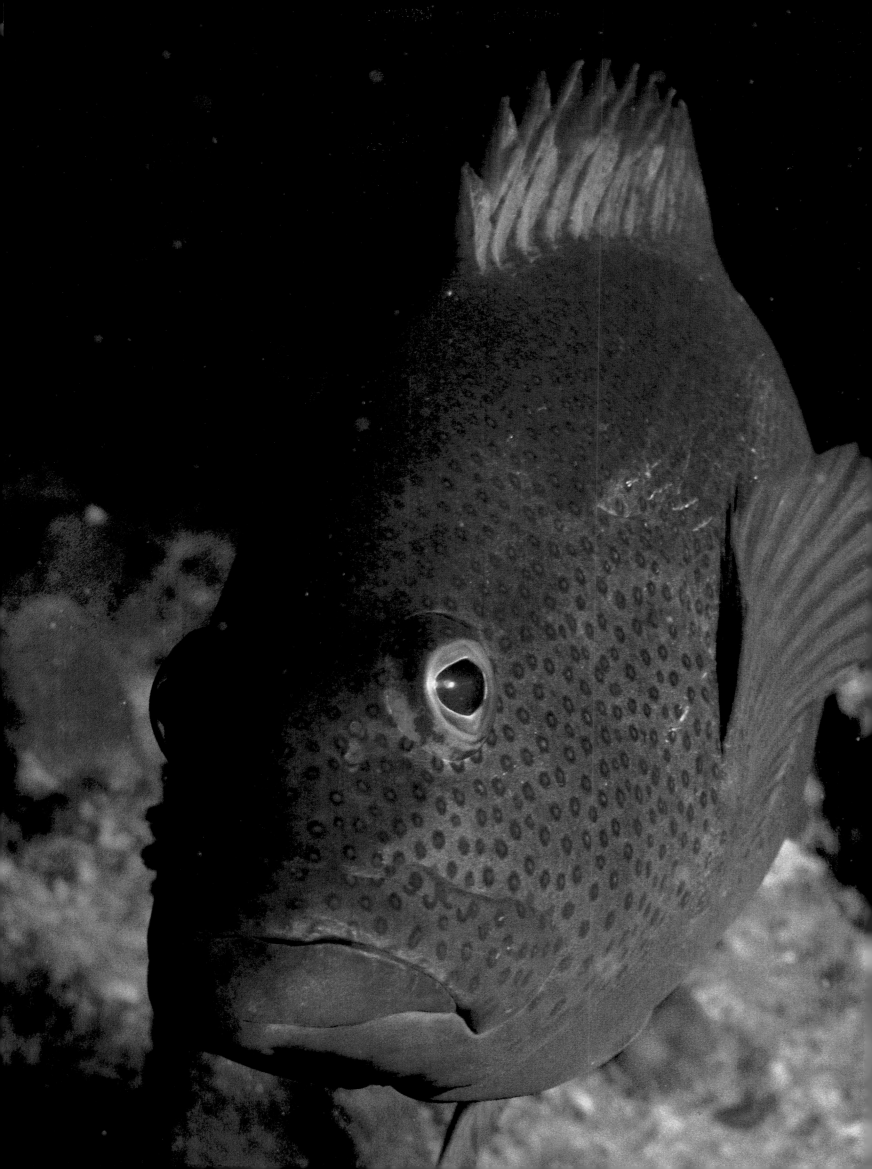

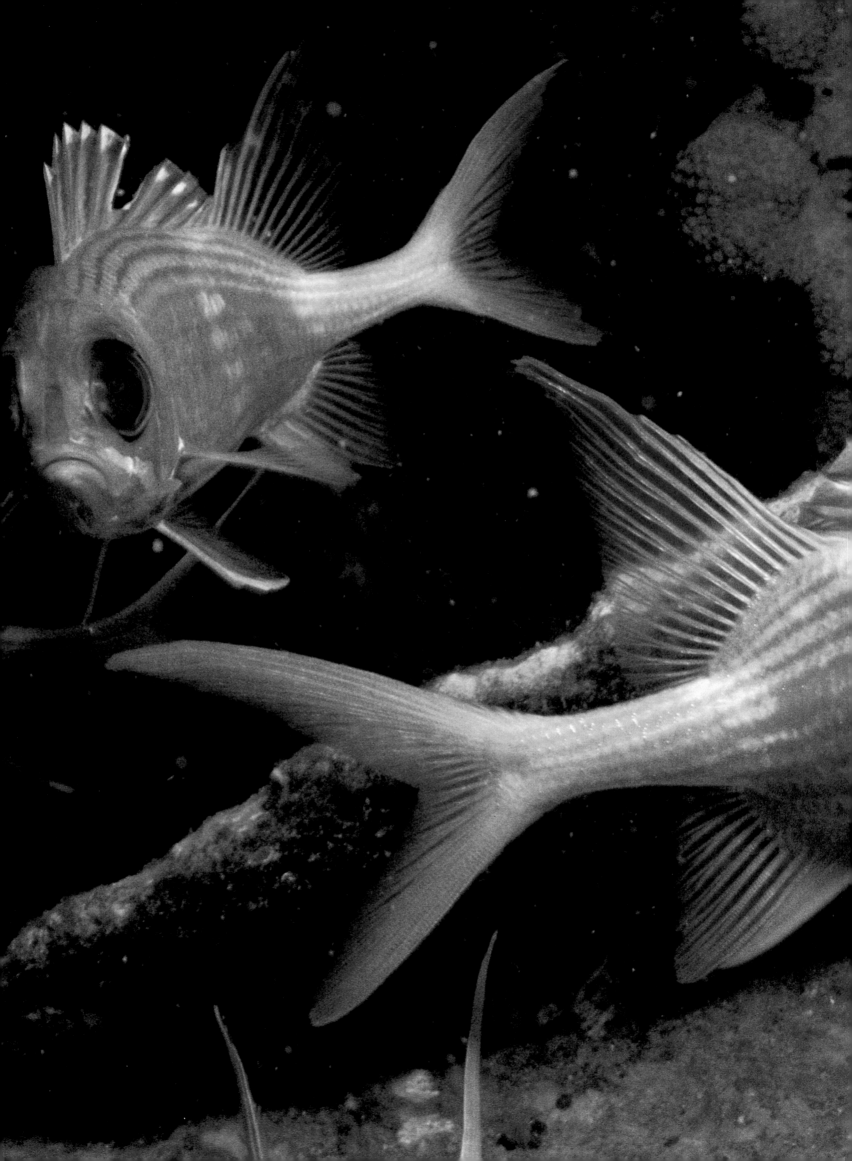

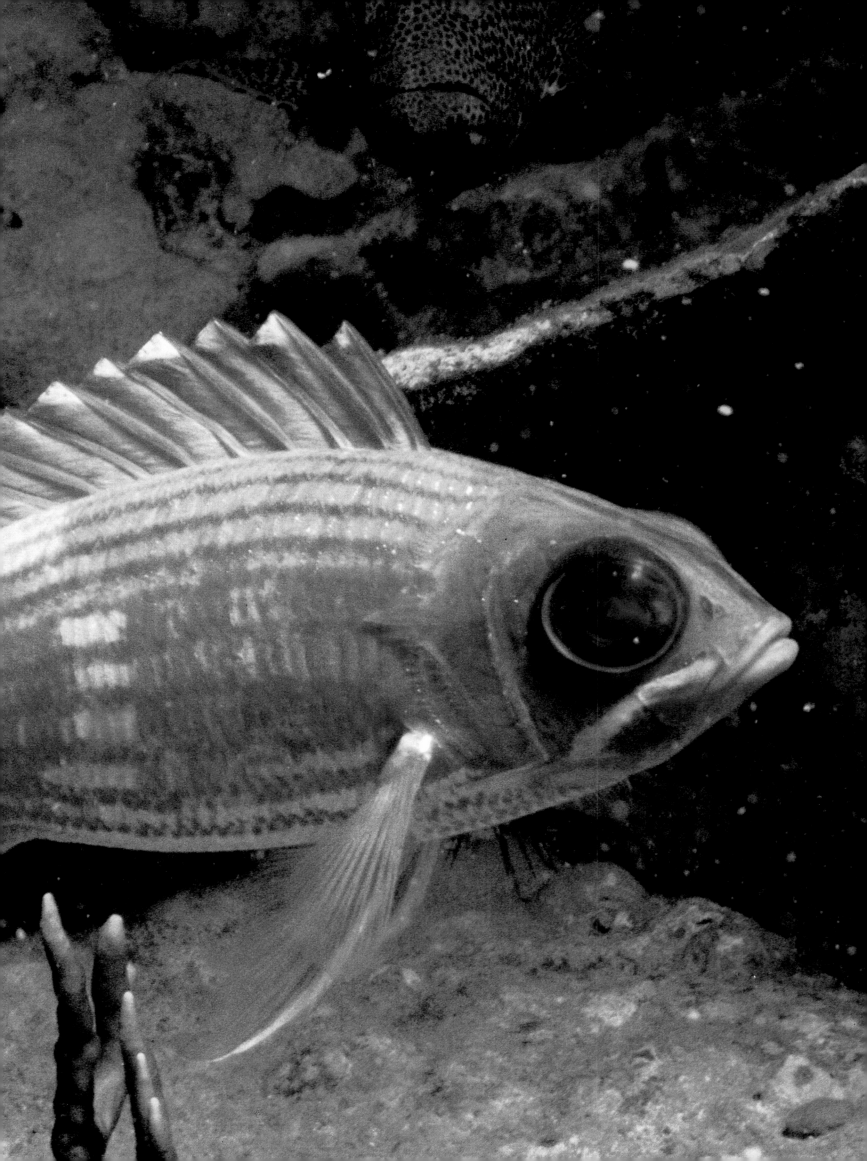

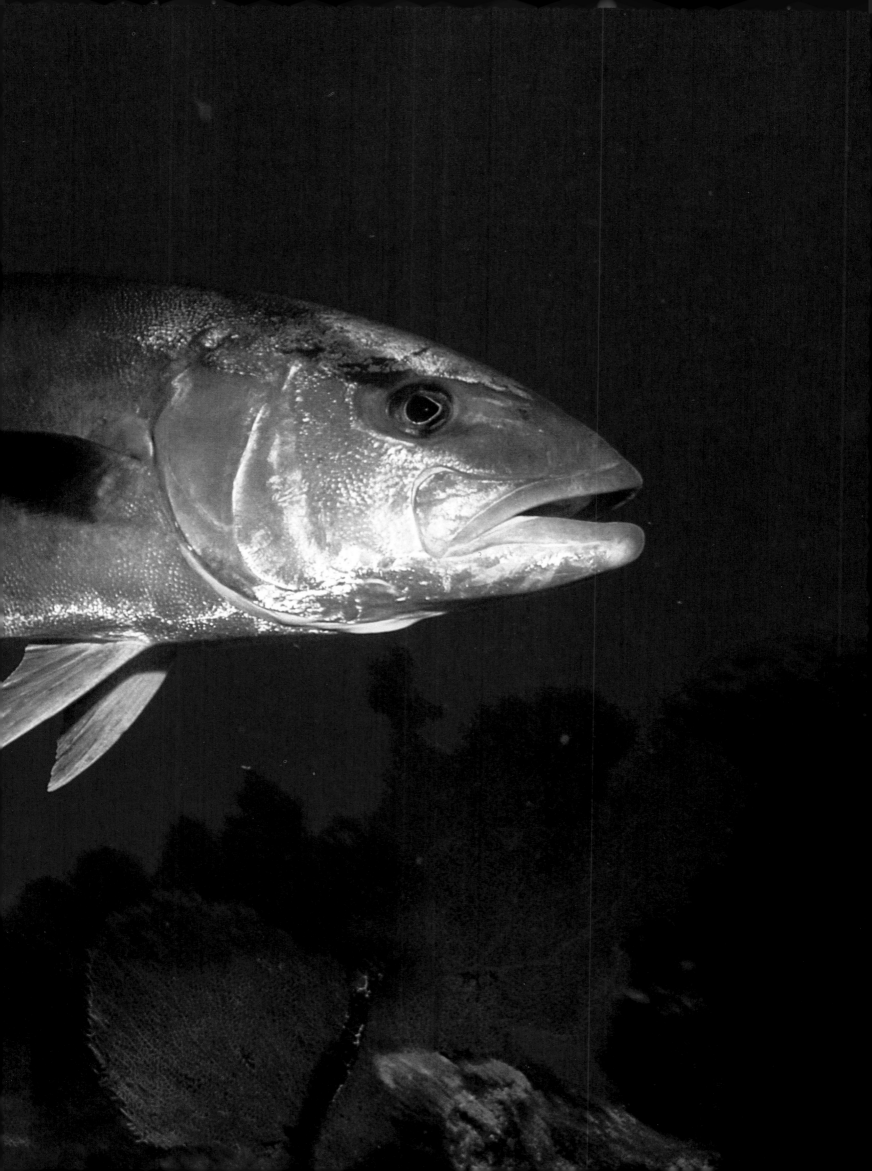

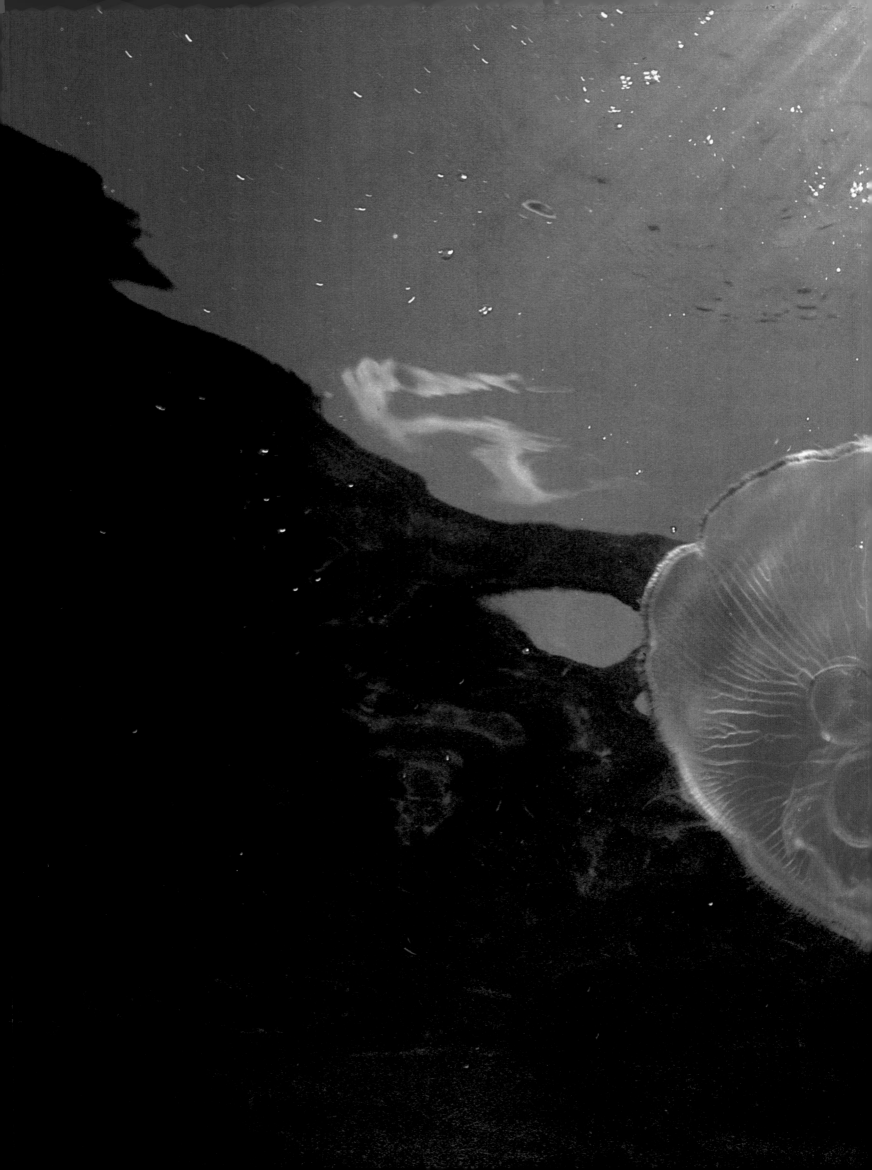

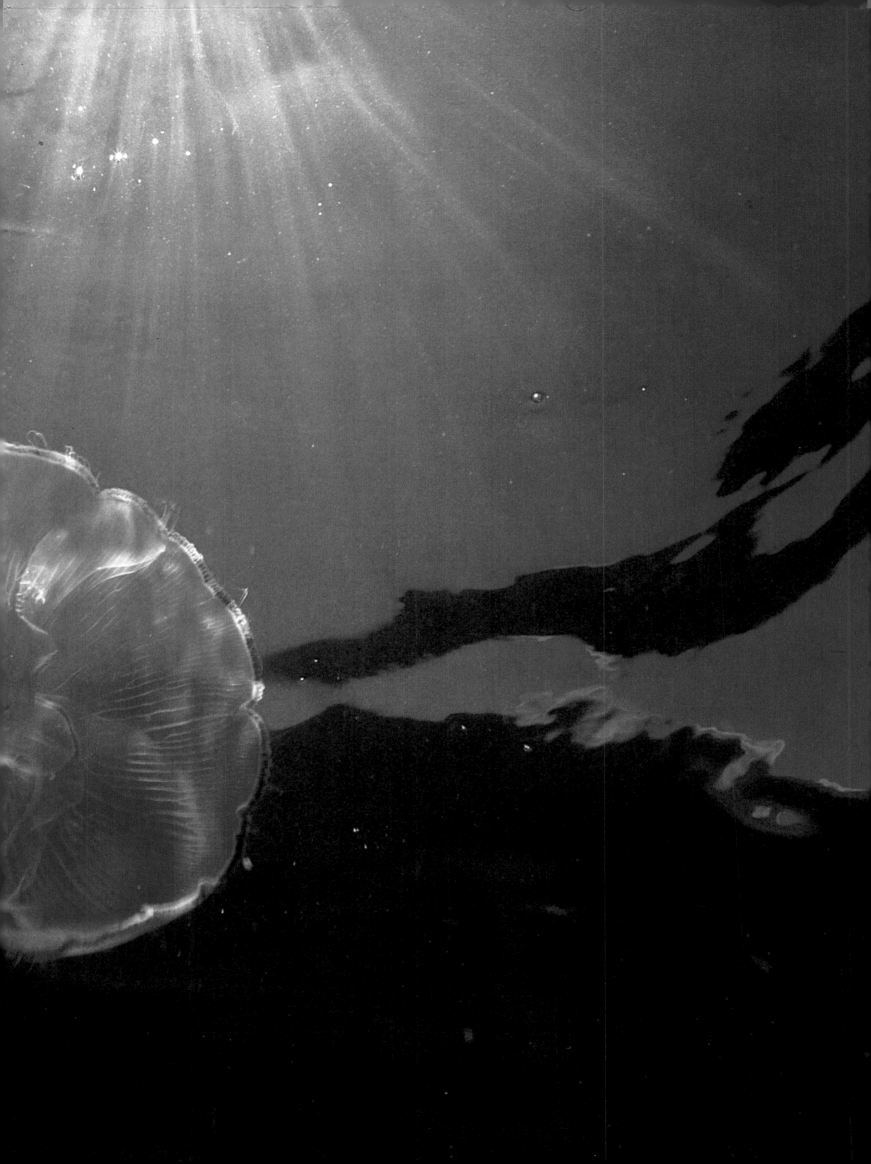

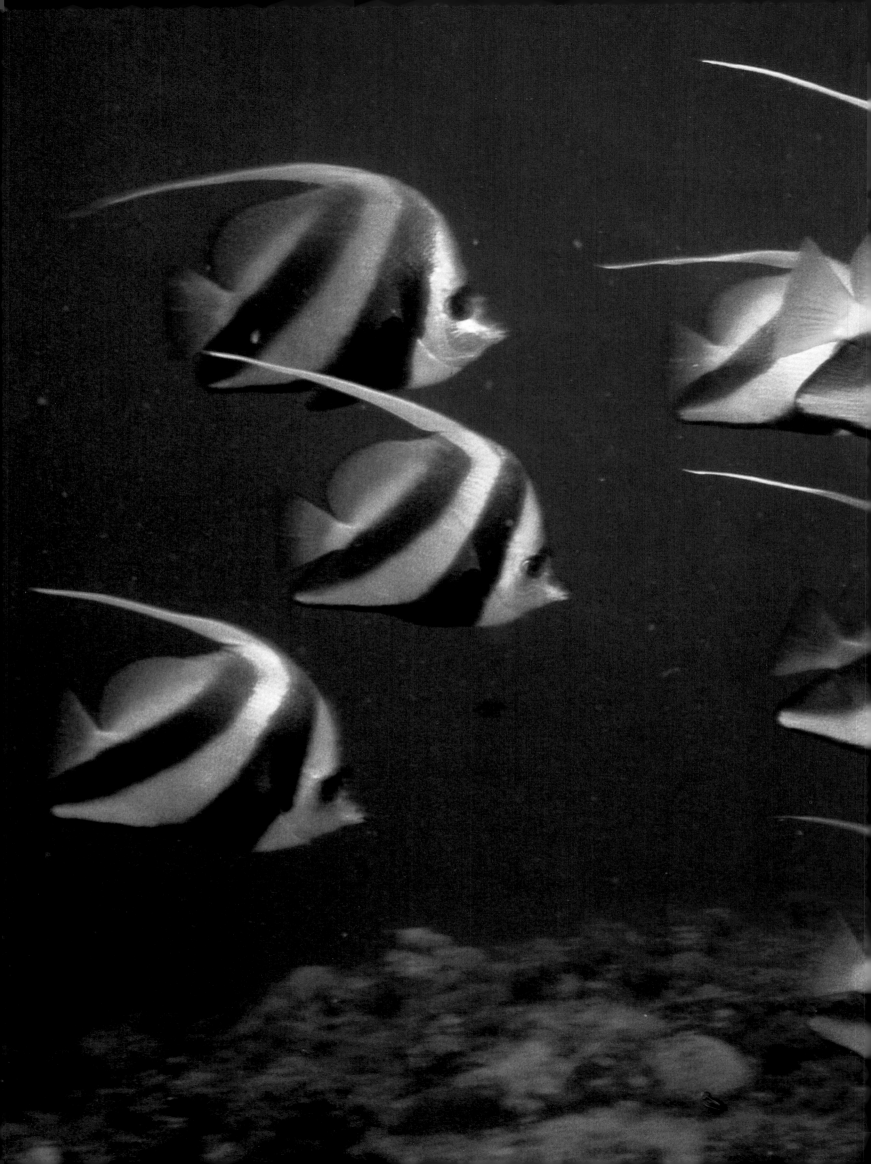

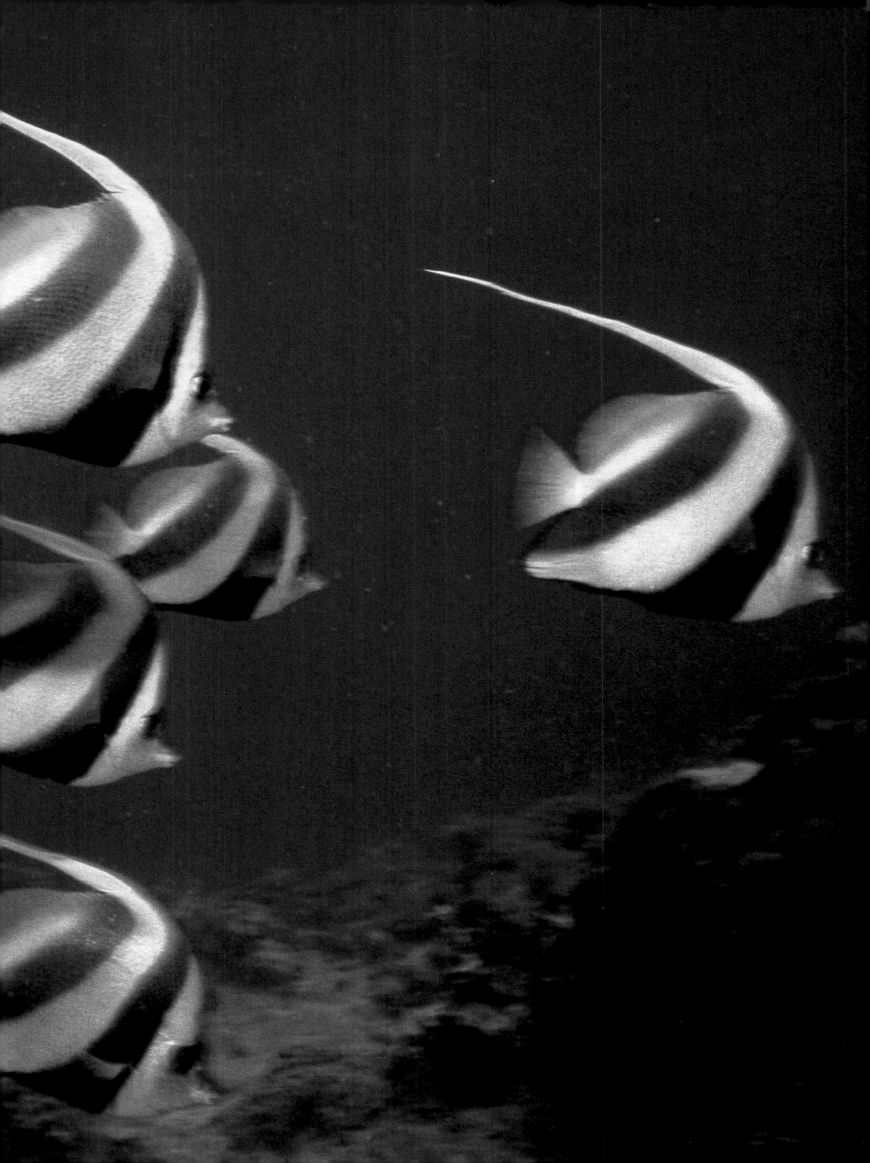

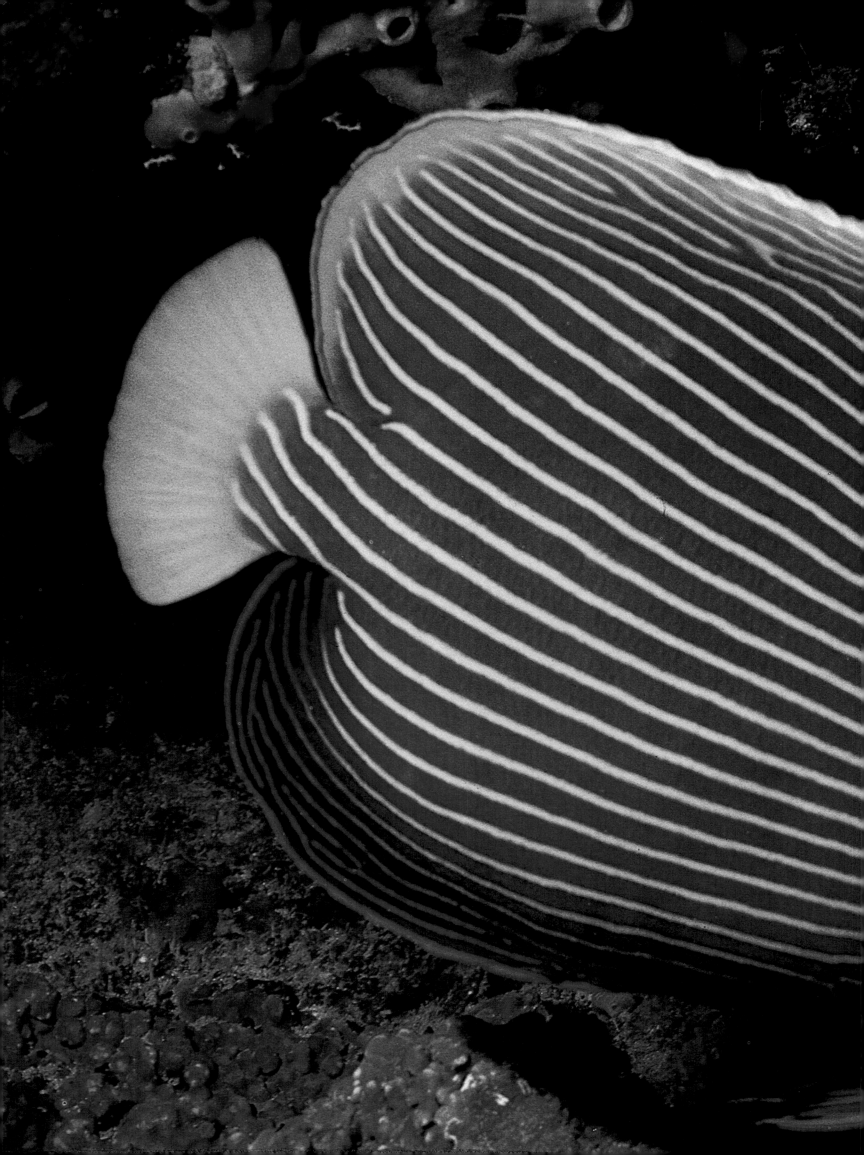

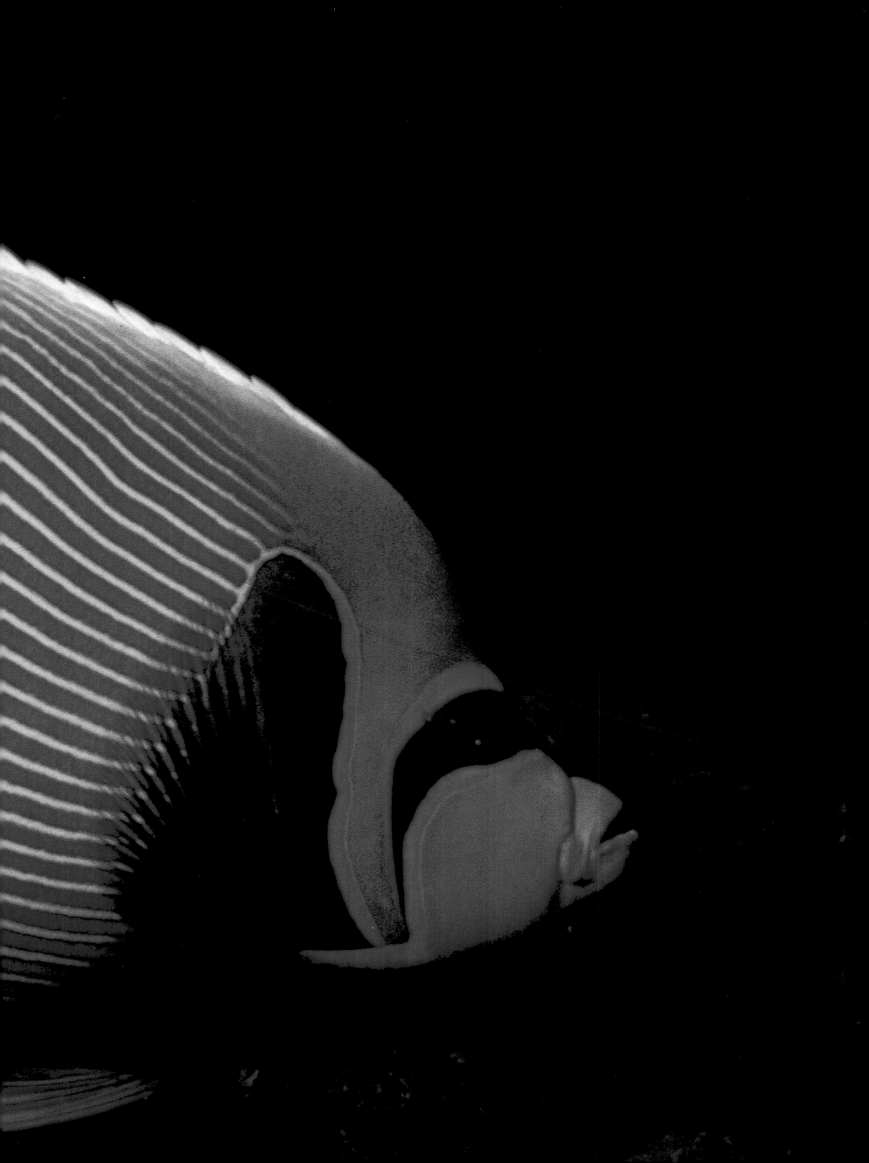

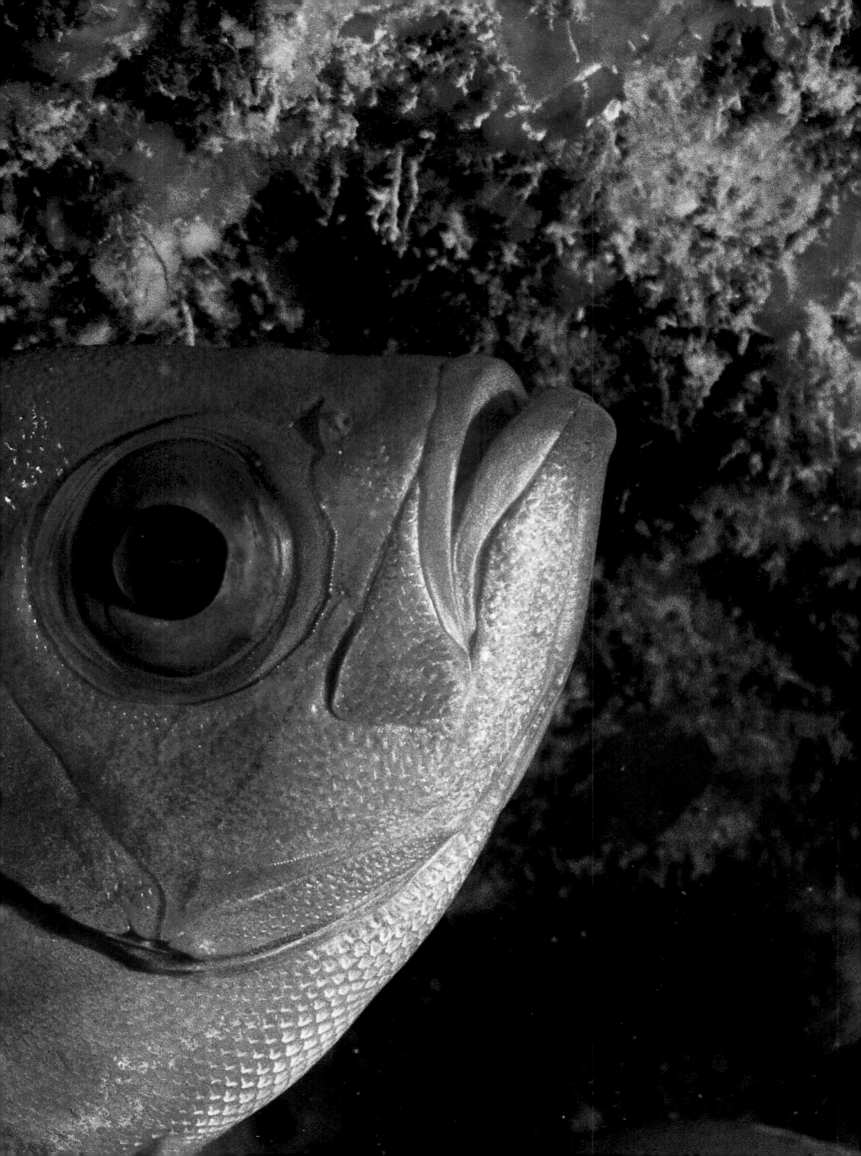

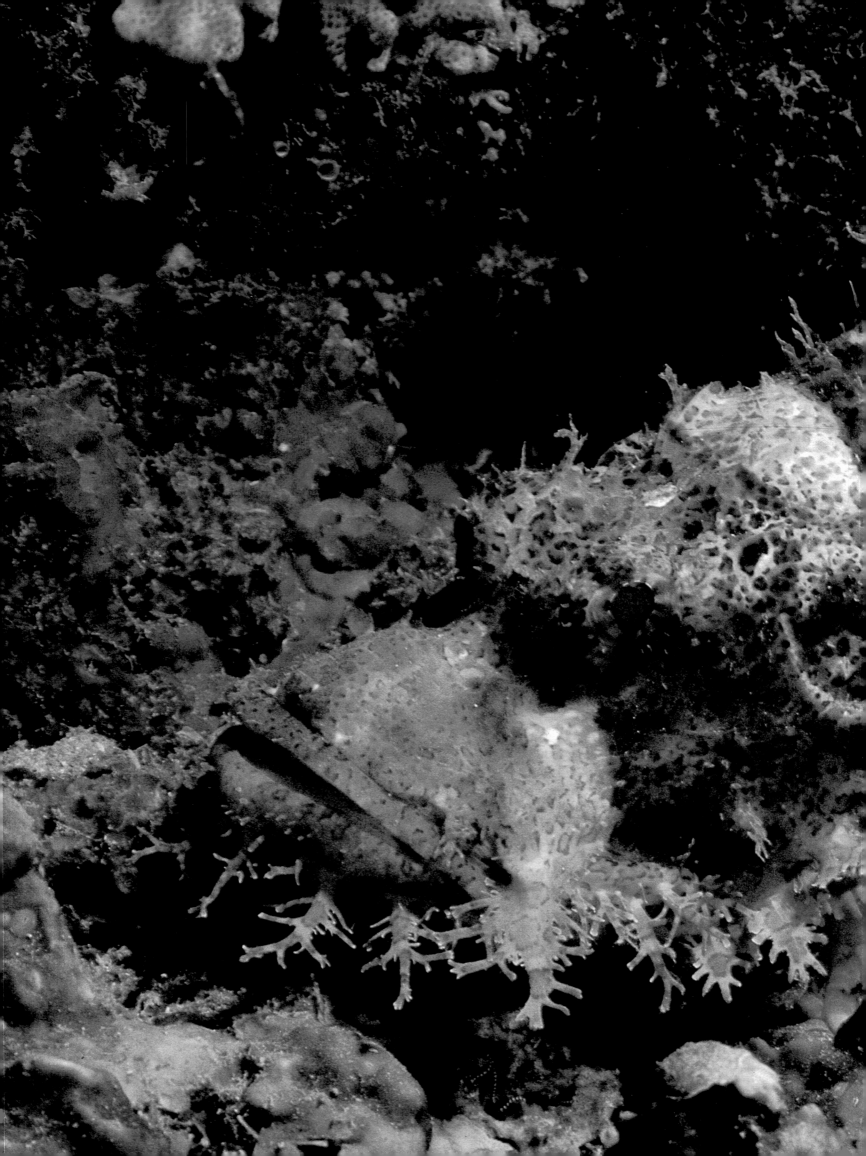

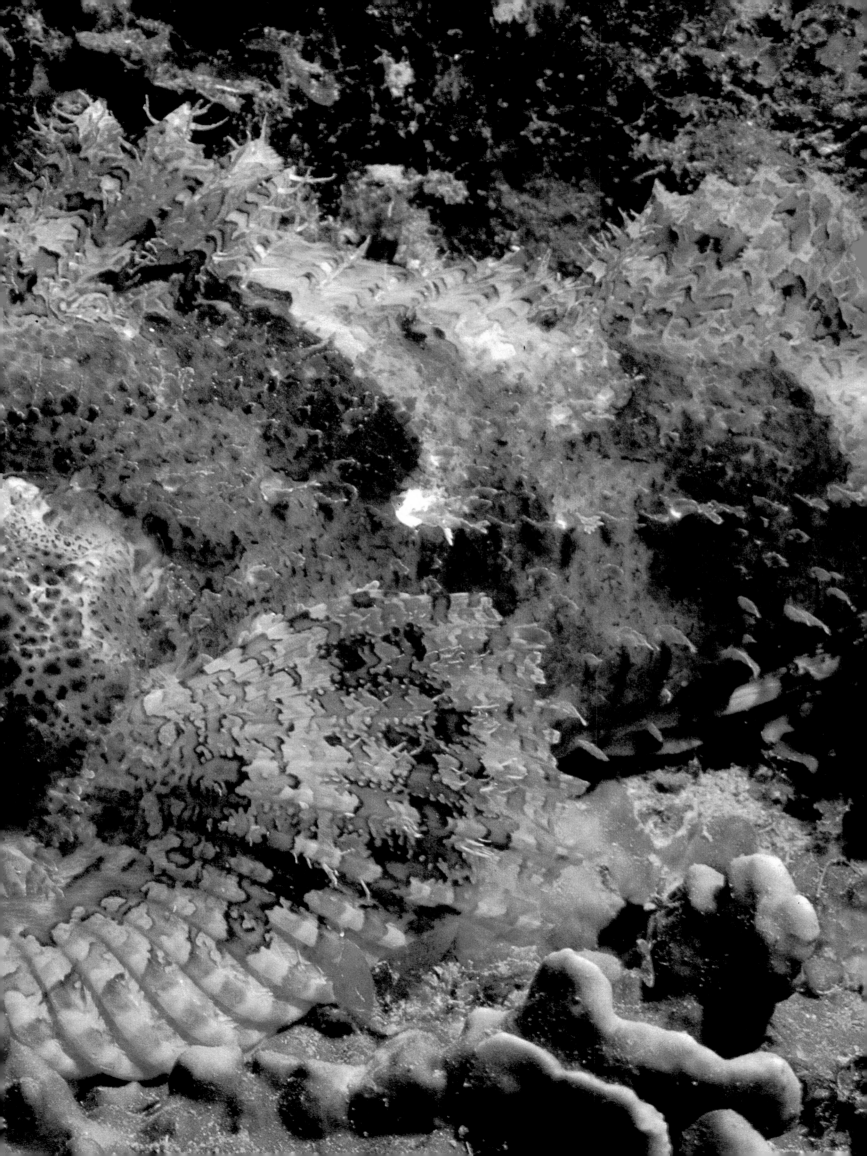

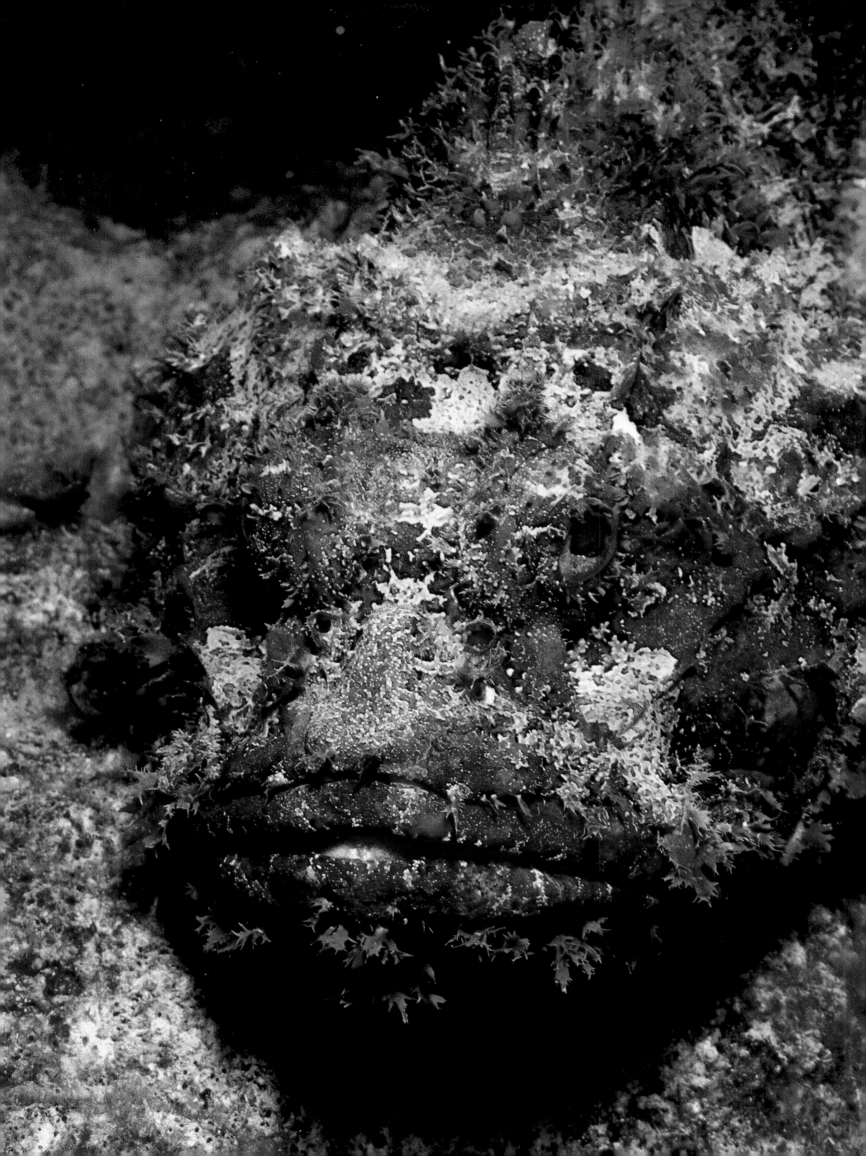

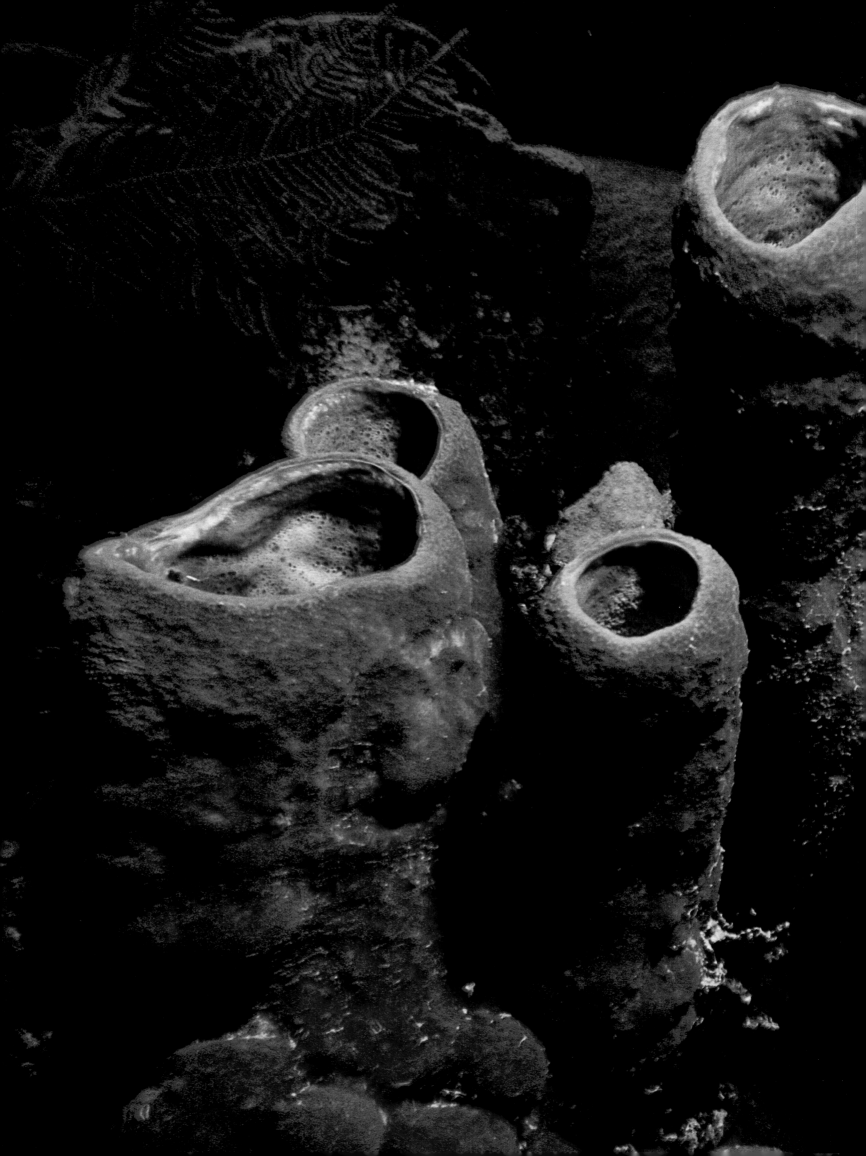

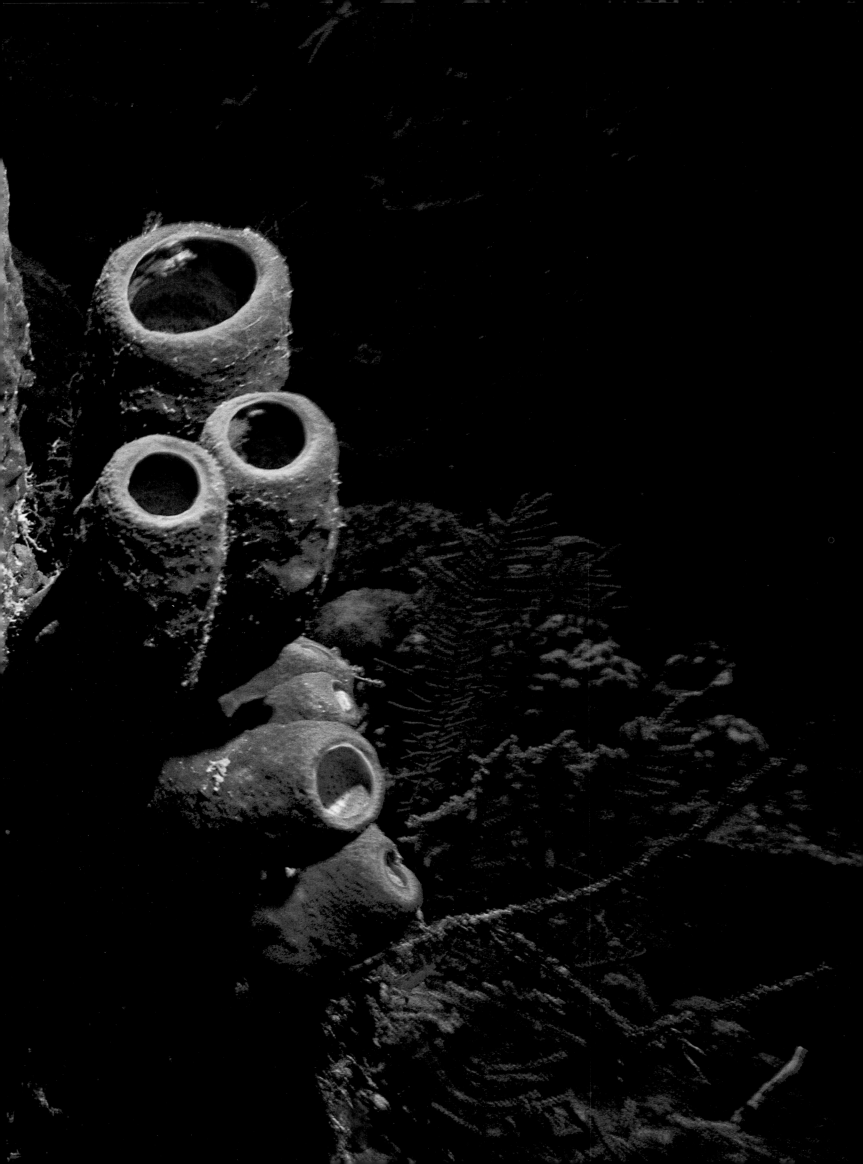

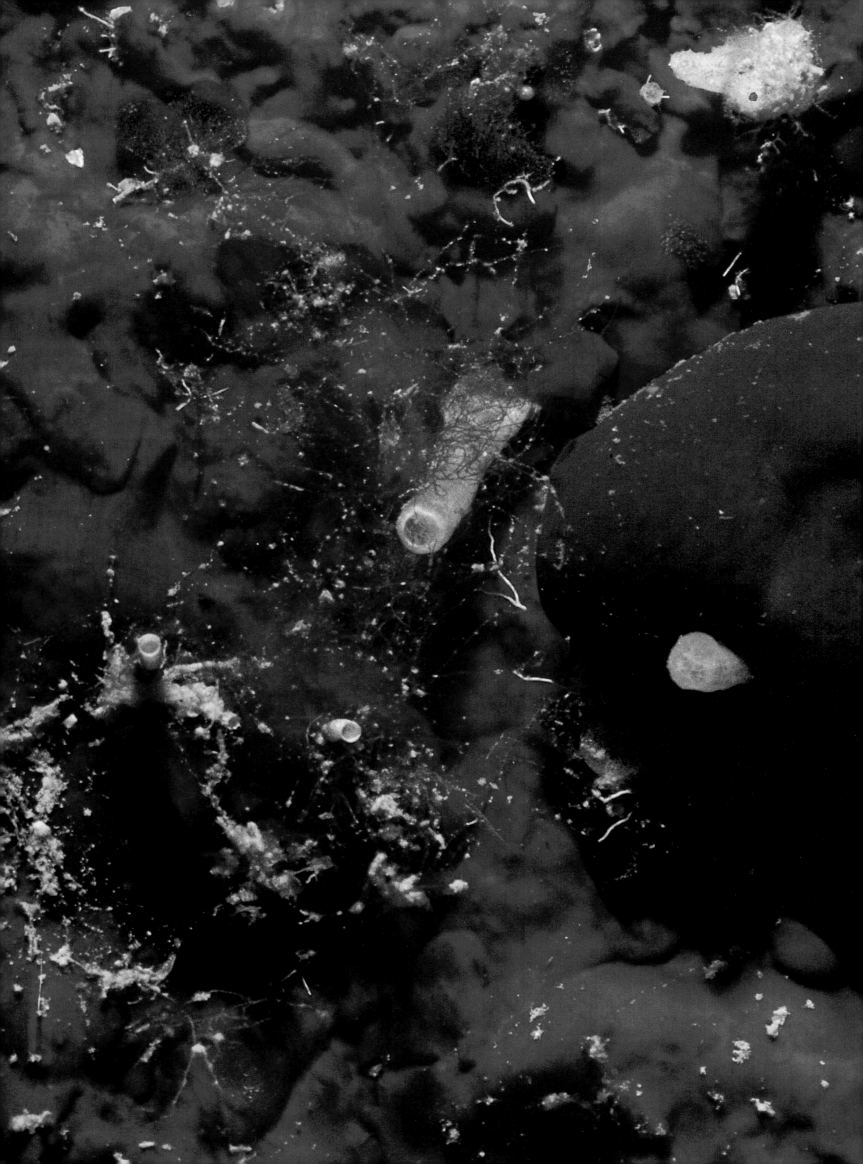

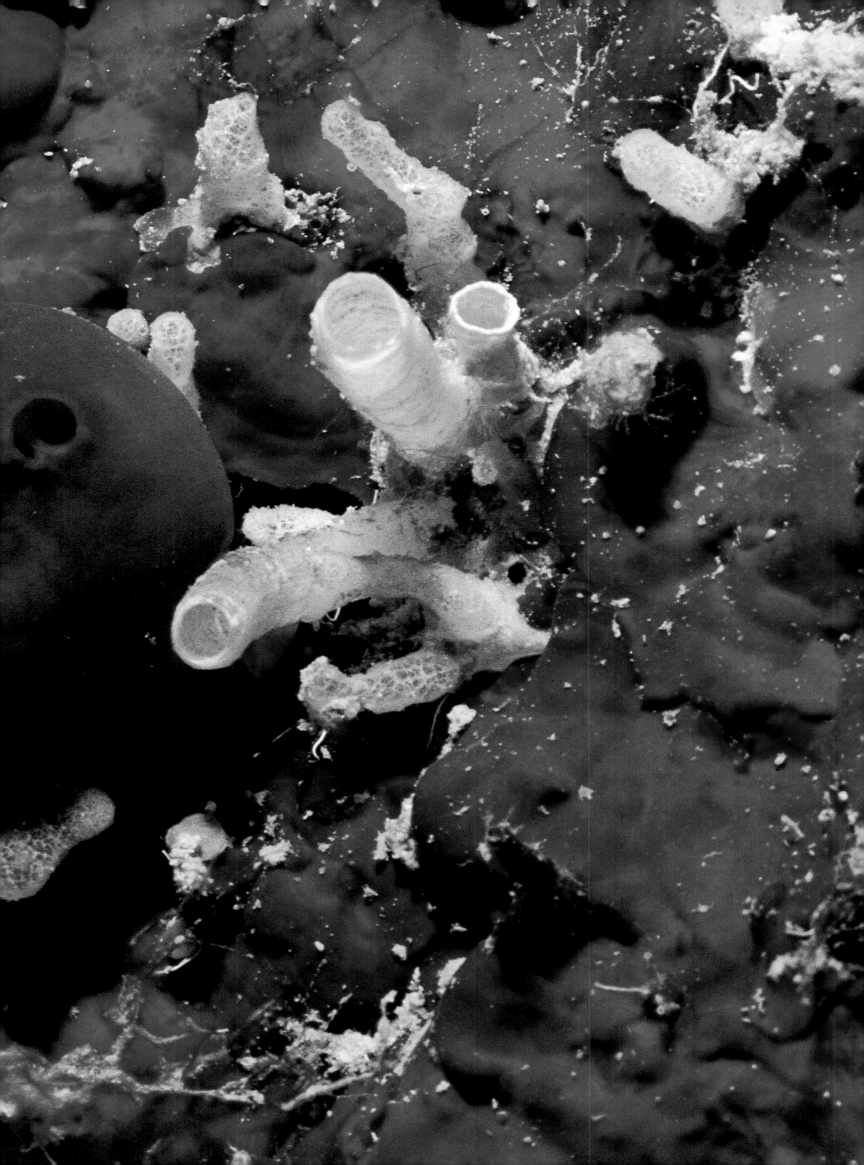

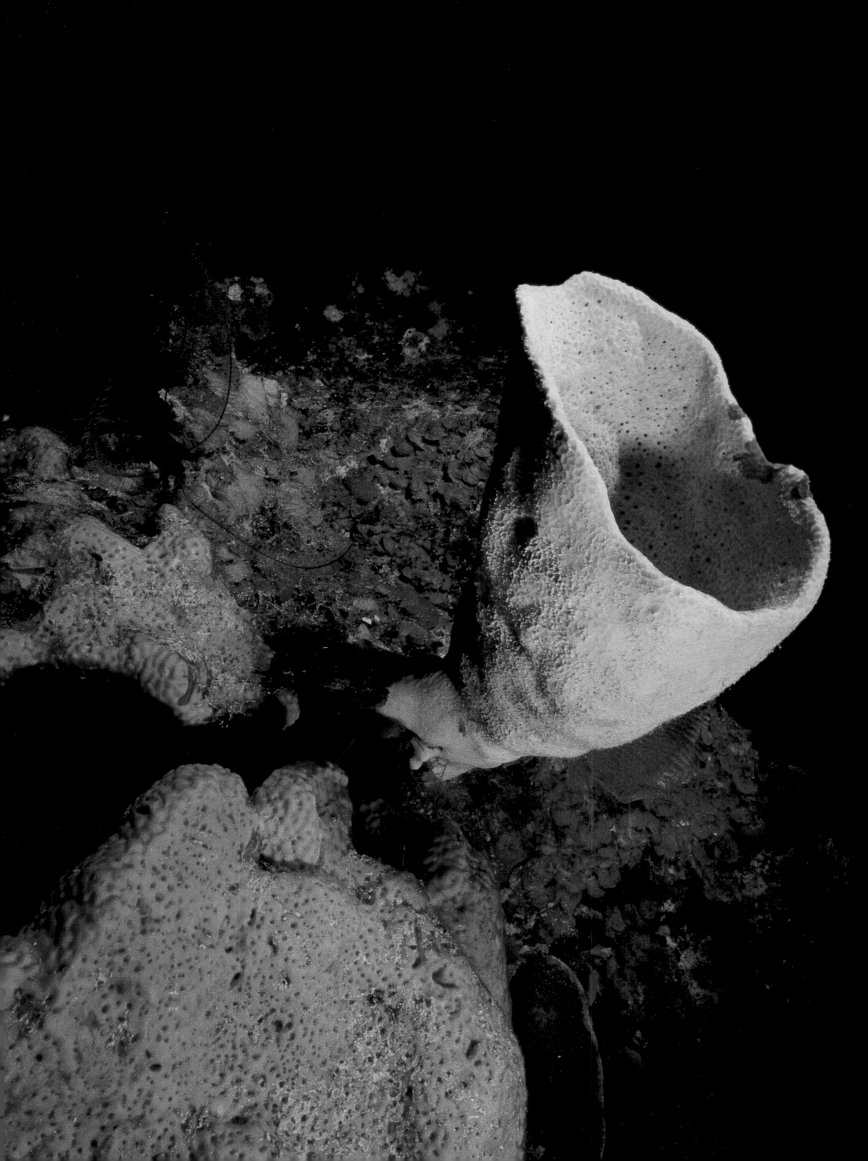

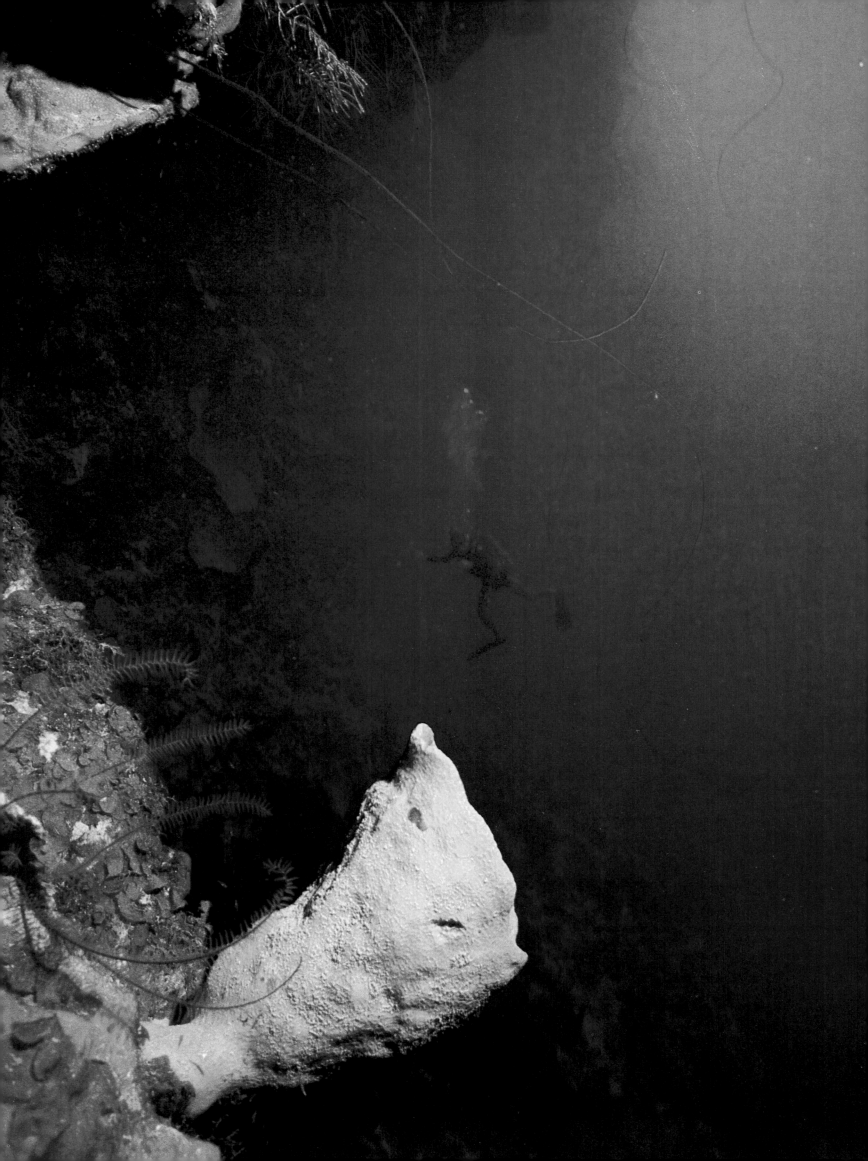

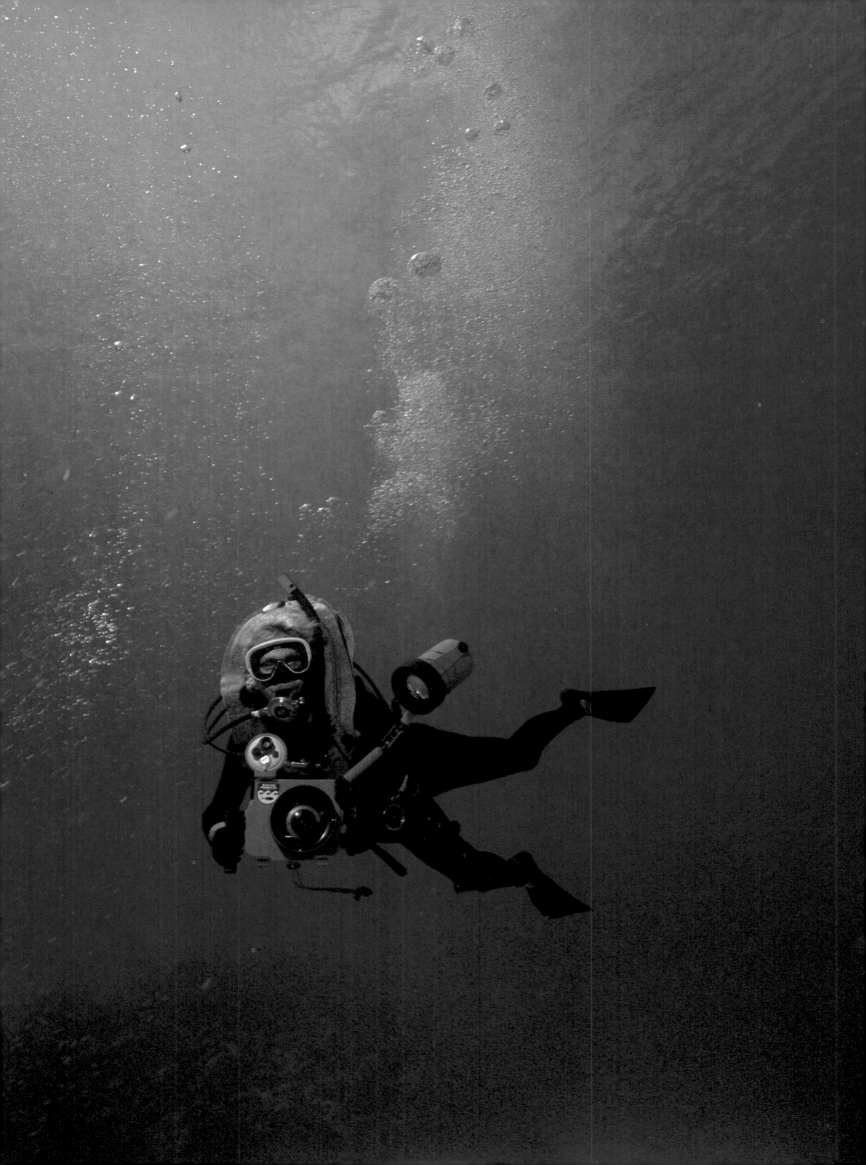

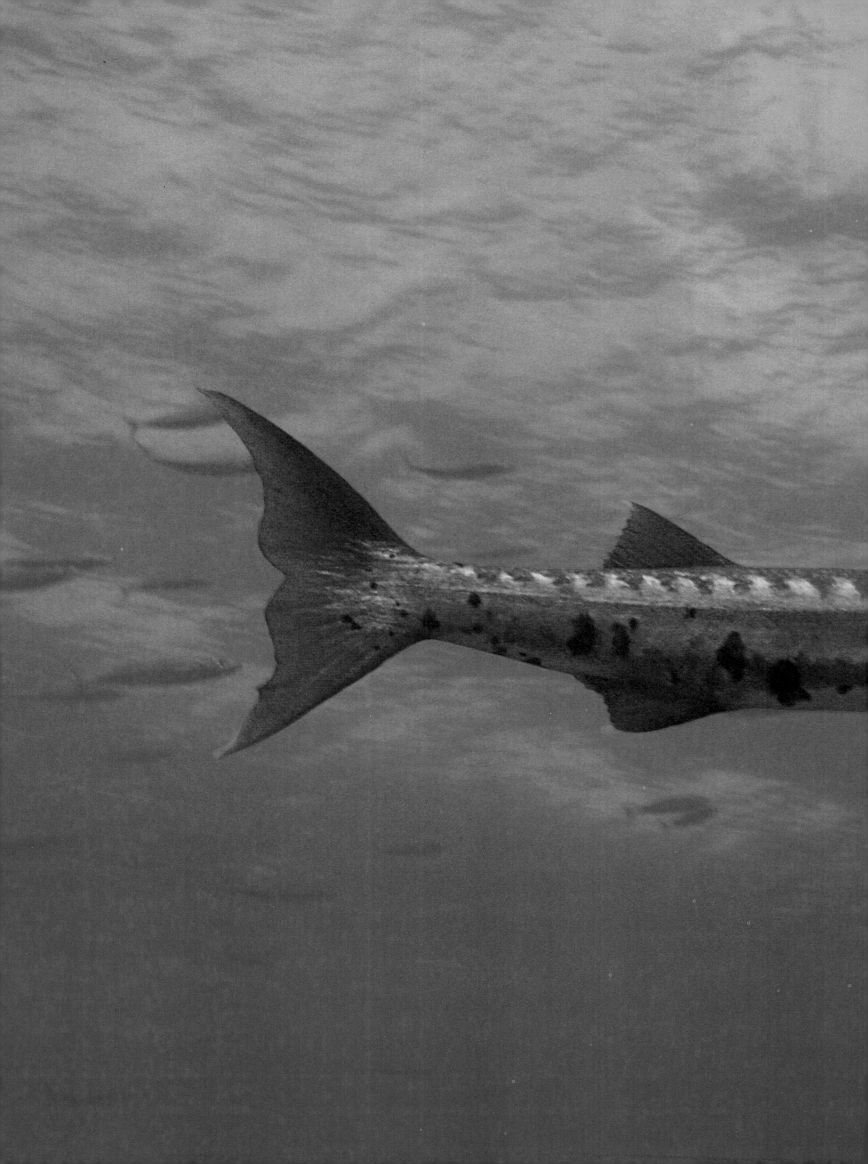

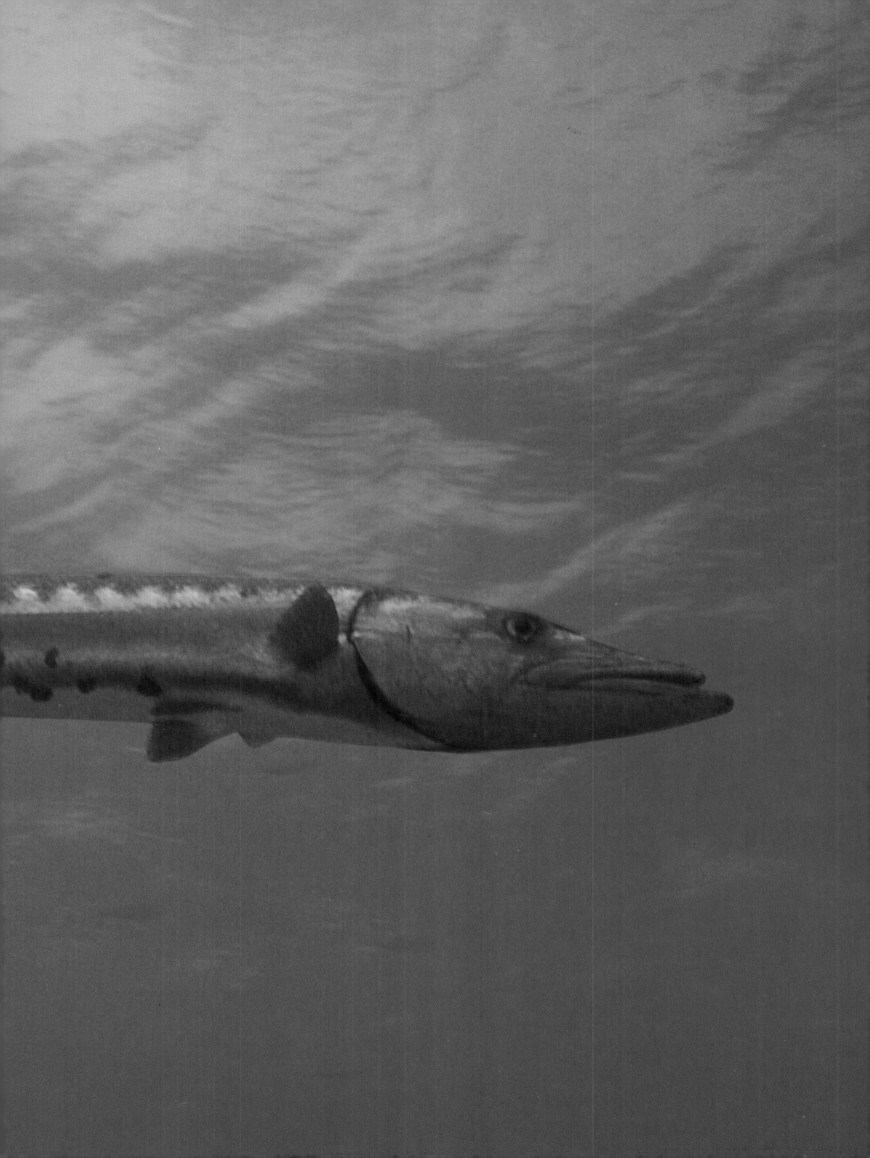

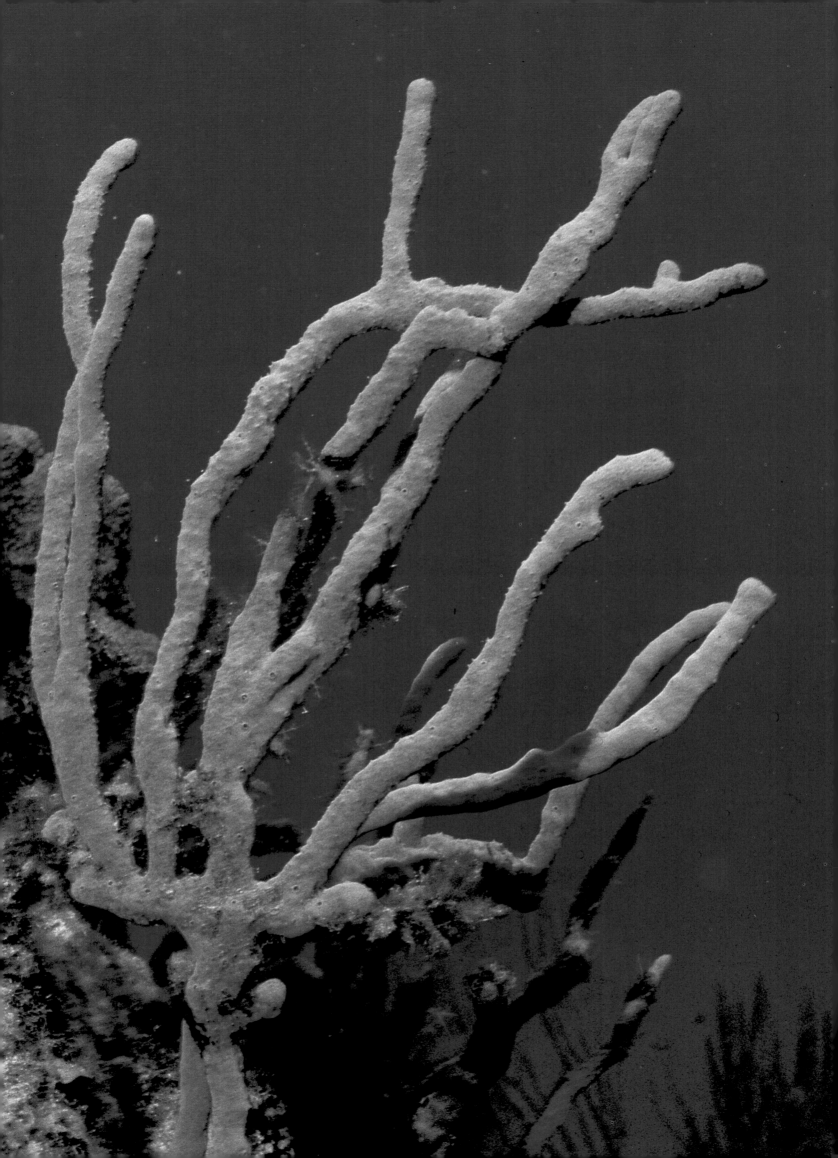

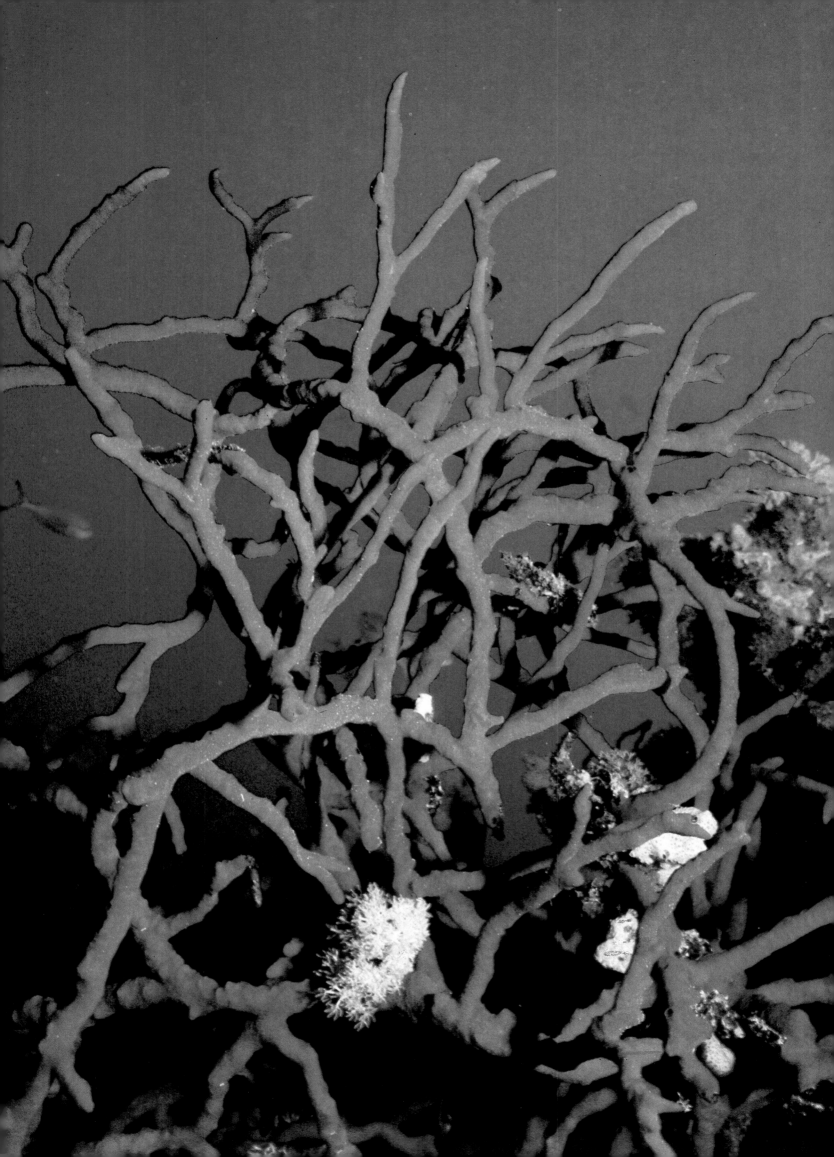

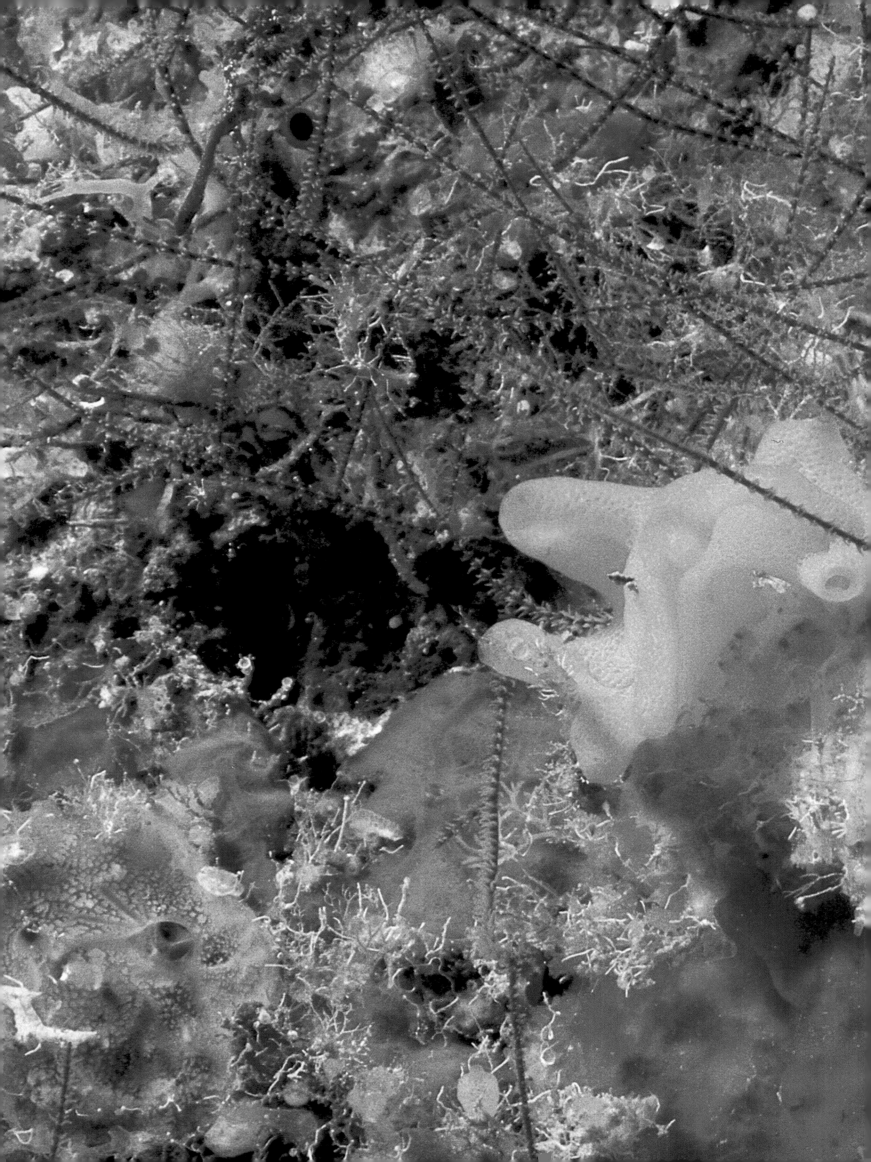

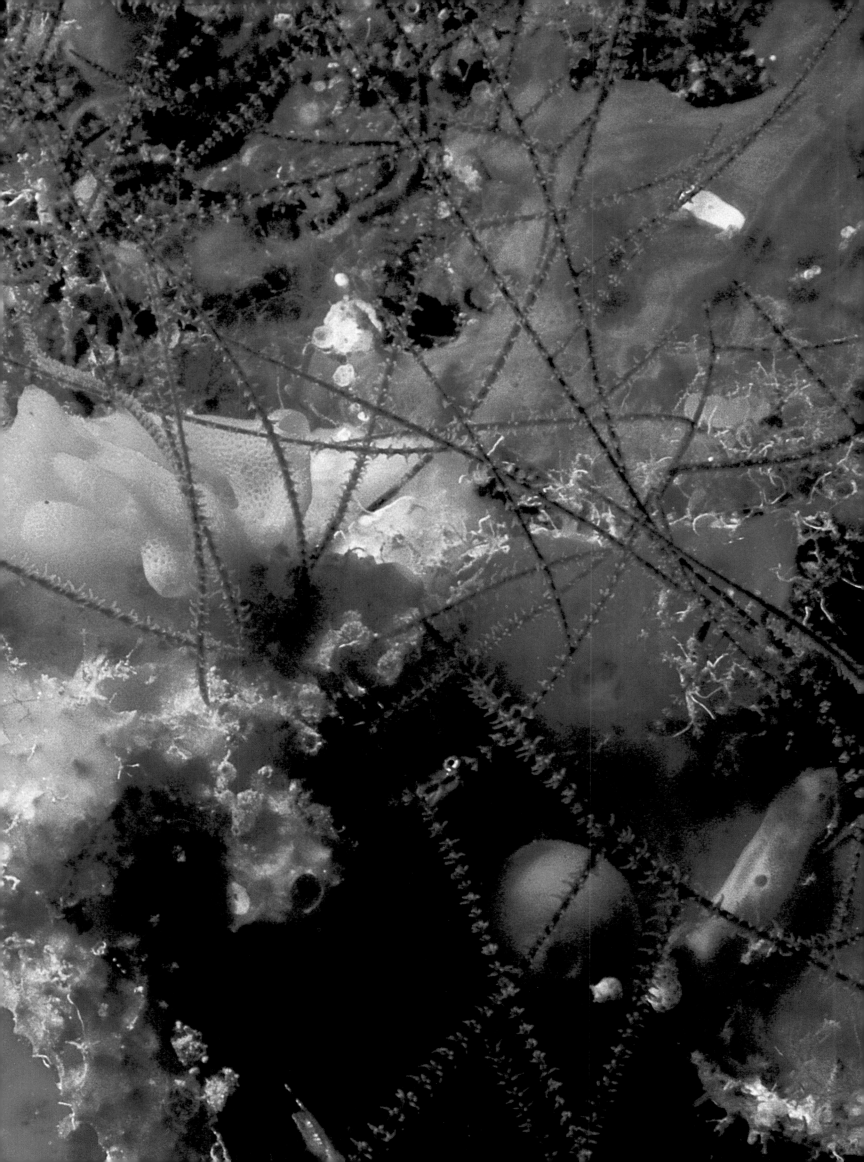

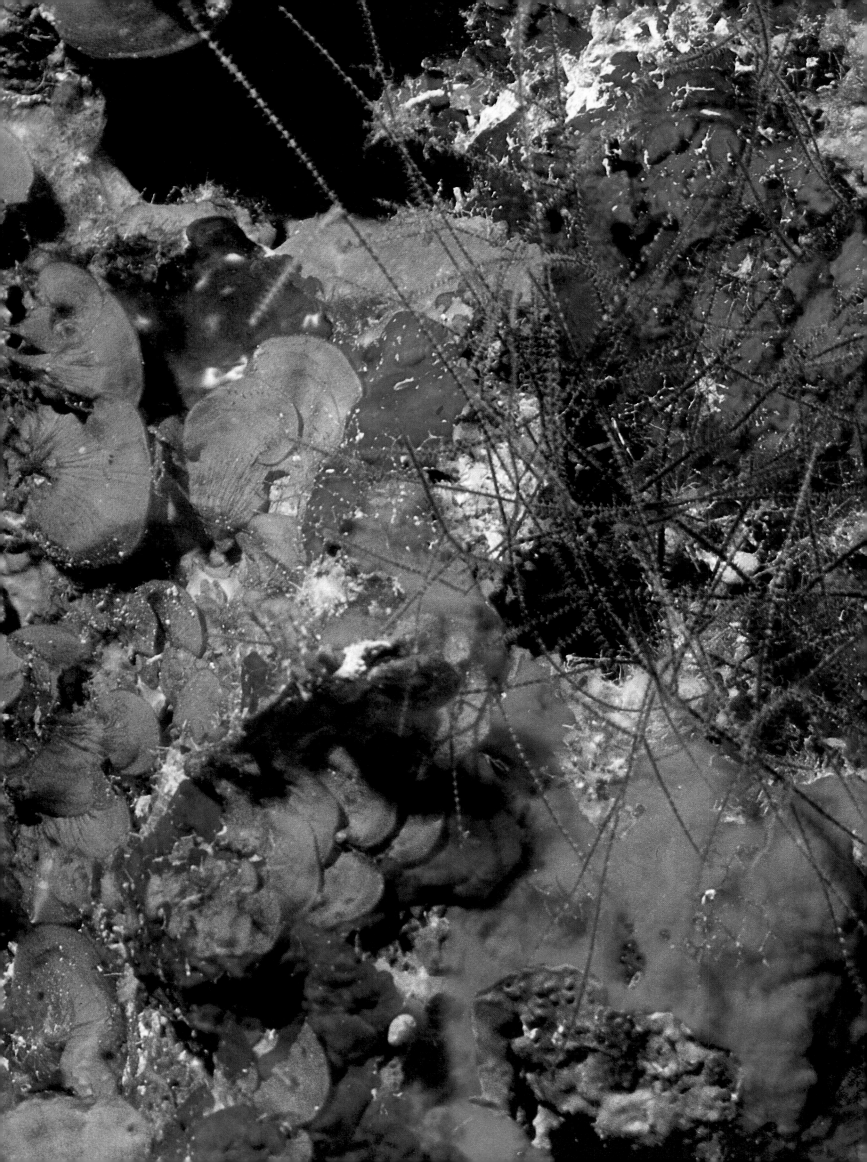

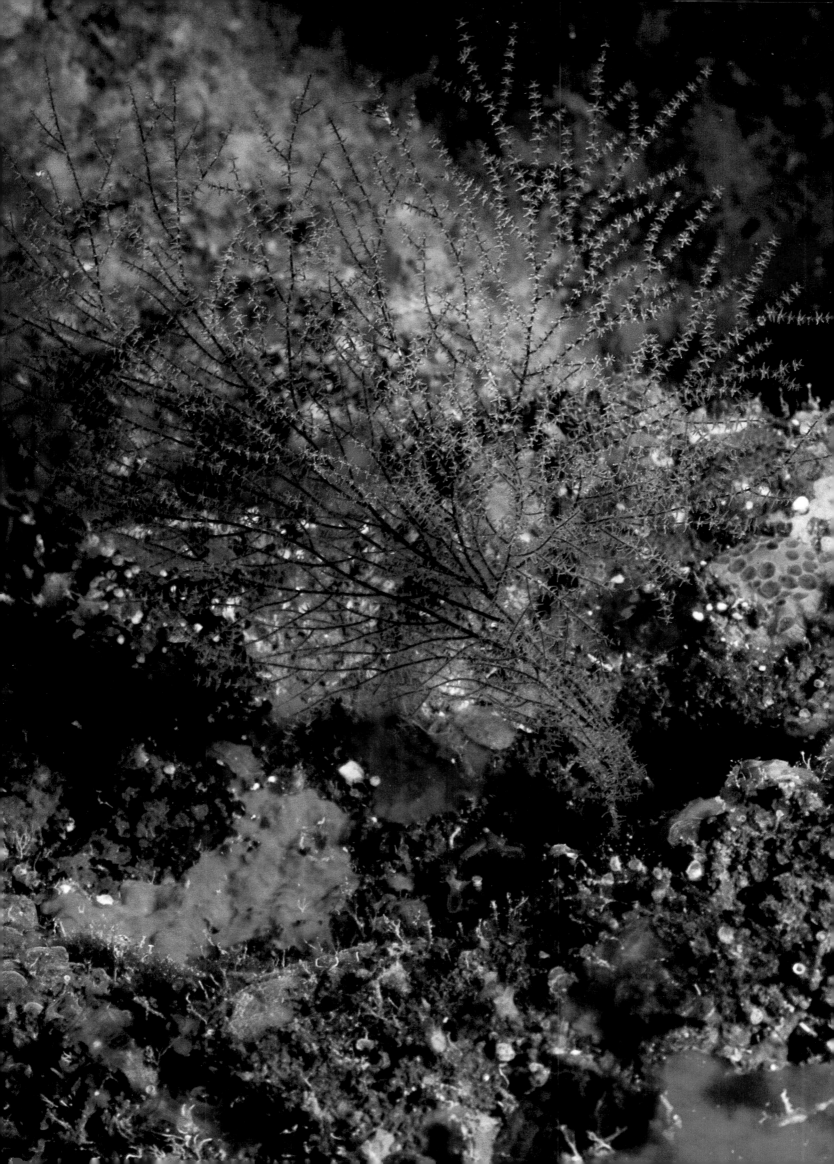

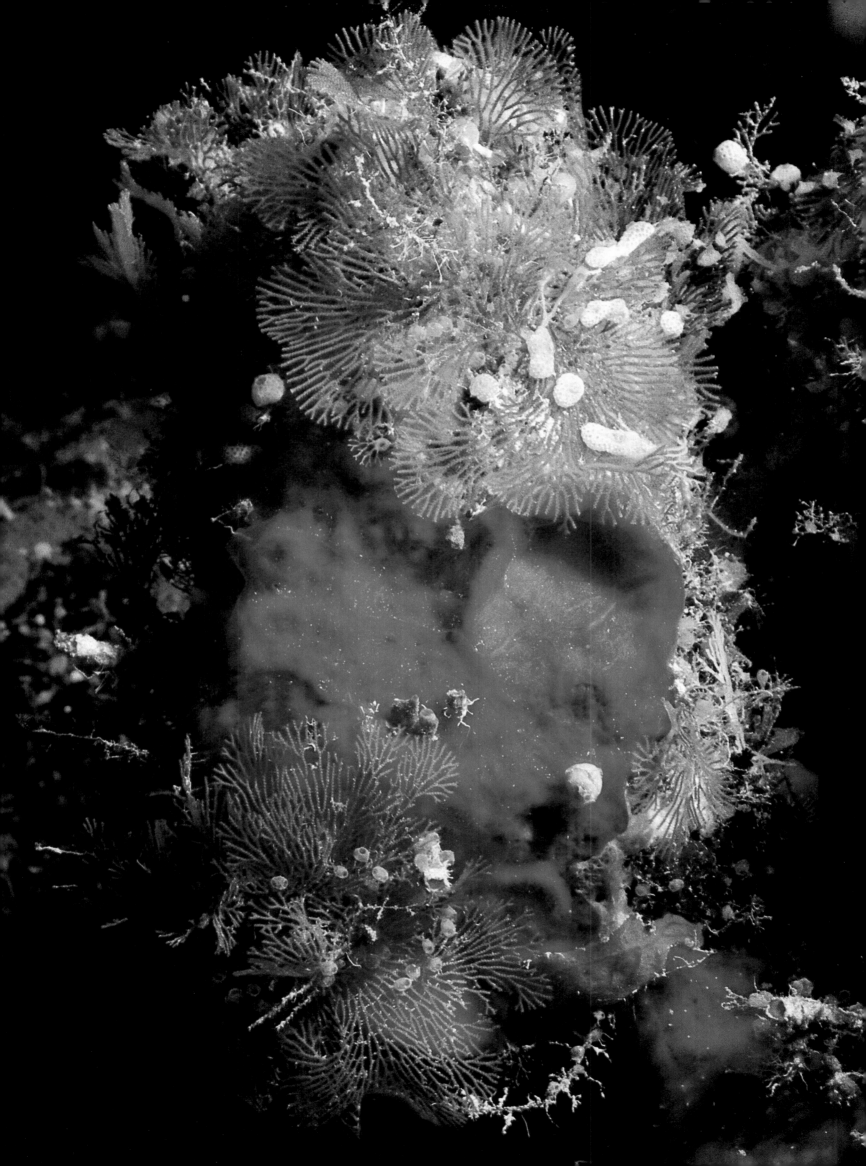

0

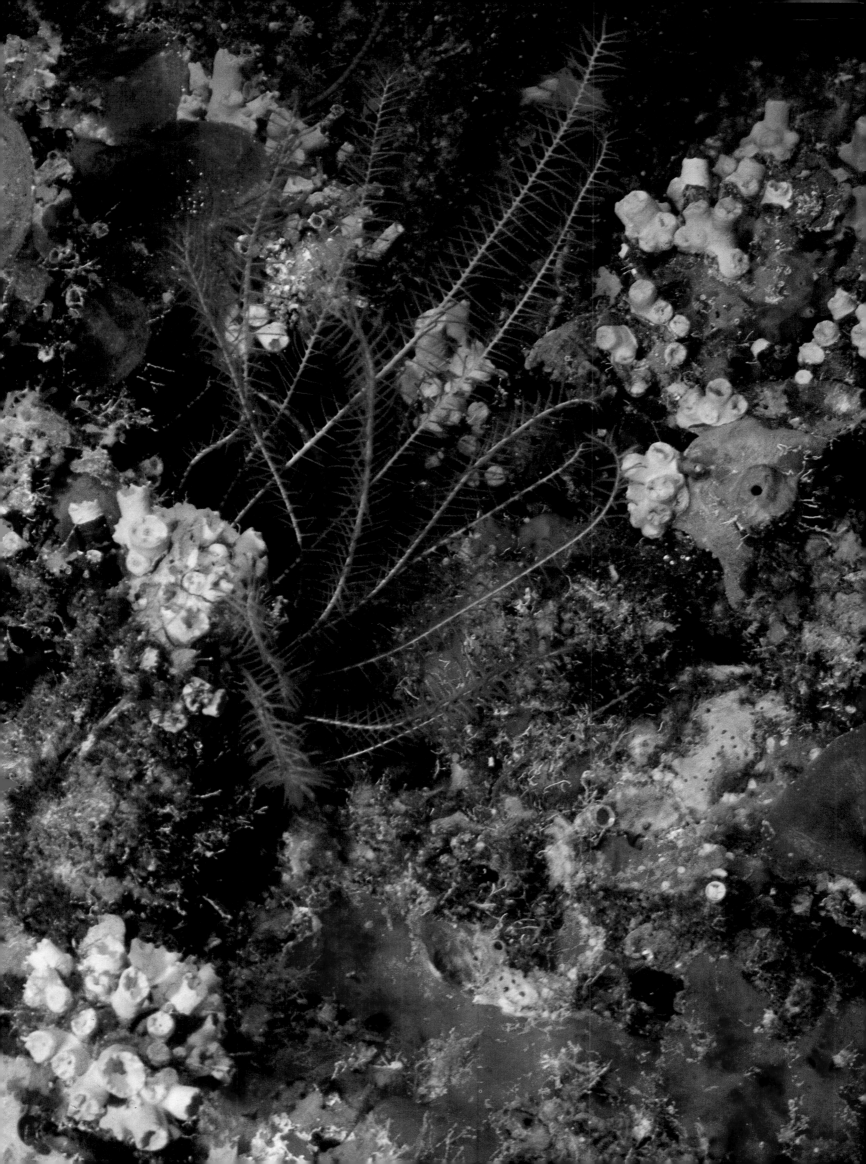

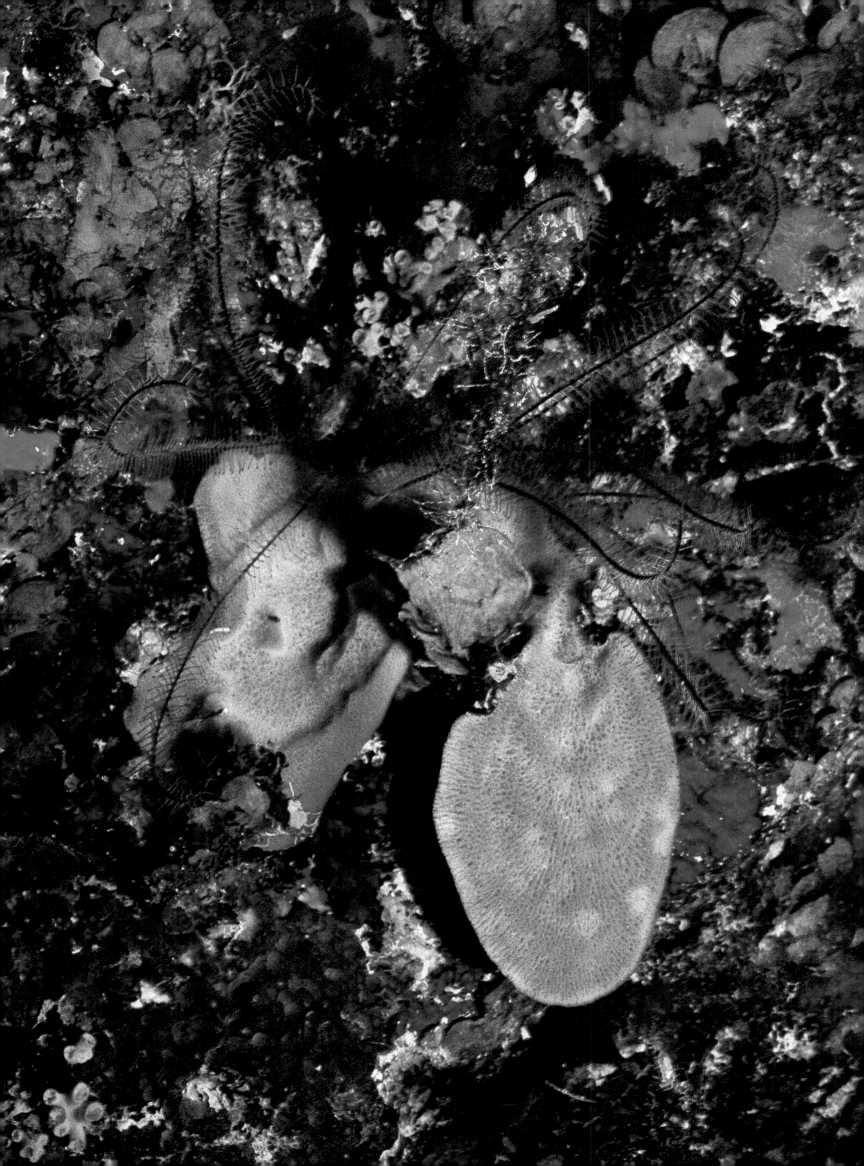

Captions

Professor Dr Wolfgang Klausewitz of the Senckenberg Research Institute, Frankfurt/Main checked the nomenclature of the fish.

Dr Georg Scheer of Darmstadt, a coral expert, checked the nomenclature of the corals.

Dr Gwynne Vevers of the Zoological Society of London checked the English nomenclature.

Beaker sponge with two gorgonians. Behind centre, *Gorgonia flabellum*; left, the branched *Pseudopterogorgia*.
North Eleuthera, Bahamas, Caribbean

A gorgonian and Blue chromis (*Chromis cyaneus*, 8 cm.).
St John, US Virgin Islands, Caribbean

Stinging coral (*Millepora alcicornis*). Right, foreground, a sponge; centre, a small colony of Leaf coral (*Agaricia agaricites*).
Roatan Island, Spanish Honduras, Caribbean

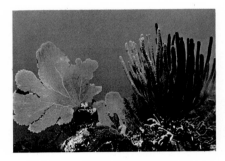

Left, a common gorgonian (*Gorgonia ventalina*). Right, a gorgonian (*Plexaurella dichotoma*).
Roatan Island, Spanish Honduras, Caribbean

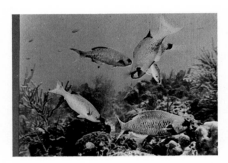

Creole wrasse (*Clepticus parrai*, 30 cm.).
St Thomas, US Virgin Islands, Caribbean

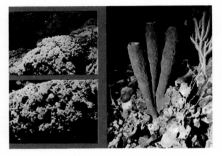

Left, above and below, alcyonarian coral.
Mafia Island, Tanzania, Indian Ocean
Right, pipe sponges.
Grand Cayman, West Indies, Caribbean

Left, alcyonarian coral (*Sarcophyton*) with erect polyps, the tentacles of which are not fully extended.
Turtle Bay, Kenya, Indian Ocean
Right, Trumpetfish (*Aulostomus maculatus*, 80 cm.) in a gorgonian (*Plexaurella dichotoma*).
Turks Islands, West Indies, Caribbean

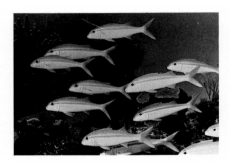

Yellow goatfish (*Mulloidichthys martinicus*, 30 cm.).
Turks Islands, West Indies, Caribbean

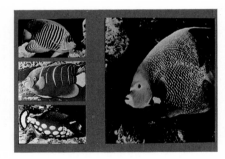

Left, above, Royal angelfish (*Pygoplites diacanthus*, 25 cm.). Centre, Yellowtail angelfish (*Pomacanthodes chrysurus*, 30 cm.). Below, Clown triggerfish (*Balistoides conspicillum*, 35 cm.).
Mafia Island, Tanzania, Indian Ocean
Right, French angelfish (*Pomacanthus paru*, 40 cm.).
Grand Cayman, West Indies, Caribbean

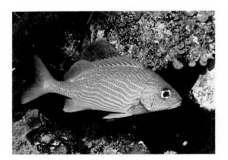

Yellow grunt (*Haemulon flavolineatum*, 30 cm.).
Turks Islands, West Indies, Caribbean

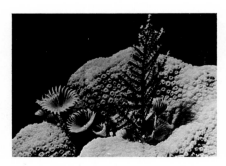

Tube-worms and hydroids growing among a star coral (*Montastrea annularis*)
Turks Islands, West Indies, Caribbean

Basket-star (*Astroglymma sculptum*, 1 m. high) on a sea fan.
North Eleuthera, Bahamas, Caribbean

A group of hydroids.
Palm Island, Grenadines, Caribbean

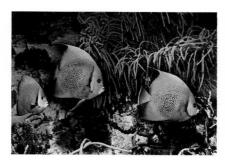

Grey angelfish (*Pomacanthus arcuatus*, 60 cm.).
Tortola Island, British Virgin Islands, Caribbean

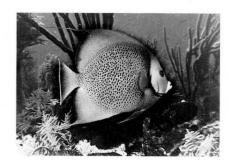

Grey angelfish (*Pomacanthus arcuatus*, 60 cm.).
North Eleuthera, Bahamas, Caribbean

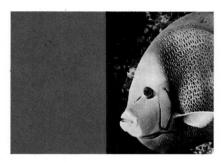

Grey angelfish (*Pomacanthus arcuatus*, 60 cm.).
North Eleuthera, Bahamas, Caribbean

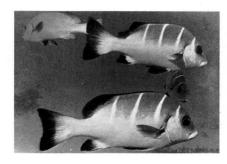

Playfair's sweetlips (*Plectorhynchus playfairi*, 70 cm.).
Turtle Bay, Kenya, Indian Ocean

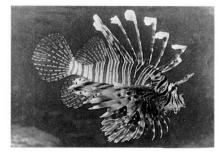

Dragonfish (*Pterois volitans*, 35 cm.). The long dorsal spines contain a powerful venom which can be dangerous even to man.
Sanganeb, Sudan, Red Sea

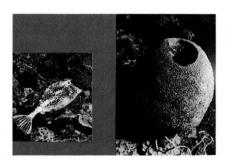

Left, Honeycomb cowfish (*Acanthostracion polygonius*, 35 cm.). Right, sponge with large opening for expulsion of water.
Turks Islands, West Indies, Caribbean

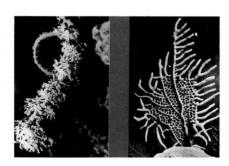

Left, the eight-armed, feathery polyps of a gorgonian belonging to the genus *Ellisella* (20 cm. high). Right, Stinging coral (*Millepora alcicornis*) overgrown by a gorgonian (20 cm. high). *Millepora* are hydrozoans with a calcareous skeleton.
Turks Islands, West Indies, Caribbean

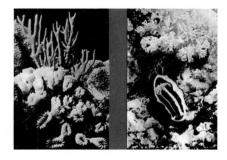

Left, in foreground, the Flower coral *Eusmilia fastigiata*; behind, Stinging coral (*Millepora alcicornis*).
Union Island, Grenadines, Caribbean
Right, the alcyonarian *Xenia* above, and a nudibranch (*Glossodoris quadricolor*, 3 cm.) below.
Mafia Island, Tanzania, Indian Ocean

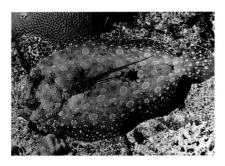

Male Peacock flounder (*Bothus lunatus*, 40 cm.).
Turks Islands, West Indies, Caribbean

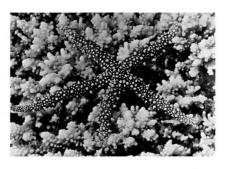

Starfish on stagshorn coral (*Acropora*, 10 cm.).
Torwartit Reef, Sudan, Red Sea

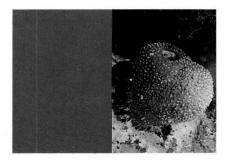

Small sponge (7 cm. high) encrusted with tiny sea-anemones.
Turks Islands, West Indies, Caribbean

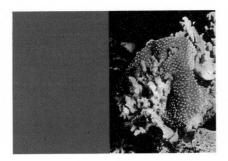

A sponge growing on the coral *Echinopora*, left;
and right, above, a finger coral (*Porites convexa*).
Turtle Bay, Kenya, Indian Ocean

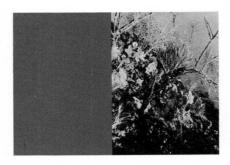

Various corals and sponges.
Grand Cayman, West Indies, Caribbean

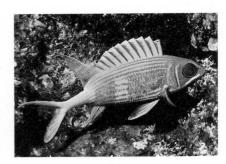

Longspine squirrelfish (*Holocentrus rufus*, 30 cm.).
Turks Islands, West Indies, Caribbean

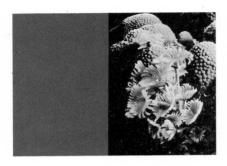

Tube-worms on a star coral (*Montastrea annularis*).
Palm Island, Grenadines, Caribbean

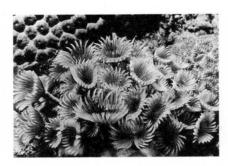

A group of tube-worms. Right, a star coral
(*Favia fragum*).
Palm Island, Grenadines, Caribbean

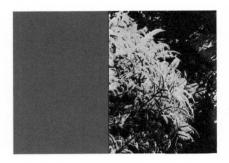

A group of hydroids (*Aglaophenia*).
Turks Islands, West Indies, Caribbean

A deepwater gorgonian (*Iciligorgia schrammi*)
covered with mucus.
Turks Islands, West Indies, Caribbean

Slender filefish (*Monacanthus tuckeri*, 4 cm.).
Turks Islands, West Indies, Caribbean

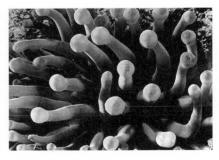

Tentacles of the large sea-anemone *Stoichactis*
with thousands of microscopic sting-cells.
Turks Islands, West Indies, Caribbean

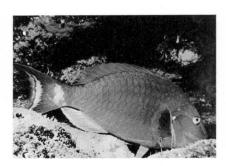

Stoplight parrotfish (*Sparisoma viride*, male,
60 cm.).
Turks Islands, West Indies, Caribbean

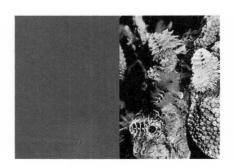

Tube-worms (*Spirobranchus giganteus*) on a star
coral (*Montastrea annularis*).
Peter Island, British Virgin Islands, Caribbean

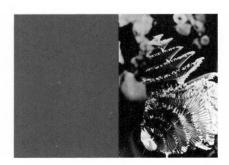

The spiral tentacle crown of the tube-worm
Spirobranchus.
Peter Island, British Virgin Islands, Caribbean

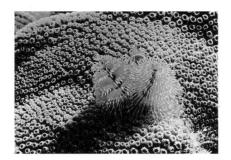

Tube-worm (*Spirobranchus giganteus*) and a star coral (*Montastrea annularis*). Union Island, Grenadines, Caribbean

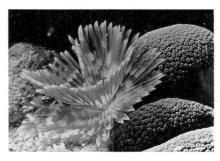

Tube-worm and a star coral (*Montastrea annularis*). Peter Island, British Virgin Islands, Caribbean

Tube-worm and a star coral (*Montastrea annularis*). Peter Island, British Virgin Islands, Caribbean

Eggs of an opisthobranch snail (*Oscanius*). Thousands of eggs are laid in mucus, which hardens into jelly-like bands. Turtle Bay, Kenya, Indian Ocean

Eggs of the shell-less snail *Oscanius* near leather coral.

Left, divers in a wreck overgrown with corals and sponges. Right, School of Smallmouth grunts (*Haemulon chrysargyreum*, 20 cm.). Palm Island, Grenadines, Caribbean

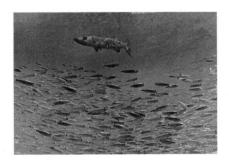

Barracuda (*Sphyraena barracuda*, 1 m.) with a school of False pilchards (*Harengula clupeola*, 10 cm.). North Eleuthera, Bahamas, Caribbean

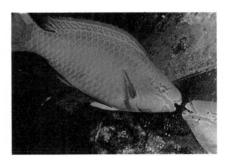

Queen parrotfish (*Scarus vetula*, male, 60 cm.). Salt Island, British Virgin Islands, Caribbean

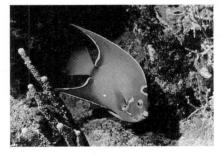

Queen angelfish (*Holacanthus ciliaris*, 45 cm.). Turks Islands, West Indies, Caribbean

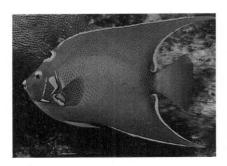

Queen angelfish (*Holacanthus ciliaris*, 45 cm.). Turks Islands, West Indies, Caribbean

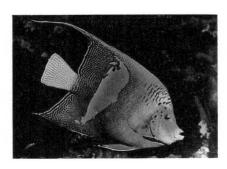

Yellowspot angelfish (*Pomacanthodes maculosus*, 40 cm.). Wingate Reef, Sudan, Red Sea

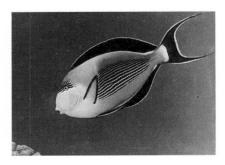

A surgeonfish (*Acanthurus sohal*, 30 cm.). Wingate Reef, Sudan, Red Sea

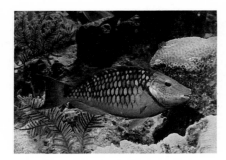

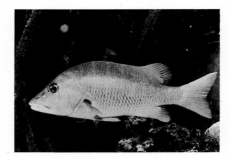

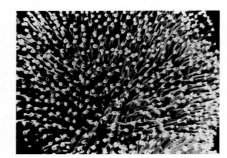

Stoplight parrotfish (*Sparisoma viride*, female, 40 cm.).
Turks Islands, West Indies, Caribbean

Schoolmaster (*Lutjanus apodus*, 50 cm.). This is one of the snappers.
Turks Islands, West Indies, Caribbean

Polyps of leather coral (*Sarcophyton*) with tentacles partly extended.
Sanganeb, Sudan, Red Sea

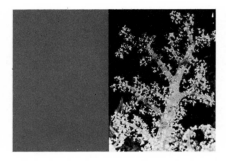

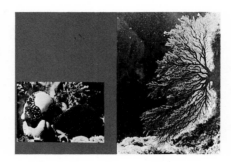

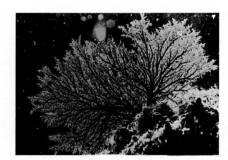

Soft or alcyonarian coral, *Dendronephthya*, with polyps extended. The tiny needle-like calcareous spicules can be seen on stem and branches.
Shab Roumi Reef, Sudan, Red Sea

Left, two white sea snails (*Amphiperas ovum*, 4 cm.) with a black-spotted mantle. Right, a gorgonian.
Turtle Bay, Kenya, Indian Ocean

A gorgonian.
Mafia Island, Tanzania, Indian Ocean

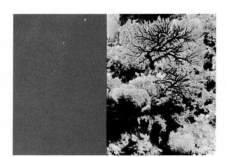

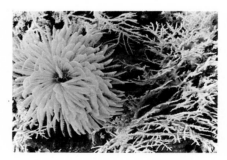

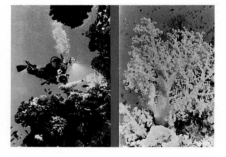

Gorgonians and soft coral.
Turtle Bay, Kenya, Indian Ocean

A tube-worm in among *Stylaster elegans*, a hydrozoan with a calcareous skeleton.
Turtle Bay, Kenya, Indian Ocean

Left, Leni Riefenstahl photographing a soft coral in the Red Sea with the aid of an electronic flash. Right, soft coral (*Dendronephthya*).
Sanganeb, Sudan, Red Sea

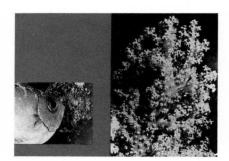

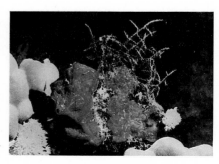

Left, Glasseye snapper (*Priacanthus cruentatus*, 30 cm.).
Palm Island, Grenadines, Caribbean
Right, Soft coral (*Dendronephthya*).
Sanganeb, Sudan, Red Sea

Left, Giant clam (*Tridacna maxima*). The edge of the mantle has light-sensitive tissue; the valves close when in shadow.
Shab Roumi Reef, Sudan, Red Sea
Right, Cock's-comb oyster covered by a sponge.
Turtle Bay, Kenya, Indian Ocean

Sponge and hydroids. Right centre and left, below, a coral (*Porites*); right, below, the alcyonarian *Xenia*.
Sanganeb, Sudan, Red Sea

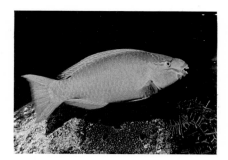

Queen parrotfish (*Scarus vetula*, male, 60 cm.).
Turks Islands, West Indies, Caribbean

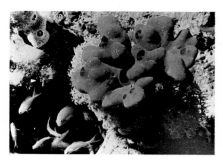

In this red sponge the pores and large openings are clearly visible. Water full of plankton is drawn into the sponge, where the plankton is removed and used as food. The small fish are Butterfly perches (*Anthias squamipinnis*).
Sanganeb, Sudan, Red Sea

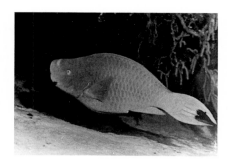

Blue parrotfish (*Scarus coeruleus*, male, 1 m.).
Turks Islands, West Indies, Caribbean

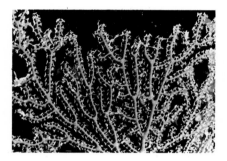

A gorgonian belonging to the genus *Lophogorgia*, with polyps extended.
Sanganeb, Sudan, Red Sea

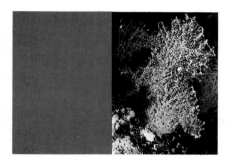

Left, a red gorgonian interwined with the long eight-tentacled polyps of a soft coral. Right, a red gorgonian (*Lophogorgia*).
Sanganeb, Sudan, Red Sea

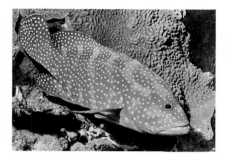

Coral trout (*Cephalopholis miniatus*, 45 cm.).
Mafia Island, Tanzania, Indian Ocean.

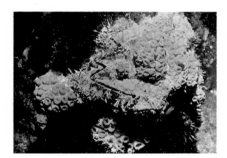

Colonies of coral (*Tubastraea*) growing on a Cock's-comb oyster (*Lopha*).
Turtle Bay, Kenya, Indian Ocean.

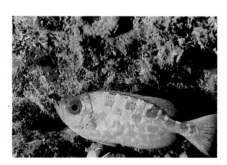

Glasseye snapper (*Priacanthus cruentatus*, 30 cm.).
Palm Island, Grenadines, Caribbean

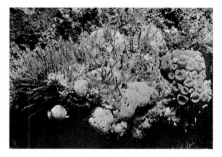

A bivalve overgrown with hydroids (pink), and right, a colony of the coral *Tubastrea*.
Turtle Bay, Kenya, Indian Ocean

The mantle edge showing between the valves of a thorny oyster (*Spondylus*). The valves close as soon as a shadow falls on them.
Mafia Island, Tanzania, Indian Ocean

Cock's-comb oyster overgrown with hydroids, sponges and coral.
Mafia Island, Tanzania, Indian Ocean

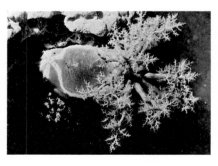

A sea cucumber (25 cm.). The long tentacles around the mouth are used for catching the small organisms on which the animal feeds.
Turtle Bay, Kenya, Indian Ocean

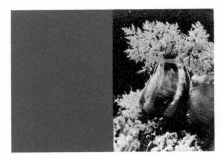
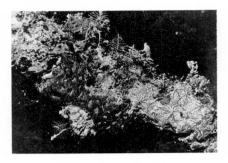
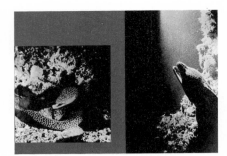

This photograph looks like a vase of flowers but it is in fact a sea cucumber (25 cm.), which is rarely found in these colours. Usually it is in shades of brownish-green. The tiny feet with which the animal propels itself forwards are clearly visible along the yellow stripes on the body.
Turtle Bay, Kenya, Indian Ocean

An underwater telephone cable overgrown with Cock's-comb oysters (left), small hydroids, a brownish-red coral (*Favia*), and a red sponge (*Spirastrella*)
Turks Islands, West Indies, Caribbean

Reticulated moray (*Lycodontis tessellata*, 1.7 m.).
Turtle Bay, Kenya, Indian Ocean

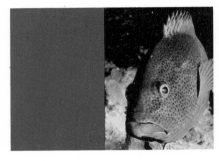
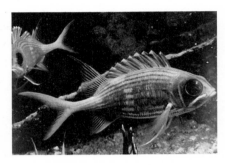
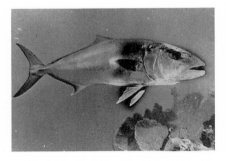

Blue-spotted argus (*Cephalopholis argus*, 45 cm.).
Salt Island, British Virgin Islands, Caribbean

Longspine squirrelfish (*Holocentrus rufus*, 35 cm.).
Salt Island, British Virgin Islands, Caribbean

Greater amberjack (*Seriola dumerili*, 1.5 m.).
North Eleuthera, Bahamas, Caribbean

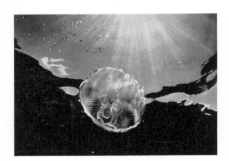
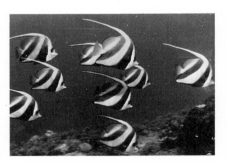
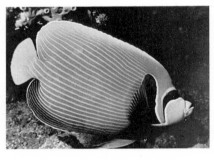

Common jellyfish (*Aurelia aurita*)
Peter Island, British Virgin Islands, Caribbean

Pennant butterflyfish (*Heniochus acuminatus*, 25 cm.).
Mafia Island, Tanzania, Indian Ocean

Imperial angelfish (*Pomacanthodes imperator*, 40 cm.).
Mafia Island, Tanzania, Indian Ocean

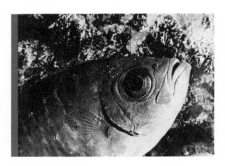

Glasseye snapper (*Priacanthus cruentatus*, 30 cm.).
Palm Island, Grenadines, Caribbean

The very venomous Hairy stingfish (*Dendroscorpaena cirrhosa*, 40 cm.).
Turtle Bay, Kenya, Indian Ocean

Hairy stingfish (*Dendroscorpaena cirrhosa*, 35 cm.). Natural camouflage makes this venomous fish almost indistinguishable from its surroundings.
Turks Islands, West Indies, Caribbean

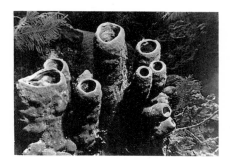

Pipe sponges (25 cm. high)
Turks Islands, West Indies, Caribbean

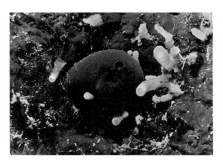

A spherical brown sponge between white and
red sponges.
Turks Islands, West Indies, Caribbean

Yellow beaker sponge (35 cm.). Below, coral
overgrown by a red sponge.
Turks Islands, West Indies, Caribbean

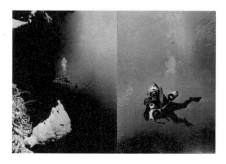

Left, this yellow sponge is the only one of this
colour found on the long outer reef off the Turks
Islands. It is found at a depth of 35 metres. Right,
Leni Riefenstahl with her underwater camera.
Turks Islands, West Indies, Caribbean

Barracuda (*Sphyraena barracuda*, 1.6 m.).
Turks Islands, West Indies, Caribbean

Left, a gorgonian belonging to the genus *Eunicea*.
Turks Islands, West Indies, Caribbean
Right, a finger-like sponge (*Axinella*) or possibly
a gorgonian.
Shab Roumi Reef, Sudan, Red Sea

Brightly coloured sponges and hydroids on the
wall of a deep outer reef.
Turks Islands, West Indies, Caribbean

Coral overgrown with sponges, hydroids and
green calcareous algae.
Turks Islands, West Indies, Caribbean

A hydroid with the polyps expanded.
Turks Islands, West Indies, Caribbean

Red sponge and colonies of sea-mats (*bryozoans*).
Turks Islands, West Indies, Caribbean

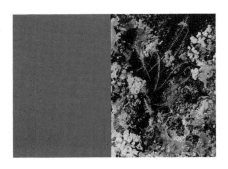

A feather-star, with sponges and coral.
Turks Islands, West Indies, Caribbean

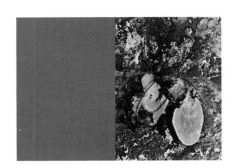

A feather-star, with sponges and coral.
Turks Islands, West Indies, Caribbean

ACKNOWLEDGEMENTS

My thanks are due to all those who helped me learn to dive, as well as fellow divers who helped me to become acquainted with the underwater world and to understand it.

Most of all I am grateful to Lufthansa, the German airline, who went to great trouble to help me prepare and carry out my diving trips. Their knowledgeable advice on the choice of interesting diving grounds was invaluable. I should also like to thank those many members of Lufthansa's air and ground crews who were so helpful about bringing photographic equipment on board.

Special thanks also to my colleague Horst Kettner, who attended the diving course with me and has since accompanied me on all my dives. He was not only my diving companion, and very much better at it than I, but he filmed and also looked after all my diving and photographic equipment.

I also thank the following:

Hermann and Jutta Paquet, whose diving course I attended and with whom I passed the test.

Günter and Gini Stolberg, with whom I made my first unforgettable dives off Turtle Bay Beach in the Indian Ocean, and under whose excellent guidance I became a confident diver.

Bertl and Lore Rung, with whose group I went diving on my first expedition to the Red Sea.

Dee Bellveal, Spyglass Hill, who showed me the finest diving grounds off the island of Roatan in Honduras.

Nancy and Roy Sefton, in Spanish Bay Reef, Grand Cayman.

Dr Steve Webster, Professor Kent Schellinger and Sally A. Adolph, marine biologists.

Bob Nose, St John, US Virgin Islands, with whom I made my most exciting dive.

George Marler, Tortola, British Virgin Islands, who showed me many interesting spots, particularly the *Rhône*, the most famous wreck in the Caribbean. He is also an excellent underwater photographer, and I was able to learn a great deal from him.

John Schultz, diving instructor of the Current Club, North Eleuthera, Bahamas, who introduced me to the mirror-reflex camera and the Oceanic camera housing.

Axel Pufahl, Mafia Island, Indian Ocean.

John Caldwell, Jr, Palm Island, Grenadines, Caribbean.

The lighthouse keepers at Sanganeb in the Red Sea, who were very helpful to me during my stay there.

Captain Abdel Halim Mohamed, who allowed me aboard his ship *Caroline* as a guest, thereby enabling me to dive on the finest reefs between Port Sudan and Suakin.

Phil and Kay Pruss, Grand Turk Island, West Indies, with whom for four weeks I made my last and unforgettable diving expedition. Thanks to Phil's enthusiasm and patience, I was enabled to take a large number of the photographs in this book.

Professor Dr Wolfgang Klausewitz, ichthyologist, Senckenberg Research Institute, Frankfurt-am-Main, who identified the fish and checked the nomenclature.

Dr Georg Scheer, biologist, Darmstadt, coral specialist, who wrote the captions for the coral photographs.

Consul W. Söhnges, who went to great trouble to ensure I had the correct contact lenses for diving. Without these I should have been unable to photograph underwater.

I should also like to thank Karl Anton and Anita von Bleyleben, Wilfrid and Karin Boemeleit, Georg Krose, Jan Breidenbach and Klaus A. Melzer.

PHOTOGRAPHIC INFORMATION

The photographs in this book were taken with the following 35 mm. cameras: Nikonos II: Nikonos III and the mirror-reflex Nikon F2S. With the Nikonos I used the lenses: U.W. Nikkor 15 mm.; Seacor Sea-Eye 21 mm.; U.W. Nikkor 28 mm.; W. Nikkor 35 mm. and the Nikkor 80 mm.

Until I had the mirror-reflex camera, I used a close-up lens, the 'Green Things II', plus an extension tube with the 35 mm. lens for scale reproductions of 1:2.

With the Nikonos cameras I used the optical viewfinders 'Sea-view III and IV' made by Seacor.

The mirror-reflex Nikon F2S was coupled to a motordrive and had an action prism-finder. I used it with the 24 mm. lens, the Micro-Nikkor 55 mm. and the Micro-Nikkor 105 mm.

The F2S was kept inside an underwater housing made by the American firm Oceanic Products. This underwater housing, made from a special alloy, together with its corrected ports and all the additional accessories, is an absolute necessity.

Apart from the Oceanic special underwater flash units, I also used other makes by Motz, Minolta and Rollei. All these were kept in various watertight plastic containers.

The reliability of all underwater flash units is of great importance. Even the best makes can be made useless by water damage. It is essential to have a spare unit always available. Repairs are impossible on remote islands and diving centres.

It is also of great importance to fix the flash units on to long flexible arms in such a way that they can easily be removed or adjusted. Only in this way can one cut out or at least reduce the unfavourable snow effect caused by the many particles floating in the water.

With adjustable flash units the best possible lighting for each individual subject can be created. But flashlight mounted right next to the lens will give flat and contrastless pictures in which the subject appears to be stuck on to the background.

A few photographs in this book were shot with two flashguns, of which one was used as a slave to trigger the other. This lighting technique achieves special effects.

I often used a slight colour correcting filter with the lens and the flash units to reduce a strong blue cast.

For filmstock I mainly used Ektachrome-X, besides Kodachrome-25, Kodachrome-64 and Ektachrome Highspeed.